FIGURES & FICTIONS
Contemporary South African Photography

STEIDL

V&A

FIGURES & FICTIONS

Contemporary South African Photography

Tamar Garb

Published to coincide with the exhibition
Figures & Fictions: Contemporary South African Photography
in the Porter Gallery, Victoria and Albert Museum, London
Curated by Tamar Garb and Martin Barnes
12 April - 17 July, 2011
Sponsored by Standard Bank

First published by Steidl and V&A Publishing, 2011

Steidl
4 Düstere Strasse
D37037 Göttingen
Germany
www.steidlville.com / www.steidl.de

Front cover: Zanele Muholi, *Martin Machapa*, 2006
Back cover top right: Pieter Hugo, *Pieter and Maryna Vermeulen with
Timana Phosiwa*, 2006
Back cover top left: Sabelo Mlangeni, *Madlisa*, 2009
Back cover middle right: Jo Ractliffe, *Roadside Gasoline Station near
Panguila*, 2007
Back cover middle left: Mikhael Subotzky, *Street Party, Saxonwold,* 2008
Back cover bottom right: Roelof Petrus van Wyk, *Young Afrikaner - a Self
Portrait, Yo-Landi Vi$$er Fig. 1*, 2009
Back cover bottom left: Zwelethu Mthethwa, *Untitled*, 2010

Design, Production and Printing by Steidl
Picture Research and Editorial Assistance by Orla Houston-Jibo

Hardback edition ISBN 978-3-86930-266-9
Paperback edition ISBN 978-3-86930-306-2

Printed in Germany

V&A Publishing

Supporting the world's leading
museum of art and design,
the Victoria and Albert
Museum, London

Contents

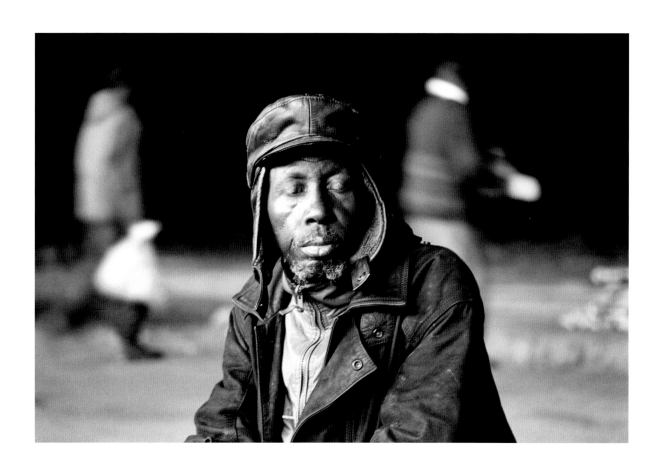

Santu Mofokeng
Eyes Wide Shut, Motouleng Cave, Clarens,
from the series 'Chasing Shadows', 2004

Foreword

by Martin Barnes
Senior Curator, Photographs
Victoria and Albert Museum

This publication, and the related exhibition being held at the Victoria and Albert Museum (V&A), highlights the work of seventeen South African photographers, all of whom live and work in the country and whose images were made between 2000 and 2010. Each photographer is represented by one or more projects that are linked by the depiction of people and a self-conscious engagement with South Africa's political and photographic past.

The project came about through lively discussions with the author of this book, Professor Tamar Garb. We compared already-known photographers and also discovered a wealth of new practitioners. This led first to the proposition of an exhibition, since no significant showing of such a range of contemporary photography from South Africa has so far been seen in the UK. In the spring of 2010, in the midst of the Icelandic volcanic 'ash cloud' and just prior to World Cup fever, we visited Cape Town and Johannesburg, meeting with photographers and their galleries. We were profoundly impressed by the articulate, passionate and knowledgeable dialogues that they had with each other, their medium and their history. The character of those initial conversations is captured in the illuminating photographers' interviews, and the round table discussion, carried out later by Professor Garb, that appear in this publication.

Given the wealth of quality material, and the knowledge of other recent surveys of South African photography, it quickly became clear that focusing on a specific theme and delimiting our selection criteria would allow, on a practical level, for a more coherent exhibition and book as well as for new insights and sharper comparisons. The emphasis on the human figure is proportionate to the greater number of photographs showing people (rather than landscapes, buildings, still life or other genres) that are made by the most engaging photographers in South Africa. Photographs showing figures raise pertinent issues of identity: about how the gaze of the camera, photographer and viewer is returned by the subject, and the balance of power that that interaction implies.

Of course, as elsewhere, many different forms and genres of photography exist in South Africa, from photojournalism to advertising and from wildlife to sports. What concerns this publication and exhibition, however, is largely in line with the V&A's focus on the art rather than the technology or practical application of photography. This is also the predominant criterion of the Museum's permanent collection (begun in 1856, the oldest and one of the most important museum collections of photographs in the world) and its exhibition programme. Many of the photographs in *Figures & Fictions* find their wider contexts not only in museum exhibitions

or collections, but in commercial galleries, international art fairs and publications. For the status of South African photography, it has been a timely coincidence that the post-apartheid period coincided with the rise to prominence, that began in the 1990s, of photography in the international contemporary art world. While some of the photographers featured in this book have gained a footing in that sphere, others have just begun to emerge there. All of them, however, are connected and in dialogue with international photographic genres and contemporary photographic practices. The methods of distribution, presentation and printing techniques open to photographers have expanded rapidly in the last ten years, offering traditional chemistry-based black and white and colour processes alongside digital technologies, and options of print size and framing styles from the spectacular to the intimate. The photographers selected here make deliberate choices of formats and styles as part of their nuanced language, giving the best fit for the ideas and associations they wish to express. While large-scale single prints may suit the warehouse-type spaces now often set aside for the display of contemporary art, much of the meaning of photographers' works is enhanced when seen in series, usually conceived as an essayistic sequence, often in a book. Many of the works shown in this book are republished extracts from such extended sequences, but can nevertheless be understood as fragments containing the essence of these whole series. They are also sometimes selected as grids or lines of images hung in a gallery, and occasionally as single representative images.

The dynamism and urgency surrounding photography in South Africa today is partly explained, perhaps, by the coincidence of a high proportion of talented practitioners, educators and galleries in mutually supportive debate and dialogue, but also by its local context: embedded in colonial history, ethnography, anthropology, journalism and political activism, the best photography emerging from the country has absorbed and grapples with its weighty history, questioning, manipulating and revivifying its visual codes and blending them with contemporary concerns. Post-apartheid, complex and fundamental issues – race, society, gender, identity – remain very much on the surface. This is reflected by image makers who harness the resulting scenes as a form of creative tension within their personal vision. Here, distinctive photographic voices have emerged: local in character and subject matter, but of wider international interest because of their combined intensity. The works featured in these pages do not rely on special pleading because of the specific situations in South Africa that they address. Instead, they arguably take their place among the most engaging and thought-provoking works of expressive photography that have been made anywhere during the last ten years.

In much of Western Europe and North America – where the canon of photographic history and the standards of judgement have traditionally been seen to reside – the strategies for making creative or artistic photography have relied increasingly on a combination of the following: formal aesthetics or craft; a knowing assimilation or subversion of genres such as photojournalism and documentary practice; the embrace and manipulation of celebrity, fashion or pop culture; art market forces; and post-modern ideas of performance, pastiche and self-reflection. There can be few other places outside of this European–American axis as in South Africa, where these ideas are utilised and combined alongside social and individual issues that seem raw, real, and

therefore to offer a heightened experience. This vivid quality is enhanced particularly in the eyes of an audience unfamiliar at first hand with this extraordinary place, its history and events. The challenge here is not to fall back on a version of exoticism, or to misjudge visual intent through lack of specific knowledge, but to re-imagine the axis for a global society without losing sight of locality.

Among many other issues, the thorny dialogue and delicate balance between the specific and the universal (and, by implication, local or global interest) is something that is of concern to many of the photographers featured here. As David Goldblatt elucidates in his interview: 'I'm always concerned with the particular: the particularity of the particular. It's the attempt to be intensely engaged with the particular that propels me, because that's essentially what the camera does, and I think it's presumptuous and dangerous to think that you are making universal statements.' Equally at stake is the threshold between documentary photography and fine art practice. If documentary could be understood as an engagement with the particular, then perhaps fine art practice stands for the universal. This is a pivotal position that much photography on the international stage finds itself addressing presently; but in South Africa the polarities seem greater or of more contrast. For Pieter Hugo: 'It's about looking for new ways of conveying truth... I'm not particularly interested in giving an itinerary of facts or recording reality but more in capturing something that's really engaged: a type of ecstatic experience where one looks at the pictures and one experiences truth, even if it's not the truth of an accountant.'

As the *Fictions* part of this book's title implies, it points not just to the geographical and social specificity of these photographs but also to the enigmatic relationship with the 'real' world that they seem to depict. One of the most compelling aspects of photography is its capacity to tangle fact with fiction. It is here, when handled consciously, that subtle creative possibilities abound. A photograph is always a translation, distillation or filter of reality seen from the physical and conceptual standpoint of the person creating the image – as well as that of the viewer. Santu Mofokeng acknowledges: 'I started seeing photographs for what they are; as representations and not as substitutes for reality – meaning, they are already a fiction.' The *Figure* part of this book's title can also be understood to imply not only the human figure but also the metaphorically figurative. Photographs can be like a 'figure' of speech, composed of familiar words but containing an ambiguity between literal and figurative interpretation.

As photography continues to be an expanding field of exciting possibilities, South African photographers have taken their places at its forefront. Professor Garb's book gives an eloquent and erudite overview of the historical, social and aesthetic contexts of South African photography, as well as in-depth and revealing readings of the seventeen selected photographers' projects. I am indebted to her insightful facility with both the wider art historical and the political positions surrounding these images. Working together has been a rare learning experience and a pleasure. The legacy of the exhibition in the form of this book will no doubt continue to be as challenging and important as it is illuminating.

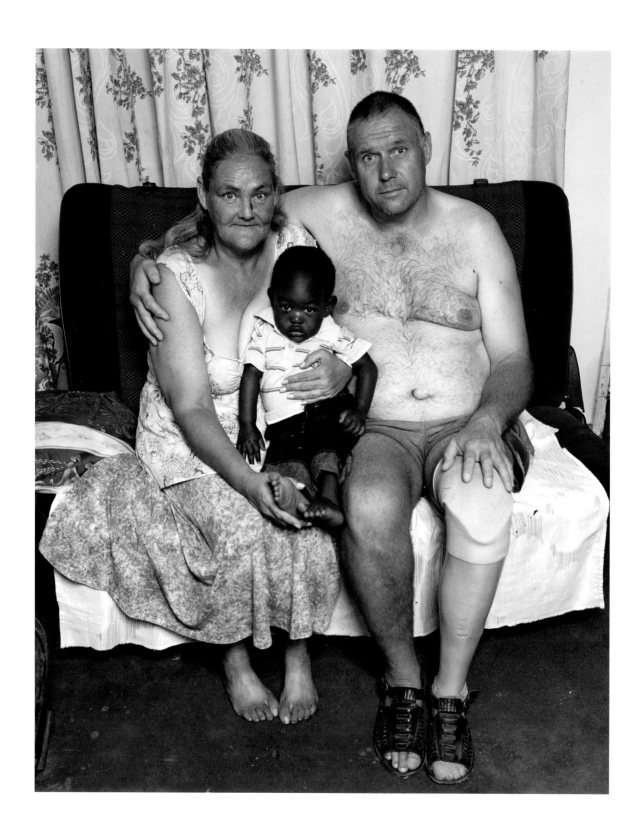

Pieter Hugo
Pieter and Maryna Vermeulen with Timana Phosiwa,
from the series 'Messina/Musina', 2006

Figures and Fictions:
South African Photography in the Perfect Tense

Tamar Garb

it has been written that all of us will change like words
in the future tense as well as in the past tense
in plural as well as in loneliness
we are into the perfect tense

and are learning how blood turns into blindness
when the heart shines into it -

Antjie Krog, 'marital song 1' (2006)[1]

In her poem on mature love, the South African poet Antjie Krog plays with the grammar of time and person. To be 'into the perfect tense' is to inhabit a moment in the 'now', made possible by an awareness of what has been before, and to imagine a future which will have been through (if not surpassed) its effects. Above all it is a tense in which temporalities collide and the business of the past is never completely over and done with. Krog's poem likens people to words, conjugated like verbs and transformed not only by historicity but also by number and place. Out of the interweaving of the singular and plural, the interdependence of 'I' and 'We', comes learning and love, she suggests, as people, like weathered words, adapt and change in time.

Krog's model of interwoven temporalities could just as well be applied to photographs, and the invocation of a tense which is always negotiating the past in the present (or the future) provides a useful metaphor through which to think about the way in which the 'contemporary' suggests a moment of suspension between what has been and what is imagined to be coming. Photographers working now play with time-bound traditions of depiction – invoking, refusing or embracing them – in order to position themselves in relation to the ever-pressing exigencies of the present. More than anything, it is this awareness of photography's history – its genealogies, vocabularies and conventions – that furnishes South African photographers with a supreme self-consciousness about the languages and modes of picturing they deploy.

From its earliest inception, photography in South Africa has depicted people. And it has filtered their representation through three dominant categories of representation, each carrying with it institutional and cultural associations. Frequently referenced is the anthropological and ethnographical past that has provided the conceptual framework through which Africa's

peoples have routinely and repeatedly been pictured. Vexed, controversial and compromised, this massive and complex archive, still only partly uncovered and understood, has become part of the material culture of the present, ripe for appropriation, reappraisal and critique. Its fictive languages – ways of dressing up, adorning and delivering its subaltern subjects – function like figures of speech to manage and master the unknown. For South Africans, the pressure of this tradition weighs heavy. Closely associated with racial essentialism, so crudely manifest under apartheid's rule of law, which policed difference according to its own invented categories, it is this mode of packaging alterity that is most readily open to ridicule or revision. But other figural traditions have also left powerful legacies. Ever present and pervasive are the protocols and conventions of portraiture, with their origins in modern European individualism but uniquely adapted and reinvented in African contexts and practices. Where the ethnographic deals in types, groups and collective characteristics, portraiture purports to portray the unique and distinctive features of named subjects whose social identities provide a backdrop for individual agency and assertion. But the performative nature of posing and the possibility of fabricating a fictitious and fabulous self for the camera introduce doubt into the veracity of the figural, so that portraits too may become sites of projection, fantasy and play. Countering the fictions and fancies of these overtly dressy genres is the sobriety and gravitas associated with social documentary photography, until recently regarded as the privileged pictorial means for revealing injustice through the representation of lived experience. With its specific ethical and political valences as the privileged oppositional genre to apartheid, documentary, arguably, still hangs over the contemporary as the truth-telling genre *par excellence*. But its own formal languages are now also being opened to question so that the reality that it constructed is beginning, itself, to be understood as partial, interested and particular.

These filters of figuration – ethnography, documentary, portraiture – continue to haunt contemporary practices. No ambitious contemporary figural photographer in South Africa works without taking cognisance of one or other of their legacies, whether to honour, refute or mimic them. This is as true for those working in post-modern reappropriations of the attitudes and poses of the past as for those adapting and reworking traditional technologies and techniques or composing new identities on camera. To depict people in this place is to participate in this pictorial history – in fact it may even be a way of writing that history – so that the fictions and fantasies of the present (as manifested in the figures and phantoms that are pictured) are always in dialogue with the residues of these traditions.

Pieter Hugo's group portrait *Pieter and Maryna Vermeulen with Timana Phosiwa*, 2006 (page 10) provides an interesting focal point for thinking through some of these issues. The photograph consists of three figures, posed frontally on an old and battered car seat, in their clean if tattered interior. Arranged like a traditional domestic portrait (frontally and formally posed), the mutilated and impoverished couple supports a young child on their adjacent laps, enfolding his vulnerable presence between them. Monumental in scale and rendered in excruciating detail, the photograph shows Pieter's prosthetic leg and podgy torso, Maryna's scabbed nose and incongruously manicured nails, as well as the op-art patterning of the upholstery and the

torn but spotless white cloth on which they sit. A democratising overallness of focus renders each bit of the image equally significant. But, at the same time, the whole orchestration of the photograph seems to frame the dramatic event which is at its heart: the tender cradling of a black child on the bodies of an ageing and ailing white couple, their flesh pressed against one another, tiny shoulder pushing on sagging breast, a brown ear hovering alongside a pink manly nipple. It is this conjunction of peoples and situation that sets the mind wondering. Who is this grouping? Where are they situated? How do they come to be so represented?

I will leave the unravelling of the picture's story to later in this essay.[2] For now, it is more pertinent to wonder about the broader historical narratives that its figural density presents. The composition reads as a family grouping, despite the difference in names that the title of the picture betrays. Given its identity as a South African photograph, this mode of presentation has particular resonance. The picture cannot help but invoke the previous ban on interracial cohabitation, let alone adoption, and the emotional intensity and physical proximity of the threesome is inevitably read against this backdrop. Skin against skin, flesh against flesh, the racial difference of the sitters is at the heart of the picture, countering past prohibitions with an almost utopian, humanist ideal. In fact, the group seems to speak to a desegregated future built on the scarred and mutilated corporeal wreckage of an earlier period. Countering the physical decrepitude of the couple is the apparent plump and promising wellbeing of the infant and the direct open warmth of three pairs of eyes, which, unashamed, look out at the viewer. Even if poverty has laid these adults low, they have learned, in Krog's formulation, 'how blood turns into blindness when the heart shines into it', and the emotional intensity of their union offsets the paucity of their circumstances. Or so the picture leads us to believe.

As a picture, *Pieter and Maryna Vermeulen with Timana Phosiwa* partakes of a number of figural conventions that invite us to read it in this way. Informed by pictorial precedents, from religious oil painting of holy trios to domestic portraiture in which named individuals – however humble – proffer themselves for portrayal, the picture projects a quiet dignity and enshrines the particularity of the sitters. With the prosaic and simple set-up of the portrait – there seems to be little pretence, subterfuge or gratuitous dressing up – it invokes the conventions of documentary photography, presenting its protagonists as if unadorned or embellished with artifice and facing the camera head-on. That the palette is carefully controlled in the process of printing so that bodies are illuminated, skin tones adjusted and textures emphasised, does little to undermine the reality effect that this kind of image projects. Hugo's picture, therefore, knowingly engages with the conventions and conditions of portraiture as well as the documentary tradition, even if it transforms them into larger-than-life, billboard proportions on the gallery wall. But Hugo's work also addresses the relationship of the photographer to subjects drawn from a particular group – in this case residents of the border town Messina/Musina – whom he sets out to record and document, not only in their individuality but as representatives of a community or culture. In this sense, Hugo's project can be thought of as ethnographic, the portrait of the Vermeulens and Timana operating as one amongst a number of pictures joined under the sign of a place to which he does not entirely belong.

Contemporary figural photography in South Africa, therefore, is the product of these interweaving and complex pictorial traditions that continuously jostle and rub up against one another. In fact it is almost impossible to keep them apart, as the modalities of figuration of which they partake have become as much the subject of photography as the worlds they purport to construct. But historically they have somewhat different trajectories and, in the context of southern Africa, their developments, whether institutional, cultural or formal, are worth tackling separately in order to identify the overlapping pictorial rhetorics to which artists working with photographs now have recourse.[3]

The camera was introduced to Africa very soon after it was invented in Europe, and photographic studios appeared in cities from Cape Town to Cairo from the middle of the nineteenth century.[4] While portraits of Africans proliferated, at the same time a demand for typological images of 'natives' emerged in Europe, producing a lexicon of 'exotic' and 'primitive' prototypes and pseudo-scientific 'specimens'. The intricate and intertwined histories of photography, anthropology and ethnography are well documented.[5] The context in which their mutual histories collide and coincide is European colonial expansion and the concomitant encounter with cultural difference that such a project entailed. Hierarchical notions of race joined modern technological inventions, of which photography was one, to manage and comprehend the ineluctable difference of cultures and peoples that the colonised world presented. Photography's purported veracity and realism made it perfectly suited to the positivist claims of new disciplines seeking credibility as science. But photographs themselves registered ways of seeing and imagining the world, according to conventions and perceptual filters, which produced as much as copied the realities they set out to picture. Whether conceived as reliable records of the past or as palimpsests of fracture and friction, such images form part of the ethnographic and racial imagination that still furnishes conceptions of the present.[6]

The development of anthropological and ethnographic photography in Southern Africa has left a vast and complex archive. Nevertheless, certain pervasive image types and bodies of work have gained visibility amongst contemporary artists, and have become exemplary of a highly contested mode of looking. Early European photographers in Africa habitually confronted the people around them by subjecting them to the ordering protocols of posing, invariably situating them outdoors, in front of characteristic dwellings or in a landscape which is perceived as their 'natural habitat'. The recurring ingredients of exotic costume and staple accoutrements – feathers, shields, cloths, animal skins and beads – arrayed on or alongside semi-naked bodies, found their way onto postcards and tourist brochures *ad nauseam* throughout the colonial period (and are still to be seen today). (Figs 1–5) Standard positions and postures were circulated: semi-reclining or seated half-naked women, bedecked in beads, strutting or standing men sporting weapons and shields, each simply and statically posed to reveal body type and carefully chosen appurtenances. Anonymity is the hallmark of these figures. They have no names, no individuality,

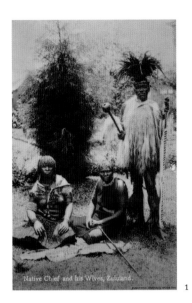

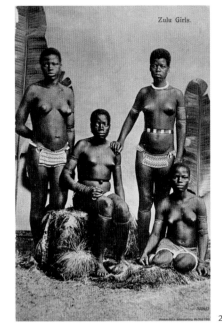

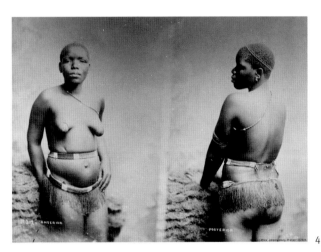

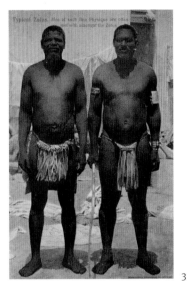

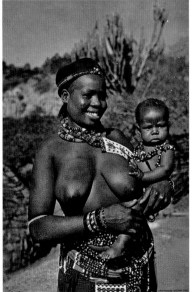

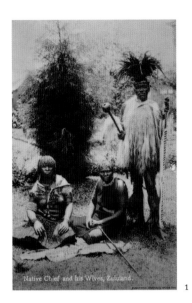

Fig. 1 Unknown, *Native chief and his wives, Zululand*, n.d.
Fig. 2 Unknown, *Zulu Women*, n.d.
Fig. 3 Unknown, *Typical Zulus: Men of such fine physique are often met with amongst the Zulus*, n.d.
Fig. 4 Unknown, *Zulu Women (Posterior /Anterior)*, n.d.
Fig. 5 Unknown, *Zulu Cosmetic Practices, African woman and infant*, n.d.

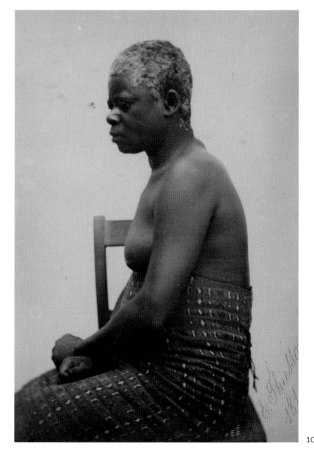

Fig. 6 Candice Breitz, *Ghost Series #4*, from 'Ghost Series', 1996
Fig. 7 Zanele Muholi, *Miss D'Vine I*, from the series 'Miss D'Vine', 2007
Fig. 8 Zanele Muholi, *Miss D'Vine II*, from the series 'Miss D'Vine', 2007
Fig. 9 Zanele Muholi, *Black Beulah*, from the series 'Beulahs', 2006
Fig. 10 E. Thiésson, *Native Woman of Sofala (Mozambique), 30 years old
with white hair*, 1845

no identifying idiosyncrasies. Instead it is race that marks and defines them as 'native types' and ethnic exemplars. This is the stock-in-trade of colonial kitsch that served to naturalise perceptions of Africans as close to nature, belonging to an earlier stage of civilisation and imbued with a sexuality and subjectivity that is ineluctably different from that of the colonising Westerner.

It was this imagery that was so controversially used by artists such as Penny Siopis and Candice Breitz in the mid-1990s in their iconoclastic appropriations and reworkings of standard colonial curiosities, in order to expose the stereotypes and ciphers that 'coloured' pervasive images of blackness.[7] Breitz, in particular, used photomontage and enlarged Cibachrome prints in her 'Ghost Series' (1996) to re-present standard tourist postcards, with the bodies now whitened out so as to invert the conventional colour coding of skin and denaturalise the signs of race. (Fig. 6) It was works like these that caused some critics to complain that white women, however well-intentioned, were still drawing on the spectacular display of black women's bodies to construct their own critical practice and in so doing denying their historic collusion in the oppression of their objectified sisters.[8] But the exoticising props and accessories of popular culture remain ripe for reworking and ridicule and are used to different ends in the gender scrambling performances of Zulu boys in beaded skirts and braided hair, playfully exposed and exploited by Zanele Muholi. (Pages 186, 187) Here exotic plastic jewellery (cheap reworkings of tribal treasures) is gaudily combined with gym slips, net skirts and hair combs (resonant of apartheid-era race-tests which assessed the frizziness of hair as a criterion of 'colour') so that the inherited iconographies of ethnicity and sexuality are simultaneously performed and deflated and signs of modernity and indigeneity are intentionally and subversively blurred.[9] The colonial archive is raided to effect, as are the worlds of 'wildlife' photography, fashion magazines and tourism in her series 'Miss D'Vine', which uses 'natural' backdrops as settings for cross-dressing urbanites, incongruously set in the 'wild'. (Figs 7, 8) The related image of *Martin Machapa*, on the other hand, situates him in an urban setting, but combines a jauntily perched trilby and provocative bare midriff with a patterned choker that stands for traditional 'African' ornament while underlying the androgyny of its young and trendy wearer. (Page 185) In Muholi's hands, photographic history provides a resource, not only of critique but of play. Deadly serious about the visual clichés of an oppressive iconographic tradition, she, like the people she portrays, feels free to use them as she likes, exposing their ethnic essentialism while queering their mode of address.

As these projects reveal, it is the visual culture of the past that provides the material for poetic and parodic subversions. Amongst the earliest extant photographs taken in southern Africa is a picture of an African woman.[10] (Fig. 10) Already here, in this tiny daguerreotype, we see the familiar juxtaposition of bare breasts and semi-naked, cloth-bound, brown body that was to bec repeatedly circulated as the overriding icon of African femininity. Produced by the French philosopher/ photographer E. Thiésson, entitled *Native Woman of Sofala (Mozambique)*, 1845, it presents a figural fantasy, both bestial and beautiful, at once 'noble savage' and neo-classical allegory.[11] The sitter appears without agency or will. Scrawled behind her lower back sits the signature of the image-maker, his cursive authority imprinted alongside the patterned cloth that wraps around her body. This underlines the conditions of production that frame the figure: the hyper-visibility of the female body functioning as the vehicle for the philosopher's will-to-know; the racially marked,

apparently timeless corporeality of her flesh juxtaposed with the proper name and the date of her capture on camera. It is the habitual exposure of the black woman's body to the prurient curiosity of the observer that is resisted in the veiled anonymity of Berni Searle's enigmatic triptychs, *Once Removed* (2008). (Page 207) In Searle's staging of her own body for her own camera, face and breasts are shrouded, so that her head, surmounted by a drenched wreath from which dye seeps gradually into her veil, staining and soiling its whiteness, can neither be seen nor perused. Nor, for that matter, can her wrapped torso, with its gently proffering hands and damp rosettes which drip and deposit their liquid effluence onto both the cloth and the floor beneath, spoiling the pristine perfection of the pose (and the colonial phantasm of the feminine) and marking the body with fluids – both violent and visceral in feel.

While Searle's reference to ritual, performance and the ethnographic is oblique and suggestive, her own body providing the armature for an enigmatic and inscrutable display, Muholi takes on the taxonomies and trappings of colonial and contemporary visual culture in a more direct and overt way. In the 'Beulahs' series (Pages 185–187) she references a type of picture-making that, at its most crude, promoted a set of recycled ingredients designed to record and characterise groups conceived as separate biological entities, although it is a generic exoticism, encapsulated in popular culture rather than the rigours of anthropometry (with its calibrations and measurements of difference) that her series addresses and undermines. It was the German anthropologist Gustav Fritsch who was amongst the first to envisage using photographs to catalogue the 'natives' of South Africa for classificatory and 'scientific' purposes. And it is to his photographs – and the modes of portrayal that they represent – that artists now refer for an exemplar of crude nineteenth-century racial profiling. No doubt they fit the bill: their conventions of posing were to become standard in anthropometric mug shots (later to morph into the identikit photos so pervasive in modern culture), and Fritsch arranged his isolated sitters like biological specimens, positioning them facing the front or in profile, without gesture or expression, so as to capture generic traits and features.[12] Small wonder that they serve as prototypes of a formulaic, classificatory set of conventions harnessed to a racialised discourse. But Fritsch's actual photographs seem to exceed the instrumental goals of his project. For, despite their uniformity of pose, no two figures in his panoply look the same, and the soft light that bathes their features renders each with exquisite particularity. In addition, Fritsch sought, at times, to convey something of the cultural specificity of his sitters, through ornament, costume and accessories as well as snippets of biographical information. On the backs and mounts of the prints are notes, naming the sitters, their homes and familial ties. (Figs 11–15) In these hastily scribbled inscriptions, whole family histories are suggested at the same time as they are subsumed into the delimiting nomenclature of paternalism. There is no doubting the racialised filter through which Fritsch viewed his subjects. He was, like the physical anthropologists who followed him, interested in the recording of 'types'.[13] For all this, in his hands, photographs *were* capable of registering difference in touching details which exceed the imperatives of classification. Accompanied by individualised ornament and dress, these features suggest the language of portraiture rather than the coercive typologies of race.[14]

11

12

13

14

15

Fig. 11 Gustav Fritsch, *Booi, Zulu, Harrismith (Album 167, no 14163)*, 1863-1866
Fig. 12 Gustav Fritsch, *Piet Nero, Griqua, Harrismith (Album 167, no 14140)*, 1863-1866
Fig. 13 Gustav Fritsch, *Booi, Zulu, Harrismith (Album 167, no 14163)*, 1863-1866
Fig. 14 Gustav Fritsch, *Secheli, Chief of the Bakuena (Album 167, no 14180)*, 1863-1866
Fig. 15 Gustav Fritsch, *Sibilo, Son of Secheli, Chief of the Bakuena (Album 167, no 14181)*, 1863-1866

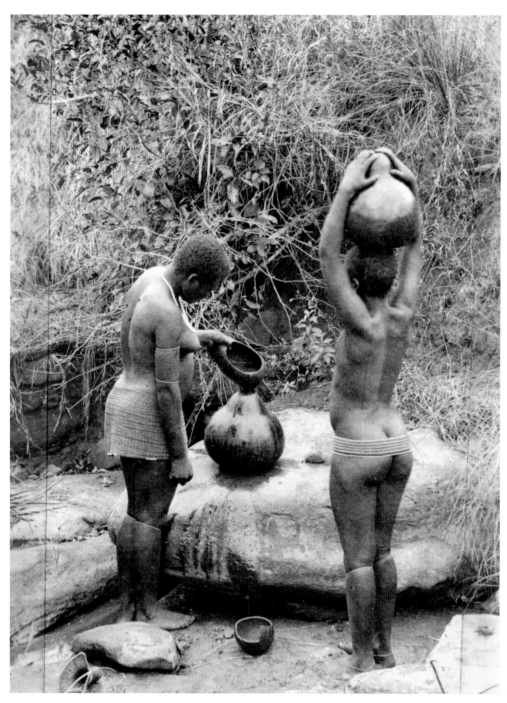

16

Fig. 16 Alfred Martin Duggan-Cronin, *At the Well*, 1920

The negotiation between portrait and prototype dramatised within Fritsch's archive is instructive. Where taxonomies and typologies diminish and destroy difference, portraiture foregrounds and celebrates it. Photography has long played with the competing demands of the typical and the unique. To investigate a set of figures is to explore the serial and the repetitive, as Fritsch so clearly did, but within this overarching framework there is room for individuation and specificity. It is here that boundaries are blurred. Anthropological studies are particularly marked by these competing claims. Photography provided an efficient means through which the unfamiliar inhabitants of the colonised world could be organised into apparently coherent entities and groups for scrutiny, study and delectation by outsiders.[15] In fact it often provided the ground of their intelligibility, and the generic took precedence over the particular. But sometimes the photographs captured distinctive and unique physiognomies and features, and it is possible that empathy was also in place, despite the display of difference and the play of power that exposure to the camera entailed.

An interesting case in point is provided by the enormous body of photographs produced by Alfred Martin Duggan-Cronin, an Irish employee of De Beers Consolidated Diamond Mines, whose work is the subject of scrutiny by many South African artists and scholars today. Duggan-Cronin is not easy to pigeonhole. He is most famous for his compendium of idealised types, *The Bantu Tribes of South Africa*, published in four volumes with accompanying texts between 1928 and 1954. The volumes, organised into eleven population groups, were intended to stand as 'records' of declining communities whose 'racial purity' and tribal customs were perceived as threatened by modernity and miscegenation.[16] In order to preserve the image of traditional societies and subjects, Duggan-Cronin routinely supplied the appropriate accessories and costumes that his figures lacked from his store of 'native' props, so that familiar items appear and reappear. The resultant photographs produce a mythic image of an idealised natural world, peopled by groups of figures decorously posed. These compositions are interspersed with statuesque single figures and head shots, placed against indeterminate settings, designed to demonstrate costume and typical features. All the images are accompanied by captions, narrativising their content and providing commentary on social and cultural mores. *At the Well*, taken from the volume *The Nguni, Section III, The Zulu*, for example, shows two young women from the rear, engaged in fetching water, which is described in the caption as 'arduous' but affording 'an opportunity for social intercourse' and 'courtship'. (Fig. 16) Weaving its own fiction around the figures, the explanatory text serves to romanticise their task and explain it in relation to what are perceived as age-old social rituals, while the bodies of the women, seen from side and back, recall standard European conventions of eroticised display.

Perceived in Santu Mofokeng's words as 'flora and fauna', the subjects in Duggan-Cronin's photographs appear as part of nature, docile and subservient to the invisible presence that records them, and immune to the industrialisation and modernisation that surrounded them.[17] It was images like these that prompted Mofokeng to construct his counter-archive, 'The Black Photo Album', a repository of scanned and re-printed portraits of modern and urban Africans, far removed from the pastoral portrayals and primitivist stereotypes of compendiums like

Duggan-Cronin's. (Figs 17–21) Rather than tampering with or defacing the received iconography of colonialism, Mofokeng bypasses it by reproducing found photos taken from the drawing rooms and cabinets of the townships and cities. Conceived in the early 1990s, as the apartheid system was crumbling and he was having to rethink his role, Mofokeng produced an alternative inventory of subjects, to resist the pervasive and ongoing circulation of images of blacks as an exotic and wonderful species, arrested in an earlier timeframe. In his celebratory reframing, the Victorian and Edwardian documents testify to the existence of his smartly-clad figures, who proudly engage the viewer and present themselves to the camera. Posing for posterity in their Sunday best and carefully-chosen costumes, these figures tell a vastly different story – not only about the history of photography but also about black lived experience – from the mythic immersion in nature that ethnographic endeavours favoured. A project of retrieval, of salvage, Mofokeng's recycling brings to visibility a visual culture long repressed beneath the pastoral fantasies of European visual anthropology and ethnography. At the same time it invents a new tradition – an alternative mnemonic lineage – that posits a metropolitan and urban trajectory on which to found an empowered black subjectivity.

There is no doubt that Duggan-Cronin's works should be seen against this background. His entire project depended on a way of looking that presupposed a profound split between his own cultivated European sensibility and what he saw as the innate beauty and simplicity of his depicted African subjects. But even Mofokeng has suggested that Duggan-Cronin's photographs, though symptomatic of their time, cannot simply be seen in relation to their overt and avowed use.[18] In fact their meaning shifts depending on the context and situation of viewing. As pictures, they are often more complex than their instrumental function would indicate and have recently been embraced as documents that testify to the 'dignity' and 'individuality' of their sitters by Nelson Mandela himself. Reading them as portraits rather than as prototypes, Mandela saw them as 'a matter of national pride' and a tribute to South Africa's diversity. What is more, they have functioned as valued records of ancestors by some of the descendents of those pictured who have been happy to affirm and acknowledge them.[19] There is nothing disinterested about this embrace of the past. No doubt it comes with its own political agendas. But it does wrest the photographs away from either the ethnographic or the aesthetic frame in which they have more often been viewed.[20] And it also opens to question the conventional post-colonial critique to which they have more routinely been subjected.

In fact Duggan-Cronin's oeuvre far outnumbered the illustrations for either the *Bantu Tribes* or his other volume, *The Bushman Tribes of Southern Africa*, which he published in 1942.[21] And even amongst the published pictures, contradictions and inconsistencies abound. They do not all do the same thing. *Modern Dress*, for example, which appeared in the volume on the Zulu, presents, as the caption tells us, men dressed in a hybrid costume of 'ornamented European cloth which is worn round the body under the bead ornaments', shot in sharp focus so that all their specificity is emphasised against the gradually fading field. (Fig. 22) True, these signs of modernity appear alongside traditional accessories and in the indeterminate location of nature, but they nevertheless depict sartorial adjustment and adaptation, proudly and majestically

17

19

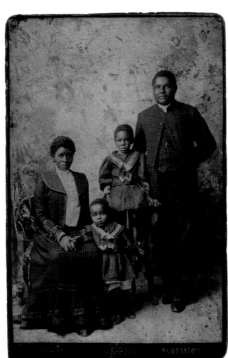

18

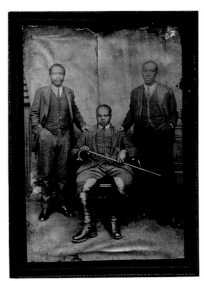

20

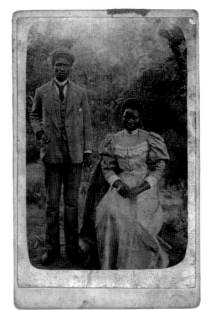

21

Fig. 17 Santu Mofokeng, *Bishop Jacobus G. Xaba (seated right) c. 1890s*
Fig. 18 Santu Mofokeng, *Bishop Jacobus G. Xaba and his family*
Fig. 19 Santu Mofokeng, *Eliot Phakane, c. 1900s*
Fig. 20 Santu Mofokeng, *Tokelo Nkole with friends*
Fig. 21 Santu Mofokeng, *Joel and Jane Maloyi, c. 1890s*
(all from the series *The Black Photo Album / Look at Me: 1890 – 1950*, 1990s)

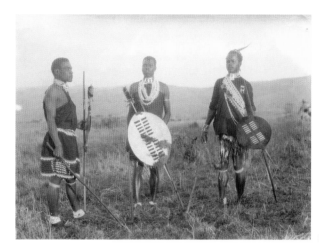

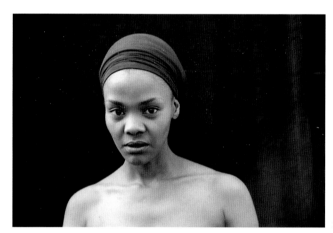

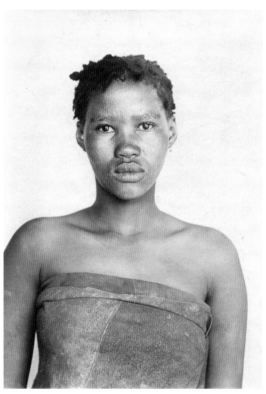

Fig. 22 Alfred Martin Duggan-Cronin, *Modern Dress*, 1935
Fig. 23 Alfred Martin Duggan-Cronin, *Korana Girl, Kimberley*, n.d.
Fig. 24 Zanele Muholi, *Nomonde Mbusi, Berea, Johannesburg*,
from the series 'Faces and Phases', 2007

displayed, in an image that, compositionally, evokes aristocratic portrait painting and proprietary occupation of the land. Even a conventional head-and-shoulders shot like *Korana Girl, Kimberley*, inscribed on the verso as 'a very good specimen of the people', is captured with such clarity, crisp contours and frontal lighting that it suggests too much of the sentient consciousness of its subject to be entirely contained by its reductionist and predictable label. (Fig. 23)

Perhaps context is everything and it is irresponsible to unleash a work from the institutional conduits that produce it. But it is interesting to wonder what would happen if this head were to be included as part of Zanele Muholi's honorific series 'Faces and Phases' (2007–2010), a collection of black and white portraits of her own community of lesbian women, brought to visibility through picturing. (Pages 188–191) In fact there are marked similarities in the frontal hieratic pose and pared down simplicity of some of the works. We can imagine them alongside each other despite the different intentions that led to their production. For, in appropriating and subverting the taxonomic and cumulative power of seriality (conventionally used to deplete rather than depict individuality), Muholi uses the same sober and solemn formal language as her unlikely and much maligned precursor.[22] Muholi's *Nomonde Mbusi* (2007), for example, shows the naked shoulders and turbaned head of the sitter, frontally lit and against a monochrome background, that is formally reminiscent of the *Korana Girl*. (Fig. 24) Of course, Duggan-Cronin was not alone in using black and white photography to survey populations.[23] August Sander (among others), as is well known and much analysed, did this in Germany at just the same time, as a means of cataloguing his own class-ridden society. But, unlike Duggan-Cronin, Sander – like Muholi after him – turned the camera on a community of which he was part, arguably providing an insider's view rather than surveying it from outside. In constructing her set of lesbian portraits, Muholi partakes in a participatory ethnography by creating a series to which she herself belongs. What is more, her practice as a photographer fits into her parallel project as an activist (working in her community with abused lesbian women and the victims of domestic violence and hate crimes), to which she is equally committed. Although Muholi does not appear as one of her 'faces' in the series, the process of making the works involves friendship, solicitation and consultation, and stems from an intersubjective engagement that is based on a shared culture and an encounter of equals. It is on this personal engagement and identification with her subjects that Muholi founds the ethics and politics of her project.[24]

The same can be said of Sabelo Mlangeni in his poignant explorations of masculine intimacy and domesticity in a male-only hostel in Johannesburg. Spending long enough amongst his subjects that he blended in and gained their trust, Mlangeni was able to inhabit the spaces that he pictured, developing a soft, suggestive language of proximity and close-up, blur and fuzz, in which people and body parts are often glimpsed through openings and doorways as they engage in both intimate exchanges and prosaic rituals.[25] In *Usbali visits the hostel*, for example, we feel Mlangeni hovering in the haze of the doorway, which both cuts and facilitates his view, and places him on the threshold of the scene on which he appears to eavesdrop. (Page 160) Both the privacy of the exchange and the presence of the witness are simultaneously registered. Mlangeni's body, though never pictured, is everywhere felt in his photographs: pressing up

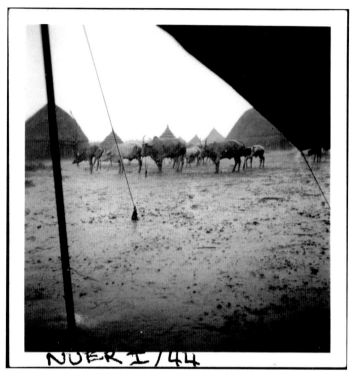

25

26

Fig. 25 Edward E. Evans-Pritchard, *August Shower*, from *The Nuer*, 1935
Fig. 26 Alfred Martin Duggan-Cronin, *Matabele Kraal Scene, Southern Rhodesia*, 1934

against lintels, lying on the floor, peering over barriers or connected by a blurred ground to a hand or a foot which is only an arm's length away. This corporeal connectedness is very different from the outsider view of the classic anthropological or ethnographical study. Even when the ethnographer registers his presence, as E. Evans-Pritchard did in his famous photograph in *The Nuer*, by including his tent flap and pole in the picture, his dry body is screened off from the rained-on world that he surveys, so that no confusion between subject and object is suggested.[26] (Fig. 25) Duggan-Cronin too, for all his patent pleasure in the aestheticised bodies he stages, views them from outside. Only very rarely does he signify his presence in a shadow or a limb that intrudes into the *mise en scène* of his photograph. And, even then, there is no mistaking the subject–object relations in place. (Fig. 26)

Picturing a world from outside may invoke desire, empathy or identification, but it always entails difference, enshrined in the gaze of the stranger. It is this inside–outside dynamic that has entered into debates on the ethics of depiction and display. When is it appropriate to portray the lives/pain of others?[27] How should the presence of the outsider be registered in the mode of picturing? Does aestheticisation amount to dehumanisation, depriving people of their histories and subsuming them into the idealising rhetorics of exoticism or even the simplified taxonomies of racism? Does insight arise from distance or is spectacle the inevitable result? Even the view from within can evoke moral and ethical dilemmas to do with exposure and betrayal, and the insider's view is not necessarily exempt from allegations of voyeurism, prurience or exploitation. Muholi's exposure of lesbian intimacy and identity, like Mlangeni's depiction of homosocial situations and sartorial transgressions, brings hidden lives to visibility through a process of consent and collaboration, but the ensuing images inevitably participate in an image culture that exceeds their authors' control.

The responsibility of the photographer to the people portrayed remains a burning and unresolved issue. When Hasan and Husain Essop, ever wary of misrepresentation or contravention, set out to represent the Cape Muslim community to which they belong, they use only their own bodies, recycling and reproducing themselves in elaborate digital constructions rather than appropriating the bodies of others.[28] (Pages 108–115) Suturing their world on screen, they manufacture the appearance of verisimilitude – evocative of movie stills – from the performances in which they themselves engage, careful to create a seamless and simulated illusion. Essentially fictitious, the scenes they produce stand in for a real that is too fraught with difficulty to picture. For the Essops, therefore, the use of themselves as surrogates allows for a freedom to explore the practices and pictorial possibilities of a culture for which certain forms of figuration are taboo or highly contentious. But the result is a pictorial world peopled only by young men, which, while functioning as an extended self portrait, necessarily enshrines the invisibility of older people, women and children who, while protected from a prurient gaze, are inevitably hidden from view. Such a participatory ethnography, therefore, can deliver its own partial and paradoxical scenarios.

As we have seen, much contemporary figural photography veers between portraiture and typology, mobilising sets in which to situate subjects, diminishing individuality in order to

register the shared markers of the social, or using the taxonomic in order to subvert and expose its effects.[29] It is this last strategy that Roelof van Wyk deploys. When van Wyk chooses, self consciously, to appropriate the language of Gustav Fritsch in order to investigate his own 'tribe' of white Afrikaners, he subjects his stripped-down friends to the historically-loaded disciplinary procedures of anthropometry – front, side, back, side – in order to explore its pictorial languages as well as its explanatory and coercive potential. (Pages 230–237) Creating a catalogue of enlarged heads, arranged in a grid or in a sequence, so that the specific conventions of posing are rendered explicit and clear, van Wyk strips his sitters of their customary power by subjecting them to the frontal light of the studio and positioning them against a depleted and dark-filled backdrop. There is nothing to distract the eye from the focus on naked flesh and unadorned skin, with moles, scars and tattoos intact. The effect is to stage as well as downplay the subjectivity of each. While revealing their bodies, van Wyk divulges nothing of the lives of his sitters. But whereas Fritsch had turned his camera on a subjugated social group, whether by consent or coercion, van Wyk invites his community to participate in a cultural experiment, part of an ongoing investigation into identity and self-exploration of which picturing forms a part. Far from diminishing themselves in the objectifying lens of the camera, van Wyk and his friends seem to revel in their own exposure. This is underlined by the scale of the photographs he produces, which, while mimicking the poses of their predecessors, refuse the modesty of their proportions – with their pseudo-scientific framing – in favour of an almost ostentatious and impressive grandeur.

Like Muholi, van Wyk turns the camera on himself. For this reason he calls the series a 'self portrait' and sees his depiction of his subjects as a coded exploration of his own historically compromised identity. But unlike the Essop brothers who proliferate images of themselves, or Searle who uses her own shrouded body through which to explore the languages and paraphernalia of the ethnographic, van Wyk stages himself by proxy, that is, through the depiction of a specific friendship group with which he closely identifies. And it is not all Afrikaans speakers that concern this 'young Afrikaner'. It is 'whiteness', its association with the historic racial politics of 'Afrikanerdom' and its vexed relationship to African identity, that van Wyk lays open to exposure.[30] As a member of this community, van Wyk is haunted by the role of his parents' generation in the institutionalisation of segregation and the implementation of the racial laws that characterised apartheid. Under Afrikaner rule (the National Party ruled from 1948 to 1994), after all, photography would be marshalled to the classificatory agendas of state, and the protocols of racial profiling would be made manifest in life-determining documents of identity, based on the image of race. It is these too that haunt van Wyk's re-enactments. The subject of much 'protest art', the notorious pass books, identity cards and mug shots which cemented and policed identity, are now part of the apartheid archive as well as the culture of critique which grew simultaneously around them. Gavin Jantjies's 'A South African Colouring Book' (1974–75), for example, contains one print which reproduced his own identity card imprinted with the words 'Kaapse Kleuring – Cape Coloured' overwritten by a stamp reading 'CLASSIFIED', and accompanied both with an extract from the 'Population Registration Act' of

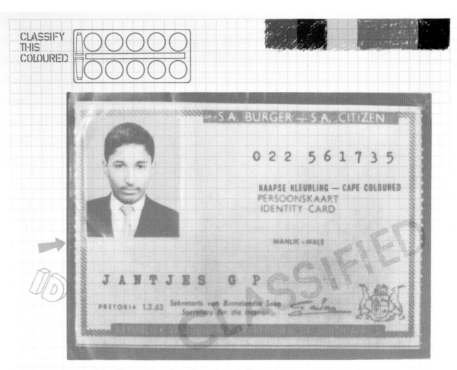

RE: The Population Registration Act (Act No. 30 of 1950)

The Population Registration Act defines three main racial groups - "WHITE" "COLOURED" and "NATIVE" (or "Bantu"). The "Coloured" group has seven sub-divisions viz "Cape Coloured" "Cape Malay" "Griqua" "Chinese" "Indian" "Other Coloured" and "Other Asiatics". The "Bantu" group is sub-divided into eight "national units" viz Zulu Xhosa Swazi North-Sotho South-Sotho Tswana Shangaan and Venda.

The general practice is to distinguish between the people in four categories - "white" "coloured" "Bantu" and "Asiatic".

The racial label put on a non-white child at birth is not only a badge of race, it is a permanent brand of inferiority, the brand of class distinction. Throughout his life his race label will warn all concerned which doors are open to him, and which are closed. In addition to the political and social taboos attached to his race identity card, it will proclaim what sort of education he may receive and the limits on his choice of employment.

If he is classified as "Coloured" he will be excluded from certain occupations reserved for "whites"; his trade union and other rights will be inferior to those of his "white fellow workers; In many occupations his pay is likely to be lower.

If he is classified as a "Bantu" he is in every way made inferior both to "whites" and "Coloureds" - in education, employment, earnings, trade union rights and everything else concerned with making a living.

Gavin Jantjes

Fig. 27 Gavin Jantjes, *Classify this Coloured*, from the series
'A South African Colouring Book', 1974-5

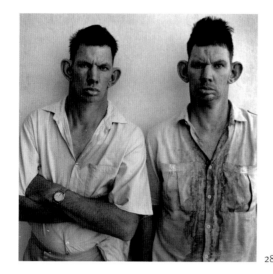

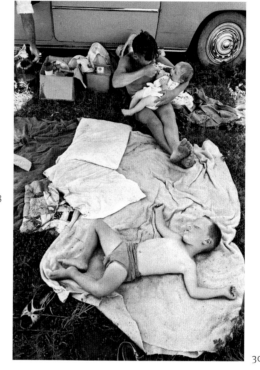

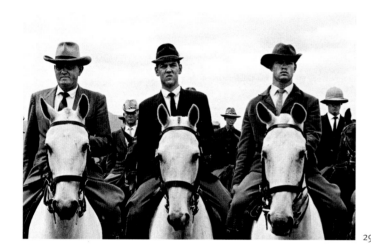

Fig. 28 Roger Ballen, *Dressie & Cassie, twins, Western Transvaal*, from
'Platteland', 1993
Fig. 29 David Goldblatt, *The commando of National Party supporters
that escorted the late Dr Hendrik Verwoerd to the party's 50th
anniversary celebrations, De Wildt, Transvaal (North-West Province)*,
from the series 'Some Afrikaners Photographed', 1975
Fig. 30 David Goldblatt, *Picnic at Hartebeespoort Dam on New Year's
Day, Transvaal*, from the series 'Some Afrikaners Photographed', 1975
Fig. 31 David Goldblatt, *The farmer's son with his nursemaid, on the
farm Heimweeberg, near Nietverdiend in the Marico Bushveld*, from the
series 'Some Afrikaners Photographed', 1975

1950 and his own gloss on its implications for the people it described as 'white', 'coloured' and 'Native' (or 'Bantu').[31] (Fig. 27) Headshots provide the visual support to underpin these categorisations and in turn form the material of an anti-apartheid piece of conceptualism and a knowing, post-modern re-enactment.

By turning the mode of looking associated with the colonial gaze of Fritsch and Duggan-Cronin onto his own community, van Wyk subjects himself to surveillance and confronts the complicity of his clan. But in working with large-scale colour prints, infused with other references – Modigliani's stretched necks, Bacon's smeared mugs, Golden Age Dutch portraits, not to mention fashion shoots and the voguish physiognomies of contemporary art photography (one thinks of the deadpan frontality and seriality of Thomas Ruff's collection of headshots from the late 1980s) – he refuses the traditional pictorial conventions and technologies that produced taxonomic representations of race. At the same time, in focusing on the group called 'Afrikaners', van Wyk engages with another powerful pictorial inheritance, to which he and his generation are heir.

More often seen as the object of study for social documentary photographers than defined by the classificatory conventions of anthropometry and physical anthropology, Afrikaners have themselves been open to a kind of visual scrutiny in the past that has left some of them wriggling and reeling in the face of their own exposure. Most contentious of these is Roger Ballen's extended series on the 'Platteland' (1994), with its Arbus-derived freak show of poor whites and small town indigents, whose bizarre and belittling exposé seems to reveal the bathetic underbelly of the self-anointed chosen race, now overtaken by time. A collection of portraits of an ill-assorted group of gnarled and disfigured individuals such as the brutalised twins *Dressie and Cassie*, Ballen's cast of characters conspires to create a picture of a community that is not only materially deprived but also spiritually and culturally impoverished. (Fig. 28) Working in black and white, and posing his sitters facing front in what appears to be their sparse, often sordid settings, Ballen's brutal realism presents a world without refinement or hope.[32] Less extreme, but more influential for 'young' Afrikaners attuned to visual history, is the most famous photo essay on this community: David Goldblatt's classic 'Some Afrikaners Photographed' (1975), a collection of black and white images produced from the early 1960s that, drawing on the American documentary traditions of Dorothea Lange and Walker Evans, sought to represent this group in all its complexity. For van Wyk and his generation, it is through documentary photography (and its photojournalistic offshoots) that an iconography of the Afrikaner has been inherited, and it is in opposition to this painful but powerful pictorial heritage that a new identity is explored and imagined.

Under Goldblatt's eyes, Afrikaners were subject to rigorous, even relentless, examination. Sometimes appearing inbred or depraved, with dour expressions, hardened by poverty and neglect, Goldblatt's 'Afrikaners' offers a tough and uncompromising view of an insular and inward-looking society. His iconic image of a commando of National Party men escorting the then Prime Minister

Hendrik Verwoerd to an anniversary celebration presents the public face of Afrikaner masculinity: fierce, uncompromising, intimidating. (Fig. 29) This is the image of Afrikanerdom that presages the stony-faced uniformity of oppression that much 'struggle' photography would circulate. But Goldblatt's photo essay proffers an intimate insight into a community that seems to betray its own weakness in unguarded, almost unconscious revelations. *Picnic at Hartebeespoort Dam on New Year's Day, Transvaal, 1965,* for example, taken from above, depicts a family scene, shot through with violence, not only in the play-acting of the boy with the gun, but in the sprawled-out vulnerability of the sleeping child whose stained underpants and dirty feet make him appear as a hapless victim. (Fig. 30) The adults in the picture are only synecdochically figured, the empty shoes of the mother or the intruding arm of the father providing neither visible pictorial nor social support to protect the lives of their children. These are pictures of a brutal and brutalised society. And yet, on other occasions, Goldblatt finds enormous tenderness in the weathered faces of his subjects and the encounters that he portrays, perhaps most touchingly captured in one photograph in the tactile, transracial contact shown between a black nursemaid and her prepubescent white ward. (Fig. 31) With the hand of the young woman clasping the shin of the leaning child, his fingers holding on to her shoulders, the physical closeness of this pair belies the economic and legislative segregation that circumscribed the contact between them.

Goldblatt's documentary approach built on a photographic language – derived from American realisms of the 1930s – that was already powerfully in place in South Africa by the 1960s. And his project of producing a visual essay on the Afrikaners – by then the people in power – was predated, unbeknown to him, by an extraordinary series of photographs produced in 1947 by the British-born Constance Stuart (later Stuart Larrabee), more often cited for her idealising ethnographic essays on the 'natives' of her adopted country.[33] Trained in Germany in the 1930s, Stuart Larrabee, an arch formalist, brought a Modernist concern with medium specificity and pictorial design to her primitivising project. Seeking out shape, pattern and texture, her exquisite set pieces of contrived authenticity and statuesque beauty construct an image of long-lived African traditions untroubled by modernity or change.[34] (Figs 32, 33) Keen to distinguish photography's task from that of painting and to develop its own poetic languages of composition, texture and tonality, she was devoted to developing it as an independent and autonomous art form and turned primarily to black culture through which to explore it.[35] But Stuart Larrabee did not restrict herself to poetic invocations of the 'tribal'. In fact, in the late 1940s, she produced a powerful body of urban images, under the general rubric of the 'Johannesburg Black Man' series, in which she set out to chronicle the effects of urbanisation on contemporary black experience.[36] One such image captures a nattily-dressed street photographer poised to shoot a top-hatted young man against the backdrop of the built-up city. (Fig. 34) It was at this time, too, that she turned her camera on the local Boer community, arguably as 'exotic' to her English sensibilities as the 'traditional' Africans she admired. Focusing on the annual Nagmaal (Holy Communion) rituals that took place outside Pretoria, she produced a body of portraits and set pieces that, while carefully posed and composed, appear to capture the puritanical Protestantism and deep conservatism of this proud but beleaguered social group. (Figs 35, 36)

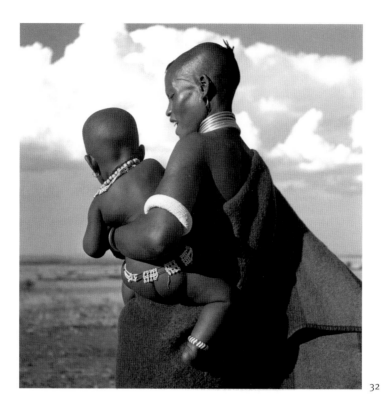

32

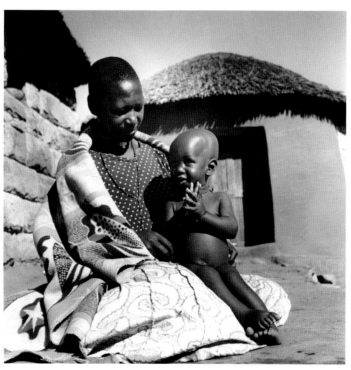

33

Fig. 32 Constance Stuart Larrabee, *Ndebele Mother and Child, Eastern Transvaal, South Africa*, 1947
Fig. 33 Constance Stuart Larrabee, *Sotho Mother and Child, Basutoland (now Lesotho), South Africa*, 1947

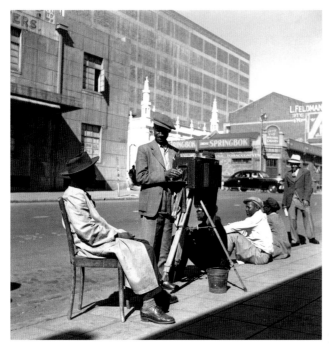

34

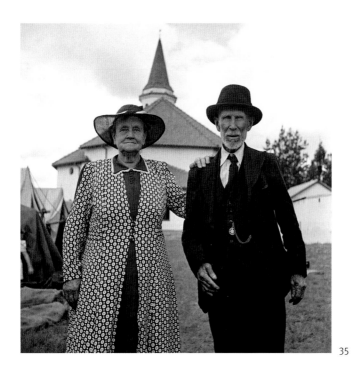

35

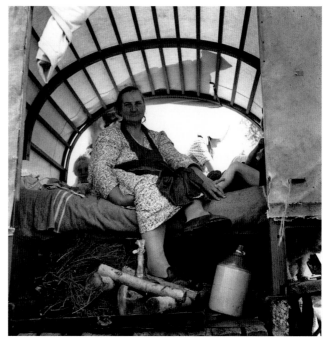

36

34. Constance Stuart Larrabee, *Street Photographer,*
Johannesburg, South Africa, 1948
35. Constance Stuart Larrabee, *Afrikaner Couple, Nagmaal,* 1947
36. Constance Stuart Larrabee, *Afrikaner Family Returning Home*
After Nagmaal (Holy Communion), near Pretoria, 1947

Whether this constitutes a 'documentary' practice is a moot point. It certainly believed in its own 'veracity', notwithstanding its arty effects. And the hallmark of the 'documentary' mode is the attachment to the idea that what it represents is 'fact' rather than an effect created through picturing.[37] But, as Abigail Solomon-Godeau has argued, because the majority of photographs produced prior to the introduction of the term in the 1920s were thought to do the work of 'documentation', the word needs to be understood historically.[38] In South Africa, the advent of documentary photography is usually traced to the 1950s, and the advent of *Drum* magazine, but something of its remit was already there in the late 1940s where it infiltrated the aestheticising and nostalgic filters of ethnographic Pictorialism with the urgent exigencies of the contemporary. What is more, its putative objectivity, unobtrusive mediation and careful (often critical) engagement with the 'real', often understood in sequences of cumulative images which would become so central to the mobilisation of the medium from the 'Drum Decade' onwards, was already emerging as a value in the work that immediately preceded it. Stuart Larrabee is not the only photographer who can be viewed in this light. Leon Levson, too, treads a careful path in this period between 'native studies' and social critique, his embrace of the modern and the metropolitan offsetting his 'ethnic' essays with an alternative iconography which has subsequently led him to be called 'South Africa's first social documentary photographer of note'.[39] Works like *Shanty town, Johannesburg* (1945–46), for example, are amongst the first to represent the makeshift encampments in which many urban black people lived.[40]

But it was emphatically with *Drum* magazine that the descriptive and 'realist' claims of documentary were harnessed to produce a counter-image of urban life and African agency, from the romantic idealisations and delimiting essentialisms that had been so dominant beforehand.[41] In this context, documentary was tied to a progressive (if liberal) social project, its evidentiary and realist effects designed to be revelatory and counter-discursive. Rendering the complexity of black life visible and providing images of its leaders was intended to dislodge pervasive images of blackness and to bring to light the conditions under which black people lived in the city.[42] Also, for the first time, black photographers now generated many of the images that were published so that the habitual spectacularisation of black life was countered by an insider's life experience. How these were translated into the expectations and successive editorial agendas of the inevitably white-run publication is complex, but at least *Drum* provided a space for the negotiation of different subjectivities – as both authors and objects of representation – to those that had hitherto been expressed. Under its aegis, documentary humanism, based on the powerful precedents of *Life*, *Picture Post* and *Paris Match*, came of age in South Africa, providing the conceptual filter for the development of photo essays and photojournalism that would deal with the mundane details of life, celebrate the emergence of new urban culture (its musicians, dancers and writers, as well as its criminal underworld) and register successive political protests in the face of an increasingly coercive state. Throughout the 1950s and early 1960s, most of the major milestones in the development of apartheid legislation and protest were pictured on its pages. Bob Gosani's 'Mr Drum Goes to Jail' (1954), for example, shot undercover, pictured for the first time the undignified methods by which prisoners were searched in Johannesburg Central

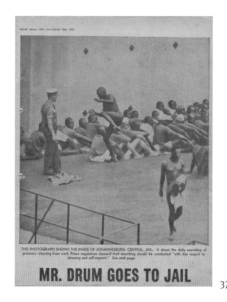

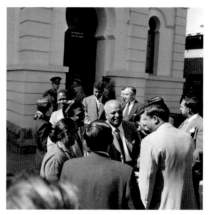

37

38

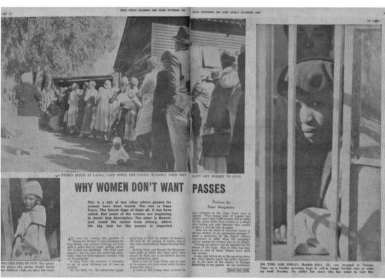

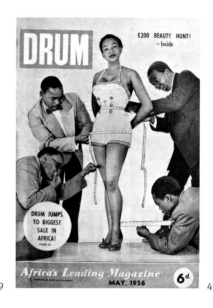

39

40

41

Fig. 37 Bob Gosani, 'Mr Drum Goes to Jail', *Drum
Magazine*, March 1954
Fig. 38 Ranjith Kally, *Treason Trial 1958*, 1958
Fig. 39 Peter Magubane, 'Why Women Don't Want
Passes', *Drum Magazine*, November 1958
Fig. 40 Jürgen Schadeberg, 'Measuring Up', *Drum
Magazine*, 1956
Fig. 41 Bob Gosani, 'Wow! These Gals Sure Can Dress',
Drum Magazine, June 1958

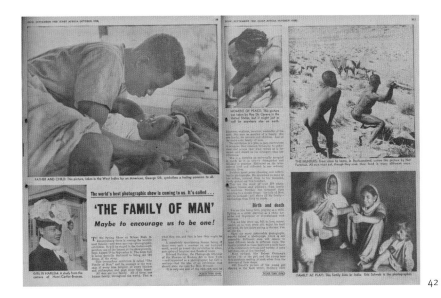

Fig. 42 'The Family of Man', *Drum Magazine*, September 1958
Fig. 43 James Ambrose Brown, 'We Are ONE', *Sunday Times*,
Johannesburg, 24 August 1958

Jail (Fig. 37), while Ranjith Kally's photos of the *Treason Trial* (1958) provided a visual record of the faces of a group who would soon be rendered invisible through banning and incarceration. (Fig. 38) Extensive photo essays like Peter Magubane's 'Why Women Don't Want Passes' (1958) interspersed portraits, extended captions and scenes from daily life, illustrating the human cost of the new bureaucratic measures aimed at limiting black women's access to the city. (Fig. 39) Such serious and penetrating studies were juxtaposed with magazine-type lifestyle features as well as images of musicians, minstrels, pin-ups and thugs, creating a glamorous, hybrid collection of figures and fantasies which captured the hardships of contemporary life as well as the strategies that people invented to cope with it. But the documentary drive of the magazine is only part of the story. Part tabloid, part literary compendium, part political pamphlet, *Drum* addressed multiple, often conflicting agendas. More and more, images of women were used to offset the harsh realities of life, and the increasingly gritty coverage was accompanied by glamour girls and fashion shoots aimed at appealing to a wide readership and lightening the publication's tone.[43] Jürgen Schadeberg's 'Measuring up for Drum Cover' (1956), for example, showed South African jazz and blues queen Dolly Rathebe, who had been one of the first *Drum* 'cover girls', posing in her swimsuit while a group of mock-serious 'gentlemen' size her up for the camera, and Bob Gosani's feature on Jo'burg's fashion-conscious 'factory girl' offers a racy and up-beat take on the resourceful, sassy urbanite that she and her outfits represent. (Figs 40, 41) Such pictures provide an image of confident self-possession, powerful counters to the fantasies of innocent, rural femininity that pictures of dusky, half-naked 'belles' routinely represented. Confident and in control, Gosani's 'new African woman' seems to command the space of the city from which her sisters were simultaneously – and ruthlessly – being excluded because of the extension of the much hated pass laws.[44] Such powerful urban icons resonate with the recent series of street portraits of young Jo'burgers of the so-called 'born free' generation, so joyously captured by Nontsikelelo Veleko.[45] (Pages 240–249) While the 1950s offered different social challenges to those faced by young people now, it is interesting to note that precedents for assertive self-presentation already existed in the context of *Drum* when an urban, African female subjectivity constituted a radical and subversive ideal. But where Veleko's cool, young, post-apartheid fashionistas revel in the hybrid and gender-bending potential of fashion, using it to unfix the conventional boundaries between masculinity and femininity, this was not yet on the agenda for their predecessors. In fact, the contributors to *Drum* were almost exclusively male, and it was to be a long time before black women writers and photographers, in any significant number, could find appropriate outlets of expression. There is no doubt that *Drum* championed traditional gender roles, but it did this in the context of an avowed celebration of the shared humanity of all its readers (men and women, black and white) in a world in which this was increasingly being brought into question.

In this context it is interesting to consider *Drum*'s fulsome endorsement of the famous 'Family of Man' exhibition that travelled to Johannesburg in 1958, opening in the very week that John Hendrik Verwoerd was sworn in as the new Prime Minister. For the editors of *Drum*, like those of the *Sunday Times*, the MoMA-originated show provided a utopian spectacle of shared universal

values: 'The exhibition is a plea to men everywhere to recognise their common humanity, to understand and accept that what unites us is far deeper – and should be far stronger – than our differences.'[46] Surveying the range of works exhibited, from the distinctly urban representation of African-Americans such as Henri Cartier-Bresson's *Girl in Harlem* to the 'wild-life' spectacle of Nat Farbman's *Hunters from Bechuanaland* (now Botswana), *Drum* downplayed differences of style and approach in order to celebrate what it saw as a visual argument for the equality of all human beings. (Fig. 42) Keen to advertise that 'The family of man exhibition is open to everyone. There is no colour bar', *Drum* joined the fact of universal access (in this most segregated of cities) to the humanist agenda that it saw the photographs embodying.[47] In this it was in line with the wider liberal consensus that united to champion the exhibition. The *Sunday Times* saw the show as an argument for anti-racism. 'I would like it to be seen by our Cabinet [sic] and by the Stellenbosch apostles of *apartheid*', wrote James Ambrose Brown, hoping against hope that it would convince them that this 'is our world and we are one people.'[48] (Fig. 43) And the editorial of the *Rand Daily Mail* used it as the hinge for an article entitled 'Humanity versus apartheid', sub-headed 'Healing the divisions in the family of man'. Here Carl Sandberg's dictum, 'There is only one man in the world and his name is all men', promoted as the theme of the exhibition, is juxtaposed with Verwoerd's assertion that 'Apartheid ... comprises the political sphere; it is necessary in the social sphere; it is aimed at in church matters; it is relevant to every sphere of life.'[49] For these liberal reformers, the reassuring humanist agenda of the show offered a powerful moral message in the increasingly racialised context of Johannesburg.[50] But this reading of the show was not inevitable. The conservative Afrikaner daily *Die Vaderland*, while covering the exhibition with a double-page spread, chose to avoid its potential political lessons and to weave a series of whimsical narratives around the 'human' stories it displayed. And the cautious daily, *The Star*, avoided any extensive coverage but printed a reproduction of a work by Constance Stuart (predictably one of her 'ethnographic studies') accompanied by the paternalistic and generalised caption: 'Study of a Native woman preparing herself for some tribal ceremony'.[51]

For the young, black photographers at *Drum*, whose offices provided a rare model of non-racial coexistence, it was not the respective merits of competing poetic languages or debates between paternalism and humanism, universalism and historicity that 'The Family of Man' seems to have dramatised.[52] They were quite happy to unite under the rubric 'Man', given that their humanity was at risk. In fact, the immediate results of the exhibition were not to halt the progression of apartheid but rather to galvanise and focus attention on the possibilities and challenges of photographing its impact on the lives of those it affected.[53] Some, like Alf Kumalo, took heart from the uneven quality of the exhibits, which served to boost his confidence and affirm his own abilities.[54] Others, like Peter Magubane, were spurred on to a newfound independence and motivation because of what they saw.[55] For Magubane, it was *Drum Magazine* that provided the context for the development of a language 'that dealt with social issues affecting black people'. The camera, he recalled, became 'a medium of liberation'. 'We were able to expose and show the world what South Africa was about. It was the only publication that told the truth about South Africa.'[56]

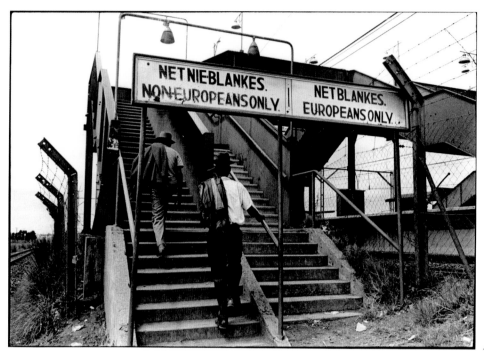

44

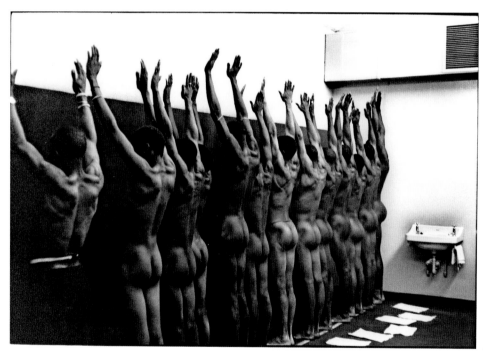

45

Fig. 44 Ernest Cole, *Apartheid sign on the entrance to Dornfontein station, Johannesburg*, from the series 'For Whites Only', Mid-late 1960s
Fig. 45 Ernest Cole, *During group medical examination the nude men are herded through a string of doctors' offices*, from the series 'The Mines', Mid-late 1960s

The belief in documentary photography's privileged role as a vehicle of truth-telling and witness was to dominate camera work in the country for at least the next three decades.[57] Exemplified in the 1960s by the sustained body of work produced by the young Ernest Cole, and published as *House of Bondage* in New York in 1967, this 'styleless style' was regarded as a powerful tool for revealing the social conditions of life under apartheid and became harnessed to the 'struggle' to defeat it.[58] For Cole, the chronicling of the indignities and humiliations of black experience, as well as the recording of the material fabric of daily life in hospitals, servants' quarters, mining compounds and public space, was part of a project of resistance and revelation that photography was uniquely placed to deliver. But the means he deployed were knowingly and strategically mobilised. Rejecting both the touristic trivialisation of black culture in the packaged spectacle of tribal dances or rural rituals, and the romanticisation of city life as featured by *Drum*, for whom he had worked in the late 1950s, he turned to European precedents (Cartier-Bresson was a powerful influence) to provide a language to express an uncompromising vision of social division and life lived under duress. His classic collection of apartheid signage illustrates the relationship between language and lived experience, its harsh black and white contrasts providing a sober and unobtrusive filter though which the bizarre designations of segregated space are boldly represented as fact. (Fig. 44) But the subtle lighting and inventive compositions of many of Cole's images were hard won, the result of meticulous planning and surreptitious shooting born of technical and artistic know-how as well as personal bravery. In the section on 'The Mines', for example, a searing photo-essay on the dehumanising living and working conditions of the miners set alongside an explanatory text, an image of naked men, arms raised and rear ends exposed in a line-up for medical examination is shot so that light catches and bathes the bodies. (Fig. 45) That this was achieved with a hidden camera, smuggled into the mine by Cole in a brown paper bag, makes the 'perfectly framed picture' that he achieved all the more telling and powerful.[59] This is not just the depiction of a humiliating subjection to the gaze, although the sparse setting and upraised arms – suggesting surrender as well as inspection – render the men both vulnerable and defenceless. Through Cole's camera, despite the repetitive nature of the poses, each man seems distinctively seen, his muscles, body shape, skin tones and hand movements subtly and sensitively revealed. Although subsumed into the narrative of photojournalism, Cole's documentary 'style' reveals the complexity and variety of its rhetoric, which while mobilised as a medium of veracity also gave voice to a number of distinctive authorial voices.

Within the rubric of documentary, then, powerful photographic projects emerged. Under the auspices of the 'struggle', social documentary and its particular uses in photojournalism (usually tied to an editorial agenda or external brief) became linked to the anti-apartheid movement and the culture of resistance, in the face of increasingly harsh censorship laws and prohibitions on the circulation of images.[60] The medium of transmission of most oppositional work was publications – many of them banned in South Africa – and photographs appeared mediated by various texts, narratives, captions and descriptions in the service of political goals. Although photojournalism was central – and the search for iconic images to feed the international press

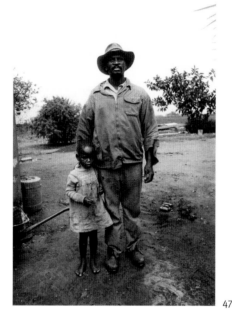

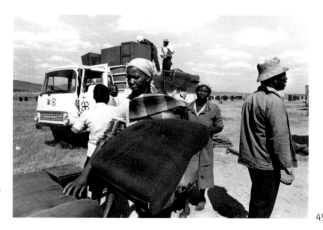

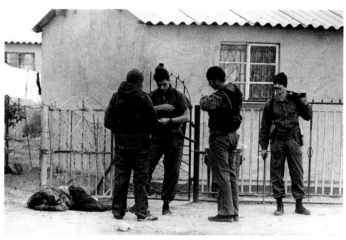

Fig. 46 Omar Badsha, *Teacher with Class of Eighty Pupils*, in *The Cordoned Heart*, 1983
Fig. 47 Paul Weinberg, *Cassava Farmer*, in *The Cordoned Heart*, 1983
Fig. 48 Gideon Mendel, *Mr. Fraser Anthony*, in *The Cordoned Heart*, 1985
Fig. 49 Guy Tillim, *The Makoma Family Arrives in a Resettlement Area of Botshabelo*, in *Staffrider*, 1987
Fig. 50 *unattributed photograph*, in *Beyond the Barricades*, 1989

became paramount – extended photo-essays giving more nuanced and multi-layered insights into lived experience also appeared. Omar Badsha's *Letters to Farzanah* (1979) is a key example. The cultural magazine *Staffrider*, founded in 1978, became an important vehicle for the emergence of an oppositional visual and literary culture, as did the founding of the collective Afrapix, modelled upon the Magnum Photos cooperative, in 1982.[61] It was through Afrapix that Santu Mofokeng was to find his photographic voice, and it was in this context too that the young Guy Tillim and Graeme Williams were to produce their early work.[62] A key agent in the dissemination of images abroad, through the International Defence and Aid Fund as well as via exhibitions and publications such as *The Cordoned Heart* (1986) and *Beyond the Barricades* (1989), Afrapix was committed to exposure, both of apartheid's ills and of the photos it generated.[63] Representative images produced under its aegis include Omar Badsha's picture of a teacher in a makeshift classroom, Paul Weinberg's *Cassava Farmer*, Gideon Mendel's *Mr Fraser Anthony, who has lived in squatter camps most of his life, Hout Bay, 1984*, all published in *The Cordoned Heart,* and Guy Tillim's *The Makoma Family Arrives in a Resettlement Area of Botshabelo*, published in *Staffrider* in 1987. (Figs 46–49) *Beyond the Barricades* set out to document the 'resistance movement' and to counter the restrictions on photography that the state of emergency of 1986 had put in place. For the photographers, camera work was there 'to record inhumanity, injustice and exploitation', and was accompanied by verbal testimony and long explanatory captions in order to tell the 'truth' about the 'struggle' and the enemy it faced.[64] A certain image of South Africa (mediated via the international press, news agencies and anti-apartheid publications) emerged and small black and white photographs dramatising state oppression, with people as victims of violence and poverty, or gathered in collective protest, were prized. Black blood was juxtaposed with white callousness, as one powerful image demonstrates. (Fig. 50) There is no doubt that such photographs served to galvanise international opinion against apartheid and were highly effective as political propaganda. And important work was produced in this context, even if the political narrative it served was pre-given and often prescriptive. As Guy Tillim put it in retrospect, 'When I think about my work in the 1980s, I feel some regrets; we were circumscribed by quite unified ways of thinking.'[65] Mofokeng realised from early on that, in addition to a politics, an aesthetic was also in place. In the early 1980s, when he started out in a newspaper darkroom, he learned, he writes, that 'black skin and blood make a beautiful contrast'.[66] Uneasy with the remit of reportage that accompanied 'struggle' photography, he sought to complicate his use of documentary, so that private experience, family life and hidden views entered into his visual repertory.[67] By the early 1990s, he had lost faith in his work as a photojournalist and questioned 'the efficacy of photography making interventions, and mobilising people around issues.'[68]

By the 1980s, a number of photographers had already used the medium to counter the prevailing preference for 'positive images of resistance and agency' and the deconstruction of documentary coexisted with its declamatory defence.[69] The capacity of an image to produce the very realities it purported to picture was of particular concern, and practitioners like Mofokeng worried about the invisible interstices of the social which fell outside of the remit of 'clenched fists and funerals' that 'struggle' photography privileged. Rather than mimic or reproduce the

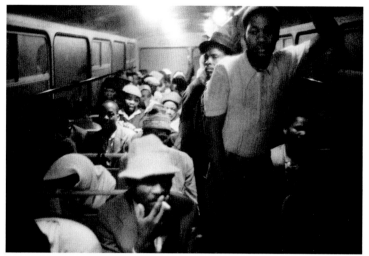

51

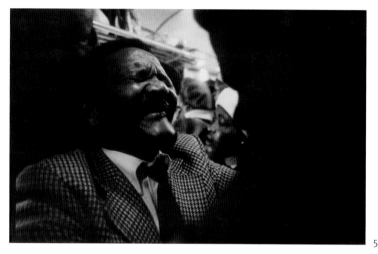

52

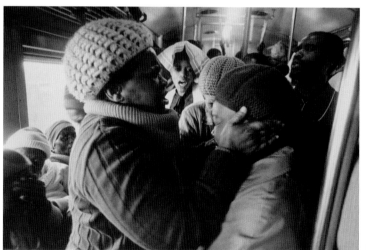

53

Fig. 51 David Goldblatt, *Going to Work: Standing room only now, on the Wolwekraal-Marabastad bus, which is licensed to carry 62 and 29 standing passengers*, from the series 'The Transported of KwaNdebele', 1983
Fig. 52 Santu Mofokeng, *Supplication*, from the series 'Train Church', 1986
Fig. 53 Santu Mofokeng, *Overcome*, from the series 'Train Church', 1986

external world, they saw photographs as sites of invention, displacing the fiction of the real with a semiotics of the visible. The interplay between visibility and invisibility played itself out in a number of ways. Not only did the modest, the banal, the everyday and the uneventful form part of the counter-rhetorical image bank that emerged – from Goldblatt's 'bus passengers' to Mofokeng's train church riders, to mention only two important investigative photo essays – but the capacity of the black and white print to give shape to the ineffable, the spiritual and the otherworldly also began to be explored. (Figs 51–53) Not that these projects were apolitical, it was just that their politics was understood differently, revealing the impact of legislation on lived experience and social life, rather than concentrating on revolutionary action, situations of conflict or protest.[70] Goldblatt's captions contextualise his figures in the system of labour that controls their movements, and Mofokeng's religious services, staged on commuter trains, can be seen to picture a subversive appropriation of space in the face of the oppressive rule of law.[71] There is nothing distanced or objective about Mofokeng's approach to his subjects. In fact his proximity to them, as they chant, sing and gesture in unison, makes him appear a participant rather than an observer in the world that he pictures, his visceral attachment to the bodies and beings surrounding him figured in the distortions of close-up faces, the view between limbs and dark silhouettes, the blur of movement and glare of lightbulbs highlighting and draining the scene. This haptic engagement places Mofokeng inside the world of his subjects, his unobtrusive presence a function both of the absorption of their prayer and of his own capacity to blend into the world he explores. Refusing the spectacle of abjection and objectification or aggression and victimisation that fed the outside world, Mofokeng explored the altogether more indeterminate realm of affect, in which the boundaries between the spiritual and the physical, the political and the personal are not easily prised apart.

Where social documentary presumes the rigorous objectivity of distance, Mofokeng insinuates himself, subtly and unobtrusively, into the scenes he fabricates. This is true, too, in 'Chasing Shadows', a series of works started in the mid-1990s which preoccupied him for nearly a decade, and in which he explored the environment and rituals accompanying a number of religious practices (a traditional Sangoma ritual, a Christian service on Easter Sunday, and members of the Zion Apostolic Church) held in the Motouleng Caves in the Orange Free State. Here spirituality is explored, not only in the esoteric rituals, costumes and gestures depicted, but in the vapours, fumes and otherworldly atmospheric effects that his pictures manage to conjure. (Pages 164–169) Lit by the light of open fires and candles, or by raking sunbeams that enter the rocky crevices, the caves are peopled by robed supplicants and priests, traditional healers and pilgrims, joined in ethereal communion with selves and the spirit world. Forms dissolve in smoke or are effectively blurred and bled, so that seepage and dissolution are everywhere felt, creating the appearance of a dream world in which boundaries are fluid while matter and movement converge. There is nothing dispassionate or distanced about these images. In fact, Mofokeng's personal investment in the scenes is confirmed by the two portraits that accompany the series, both of them of his late brother Ishmael, who turned to traditional healing in these very caves when faced with his illness from AIDS. In both of these, the focus

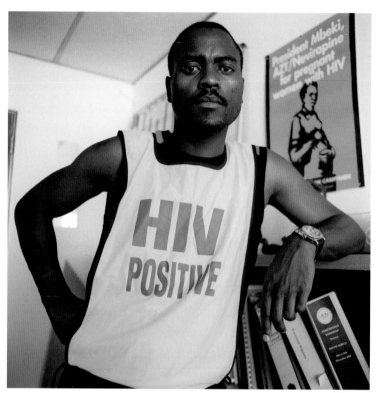

54

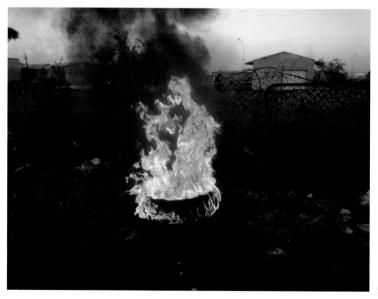

55

Fig. 54 Gideon Mendel, *Mlungisi*, 2010
Fig. 55 Mlungisi Dlamini, *Untitled*, 2010

on the face is intense. Seen from close up, it feels open to the touch or caress of the viewer. In **Ishmael** the monochromatic texture of skin and hair reads as conté crayon or charcoal, *sfumato*-like shading describing the shape and contours of the features while the abstracted blur of the foreground registers the too-close presence of the photographer, who cannot keep his distance. (Pages 168, 169) In *Eyes Wide Shut*, the shallow depth of field creates a heightened emphasis on the sitter, while the blurred presence of the figures behind suggests – but does not describe – a wider context for the intense encounter that the portrait stages. (Page 6) The pictorial effects and emotional intensity of the images are distinct from the crispness and clarity of much reportage, invoking some of the Pictorialist strategies – dramatic lighting, soft edges, rich tonalities, deep sonorous blacks – that had become tainted with the conservative poetics and politics of an earlier timeframe and are now reappropriated to new ethical and artistic imperatives.

'Chasing Shadows', like 'Child-Headed Households', a project that extends Mofokeng's engagement with AIDS beyond his personal loss, expands the possibilities of black and white photography to encompass its metaphoric and allegorical associations. By the 1990s, the ongoing use of black and white stands as a deliberate artistic choice in the face of the overwhelming preponderance of colour within photojournalism as well as the art world.[72] And it is its traditional, tonal subtleties that Mofokeng continues to explore in his restrained domestic scenes. Not for him the head-on confrontation with the effects of the disease that so much photography now deals with. Nor is he interested in the therapeutic potential of empowerment that the camera is thought to provide, epitomised in the heart-warming community projects facilitated by Gideon Mendel and others in which the portrayal of defiant AIDS sufferers can be counterbalanced by the images they themselves generate.[73] (Figs 54, 55) For Mofokeng, it is the quiet resilience of children, caught in the everyday, that captivates his imagination. Light is the key to this exploration, at once rendering the visible world in minute detail and sucking it into sonorous shadow, playing with subtle gradations and stark contrasts so that the texture of life is simultaneously laid bare and rendered mysterious and awesome. (Pages 170-–171)

Expanding the field of the monochrome, Mofokeng participates in a world that is no longer circumscribed by black and white dictates and truisms. In this he is joined by younger photographers, who extend the parameters of the medium while seeking out new worlds to picture. We have already looked at the way in which Sabelo Mlangeni, powerfully influenced by Mofokeng and by his teachers at the Johannesburg-based Market Photo Workshop such as Jo Ractliffe, uses blur and fragmentation to figure a world of male intimacy and eroticism.[74] How to render the invisible visible: this is what concerns so many photographers now, intent on questioning the relationship between representation and the real, image and spectacle, in a place in which photography's mimetic role has been so powerfully and importantly dominant.[75] In some projects, the use of images to achieve visibility for marginal groups or underrepresented constituencies remains urgent and necessary – witness Muholi's lesbian lives so celebrated in 'Faces and Phases', or Mlangeni's 'Country Girls' in which a fringe community of rural transvestites is sparely and sympathetically documented – but in others, the lyrical and metaphoric possibilities of black and white are extended and pushed beyond depiction and description to symbolic or even surreal ends. (Pages 188–191 and 152–157) Sometimes the same photographers move

between modes. Mlangeni's 'Invisible Women' (2006), for example, follows on from Mofokeng in the use of blur and movement to conjure an eerie night vision of the windswept Johannesburg streets populated by women workers, who, ghost-like, appear in the dark to do their cleaning and vanish from view by daylight. (Figs 56–58) For Jo Ractliffe, who in the late 1980s was already questioning the limits of photographic veracity, it is the capacity of the medium to register the history-laden residues of traumatic events and experiences that is the subject of ongoing enquiry.[76] For her, photography has never been purely evidentiary or documentary. In fact, as Okwui Enwezor has argued, she has long been concerned with 'formulating a photographic antidote to documentary literalism', not only through experimenting with technology – at times deprofessionalising her equipment by using toy or amateur cameras – but through disrupting the seen world by blurring, overlapping, fragmenting and framing so that the constructed nature of vision and memory is always part of the picture.[77] *Vlakplaas: 2 July 1999 (drive-by shooting), 2000*, for example, was shot on a plastic Holga toy camera, the banality and emptiness of the world it captured jarring with the symbolic significance that the name had acquired as the locus of apartheid-era death squads and torture camps.[78] (Fig. 59) Vlakplaas is filtered through car window, camera aperture, memory and myth, so that the black and white images that result register much more than the appearance of the place, and are wholly inadequate as 'documents' of its historical importance. Emptied of action or interaction, *Vlakplaas* provides a powerful counter-image to the confrontational representations of oppression that the photography of resistance had routinely and repeatedly engendered.

The name 'Vlakplaas' is enough to invoke the trauma of the recent past in the minds of most South Africans. So too is the concept of 'The Border' for those who grew up under apartheid. Under compulsory conscription, young white men were sent to fight the 'border wars' that raged from the late 1960s to the late 1980s between South Africa and its allies on the one side and Namibian and Angolan independence fighters (and their allies Cuba and Russia) on the other. 'The Border' is simultaneously an historical war zone, a contested boundary between ideologies and national struggles, and the repository of fantasy – what Ractliffe has called 'a secret, abstracted place, full of myth and romance even.'[79] When provided with the opportunity to photograph in Angola in 2007, Ractliffe returned to a book she had read in the 1980s, Ryszard Kapuściński's *Another Day of Life*, which chronicled the end of colonial rule and Angola's transition to independence. It was this book that had informed her series of photomontages 'Nadir' (1988) in which vicious and deranged stray dogs were superimposed on the apocalyptic and emptied-out landscapes of forced removals and abandoned debris unfit for human habitation. (Fig. 60) But while mobilising her imaginary construction of Angola – built from text, memory and projection – Ractliffe also had to deal with what she found when confronted with its sheer physical impact. Starting out by rejecting the possibility of doing a 'social documentary project, or a forensic study', and looking for 'something more oblique, something emblematic of that other world' of remembrance, fantasy and fable, she chose to revisit Kapuściński's haunts and the vestigial remains of empire and war. Amongst the ruins she found were the tiled murals at the Fortaleza de São Miguel, mapping Portuguese explorations in Africa, and showing a wonderworld of exotic

Fig. 56 Sabelo Mlangeni, *Invisible Woman I*, 2006
Fig. 57 Sabelo Mlangeni, *Invisible Woman II*, 2006
Fig. 58 Sabelo Mlangeni, *Invisible Woman III*, 2006
(from the series 'Invisible Women', 2006)

60

Fig. 59 Jo Ractliffe, still from *Vlakplaas: 2 July 1999 (drive-by shooting)*, 2000
Fig. 60 Jo Ractliffe, *Nadir 15*, from the series 'Nadir', 1988
Fig. 61 David Lurie, *Somali Man and Child*, from the series 'The Right to Refuge', 2008

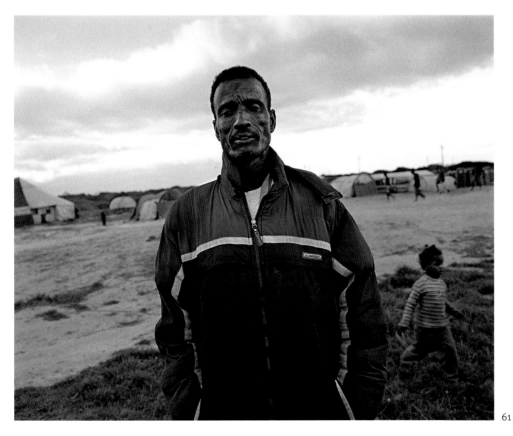

plants, animals and indigenous folk, now scarred by conflict and neglect, a haunting reminder of both the grandeur and the violence that characterised a former era. The ruins provided a perfect, ready-made emblem for the imprint of the projects of the past on the scarred remains of the present. (Pages 202–203) Figural ciphers stand in for fictive and actual lives. These semi-allegorical works form part of the larger project, which Ractliffe entitled 'Terreno Ocupado' after a signpost that she observed placed starkly in a field which seems vacant but which is marked by the connotations of colonialism and conflict that the words 'occupied territory' suggest. (Page 194–195) In addition to its past occupants – and the hidden landmines that periodically explode – the territory is also home to a huge population of landless migrants and displaced people, uprooted by war and harassed by speculators and developers now keen to move them on. It is they and their immediate environment, in particular Luanda's biggest open air market, Roque Santeiro, a sprawling overpopulated meeting place situated on the edge of a hilltop overlooking the sea, that is the focus of Ractliffe's investigation. Faced with the particularity of this place (and despite her initial unease with the language of 'social documentary') Ractliffe decided to 'shoot straight' – and in black and white – in order to achieve what she calls 'a more direct engagement' with her 'subject'.[80] (Pages 196–201)

It was Luanda's 'strangeness' that, in Ractliffe's words, necessitated 'careful looking'. And 'careful looking' involves avoiding the gratuitously spectacular, sentimental or sensational, the well-worn stuff of aid advertising, colour supplement features and photojournalism epitomised by Kevin Carter's award-winning Ethiopian famine shot, which both shocked and enthralled the world.[81] From the start, Ractliffe's visual engagement with this foreign but familiar place was mediated by an awareness, not only of her own subject position as an outsider, but of its historical layering as both an 'occupied territory' and a repository of fantasy, signalled as much by absences – signified by clothes on the line or markings on worn tiles – as by the obdurate physicality of a debris-strewn hillside or makeshift video store replete with American movies. A modern market, where not only commodities but dreams and desires are traded, Roque Santeiro, for all its poverty, sells stuff with which we can all identify: movies, flour, petrol, to name only a few.[82] Ractliffe's attention to detail (what Goldblatt terms its 'plain factuality redolent with history and yet with that quality of portent and mystery in ordinary things') mobilises 'straight photography' to exceed its literal limitations.[83] At the same time, Ractliffe avoids the generalisations and abstractions of the ethnographic encounter, which the confrontation with the 'other' invariably invokes, by the delimiting particularity associated with the document holding the figure in fragile equilibrium between these different modes of picturing.[84]

Ractliffe is only one amongst a number of contemporary South African photographers who choose to work in the previously forbidden terrains of Africa, opening themselves up to the accusation of neo-colonialism and voyeurism and of riding on the back of the continent's continuing woes. These are the allegations that are sometimes levelled against Pieter Hugo

and Guy Tillim, for example.[85] For Ractliffe, it is the borderland that beckons, compelling her to rethink her own identity and the troubled foundations on which self and nationhood are built. For Guy Tillim, who, as we have seen, cut his teeth as a photojournalist wedded to oppositional politics and the evidentiary use of the image, the demise of apartheid engendered new possibilities of picturing – the development of a personal palette, an engagement with the lyrical, the suggestive and the oblique – at the same time as it allowed for new ways of being and belonging in Africa. As South Africa became reintegrated into the continent, so South Africans, of all population groups, have been forced to re-examine their relationship to their neighbours, and the border, once policed by the SADF to ward off 'communists' and 'freedom fighters', now provides a buffer against economic migrants and refugees who constitute the newly-vulnerable of impoverished inner cities and townships. To register their plight, and the xenophobic violence which they face, David Goldblatt – who since the 1990s had turned to colour – returned recently to black and white, in a searing image of recumbent bodies sheltering in self-protective foetus-like positions in the Johannesburg Methodist Church.[86] (Page 128) For Goldblatt, the formal severity of black and white (as well as its historical association with truth) is appropriate for the project of social critique that current economic conditions and political failures necessitate.[87] Other documentary photographers like David Lurie have also used black and white to picture the plight of refugees, squatting precariously in camps. (Fig. 61) And Jodi Bieber, long engaged in exploring and expanding the languages of reportage, has produced a powerful series of pictures chronicling the precarious journey across the border from Mozambique and registering the shifting uncertainty of itinerant lives, moving in and out of view. (Figs 62, 63) For Tillim, the insecure lives of inner city dwellers – many of whom are migrants – formed the subject of his 'Jo'burg' (2004) pictures, a sustained portrait of life in the condemned tenements and tower blocks of the city.[88] (Figs 64, 65) But rather than use the sober tonalities of black and white he began to experiment with colour, in deliberate and careful compositions. And already in this series we see the fragmented scenes and filtered viewpoints that would characterise the later 'Petros Village' (2006) shot in a village in Malawi, but here it is the dilapidated architectural structures and decayed buildings that provide the filters and frames through which half-lit figures and scantily furnished interiors are viewed. (Pages 222–227) Looking askance, or through barriers, disruptions and doorways, Tillim foregrounds the artifice of seeing and the contrivances of creating a picture. It is this critical disruption of vision that Graeme Williams, also an erstwhile social documenter, was to turn to effect in his extended photo essay on the outskirts and edges of towns or the indeterminate locations of leisure, creating dysfunctional and dystopian dream-spaces seen in vibrant colour, bleached shades and cast shadows, which unsettle the position of viewing as well as the vantage point of the photographer. (Pages 253–261) Williams's is a world made strange rather than intelligible through unlikely juxtapositions, distortions of scale and orchestrated ambiguities of actual and depicted space as well as the figures that occupy it.[89]

For Pieter Hugo, the border is both a concrete location at the edge of the known and the familiar – a place where the boundaries between self and other become blurred – and an imposed

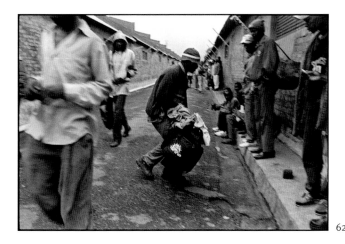

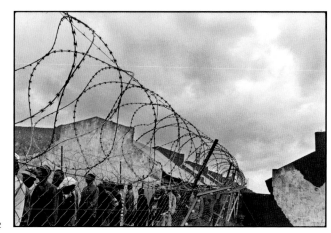

62

63

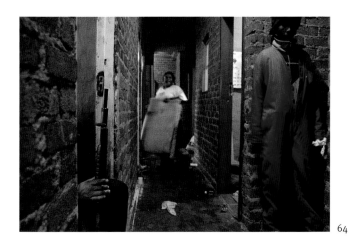

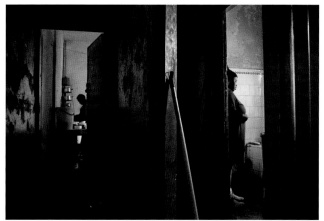

64

65

Fig. 62 Jodi Bieber, *Untitled*, from the series 'Going Home -
Illegality and Repatriation – Mozambique/South Africa', 2000
Fig. 63 Jodi Bieber, *Untitled*, from the series 'Going Home -
Illegality and Repatriation – Mozambique/South Africa', 2000
Fig. 64 Guy Tillim, *Eviction by the Red Ants, Auret Street,
Jeppestown*, from the series 'Jo'burg', 2004
Fig. 65 Guy Tillim, *Milthred Court, Kerk Street*, from the series
'Jo'burg', 2004

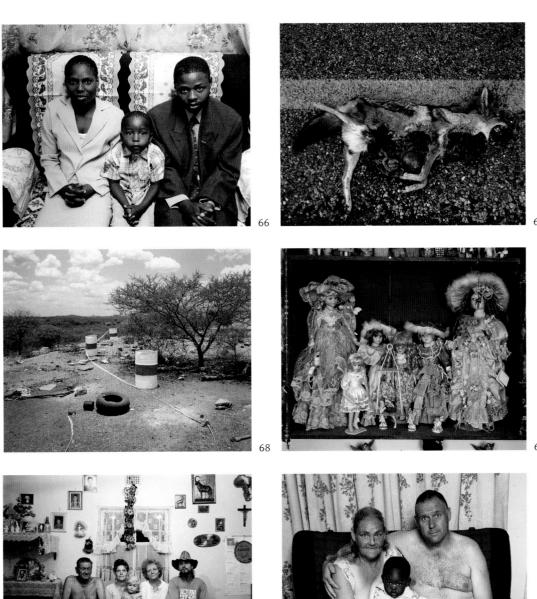

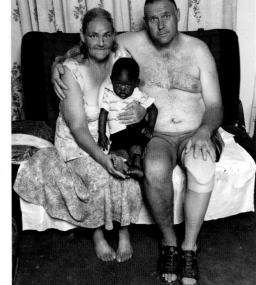

Fig. 66 Pieter Hugo, *Thina Lucy Manebaneba with her son Samuel Mabolabola and her brother Enos Manebaneba in their living room after church*, 2006
Fig. 67 Pieter Hugo, *On the Highway outside Musina*, 2006
Fig. 68 Pieter Hugo, *At the abandoned Campbell copper mine*, 2006
Fig. 69 Pieter Hugo, *Rose Brand's doll collection*, 2006
Fig. 70 Pieter Hugo, *Jan, Martie, Kayala, Florence and Basil Meyer in their home*, 2006
Fig. 71 Pieter Hugo, *Pieter and Maryna Vermeulen with Timana Phosiwa*, 2006
(all from the series 'Messina/Musina', 2006)

barrier subject to political and historical will. In 'Messina/Musina, a series exploring South Africa's northernmost outpost on the border with Zimbabwe, the contested nature of place is signalled by the slash that separates the old colonial name Messina from its precolonial designation as Musina. And the feeling of a temporal and political rupture – a violence or rip at the heart of its sense of self – is conveyed by the way the series is put together: frontal and statuesque portraits of ordinary folk which appear frozen in time are interspersed with pictures of dead animals, entrails exposed; bleak and unforgiving landscapes sit alongside stuffed and painted creatures, referencing the wildlife it both boasts and destroys; and mannequins and dolls provide figural surrogates for the static, strangely passive sitters who populate the pictures. Hugo, who began his career as a photojournalist, faces the world head-on, rejecting the surreptitious shooting and unobtrusive presence of reportage in favour of confrontational and declarative statements, monumental in scale and spectacular in their mode of address. For him, this borderline place provides the locus for a pictorial exploration of shifting and reshaped identities, from the itinerant Zimbabwean beggars who literally cross over the border once a month, to the motley residents of the town, ranging from a white Christian family (proud 'Africans' displaying a map, wildlife trophies and a cross), immaculately dressed newly-enfranchised citizens, and what appears to be a hybrid family unit, that we have already looked at in detail. (Figs 66–71) An interracial grouping, the portrait of *Pieter and Maryna Vermeulen with Timana Phosiwa* (2006) stands out in the series for the potential challenge it offers to the old delineations of apartheid, with its fear of mixing and miscegenation, and its careful policing of boundaries (Fig. 71). In fact the Vermeulens, and their ward, present an image of social cohesion, only momentarily, in the time of picturing. For the actual relation of the sitters is more complex than the portrait pretends, and external knowledge, gleaned from Hugo himself, underlines the couple's and the infant's vulnerability rather than endorsing their coherence as a group.[90] While the Vermeulens, it appears, are the impecunious tenants of the child's hospitalised father, the boy is only temporarily in their care. Whether such extraneous information is relevant to our reading of the picture is debatable. Of course it dislodges assumptions that the image represents a family. But it also points to the rhetorical power of the historic genres that inform it and that led to the proposition that it pictures a group of (once prohibited, but now possible) relatives. At the heart of the picture's story is race. And it was race that generated doubt as to its narrative coherence from the start, despite attempts to read it as indifferent to or subversive of the race-determining agendas of the past. Situated on the border of the country, this mixed 'family' group also sits on the historic border of intelligibility in a place in which race, above everything, remains the hyper-visible marker of identity, above all dominating debates on 'Africanness'.

While South Africa has absorbed millions of African refugees in the last few years, Africa too, once home for political exiles but out of bounds for many South Africans, has become accessible to tourists and travellers from the south. At the same time, its historic role as the haunting hinterland of apartheid's one-time enemies has rendered it fascinating to a generation of politicised photographers, no longer hamstrung (and excluded) by their pariah status as white South Africans, and possessed of powerful fantasies of a once-forbidden land.[91] But

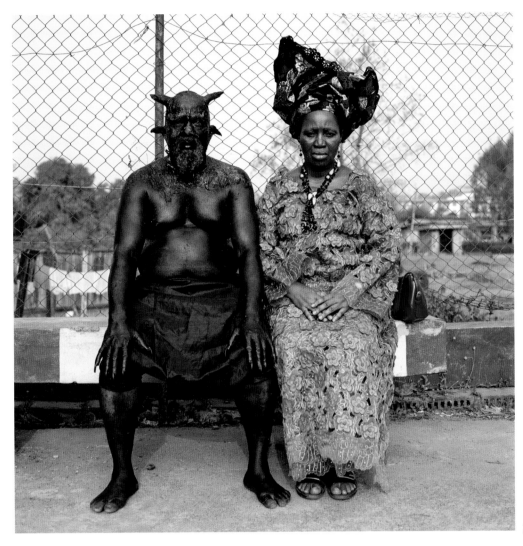

72

Fig. 72 Pieter Hugo, *Chris Nkulo and Patience Umeh.*
Enugu, Nigeria, 2008, from the series 'Nollywood', 2008

the relationship to Africa remains fraught and Hugo's position is interesting in this regard. When questioned on his right to exercise 'the gaze of the white male photographer in Africa', so compromised by history, he invoked in his own defence Goldblatt's identity as 'an English speaking Jew' who photographed Afrikaners, a group to which Hugo himself belongs. To restrict picturing to the insider's view is for Hugo nothing short of 'absurd'.[92] In fact it is his consciousness of the dynamic interplay of the insider–outsider relationship that produces the conditions for his project of critical and engaged looking, not only at the world around him, but at the fictions and representations that produce it. The 'spectacle of Africa' is already a given of its representation. What Hugo does is to enter into its spectacularisation, testing its limits and terms. Intrigued by performances of identity and self-conscious modes of display, Hugo often concentrates on figures already engaged in masquerade, theatre or disguise, revelling in the tacky artifice of Nollywood, for example, or the hybrid enactments of Nigeria's 'Hyena Men', a group of travelling performers and traditional healers whose sartorial scrambling of indigenous signifiers and urban accessories, together with their manifest 'taming' of the wild, project powerful and subversive subjectivities. (Pages 132, 133; Fig. 72) His subjects, whether the marginalised scavengers of Ghana's technology dumps, arrested against an apocalyptic backdrop of smoke and recycled computer waste, or the camouflaged honey collectors, bedecked in leaves, logos and bin-liner masks and surrounded by verdant forest, appear to present themselves for picturing. (Pages 136–139) Hugo never looks surreptitiously. Photographing people, for him, involves elaborate negotiation, contract and collaboration. It is a social transaction – often fraught and requiring intermediaries and interlocutors – that prefigures the setting up of the shot. And his own discomfort with his lanky, obtrusive presence – his own body is also at stake – is what produces the anxiety from which his unsettling pictures are born. What results are monumental tableaus of unashamed, almost brazen, theatricality. What they mask is the unease – both psychic and social – that inevitably leads to their production.[93]

For Tillim, it is the destabilisation of the visible world, and his own position as its embodied chronicler, that is crucial. In 2006, he was commissioned by the Rome Photo Festival and funded by an NGO to shoot in a village in Malawi. Refusing to provide the standard images of famine showing 'crying women, coffins, sick children' that were expected of him, Tillim succeeded in alienating his sponsors, because the quiet, unsensational images he produced were useless for the purposes of advocacy.[94] Profoundly aware of the dangers of creating a spectacle out of African poverty, and of his own subject position as an outsider – he already had extensive experience of photographing on the continent[95] – Tillim approached the village cautiously, shooting fragmentary scenes of daily life as if crouching on the parched ground with the people and animals he pictures, rather than surveying them from a distance. Body parts intrude from the edges, shadows and strings create diagonals and patterns across tawny planes, while half-glimpsed figures emerge and retreat, at times fleeing from visibility and at others only partially understood. Things and creatures – bikes, vessels, chickens and dogs – coexist in a low-lying world in which food is prepared, adults interact and children play against a backdrop which is earthbound and barren. By limiting access to the sky, or any extended vistas and views,

Tillim gives form to the locality and condition of poverty, as experienced 'on the ground' from a proximate and embedded vantage point. (Pages 222–227) It is the unobtrusive insertion of his own corporeality in the modest interstices of social life that asserts the shared humanity of photographer and subjects, underlined by the parallel project of portraiture, shot face-on, of the individual inhabitants of the village. Working in the documentary tradition of the photo essay, but countering its claims to detachment with a highly personalised position and palette drawn from the earth tones beneath him, and refusing the traditional outsider view of the ethnographer (for all his strangeness to the scene) by insinuating his own body-bound viewpoint into the world he pictures, Tillim (like Hugo) also embraces the portrait as a vehicle of individuation and distinction. Positioned like poignant caesuras alongside and amongst the half-glimpsed scenes of daily life, the portraits lend a quiet dignity to the villagers.[96] There is nothing exotic or exploitative in the way that they are imaged. In fact they often appear to present themselves for picturing, sometimes smiling or looking out at the spectator, or isolated against dark, impenetrable grounds without defensiveness or distance. Crucially, they are named individuals, not representatives of a 'tribe' or a 'race'.

It is, in part, through a personal palette and chromatic manipulation (facilitated by digital printing) that Hugo and Tillim counter the language of photojournalism with which they both began their careers. In this they have much in common with other photographers working in South Africa after 1990. Williams and Goldblatt are just two that come to mind. The ubiquity of black and white photography prior to that has much to do with the fiction that, as a mode of picturing, it was more linked to truth than was colour, which was tainted with the smear of make-believe and the vulgarity of commerce and consumerism.[97] This point of view was most clearly (and famously) articulated in 1980 by Roland Barthes in his statement, 'colour is the coating applied later on to the original truth of the black and white photograph ... colour is an artifice, a cosmetic.'[98] Barthes's binary of tone and colour, truth and artifice mirrors debates on the competing claims of sculpture and painting which have circulated in European academic theory since at least the seventeenth century. Traditionally, black and white took on the mantle of sobriety and reason associated with sculpture, while colour was marked with the trivial mendaciousness of make-up: feminine, meretricious and deceptive. A re-examination and valorisation of colour, therefore, became one of the means through which the historical conventions of documentary could be questioned and exposed at the same time as new definitions of veracity could be explored. For some erstwhile photojournalists and documentary photographers, the embrace of colour marked a breaking point, both politically and poetically. Zwelethu Mthethwa, who is also a painter, is one unashamed colourist who works against the gritty realism of much black and white documentary, eschewing its monopoly on morality and formulating a new argument for the ethics and efficacy of colour. Black and white, he argues, has bequeathed a bleak and impoverished picture of black life, based on the circulation of set pieces and stereotypes that, though they may critique, also mirror the binaries that apartheid put in place. When in 1996 Mthethwa embarked on a programme of photographing an informal settlement outside Cape Town, he used colour to 'give some dignity back to the sitters' whose lives, he believes, had

been doubly depleted: by the system in which they lived and by the figural mediations through which they were seen.[99] Colour, for Mthethwa, confers a three-dimensional complexity on lived experience, allowing the agency of the sitter to be expressed – in vivid decorative interiors and costume – and asserting the presence and contemporaneity of the scene.[100] (Figs 73–75)

It is colour too that is foremost in Mthethwa's recent project 'The Brave Ones' (2010), set in the rich green countryside of KwaZulu-Natal, which forms a grassy backdrop for a series of posed scenarios of young boys and men, carefully arranged to show off their extraordinary costumes and accessories. (Pages 174–181) Members of the Shembe community, a flourishing African Independent Church based near Durban, the young men wear a distinctive uniform of 'helmet, kilt and boots' that has come to be known as the 'Scotch', each element of which signals a moment of colonial encounter and subversive appropriation.[101] Transforming the hard hat of Empire into a ceremonial head-covering and replacing the Zulu fur girdle with the legendary kilt of the 'folk/ warrior Highlander', the costume also consists of football socks and workers' boots, providing a reference to modern forms of labour and leisure. Kilt-wearing Scotsmen had been visible in Natal since the early nineteenth century so that, by the time Isaac Shembe came to found his church in the early twentieth century – in the wake of the South African War in which Scottish regiments had fought – they had come to stand for a once-elite martial masculinity, albeit wild and 'untamed' and a separate settler community (themselves ethnically marked) whose costume provided the material for an inventive cross-cultural hybrid. (Fig. 76–78) Mthethwa revels in the sartorial scrambling that ensues, using large-scale digital prints and heightened focus to reveal pink-skirted lads and crimson-girdled youths with frilled shirts, bowties and traditional Zulu beadwork posed ceremoniously against expanses of green. Isolating his figures, Mthethwa frames and foregrounds them. Not for him the robust ceremonies and dances for which they are clothed and which are so evocatively captured in Paul Weinberg's extensive black and white ethnographic study of their world.[102] For Weinberg, costume is only made intelligible in relation to custom, and it is this that he seeks to capture in images that contrast male and female ritual and dress. (Figs 79–82) Omar Badsha too made an extensive study of this community and its home in Inanda, north-west of Durban, in the 1980s, but he was interested in documenting the impoverished circumstances of enforced segregation against which their rituals and ceremonies can be viewed.[103] (Figs 83, 84) For Mthethwa, though, it is decontextualisation which is crucial. Isolating his figures against the fields, and exploiting the rich chromatic contrasts which good rainfall has produced, Mthethwa makes colour and pose his priorities, allowing the spectacular presentation of the figures to shield off any ethnographic or documentary content. Rather, it is the gender ambiguities and cross-cultural valences that register. Out of context, the hyper-masculine resonances of the traditional costume are minimised, and the mode of address of the figures (the way they cock their elbows, lean against trees and tilt their hips, together with the vulnerability that naked knees and patterned skirts now suggest) undermines normative assumptions around macho African maleness. Like Muholi, Mthethwa manipulates traditional cultural signifiers to unleash them from the circuits of meaning in which they habitually reside. Both Zulu artists, interested in the external trappings of gender identity, they use the conventions

73

74

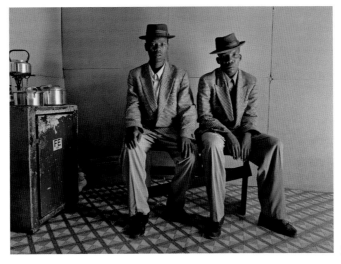

75

Figs. 73-75 Zwelethu Mthethwa, *Untitled*, 2001-03
(from the series 'Interiors')

76

77

78

Fig. 76 *'Evening promenade with the Royal Scots Fusiliers at Landman's Drift'*, *Illustrated London News*, 5 July 1879
Fig. 77 *'The captivity of Cetewayo: The ex-king appreciates the Highland bagpipes'*, *Illustrated London News*, 29 November 1879
Fig. 78 Zwelethu Mthethwa, *Untitled*, from the series 'The Brave Ones', 2010

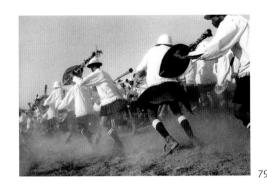

79

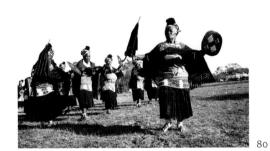

80

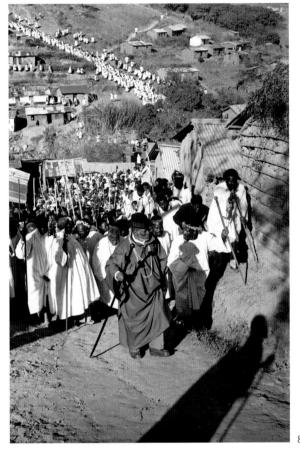

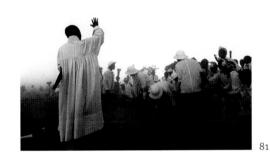

81

83

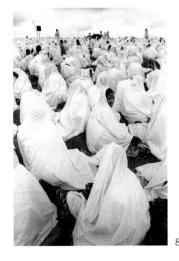

82

84

Figs. 79-82 Paul Weinberg, *Shembe*, 2000
(all from from the series 'The Moving Spirit', 2000)
Fig. 83 Omar Badsha, *A Shembe Leads His Followers on the*
Anniversary of the Founder's Death, 1983
Fig. 84 Omar Badsha, *Shembe Village*, 1983

of posing – derived from painting as much as from photography – and the coded accretions of costume to celebrate a creative creolisation of appearance in which nothing remains secure. Masculine and feminine, traditional and modern, authentic and synthetic: all are interwoven and enmeshed. So too is the idea of genre. Mimicking portraits, in the isolating of figures and the poses purloined from oil painting, the works do not entirely fulfil their figural remit, the ethnographic push to the collective – despite the resistance to context – still evident in the interest in typologies and groups. We know little about the people depicted, who they are, what they are called, where they live. As such, the pictures mobilise the aesthetic language of portraiture while denying the knowledge it is traditionally made to produce.

Throughout this essay, the individuating imperatives of portraiture – which thematises the identity of the sitter as well as the intentionality of the artist – have been pitted against the generalising claims of taxonomies and types, to which much photography of the figure is harnessed. Of course these are not watertight categories and we have repeatedly seen how their boundaries blur and collapse, so that the particular invades the generic, and the ostensibly private partakes of the social.[104] But, despite these overlaps, figuration is made manifest through institutions and genealogies, which can be historically mapped and traced. And the uses to which figures are put – the fictions that inform and surround them – differ depending on the filters through which they are viewed. Photographic portraiture has its own specific trajectory in Africa, emerging as an increasingly democratised medium that made the capturing of a likeness – traditionally the purview of the wealthy and privileged – more and more available for the middle classes and newly-enfranchised urbanites, from both settler and colonised communities.[105] From the mid-nineteenth century, photographic studios proliferated, servicing a need for *cartes de visite* images, as well as family shots and individual commemorative portraits that were treasured and exchanged in both private and public circuits.[106] The earliest commercial portrait studios in South Africa seem to have developed in the 1850s and were at first reserved for whites, but by the late nineteenth century an urban black elite had appropriated the poses and postures of Victorian respectability for themselves and the studio became a powerful site for the refusal of ethnic essentialisms that circumscribed images of Africans. What's more, the studio enabled the adumbration of an emerging modern subjectivity in which props, backdrops, costumes and attitudes combined to construct socially desirable personae. Santu Mofokeng's 'The Black Photo Album, as we have seen, provides a useful collection of such images – rephotographed and projected through a 35mm continuous carousel slide show – and reveals an array of dignified family groupings, arranged according to the conventions of respectable European society. *Bishop Jacobus G Xaba from Bloemfontein*, for example, is represented by two pictures in which he and his finely dressed family take up their allotted positions as 'civilised' Christians in furnished interiors, in which they appear to be 'at home'. (Figs 17, 18) Looking out at the viewer, they are quietly self-possessed. But the studio is a space of fantasy as much as it produces the 'real', and

Mofokeng's inventory also includes a number of images in which the artifice and pretence of the setting, while framing the sitters, is shown to unravel and give way. *Tokelo Nkole with friends*, for example, depicts a group of elegant young men posing in front of a makeshift curtain and scrappy floor-covering that form an unstable and dilapidated background. (Fig. 20) A disjunction between the appearance of the sitters and the decrepit (and fake) nature of their surroundings puts their identity at risk, and points to the performative nature of posing and the portrait studio as a space of masquerade, theatricality and display.

Perhaps it is a case of suspended disbelief that such fissures and fractures betray. Throughout the twentieth century, the aspect of play and fancy dress that posing for a portrait entails has become part of the language of the genre. Studio photography has revelled in its capacity to manufacture dreams and create hybrid and composite identities. Often scrambling the 'tribal' and the 'modern', the studio provides a creative space for the questioning and revealing of these antinomies. A survey of such practices is beyond the scope of this essay, but Dr Arthur Bolton's strange studio portraits of the Zulu community in Durban, produced in the 1950s and 1960s, provides just such a site of exposure. (Figs 85–87) Against a painted architectural backdrop of a palatial, almost baroque, interior – and an occasional floral wreath that reads as a theatre prop – Bolton poses his figures in a variety of outfits drawn from both traditional Zulu and Western dress. With no recourse to 'authenticity' of either setting or costume, Bolton creates *avant la lettre*, a post-modern *pot pourri* that seems remarkably self-aware. In fact he appears to revel in the way these worlds collide, taking care to leave evidence in his photographs of the fabricated nature of the set. No attempt at illusionism is made. Photographic portraiture, he seems to demonstrate, is all a matter of contrivance. So too appear to be the trappings of identity.

It is hard to know what was at stake for Bolton.[107] But the ingredients of his amateur practice are representative of a wider tendency in studio portraiture. In 1961, Sukhdeo Bobson Mohanlall, for example, founded a studio in Durban and was soon to become the city's most fashionable portraitist, developing a technique of coloured printing on postcard-size prints that was highly prized and admired. Through the 1960s and early 1970s, he specialised in hybridised sartorial constructions – part traditional Zulu beadwork, part modern urban chic – staged on a patterned linoleum floor, in front of a royal red curtain and a basket of artificial flowers. (Figs 88–90) We have seen some of these ingredients mobilised in Muholi's art practice – with the added twist of gender-bending play-acting – but here they are presaged by the world of commercial studio portraiture. Highly popular, such images allowed customers to have the best of all worlds, proclaiming their Zulu heritage while asserting their modern mobility. Mohanlall's portraits bear the marks of what has become associated with African studio photography – the highly developed use of pattern and props, the frontal mode of address and the strong sense of performativity and artifice – which counters mythologies of the natural.

In fact brazenly artificial backdrops – as the conduits of dreams or the markers of place – have become part of the vocabulary of portraiture, permeating amateur and art practices alike.[108] It is these, the stock-in-trade of the studio, that Dave Southwood memorialises in his images of studio backdrops, evacuated of the people who might occupy them. (Fig. 91) Such fictions appear

85

86

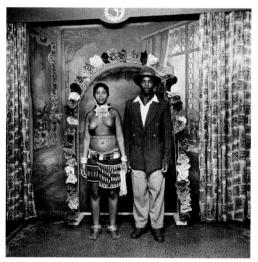

87

Figs. 85-87 Arthur Bolton, *Studio Portrait, Stanger, KwaZulu-Natal, South Africa*, c. 1950

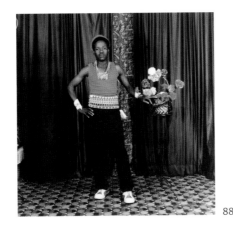

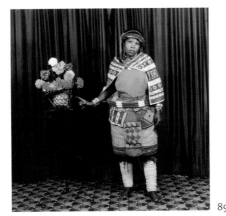

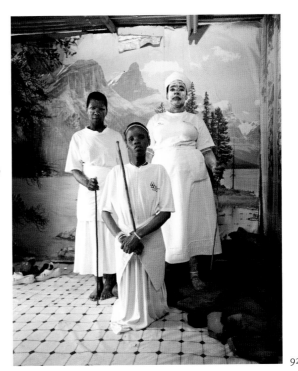

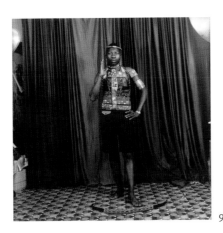

88

89

90

91

92

93

Figs. 88-90 Sukdeo Bobson Mohanlall, *Untitled*,
late 1960s – early 1970s
Fig. 91 Dave Southwood, *Photo Studio, Khayelitsha*,
from the series 'Studio Project', 2000
Fig. 92 Adam Broomberg & Oliver Chanarin, *Nyanga
Graduates*, from the series 'Mr. Mkhize's Portrait', 2005
Fig. 93 Sue Williamson, *Richard Belalufu*, from the series
'Better Lives', 2003

in the backgrounds of countless portraits, taken all over the country, as Adam Broomberg and Oliver Chanarin's restaging of a graduation portrait in an Eastern Cape studio testifies.[109] (Fig. 92) And it is these too that Sue Williamson invokes in her life-sized stagings of immigrants, situated in front of their adopted 'home', as signified by enlarged, emblematic black and white renderings of a majestic Table Mountain overwritten by the signs of commerce.[110] (Fig. 93) The disjuncture between the coloured space of the 'real' and the monotone shades of the 'pictured' registers the artifice of the sitting, while the attempt at a reconciliation of scale begs for a suspension of disbelief. It is possible to have both at once. And not only in the realm of fine art.

When Terry Kurgan decided in 2001 to explore the world of the photographers of Johannesburg's Joubert Park, she entered into a subculture that had been functioning in the city for decades. Resident in the park were a variety of street photographers, each of whom had their own style and specialisation, which they advertised on boards pasted with unclaimed photographs and signs, designed to draw in customers. Like Mofokeng's salvaged effigies, these abandoned tokens constitute a rich repository of memory. Never collected by their owners, 300 were bought and treasured by Kurgan, who was moved by the relationships and possibilities that they pictured. (Figs 94–95, 97–99) The park provided a popular backdrop for special occasions and commissions, its fountain, adjacent art gallery and lawns producing ready-made picturesque settings. It was against the park's surroundings, thrown out of focus with a shallow depth of field, that Kurgan herself set her portraits of the 40 photographers who agreed to take part in her project. (Pages 142–149) But her collaboration with the photographers also involved responding to their needs and extending the range of their practice. What became clear was that, above all, what they wanted was a studio to expand the possibilities of their work. Working with six of them, Kurgan designed and produced a portable photographic studio, replete with lighting and exotic backdrops, chosen and enlarged from available library photo stock. (Fig. 96) The selected backdrops included sunset at the beach and on the Jo'burg skyline, Sol Kerzner's fantasy palace of 'the lost city' erected at his resort, Sun City, zebras in the bush, and acacia trees with dramatic lighting by photographer Obie Oberholzer. (Figs 97–99) Blown up and printed onto rolls of canvas, these were attached to the wall of the makeshift studio and used until they eventually perished. Any of them could be selected against which to pose for posterity. No matter that the seams were visible and the grass grew against the sea. (Fig. 97) In the realm of the image, you could be in two places at once. In the studio anything is possible.[111]

It is the idea of the studio as a place of imaginative re-enactment, together with the characteristics of pattern, performativity and artifice – associated particularly with the African portrait studio – that Kudzanai Chuirai reproduces in his portraits of bling-bedecked urbanites posed in front of an ANC commemorative cloth, hung like a proverbial banner behind them. (Pages 104–105) Placed between medallions of Thabo Mbeki (the past president of South Africa), or obscuring his iconic black and white bust, the newly-empowered yuppies of democracy are shown drowning in gold, while the ideal of the rainbow nation (encapsulated in the three-shaded repetitive icon imprinted all around them) is reduced to a decorative motif. For Chuirai, it is the language of portraiture – as a conduit of social values rather than a medium of psychological

94

97

95

98

96

99

Fig. 94 Varrie Hluzani, *Unclaimed Portrait*
Fig. 95 Mduduzi Ntshangase, *Unclaimed Portrait*
Fig. 96 Terry Kurgan, *Photographer in the studio in Joubert Park with clients*, 2001
Fig. 97 John Makua, *Unclaimed Portrait*
Fig. 98 Godfrey Ndlovu, *Unclaimed Portrait*
Fig. 99 Godfrey Ndlovu, *Unclaimed Portrait*
(all from the series 'Park Pictures', 2004)

insight – that is of interest here. This is made abundantly clear in his series 'The Black President' that he 'directs' rather than photographs, using an actor to perform a number of stereotypical roles drawn from Hollywood film, music videos and popular culture. (Pages 99–103) Posing his model with props – each redolent of cliché or quotation – Chuirai raids our image culture so that the figure functions only as an armature for a number of easily recognisable caricatures. Here it is the popular icons of African masculinity that are open for perusal and display. Drawing on the fashion shoot as much as the African studio – one thinks of the self-conscious identity replays of Samuel Fosso, for example – in fact these are not portraits at all, but rather register the repertoire of poses from which popular culture is made and which in turn provide models for behaviour.

The idea of the 'model' is pertinent to Jodi Bieber's series 'Real Beauty'. (Pages 89–95) But here it is the ordinary and the everyday that rubs up against the dreamspace of the studio. In an extended project on ideals of female beauty – prompted by the 'Dove' soap advertising campaign showing regular women in their underwear – Bieber presents an array of body types and attitudes, designed to counter normative and coercive idealisations. In each, a semi-naked woman (from a variety of ages, ethnicities and body shapes) is invited to take up a pose of her 'choice', performing her sexuality against a familiar and personal backdrop.[112] The resultant images are both reassuringly diverse and depressingly conformist. While the range of body types and appearances is wide, and Bieber's refusal to touch up or embellish produces a realist rendition of bodies marked by the wear and tear of time, the range of poses and modes of address seems to derive, largely, from the recycled clichés of lingerie adverts or the pervasive postures of soft pornography. Wearing their 'sexiest' underwear, the models seem to hanker after the very perfection that the project is seeking to undermine. Nevertheless, the series produces striking and unnerving images, all the more poignant because of the disjuncture between the 'real' beauty it presents and the 'ideal' images it mimics. In fact it reveals their inseparability and inevitable co-dependence. Witness the bravery of the elderly white-haired diva, fag in hand in her kitchen, whose lacy black bra strap points, inadvertently, to the sagging flesh of her upper arm, or the corpulent brown-haired poseur with heels and pearls in place whose attitude mimics the trimmed-down perfection of countless goddesses but whose rolls of fat and cellulite exceed the prescriptive ideal. (Pages 89, 90) Ironically, the figure that conforms most emphatically to a Western ideal of perfection – as enshrined in fashion magazines and the movies – is in danger of being thought ill in a place in which skinniness may be associated with AIDS and plumpness regarded as a sign of plenty. (Page 95) It is the cultural relativism of typologies, as well as the unique permutations of lived corporealities, that the project so successfully stages. But the large-scale coloured prints – resembling advertising shots themselves – also provoke questions about voyeurism and the display of women's bodies that, though here under scrutiny, are simultaneously rehearsed and replayed.

For Bieber, the individual act of posing of each of her participants was part of a wider investigation of social values and norms. Although each image is a portrait, it makes sense in relation to the others in the series to which it necessarily belongs. The same can be said for two projects by David Goldblatt in which seriality and repetition vie with individuality in the staging of

subjectivities. Attuned to the changes in the landscape that the demise of apartheid engendered, Goldblatt, ever a critical eye, became aware of numerous handmade signs that had begun to appear all over Johannesburg once the prohibition on informal trade which had prevailed for decades was lifted. Unlike Bieber, who advertised for her sitters, Goldblatt responded to *their* advertisements, which he also photographed, but instead of engaging the tradesman at the other end of the phone line, he asked permission to photograph him at the location of one of his jobs. What results is a series of diptychs that testify to the resourcefulness of the artisan as well as the freeing-up of the society to which he belongs. The handwritten script of the signs imprints the mark of the worker, supplies his name and identity and asserts his agency in relation to the image he presents for the camera. In that sense, Goldblatt produces a counter-taxonomy, a humanist interest in individuation offsetting the collective identity that the series simultaneously projects. (Pages 124–127) In keeping with his documentary origins, Goldblatt uses his images to testify to a social phenomenon that he observes. But the conventions of the portrait, in which the specificities of the named sitter are made apparent through likeness, accessories and location, are here invoked in large-scale coloured prints that advertise themselves as pictures at the same time as they thematise the advertising of trades and tradesmen.

As we have seen, Goldblatt, like many other South African photographers, had embraced colour in the 1990s. Coinciding with the advent of democracy – and a feeling of political optimism – were the new digital printing technologies that made working with colour more controllable. In this decade, too, South African photography entered into the international art world in which large-scale coloured prints had already been increasingly visible since the late 1970s. Recently, though, it is to the traditional valences of the tonal that Goldblatt has returned, propelled by an awareness of the still-entrenched legacy of apartheid inequities and the failures of the new political establishment adequately to address them. In ongoing projects on housing, poverty and social deprivation, Goldblatt explores the social while penetrating beyond it to the personal, using the juxtaposition of text and image to do so. Nowhere is this more evident than in his ongoing project to document ex-offenders at the scene of their crimes. (Pages 118–123) These images, accompanied by extensive captions in which Goldblatt recounts the stories of each of his subjects (who range from petty thieves to drug lords and ex-security branch murderers), evoke photography's historic role in forensics and criminology. But they do not, like the institutionalised headshots from penitentiaries and physical anthropology, create types or generic physiognomies. Each is unique, not only in features and mode of address, but in terms of the situation and story of the crime, recounted in the captions which provide narrative filters through which to interpret the portraits. We read of Hennie Gerber, an ex-member of the South African police force, who failed to gain amnesty from the TRC[113] for a brutal and gratuitous murder, shown in the forest in which he tortured and killed his victim, and of the shoplifter, Errol Seboledisho, a church-going youngster gone wrong, who peers over the racks of clothes in the very same store that he burgled. (Pages 119, 123) Amongst his subjects, too, is 'Blitz', a seasoned criminal and gang member whose tattooed neck and overall demeanour relate to an underworld that has, itself, produced a whole genre of images. (Page 121)

Goldblatt's interest in crime emerges in the context of a country obsessed with criminality. During apartheid, political dissenters were criminalised and prisons became places of mystique in which hidden leaders were held, while their faces were banned from public view. (Oddly enough, under apartheid, portraits themselves were regarded as potentially subversive and the prohibition against publishing images of political detainees produced a kind of celebrity prisoner known more by name than by appearance.) But at the same time, the prison population swelled with predominantly black petty thieves, gangsters and hard-core thugs, incarcerated in dire conditions. Since the end of apartheid, new forms of violence have proliferated, while traditional crimes have spilled over into once sequestered and protected white neighbourhoods. Everyone now lives in fear, as Mikhael Subotzky's monumental group portrait of a protest against violent crime testifies. (Fig. 100) But, simultaneously, a curiosity about criminal subcultures has also emerged. Over the last decade and a half a new type of photograph has appeared, set in the ganglands and prisons of the Cape Flats, which records the imprint of this culture on the bodies and lives of its members. Portraiture and social documentary coincide in these projects, which situate subjectivity socially as well as individually. As part of their project exploring the varying identities which immediately followed the advent of democracy, for example, Adam Broomberg and Oliver Chanarin photographed Abdullah Adams, one-time member of the notorious 'Numbers' gang, and accompanied his image with a first-person narrative in which he attributes his behaviour to the effects of apartheid's forced removals.[114] (Fig. 101) Presenting his tattooed torso and weathered face to the camera, Adams reveals his acculturated markings as signs of an ill-spent youth, but his iconic representation presages a now-widespread tendency to represent such bodies for display. We see this manifested recently in a series produced by Araminta de Clermont. (Fig. 102) For Broomberg and Chanarin, the images are always inserted into photo essays with accompanying narratives, which contextualise and explain them. In 2003, they published an extensive study of Pollsmoor Maximum Security Prison in which portraits, figural fragments and compositions sit alongside still-lifes and interiors as if to create a portrait of a society as well as the characters that inhabit it.[115] (Figs 103, 104) It was this culture, too, that became the subject of Mikhael Subotzky's project 'Die Vier Hoeke' (The Four Corners), 2004, a series of panoramas and populated interiors set in the homosocial culture of the gaol: incarcerated lives rendered visible – even spectacular – on an heroic and unprecedented scale. (Figs 105, 106)

It is not the culture of criminals but the fear and anxiety they produce that Subotzky's recent project 'Security' seeks to unveil and explore. Far from the psychological intensity of the portrait as explored by Goldblatt, for example, or the figurative density of his own earlier explorations of the criminal, Subotzky now looks on from a distance at the structures and rituals of surveillance that social division has produced.[116] Inspired by the deadpan seriality of Bernd and Hilla Becher, but eschewing their stark black and white aesthetic, Subotzky searched the streets of Johannesburg for the ubiquitous garden sheds that have become the 'offices' for security guards in the rich and luxurious suburbs.[117] Viewing them head-on, but not close-up, so that the huts nestle in their surroundings, occupied by the uniformed attendants for whom they serve as shelter and 'home', Subotzky explores the ironies that the pictorial juxtapositions suggest:

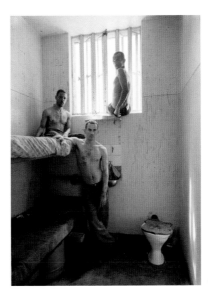

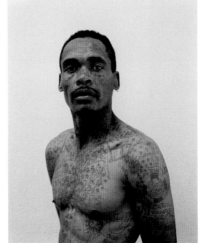

100

102

101

103

104

Fig. 100 Mikhael Subotzky, *Silence the Violence March, Cape Town, 2006*, from the series 'Security', 2006
Fig. 101 Adam Broomberg & Oliver Chanarin, *Abdullah Adams, Manenberg*, from the series 'Mr. Mkhize's Portrait', 2005
Fig. 102 Araminta de Clermont, *Mr. Green*, 2008
Fig. 103 Adam Broomberg & Oliver Chanarin, *Timmy, Peter and Frederick, Pollsmoor Maximum Security Prison, Cape Town*, from the series 'Ghetto', 2005
Fig. 104 Adam Broomberg & Oliver Chanarin, *Dion, Pollsmoor Maximum Security Prison, Cape Town*, from the series 'Ghetto', 2005

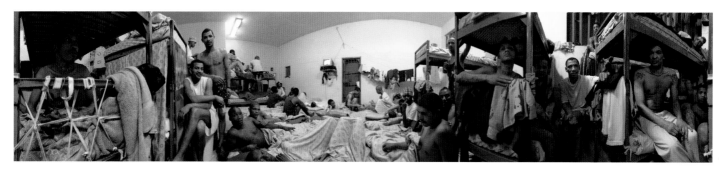

105

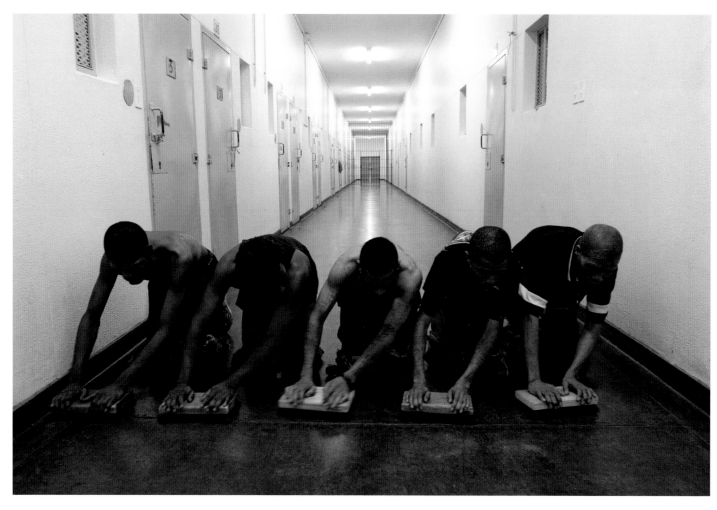

106

Fig. 105 Mikhael Subotzky, *Cell 508b, A Section, Pollsmoor*,
from the series 'Die Vier Hoeke', 2004
Fig. 106 Mikhael Subotzky, *Pasvang, Pollsmoor Maximum
Security Prison*, from the series 'Die Vier Hoeke', 2004

double-storey mansion and miniature peak-roofed 'house', high-walled sequestration and hired protection against vulnerability. (Pages 215–219) Suburban lifestyles are shown to be bought at a cost. Nowhere is this more evident than in the apparently informal gathering of a 'street party', under the jacarandas (signatory tree of Johannesburg) of a quiet residential neighbourhood. (Page 218–219) Alongside the *braai* lolls a guard, wearing the familiar fluorescent security jacket, a presence but not a participant in the social gathering he surveys.[118] Segregated, still, by colour as well as by class, a nondescript everyday scene acquires the emblematic significance of a billboard. Scale is what produces this effect, making of the incidental and ignominious something spectacular and symbolic.

The idea of spectacle has haunted this essay from the start. And it is also among the themes that emerged in the roundtable discussion as well as in a number of the interviews that *Figures and Fictions* has generated. This is unsurprising, given the historic visualisation of Africa as the locus of extreme social and political exhibitionism, a place of corporeal excess, exoticism, violence and impenetrability with the black African serving in modern Western discourse as a figure of primitive regression, atavism and brute physicality.[119] The fear of reproducing or legitimating such discursive constructions – hypostasised as image – still permeates debates on the representation of African subjects, not least in photography, whose earlier culpability in the circulation, reproduction and perpetuation of such fictions is now well documented and acknowledged. In the context of South Africa, a culture of such intense contrasts of geographical beauty and social decay, flamboyant extravagance and material deprivation, unprecedented generosity and unspeakable violence, the dangers of trading in Manichaean oppositions and paper cut-out simplifications are widely felt. But the argument against reproducing the colonial distillation of Africa into a one-dimensional spectacle – without depth, complexity or contradiction – was already mounted in 1984 by the South African literary critic Njabulo Ndebele in his powerful and important essay 'Rediscovery of the Ordinary', in which he accuses much 'protest literature' of reducing black experience to little more than an inversion of the obscene spectacle of apartheid.[120] Obsessed with surface appearance, dramatic events and simplistic moral divisions, the stories and images it generated were often inadequate, in Ndebele's view, to the complexity of lived experience and the ethical dilemmas or emotional contradictions it engendered. Nor was its narrative style – based on description and delineation of events – sufficiently self-reflective or productive of a new African-derived aesthetic that would explode conventions of thought. Photographic discourse too, as we have seen, has long been engaged in a self-critical internal dialogue on both the subjects and the situations it pictures, as well as the means it has deployed to do so. In terms of Ndebele's definitions, much 'struggle photography' (particularly the photojournalistic focus on destitution, immiseration and social conflict) produced a partial if powerful picture of a society in crisis and despair. And it is in dialogue with its formal conventions as well as its prescriptive views that many contemporary

photographers define their own concerns. Although its political imperatives may be distinguished from the voyeuristic explorations of some ethnographic/anthropological representations, the construction and framing of experience that both genres endorsed each produced their own kind of spectacle to which practitioners now remain heir. Portraiture, of course, could make this its overt subject, often frankly acknowledging the artifice and affectation that posing for the camera entailed. But if we end where we began, with Antjie Krog's celebration of the perfect tense as a metaphor for language's registration of time's passage, and the mutilated remains of the past (its 'mortal fractures',[121] to use another of her phrases) providing the foundation from which a future will have been imagined, then this legacy itself can be seen as a productive source of a new pictorial and political consciousness. Whether in the celebration of the ordinary rituals and encounters of daily life, played out in Mlangeni's hostels or Mofokeng's households, or at the other extreme, in the hyper-performativity and excess of Chuirai's media-drenched puppets or Hugo's self-knowing protagonists who look directly out at the viewer, the spectre of past picturing is always negotiated and referenced. Muholi's lesbian lovers, like Goldblatt's ex-offenders, create new taxonomies of difference to counter the specular orthodoxies and clichés of previous image regimes. But the careful negotiation of spectacle both has been, and will have been, the challenge.

I am deeply grateful to the photographers who appear in Figures and Fictions, both for their work and for their extraordinary input into my thinking for this project. I have learned so much from them and have taken great pleasure in our dialogue and correspondence. I have benefitted too from my conversations with Federica Angelucci, Elizabeth Edwards, Liza Essers, Michael Godby, Patricia Hayes, Bronwyn Law-Viljoen, Sarah Nuttall, Michael Stevenson and Liese van der Watt. Claudia and Jürgen Schadeberg showed me enormous hospitality and generosity at a crucial stage of the project. Paul Weinberg gave me a base in 2010 at 'The Centre for Curating the Archive', University of Cape Town, and has been unstintingly generous with his time and expertise. Abigail Solomon Godeau provided crucial feedback on an earlier version of this essay and I have drawn extensively on her photographic writings as well as her expert advice. Impeccable research assistance and editing was provided along the way by Amy Halliday. Martin Barnes at the V&A has been an intellectual partner throughout this project and Michael Mack at Steidl has provided invaluable encouragement and advice. Orla Houston-Jibo was indispensable as my picture researcher and Laurie Britton Newell was a crucial member of the curatorial team that put the show together. My mother, Cynthia Garb, has fed, driven, cajoled and consoled me on many a research trip to South Africa. And throughout, I have relied heavily on the expertise, advice and support (both emotional and technical) of Rasaad Jamie whose knowledge of photography, familiarity with South Africa and unmatched levels of tolerance have helped in more ways than I can articulate. It is to him, and our son Gabriel Jamie, both a product of our past and one who has surpassed us, that I dedicate this essay.

1. From Antjie Krog's magisterial poem about love, language and time, published in *Body Bereft*, Paarl, Umuzi, 2006, p. 9.

2. Hugo himself discusses the particular circumstances in which the picture was taken in his interview. See p. 274.

3. Not all of the exhibitors in the show would be comfortable with the designation 'artist'. Some, like David Goldblatt, refuse this label and prefer to be known as photographers. Others are self-declared artists who work with photographs amongst other media. This distinction signals the different institutional histories at stake, but the boundaries between these are difficult to sustain in the context of the contemporary gallery.

4. The first photographic studios in the Cape appeared in 1846. See Marjorie Bull and Joseph Denfield, *Secure the Shadow, The Story of Cape Photography from its beginnings to the end of 1870*, Cape Town, Terence McNally, 1970, pp. 29–42.

5. The literature on this field is too vast to enumerate here. My own understanding has been influenced by the groundbreaking volume edited by Elizabeth Edwards, *Anthropology & Photography*, New Haven and London, Yale University Press, 1992, and by important revisionist works such as Christopher Pinney and Nicolas Peterson, *Photography's Other Histories*, Durham and London, Duke University Press, 2003, and Christopher Morton and Elizabeth Edwards, *Photography, Anthropology and History; Expanding the Frame*, Farnham and Burlington, Ashgate, 2009. In the context of Southern Africa, see the work of Wolfram Hartmann, Jeremy Silvester and Patricia Hayes in *The Colonising Camera: Photographs in the Making of Namibian History*, Athens, OH, Ohio University Press, 1999, and Keith Dietrich and Andrew Bank (eds) *An Eloquent Picture Gallery: The South African Portrait Photographs of Gustav Theodor Fritsch, 1863–1865*, Johannesburg, Jacana Media, 2008. See also Michael Stevenson and Graham Stewart, *Surviving the Lens: Photographic Studies of South and East African People, 1870–1920*, Vlaeberg, South Africa, Fernwood Press, 2001. For the relationship between missionary narratives and 'ethnographic' photography see Michael Godby, 'The Photograph Album of an Unknown Missionary in Natal, c. 1930: The Good News – and the Bad', *South African Historical Journal*, 61(2), 2009, pp. 357–371.

6. For a detailed discussion of these two modes of understanding the historical relationship between photography and anthropology, see C. Pinney, 'The Parallel Histories of Anthropology and Photography', in Edwards 1992, pp. 74–95.

7. For a highly critical account of these and other related practices, see Okwui Enwezor, 'Reframing the black subject; Ideology and Fantasy in Contemporary South African Representation', *Third Text*, 11(40), 1997, pp.21–40.

8. Breitz's appropriation of the colonial archive prompted a huge debate around the ethical implications of critiquing racism through the ongoing use of black women's bodies. Other works involved collaging pornographic pictures of white women with images of 'native' women in order to construct visual analogies between the oppression of both groups. See Enwezor (1997); Olu Oguibe, 'Beyond Visual Pleasures: A Brief Reflection on the work of Contemporary African Women Artists', in Salah Hassan (ed.), *Gendered Visions: The Art of Contemporary African Women Artists*, Trenton, N.J., Africa World Press, 1997, pp. 63–72; and ripostes in Brenda Atkinson and Candice Breitz (eds), *Grey Areas: Representation, Identity and Politics in Contemporary South African Art*, Johannesburg, Chalkham Hill Press, 1999.

9. Judith Stone describes the processes of race testing in her biography of Sandra Laing, whose appearance led her to be classified 'coloured' while her biological parents were classified 'white': 'She could be given the "pencil test": a board member would place a pencil in her hair, and she'd be asked to bend forward. If her hair was straight enough that the pencil slid through she'd be declared white; if not, coloured.' Judith Stone, *When She was White*, New York, Hyperion, 2007, pp. 94–95.

10. See A.D. Bensusan, *Silver Images: History of Photography in Africa*, Cape Town, Howard Timmins, 1966. Pam Warne

makes the important point that black women's bodies were more often the subjects of photographs than the authors of them until very recently. See P. Warne, 'The Early Years, Notes on South African Photographers before the Eighties', in Robin Comeley, George Hallet and Neo Ntsoma, *Women By Women: 50 Years of Women's Photography in South Africa*, Johannesburg, Wits University Press, 2006, pp. 15–25.

11. For a discussion of photography and the European image of the 'African Venus' see N. Monti, *Africa Then, Photographs 1840–1918*, New York, Alfred Knopf, 1987, pp. 72–76. See also D. Willis (ed.), *Black Venus: They called her 'Hottentot'*, Philidelphia, Temple University Press, 2010.

12. For discussions of Foucauldian ideas of surveillance, discipline, portraiture and the body in relation to photography, see Allan Sekula's 'The Body and the Archive', *October*, 39, Winter 1986, 3–64; John Tagg's *The Burden of Representation: Essays on Photographies and Histories*, Minneapolis, University of Minnesota Press, 1988 (1993); and David Green's 'On Foucault: Disciplinary Power and Photography', *Camerawork*, 32, 1985, pp. 6–9.

13. Physical anthropologists believed in a hierarchy of races that was the product of evolution. To record human development from Africans (the lowest) to Caucasians (the highest) they used photographs, which they believed provided evidence. See Elizabeth Edwards, 'Photographic "Types": The Pursuit of Method', in Joanna Cohan Scherer (ed.), *Picturing Cultures: Historical Photographs in Anthropological Inquiry*, Special Issue of *Visual Anthropology* 3 (2+3), 1990, pp. 235–258.

14. But in Fritsch's later engravings of racial types, such markers of distinction are minimised. Once repackaged and relocated in the institutionalised circuits of emergent German anthropology, the portrait busts were carefully chosen to serve new ends, their idiosyncratic delicacy and markers of distinction downplayed in favour of preconceived generic and typical traits. I am indebted in my account of Fritsch's project to Andrew Bank, 'Anthropology and Portrait Photography: Gustav Fritsch's Natives of South Africa, 1863–1872', *Kronos, Journal of Cape History*, 27, November 2001, 43–76; Michael Godby, 'The art history of an anthropological image: Gustav Fritsch's Collection of photographic native portraits, 1863-1866' in Deitrich and Bank 2008, pp. 124–133; and Udo Krautwurst, 'The Joy of Looking: Early German Anthropology, Photography and Audience Formation' in A. Hoffmann, *What We See, Reconsidering an Anthropometrical Collection from Southern Africa: Images, Voices, and Versions*, Basel, Basler Afrika Bibliographien, 2009, pp. 148–181.

15. See Christopher Pinney, 'The Parallel Histories of Anthropology and Photography', in Edwards 1992, pp. 74–96 for a detailed discussion of the complex relationship between these.

16. See L. Jacobson, 'The development of an ethnographic photographer', in *Thandabantu – a photographic journey through Southern Africa*, Kimberley, McGregor Museum, 2007, p. 8. Jacobson argues that the coherence of the groupings is itself now the object of debate and dispute as identities were more fluid than Duggan-Cronin's taxonomies implied.

17. See the interview with Mofokeng in this volume, p. 281. For Mofokeng's discussion of his own work in relation to Duggan-Cronin, see S. Mofokeng, 'The Black Photo Album/Look at Me: 1890–1950', reprinted in Okwui Enwezor (ed.), *Contemporary African Photography from the Walther Collection, Events of the Self, Portraiture and Social Identity*, Göttingen, Steidl, 2010, p. 171. See also Lauri Firstenberg, 'Representing the Body Archivally in South African Photography', *Art Journal*, 61(1), Spring 2002, pp. 58–67.

18. I am grateful to Mofokeng for a lengthy correspondence on this issue, July 2010.

19. There are still some surviving sitters who visit the McGregor Museum in Kimberley, where they are housed, in order to see and admire their images. See Anna Douglas, 'Life Less Ordinary', in *Life Less Ordinary: Performance and Display in South African Art*, Nottingham, Djanogly Art Gallery, 2009, p. 7. Such a revisionist way of thinking about colonial photography and its capacity to speak to the agency of those pictured is explored in Morton and Edwards's *Photography, Anthropology and History, Expanding the Frame* (2009), where a number of essays deal with the issue of the recognition and embrace of ancestors in photographs which have long been thought of as oppressive and objectifying in post-colonial criticism.

20. Duggan-Cronin's photographs are prized collectors' items. For a sensitive discussion of their artistic merits which also takes account of their ethnographic origins, see Stevenson and Graham-Stewart 2001, pp. 9–35.

21. These were annotated and introduced by the scholar Dorothea Bleek, whose own project on the San has been the subject of much interesting (and controversial) scholarship. See Pippa Skotnes (ed.), *Miscast: Negotiating the Presence of the Bushmen*, Cape Town, University of Cape Town Press, 1996; and Andrew Bank, *Bushmen in a Victorian World: The Remarkable Story of the Bleek-Lloyd Collection of Bushman Folklore*, Cape Town, Double Storey, 2006. The San themselves have been repeatedly photographed in a number of projects, from Bleek herself onwards. See for example Jürgen Schadeberg's images in George Hulme and Jürgen Schadeberg, *Kalahari Bushmen Dance*, London, Wildwood House, 1982; and Schadeberg's *The San of the Kalahari*, Pretoria, Protea Bookhouse, 2002. See also Paul Weinberg's *In Search of the San*, Johannesburg, The Porcupine Press, 1997.

22. For a thoroughgoing dismissal of Duggan-Cronin as perpetuating an aestheticising and idealising agenda, see Darren Newbury, *Defiant Images, Photography and Apartheid South Africa*, Pretoria, Unisa Press, 2009, pp. 15–17.

23. His project uncannily resembles that of Edward Curtis who had, just before him, set out to 'chronicle' native North Americans, believed to be a 'dying breed', in *The North American Indian*, issued in 20 volumes between 1907 and 1930.

24. In this she is comparable with artists like Catherine Opie, whose inclusive documentation of marginalised communities is premised on the notion that making visible hitherto occulted sub-groups is a political gesture in itself.

25. As Mlangeni put it: 'I did not choose to be invisible, but ended up blending with the people in the hostel. I became one of them, I spent so long there that they never really cared what I was doing.' See Federica Angelucci, in *Sabelo Mlangeni, Men Only*, Cape Town, Michael Stevenson, 2009, p. 3.

26. See C. Pinney, 'The Parallel Histories of Anthropology and Photography', in Edwards 1992, p. 76, for a discussion of this picture.

27. For a recent discussion of this issue, see Susan Sontag's *Regarding the Pain of Others*, New York, Farrar, Strauss and Giroux, 2003. Sontag had already raised this issue in her discussion of Diane Arbus in the 1970s. See *Diane Arbus: An Aperture Monograph*, 1972. For discussion critical of Nan Goldin and Larry Clark's work in relation to voyeurism, spectacle and insider/outsider dynamics, see Abigail Solomon-Godeau, 'Inside/Out', in San Francisco Museum of Modern Art, *Public Information, Desire, Disaster, Document*, 1994, pp. 49–61. For Solomon Godeau, inclusion of the photographer in the community pictured offers no defence against allegations of exploitation of socially marginalised groups, routinely exposed by the camera. The overall image culture into which a work is inserted still affects the power relations pictured, even if from an insider viewpoint. See also the special issue of *Art South Africa* –'Three Essays on Photography' – with extensive comment and discussion in relation to the local context: 8(2) 2009.

28. For the Essops' explanation of this, see interview p. 267.

29. August Sander, Thomas Ruff, Fiona Tan, to name just a few, deal with seriality and singularity in the adumbration and exploration of the subject and the social.

30. By 'Afrikanerdom' is meant Afrikaans nationalism, originating in the culture of the Dutch-descended Boers and defined in opposition to the British as well as to the indigenous and immigrant populations of Africans. For a comprehensive and fascinating account of the history of this group see H. Giliomee, *The Afrikaners, Biography of a People*, Virginia, University of Virginia Press, 2003.

31. For a historical overview of racialised thinking and its naturalisation in language, see Tzvetan Todorov, *On Human Diversity: Nationalism, Racism, and Exoticism in French Thought*, Cambridge, MA, Harvard University Press, 1998. For photography's historic role in classificatory politics, see Allan Sekula's 'The Body and the Archive', *October, 39*, Winter 1986, pp. 3–64; John Tagg's *The Burden of Representation: Essays on Photographies and Histories*, Minneapolis, University of Minnesota Press, 1988 (1993); and David Green's 'On Foucault: Disciplinary Power and Photography', *Camerawork*, 32, 1985, pp. 6–9; as well as David Green in 'Veins of Resemblance: Photography and Eugenics', *Oxford Art Journal*, 7(2), 1985, 3–16 and in 'Classified Subjects', *Ten.8*, 14, 1984, pp. 30–37.

32. Ballen's more recent work, though, is a hybrid of this and his own psychological world. It could be argued that he creates, like Arbus, a psychological personal fiction or mythology based on real characters and heightened or semi-constructed spaces. See, for example, *Boarding House*, 2009, and *Shadow Chamber*, 2005.

33. Goldblatt has assured me that he was not aware of these pictures when he produced his own series (email correspondence, August 2010). Interestingly, Darren Newbury, in a lengthy and interesting chapter on Stuart Larrabee in *Defiant Images*, does not deal with this series, choosing rather to concentrate on her more prolific African rural and urban subjects in his assessment of her as a politically conservative figure who succumbed to an aestheticist model rather than embracing the political potential of social documentary; Darren Newbury, *Defiant Images: Photography and Apartheid South Africa*, Pretoria, Unisa Press, 2009, pp. 15–42. For a useful, if short, account of her African portraits, see M. Godby, 'African Contrasts', in *Lines of Sight: Essays on the History of South African Photography*, Cape Town, South African National Gallery, 1999, p. 19.

34. In fact, the traditions of the Ndebele that Stuart Larrabee and her associates (such as the painter Alexis Preller and the architect Norman Eaton) defended were fairly recent and promoted by the Afrikaner communities who had deprived them of their land and turned them into labourers and servants. See Brenda Danilowitz, 'Constance Stuart Larrabee's Photographs of the Ndzunza Ndebele: Performance and History Beyond the Modernist Frame', in Marion Arnold and Brenda Schmahmann (eds), *Between Union and Liberation: Women Artists in South Africa 1910–1994*, Aldershot and Burlington, Ashgate, 2005, pp. 71–93.

35. See C. Stuart, 'Photography as an Art', from *Pretoria: A City of Culture, 1938–39*, cited in Newbury 2009, p. 19.

36. For a discussion of the work in relation to a statement published by Stuart Larrabee herself, see Newbury 2009, pp. 29–32.

37. I am drawing here on Jacques Ranciéres's understanding of documentary and fiction: 'The real difference between them isn't that the documentary sides with the real against the inventions of fiction, it's just that the documentary instead

of treating the real as an effect to be produced, treats it as a fact to be understood'. In *Film Fables*, Oxford and New York, Berg Publishers, first published 2001, translated in 2006, p. 158.

38. See A. Solomon-Godeau, 'Who is Speaking Thus? Some Questions about Documentary Photography', in *Photography at the Dock, Essays on Photographic History, Institutions, and Practices*, Minneapolis, University of Minnesota Press, 1991, reprinted in 2009, p. 169.

39. See Gordon Metz, 'Out of the Shadows', Introduction to *Margins to Mainstream: Lost South African Photographers (Ernest Cole, Bob Gosani, Leon Levson, Willie de Klerk, Ranjith Kally, Eli Weinberg)*, Cape Town, Mayibuye Centre, 1994.

40. For a discussion of Levson in context, see Newbury 2009, pp. 43–70.

41. Darren Newbury has charted the transformation of *African Drum* to *Drum* magazine and shown how its earlier rural and ethnographic approach was gradually displaced by the embrace of the urban and the modern. See Newbury 2009, pp. 81–172. For an incisive discussion on the pictorial conventions of the documentary mode, see Steve Edwards, *Photography, A Very Short Introduction*, Oxford, Oxford University Press, 2006, pp. 12–39. To claim that documentary had 'realist' ambitions is not to say that it was mindlessly mimetic but that it adumbrated an equivalent of the 'real' as a critical aesthetic.

42. For an excellent essay on the complex literary contents of *Drum*, see M. Chapman, 'More than Telling a Story; *Drum* and its Significance in Black South African Writing', in M. Chapman (ed.), *The Drum Decade, Stories from the 1950s*, Pietermaritzburg, University of Natal Press, 1989 (reprinted 2001), pp. 183–232.

43. For a discussion of the competing cultures of political reportage and fiction in the magazine, see Njabulo Ndebele, 'Rediscovery of the Ordinary' (1984), reprinted in *Rediscovery of the Ordinary, Essays on South African Literature and Culture*, Scottsville, University of KwaZulu-Natal Press, 1991, pp. 44–45.

44. The campaign against the extension of passes to women was at its height in 1955. See P. Magubane, 'Why Women Don't Want Passes', *Drum*, November 1958, pp. 26–30. In March 1956, thousands of women marched to Pretoria to protest against the law. For a discussion of the all-male photographic record of this event, see P. Siopis, 'On Both Sides Now, Fifty Years of South African Women behind and in front of the Lens', in R. Comley, G. Hallett and N. Ntsoma, *Women by Women*, Johannesburg, Wits University Press, 2006, pp. 9–10.

45. 'Born free' is the phrase often used to describe the generation raised after the end of apartheid.

46. *Drum*, September 1958, p. 37.

47. *Drum*, September 1958, p. 39.

48. James Ambrose Brown, 'We Are ONE', *Sunday Times*, 24 August 1958, p. 8.

49. Patrick van Rensburg, 'HUMANITY versus APARTHEID', *Rand Daily Mail*, 15 September 1958, p. 8.

50. In keeping with its 'universalising' rhetoric and sentimental conception of birth and death as shared human experiences that transcend history, the exhibition had omitted any reference, pictorial or otherwise, to the racist scourges of mid-twentieth century Europe where death had been industrialised and mechanised as extermination. For an important analysis of the exhibition as symptomatic of the repression of the 'Shoah' see V. Schmidt-Lisenhoff, '1955-2001. The Family of Man' and 'here is new york' (sic). in J. Back and V. Schmidt-Linsenhoff, *The Family of Man, Humanism and Postmodernism: A Reappraisal of the Photo Exhibition by Edward Steichen*, Marburg, Jonas Verlag, 2004, pp. 9–27.

51. See 'My Kind ... Luister ... Só Doen 'n Mens Dit', *Die Vaderland*, 30 August 1958, p. 13; and *The Star*, 13 August 1958, p. 9.

52. The show has been roundly condemned by twentieth century theorists for its humanist agenda, aestheticisation, decontextualisation and depoliticisation of the images and for its complicity with a triumphalist narrative of US foreign policy and Cold War propaganda. The most influential critique in this vein was penned by Roland Barthes on the occasion of its opening in Paris in 1958. Barthes condemned the 'myth' of a universal 'human community' promoted by the exhibition's failure to represent difference, history or social division. See R. Barthes, *Mythologies*, translated by Annette Lavers, New York, Noonday Press, 1972 (originally published 1957). See also Blake Stimson, 'Photographic Being and the Family of Man', in *The Pivot of the World, Photography and Its Nation*, Cambridge MA, MIT Press, 2006, pp. 59–104; Eric J. Sanden, *Picturing an Exhibition: The Family of Man and 1950s America*, Albuquerque, University of New Mexico Press, 1995; and the excellent collection of critical essays in Back and Schmidt-Linsenhoff 2004. For a discussion of its reception in the context of *Drum*, see Darren Newbury 2009, pp. 154–160.

53. David Goldblatt remembers vividly the impact that it made on photographers. See interview p. 269.

54. See interview with Darren Newbury 2009, p. 157.

55. 'In 1956 (sic), when the "Family of Man" exhibition came to Johannesburg, I looked, and I said, "These are great

pictures. If these photographers who took these pictures can do this, why shouldn't I?" I began working very, very hard to try and reach the standard of those pictures that I saw.' In 'Peter Magubane, A Black Photographer in Apartheid South Africa', published in Ken Light, *Witness in Our Time, Working Lives of Documentary Photographers*, Washington and London, Smithsonian Institution Press, 2000, p. 56.

56. David Goldblatt, too, remembers the powerful impact that seeing the exhibition had on him and recounts how it motivated him in his early development as a photographer. Interview with the author, Cape Town, July 2010.

57. Evidence of its longevity is demonstrated by the work exhibited at the Bonani Festival of Photography under the directorship of Omar Badsha, 2010. For a discussion of this legacy, see Jon Soske, 'In Defence of Social Documentary Photography', in O. Badsha, M. Norgaard and J Rajgopaul, *Bonani Africa, 2010*, South African History Online, pp. 3–8. Available online at http://www.sahistory.org.za/pages/saho stuff/saho-exhibitions/bonani/program.htm

58. E. Cole's *House of Bondage* appeared with the subtitle 'A South African Black Man Exposes in his Own Pictures and Words the Bitter Life of his Homeland Today' and was introduced by the American journalist with whom he worked, Joseph Lelyveld. New York, Random House, 1967. The photographs were accompanied by essays that mediated the images in particular ways. The book was banned in South Africa, as was Cole himself, who died in exile in New York in 1990. His photographs have been the subject of a recent exhibition which has, for the first time, wrested them away from the explanatory filters and cropping of the book and opened them up for new forms of interpretation. G. Knape (ed.), *Ernest Cole Photographer*, Göteborg and Göttingen, Hasselblad Foundation and Steidl Publishers, 2010.

59. The phrase is Struan Robertson's, a colleague and friend of Cole's at the time. In his fascinating account of their relationship and Cole's working practices, Robertson writes: 'He could have sneaked the picture with a wide-angle but his visualization of the image required a medium telephoto lens to prevent too steep perspective on the line of men. The problem was that a medium-tele, plus the reflex camera on which he would have to use it, were too bulky to be hidden under a jacket. The reflex cameras of those days had no built-in electronics, so you could remove the pentaprism finder and shoot from the waist-level, framing the picture on the exposed glass. Accordingly, Ernest put the camera, minus prism and with the tele-lens fitted, in the bottom of the bag. Focus and exposure were pre-set from the light and distance he had observed on his previous visit. Carefully he tore open the end of the bag next to the lens, leaving the paper as a flap, then taped a cable-release up the opposite inside corner. On top of the camera he put a paper napkin, sandwiches and an apple. Carrying the bag into the mine as his lunch, he got himself into position, pushed the "lunch" aside far enough to see the screen and opened the flap. Framing the shot on the ground glass, all he had to do was wait for the decisive moment and press the cable release. The result was a perfectly framed picture which, like all his pictures, told a powerful story.' (Knape 2010, p. 32.)

60. It is sometimes difficult to separate documentary and photojournalistic practices and I am intentionally blurring my use of these terms as images often circulated between external editorial agendas and 'private' documentary projects. The distinction between them as either 'story' driven or privately motivated is made by Martha Rosler in 'Post-Documentary Photography', *Decoys and Disruptions: Selected Writings, 1975–2001*, Cambridge, Mass., MIT Press, 2004, p. 225. For the broad context of political art and photography in South Africa during this period, see Sue Williamson (ed.), *Resistance Art in South Africa*, New York, St. Martin's Press, 1989.

61. I am grateful to Paul Weinberg for detailed discussions about Afrapix and its remit. Early members included Omar Badsha, Jeeva Rajgopul, Cedric Nunn, Paul Weinberg and Peter McKenzie. They were later joined by Lesley Lawson, Chris Ledochowski, Guy Tillim, Steve Hilton-Barber and Santu Mofokeng (amongst others). It was in this context that collectivist ideals prevailed with workshops and pedagogic initiatives supporting a unique non-racial community of cultural workers and activists. For a vivid description of this moment, see P. Weinberg, 'Documentary Photography: Past, Present and Future', *Staffrider*, 9(4), 1991, pp. 95–97. For an impassioned defence of documentary, see Peter McKenzie's speech delivered at 'The Culture of Resistance' conference held in Gaberone, Botswana, in 1982, discussed in Newbury 2009, pp. 237–240.

62. In Mofokeng's words: 'I joined the Afrapix collective in 1985. I had no work, no equipment and no resources. Afrapix gave me a home. It provided me with money to buy a camera and film in order to document Soweto and the rising discontent in the townships.' S. Mofokeng, 'Trajectory of a Street Photographer: South Africa 1973–1998', in R. Bester, J.-E. Lundström and K. Pierre (eds), *Democracy's Images: Photography and Visual Art after Apartheid*, Umea, BildMuseet, 1988, p. 44. For a succinct and useful summary of these developments, see P. Hayes, 'Power, Secrecy, Proximity: A History of South African Photography', in A. Tolnay (ed.), *Zeitgenössiche Fotokunst Aus Südafrika (Contemporary Art Photography from South Africa)*, Heidelberg, Neuer Berliner Kunstverein und Edition Braus im Wachter Verlag GmbH, 2007, pp. 136–142 (English translation).

63. Afrapix's extraordinary archive is housed at The Centre for Curating the Archive, at the University of Cape Town, under the curatorship of Paul Weinberg.

64. See 'Preface', co-authored by 'The Photographers' in *Beyond the Barricades*, London, Kliptown Books, 1989, p. 7.

65. Quoted in Hayes 2007, p. 40.

66. S. Mofokeng, 'Lampposts', in *Santu Mofokeng*, Johannesburg, David Krut Publishers, 2001, p. 27.

67. See Firstenberg 2002, p. 60.

68. In Mofokeng's words: 'I am disillusioned by my work as a journalist and documentary photographer. Having put up a show at the gallery, seeing how my work gets absorbed, interpreted and assimilated into the mainstream, I have questions on the efficacy of photography making interventions, and mobilising people around issues.' Mofokeng 2001, p. 36.

69. P. Hayes, 'Visual Emergency? Fusion and Fragmentation in South African Photography of the 1980s', *Camera Austria*, 100, 2007, p. 18.

70. Njabulo Ndebele, in 'Rediscovering the Ordinary', made a plea for literature to do the same in the 1980s (Ndebele 1984).

71. For a discussion of Mofokeng's works in this light, see Bronwyn Law-Viljoen, 'Sacred and Profane Ground: The Work of Santu Mofokeng', *ArtThrob*, 82, June 2004. Available online at: http://www.artthrob.co.za/04june/reviews/dkrut. html/ See also Michael Godby, '*Santu Mofokeng's Chasing Shadows*', in *Voice-Overs, Wits Writings, Exploring African Art Works*, University of Witwatersrand Galleries, 2004, p. 62.

72. Colour was already widely used in photojournalism by the end of the 1970s. Susan Meiselas's controversial use of the medium in her Nicaragua project is well known. In 1979, colour could still be regarded as 'shocking' when mobilised to critically document revolution and war but it was already prevalent globally in photojournalism at this point. See Martha Rosler's critique of Meiselas, 'The Revolution in Living Color: The Photojournalism of Susan Meiselas', *In These Times*, June 17–30, 1981, reprinted in Rosler 2004, pp. 245–258. By the 1990s, 'black and white' is seen as both an expensive and an archaic technology, now reserved primarily for 'art' photography. In South Africa, black and white remained the dominant medium of oppositional and political camerawork throughout the 1980s.

73. See online at http://throughpositiveeyes.org/ for entry into the online exhibition 'Through Positive Eyes' organised by Gideon Mendel in collaboration with MAKE ART/STOP AIDS. The AIDS pandemic has prompted a range of important art and photography projects. For a useful survey of some of these see 'Love and Gender in the Time of Aids' in Sue Williamson, *South African Art Now*, New York, Collins, 2009, pp. 121–146.

74. The Market Photo Workshop was founded by David Goldblatt in Johannesburg in the late 1980s. In Goldblatt's words: 'The Workshop was founded and funded on the ideal of making visual literacy and photographic craft available to people of all races ... It was unique in apartheid South Africa.' See Special Issue of *Camera Austria* devoted to its history and graduates: *Camera Austria*, 100, 2007, p. 13.

75. For an interesting discussion of visibility and invisibility and the legacy of documentary, see R. Bester, 'From the Market Photo Workshop', *Camera Austria*, 100, 2007, pp. 44–47.

76. See Brenda Atkinson, *Jo Ractliffe: Artist's Book*, Taxi-001, David Krut Publishing, 2000, pp. 15–16. For Ractliffe's own account of the transition from pre- to post-1994 photography in South Africa, see the discussion with Peter McKenzie and Sean O'Toole in *Camera Austria*, 100, 2007, pp. 130–135.

77. See Okwui Enwezor, 'Exodus of the Dogs', in Jo Ractliffe, *Terreno Ocupado*, Johannesburg, Warren Siebrits, 2008, pp. 84–89.

78. The extent of its use as a base for counter-insurgency operations was revealed during the Truth and Reconciliation Commission Hearings. For a discussion of these revelations and a critical account of the piece, see Atkinson 2000, pp. 12–13.

79. See interview with Michael Smith: 'Jo Ractliffe on Terreno Ocupado at Warren Siebrits', *ArtThrob*, 134, October 2008, available online at: http://www.artthrob.co.za/08oct/interview.html/ In a later project, Ractliffe describes 'The Border' as 'a secret location where brothers and boyfriends were sent as part of their military service'. See *As Terra do Fim do Mundo*, Cape Town, Michael Stevenson, 2010, p. 7.

80. Cited in interview with Michael Smith (2008).

81. Carter was a member of the famous Bang Bang Club, a group of four photojournalists, active in the South African townships and noted for their brave and risk-taking exploits in documenting violence and police brutality. In addition to Carter, they included Ken Oosterbroek (killed while covering a battle in the township of Tokoza), Greg Marinovich and João Silva.

82. Ractliffe describes the extent of the merchandise on sale in an extended caption: 'Here you can buy everything – fresh fruit and vegetables, meat, fish, live animals, ice, clothing, shoes and accessories, appliances, furniture, building materials, machine parts, coffins, medicine and herbal remedies.' This list is not exhaustive and she goes on to describe it as 'Africa's biggest black-market, a place where anything can be sourced, even a Mig jet.' See caption for 'Woman on the footpath from Boa Vista to Roque Santeiro market', in *Ractliffe* 2008, p. 93.

83. See D. Goldblatt, 'The Particular and the Universal in the Photography of Jo Ractliffe', in Ractliffe 2008, p. 91.

84. Jill Bennett discusses Ractliffe's self-conscious exploration of modes of picturing in relation to another project in *Empathic Vision: Affect, Trauma and Contemporary Art*, Stanford, Stanford University Press, 2005, pp. 83–86.

85. Bettina Malcomess writes in relation to Tillim: 'A lot of people express discomfort with Tillim's work. Why do we need another white photographer taking photographs of poor Africans, selling these for close to R20,000 a print? … Guy Tillim's, photographs are, to quote Ed Young, just too "fucking gorgeous".' See Bettina Malcomess, 'Guy Tillim at Michael Stevenson Contemporary', *Artthrob* review, 2006, available online at: http://www.arthrob.co.za/06june/reviews/Stevenson.html/ The same issue is dealt with in relation to Hugo in 'Pieter Hugo in conversation with Joanna Lehan', 21 February 2007, printed in Pieter Hugo, *Messina/Musina*, Rome, Punctum Press, 2007. See also interview with Hugo in this volume, pp. 273.

86. The development of large-scale colour photography in the 1990s is interesting. Although such a move in Europe was made in the 1970s and 1980s, at that point South African photography was very much linked to social critique, opportunities to exhibit in galleries were minimal, because of both the cultural boycott abroad and censorship laws at home, and it was not until the 1990s, in the context of democracy and the embrace of the art world as a forum for the display and circulation of photographs, that colour really took off.

87. For a discussion of Goldblatt's return to black and white in the post-apartheid period, see my 'A Land of Signs' in *Home Lands – Land Marks: Contemporary Art from South Africa*, London, Haunch of Venison, 2008, reprinted in *Nka: Journal of Contemporary African Art, 26*, Spring 2010, pp. 6–29.

88. See my discussion of these in 'A Land of Signs', as well as Okwui Enwezor's 'The Indeterminate Structure of Things Now', both in Tamar Garb 2008.

89. For a brief discussion of this project, see *Graeme Williams Photographe/Photographer*, with text by Gary van Wyk, Paris, editions de l'oeil, 2010.

90. Hugo describes the relationship between the three: 'Pieter and Maryna have a very complex relationship with the child in their arms. They are renting accommodation from the father of the child. The father was shot in the spine during a heist, and has spent months in hospital and rehabilitation while they've taken care of his child.' See 'Pieter Hugo in conversation with Joanna Lehan', 21 February 2007, in Pieter Hugo, *Messina/Musina*, Rome, Punctum Press, 2007, np.

91. William Kentridge has written tellingly about the relationship of white South Africans to the rest of Africa during apartheid in relation to Vivienne Koorland's work. See 'Painting Maps', in *Vivienne Koorland, Reisemalheurs (Travel Woes)*, London, Freud Museum, 2007, pp. 23–28.

92. See 'Pieter Hugo in conversation with Joanna Lehan' in Hugo 2007, np.

93. For a discussion of theatricality (and attempts to overcome it) in modern portrait photography, see M. Fried, *Why Photography Matters as Art as Never Before*, New Haven and London, Yale University Press, 2008, pp. 144–191. For discussions of Hugo's work in Africa, see Bronwyn Law-Viljoen, 'Pieter Hugo: The Critical Zone of Engagement', *Aperture*, 186, Spring 2007, 20–29; and Ashraf Jamal, 'Pieter Hugo: No Apologies', *Art South Africa*, Summer 2009.

94. See Bettina Malcomess, 'Guy Tillim at Michael Stevenson Contemporary', *Artthrob* review, 2006, available online at: http://www.arthrob.co.za/06june/reviews/Stevenson.html/

95. For a fascinating account of Tillim's work in Africa, see R. Bester, 'Photographer Now', in *Guy Tillim*, DaimlerChrysler Award, 2004, pp. 100–106.

96. The project exists in both book and exhibition form. The book is structured as a fold-out with the portraits interspersed, periodically, among the village shots. This structure can be reproduced in an exhibition context or the pictures can be arranged in a grid or more informal groupings. In each case, the portraits are 'framed' by the contextualisation of the series. They do not stand alone. See Guy Tillim, *Petros Village*, Rome, Punctum Press, 2006.

97. These associations – particularly in South Africa – remained true throughout the 1980s despite the increasing appearance of colour, globally, in photojournalism from the late 1970s onwards. The appropriateness of colour for politically engaged projects was raised by Susan Meiselas's work in Nicaragua in the late 1970s. See interview with Kristen Lubben in *Susan Meiselas In History*, New York and Göttingen, ICP and Steidl Publishers, 2009, p. 116.

98. Roland Barthes, *Camera Lucida: Reflections on Photography*, (1980) trans. Richard Howard, London, Vintage, 1993, p. 9.

99. For a lengthy discussion of this issue and its relationship to humanism, see Okwui Enwezor, 'Photography after the end of Documentary Realism: Zwelethu Mthethwa's Colour Photogaphs', *Zwelethu Mthethwa*, New York, Aperture, 2010, pp. 100–115. See also Michael Godby, 'The Drama of Colour: Zwelethu Mthethwa's Portraits', *Nka: Journal of Contemporary African Art*, 10, Spring/Summer 1999, pp. 46–49.

100. Of course, there is more than this going on. The use of colour also reveals the commodified world to which these impoverished sitters are subject, and sets up an interesting dialogue between their social situation and that pictured in the recycled advertising imagery with which they surround themselves. I am indebted for discussions of this to Rebecca Mundy's MA dissertation 'Performing Colour: Questions of dignity and identity in Zwelethu Mthethwa's colour photographs', University College London, 2010.

101. I am indebted here to the excellent article on Shembe costume by Robert Papine, 'The Nazereth Scotch: dance uniform as admonitory infrapolitics for an eikonic Zion City in early Union Natal', *South African Humanities*, 14, December 2002, 79–106. See also Sandra Klopper, 'Mobilizing cultural symbols in twentieth century Zululand', in R. Hill, M. Muller and M. Trump (eds), *African Studies Forum*, 1, Pretoria, HSRC, pp. 193–225.

102. Weinberg also produced a film, 'Dancing for God', which follows the Shembe on their annual pilgrimage and integrates costume and custom. The black and white photographs are published in the context of a comparative study of contemporary forms of spirituality, *The Moving Spirit: Spirituality in Southern Africa*, Amsterdam, Mets and Schilt, 2006.

103. See Omar Badsha, *Imijondolo: A photographic essay on forced removals in South Africa*, Durban, Afrapix, 1985.

104. I have written extensively elsewhere on portraiture as a social art, produced in history and in relation to constructions of class and gender. See Garb, *The Painted Face: Portraits of Women in France, 1814–1914*, London and New Haven, Yale University Press, 2008; and Garb, *The Body in Time: Figures of Femininity in Late Nineteenth-Century France*, Seattle, University of Washington Press, 2008.

105. For the prevalence of portraiture in Africa, and the mobilisation of the portrait as a medium of African self-assertion and agency, see Okwui Enwezor, 'Life and Afterlife in Benin: Photography in the Service of Ethnographic Realism', in Alex van Gelder (ed.), *Life & Afterlife in Benin*, London, Phaidon Press, 2005, pp. 6–15.

106. For a discussion of the relative development of ethnological, anthropological and portrait photographs in the nineteenth century, see Karel Schoemann, *The Face of the Country; A South African Family Album 1860-1910*, Cape Town, Human & Rousseau, 1996, pp. 13–57. For a fascinating history of the development of nineteenth-century photography in the Cape, see Bull and Denfield, *Secure the Shadow* (1970).

107. Little is known about Bolton's practice, except that these daring and elaborate confections coexisted with more predictable and often distasteful studies of eroticised Zulu maidens. I am grateful to Paul Weinberg for making his archive available to me at The Centre for Curating the Archive, University of Cape Town.

108. Steve Edwards has written on the social and pictorial function of backdrops in nineteenth-century photography. See S. Edwards, *The Making of English Photography*, Pennsylvania, The University of Pennsylvania Press, 2006. For their inventive and multi-layered uses in Indian vernacular photography, see Christopher Pinney, *Camera Indica; The Social Life of Indian Photography*, London, Reaktion Books, 1997, pp. 173–180.

109. This image appears in the context of the book *Mr. Mkhize's portrait & other stories from the new South Africa*, London, The Photographers' Gallery, 1998. It offers a pictorial essay, accompanied by personal statements by the sitters on questions of identity and modes of picturing in post-apartheid South Africa.

110. These form part of an elaborate project of video, audio tape and stills (*Better Lives*, 2003) on the subject of migration and home.

111. For a fascinating account of this project, see Ruth Rosengarten, 'Material Ghosts: Terry Kurgan's Park Pictures', in Terry Kurgan and Jo Ractliffe, *Johannesburg Circa Now*, 2005, pp. 30–43. See also L. Bethlehem and T. Kurgan, 'Park Pictures: on the work of photography in Johannesburg', *African Identities*, 7(3), 2009, pp. 417–432.

112. Bieber advertised widely for her models, pasting up notices in the gym, on the university noticeboard, community centres and clubs, and providing her phone number so that interested participants could get in touch. She was keen to trawl as wide a range of cultural and economic backgrounds as possible. Information supplied by Bieber to me in September 2010. Bieber has described the shoots as a 'collaboration' between the models and herself and, in addition to photographing them, she interviewed the women at length. See the extended statement on her website at http://www.jodibieber.com/index/ The idea of including interviews and contextual material supplied by the subjects in order to ensure that they are active participants in a project has been around since the 1970s. A classic example in relation to questions of gender and voyeurism is Susan Meiselas's 'Carnival Strippers' which set out to document the lives of women employed as strippers in the mobile strip joints of the 1970s and included their own testimony and life stories. In Meiselas's case the texts form an integral part of the project and the photographs are not exhibited separately. See A.Solomon-Godeau, 'Caught Looking', in Lubben 2009, pp. 90–99.

113. The Truth and Reconciliation Commission was set up in 1995 to bear witness to and record crimes related to human rights violations under apartheid. In some cases amnesty was sought. For an important account of the process, see Antjie Krog, *Country of my Skull*, London, Vintage Books, 1999.

114. The criminal is only one character that Broomberg and Chanarin explore in a book that juxtaposes narrative and image and tests the limits of each. Amongst other participants in the project are schoolgirls, police officers, infants, traditional healers (see Fig. 85), train drivers etc. See A. Broomberg and O. Chanarin, *Mr. Mkhize's portrait & other stories from the new South Africa*, London, The Photographers' Gallery, 1998.

115. This project was accompanied by a lengthy text of Jonny Steinberg's, author of the award winning book on Cape crime, *The Number: One Man's Search for Identity in the Cape Underworld and Prison Gangs*, Cape Town, Jonathan Ball Publishers, 2004.

116. A number of important photographic projects have explored the transformation of urban architecture through the development of security devices, barriers and placards. See for example Kendall Geers's series *Suburbia*, 1999, shown at Documenta XI, Kassel.

117. In a conversation in Johannesburg in July 2010, Subotzky talked to me of his admiration for the Bechers and of having been influenced by their work.

118. 'Braai' is the South African word for barbecue (short for *braaivleis* meaning grilled meat) and is used by all language groups, although its origins are Afrikaans.

119. For influential discussions of this issue see Christopher L. Miller, *Blank Darkness, Africanist Discourse in French*, Chicago, University of Chicago Press, 1985; and V.Y. Mudimbe, *The Invention of Africa: Gnosis, Philosophy, and the Order of Knowledge*, Chapel Hill, Indiana University Press, 1988. On the African as the absolute Other to Western notions of self, see A. Mbembe, *On the Postcolony*, Berkeley, Los Angeles and London, University of California Press, 2001, pp. 1–9.

120. Njabulo S. Ndebele, 'Rediscovery of the Ordinary', 1984, reprinted 1991, pp. 31–54. This essay is interesting to juxtapose with Albie Sachs's powerful and controversial analysis of the ANC's attitude to art and culture in 1989. See 'Albie Sachs, Preparing Ourselves for Freedom', in David Elliot (ed.), *Art from South Africa*, Oxford, Museum of Modern Art, 1990, pp. 10–15.

121. A fragment from 'marital song' goes: 'belovéds and worn-out lovers/are celebrated like wine so that none of us would forget/how the dew of the world sings and sings the body's shadow/assembled here, let us praise the transient arms/let us praise the mortal fractures/let us honour this hail of whole-heartedness ...' Krog (2006), p. 9.

Jodi
Bieber

Born 1966, Johannesburg, South Africa
Based in Johannesburg, South Africa

After completing three short photographic courses at the The Market Photo Workshop in Johannesburg in September 1993, Jodi was selected to participate in a photographic training programme at *The Star* newspaper with the late Ken Oosterbroek. She continued to work as a photographer on *The Star* leading up to and during South Africa's first democratic elections. In 1996 she was chosen to participate in the World Press Masterclass in Holland and started working on assignments for international publications including *The New York Times Magazine*. She also works for non-profit organizations like Médicins Sans Frontières on special projects for books and exhibitions.

Over a ten-year period (1994 – 2004) her personal work has focused on the country of her birth, South Africa, photographing young people living on the fringes of South African society, published in 2006 in a book, *Between Dogs and Wolves – Growing up with South Africa*. She continues to exhibit internationally and her most recent body of work, *Soweto* was published in a book in May 2010.

Bieber's most recent award is the World Press Photo of the Year 2010, awarded in February 2011 for her portrait of a young woman, disfigured as a punishment, in Afghanistan. Other awards include 8 other World Press awards, a 1st Place in Picture of the Year International 2009, the Prix de le l'Union Europeene at *Rencontres de Bamako Biennale Africaine de la Photographie*, November 2009.

Bieber has taught or been a guest lecturer at the Market Photography Workshop, London College of Communication (UK), Westminister University (UK), ICP school of Photojournalism (USA) and at PhotoEspaña.

Jodi Bieber
Claire, from the series 'Real Beauty', 2008

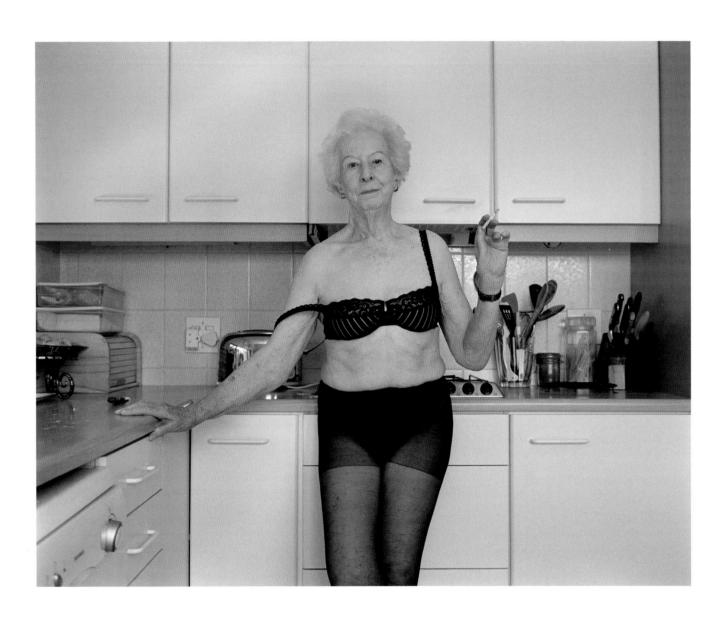

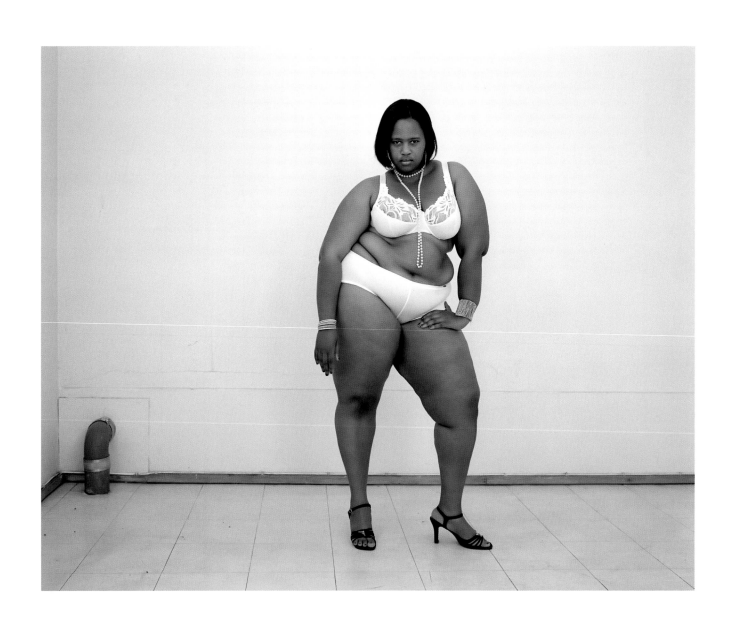

Jodi Bieber
Babalwa, 2008

Brenda, 2008
(both from the series 'Real Beauty', 2008)

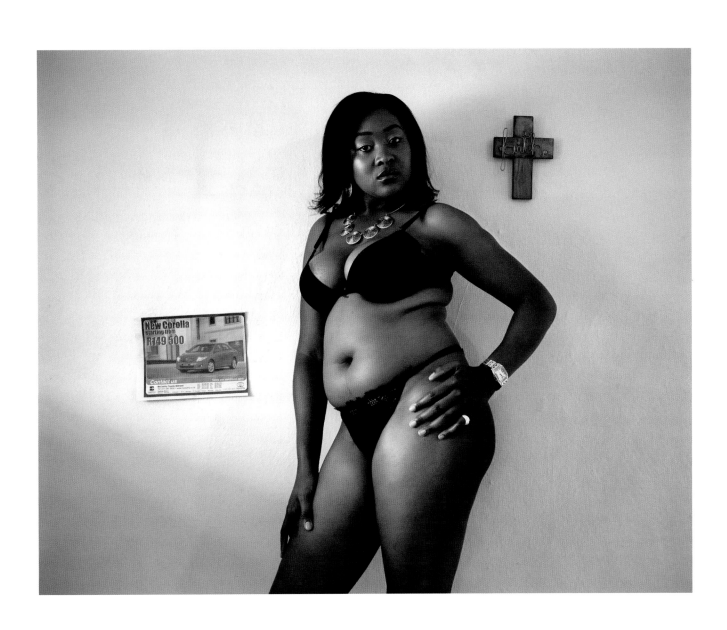

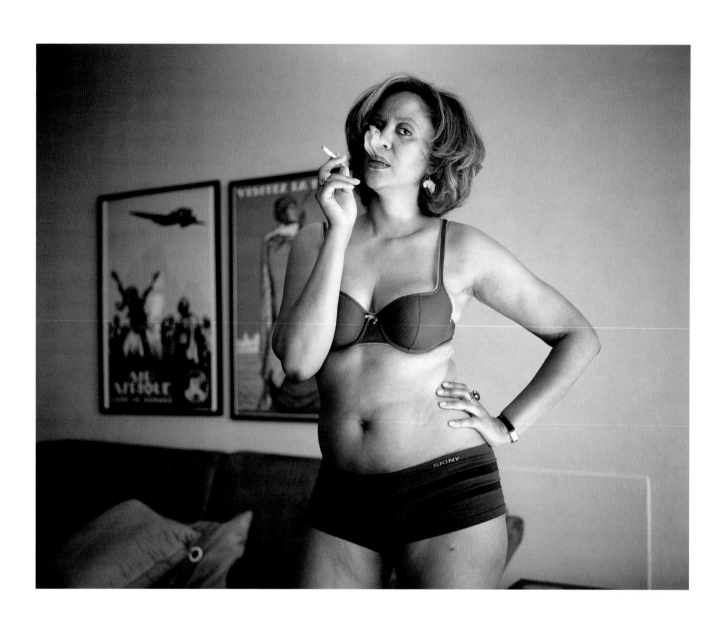

Jodi Bieber
Gail, 2008

Maria, 2008
(both from the series 'Real Beauty', 2008)

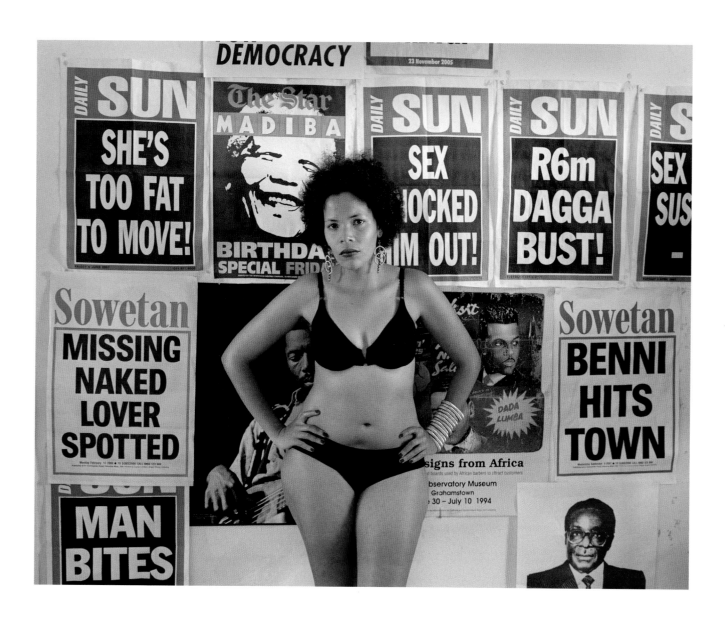

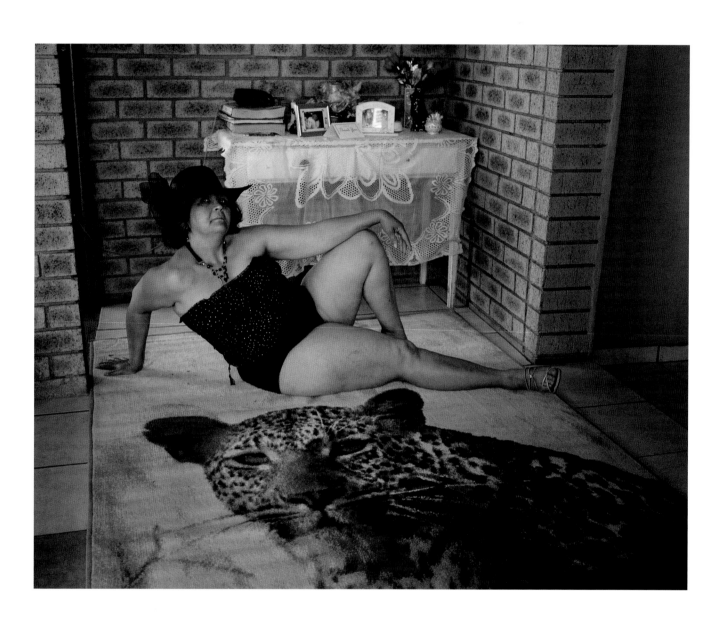

Jodi Bieber
Lucille, 2008

Mpho, 2008
(both from the series 'Real Beauty', 2008)

94

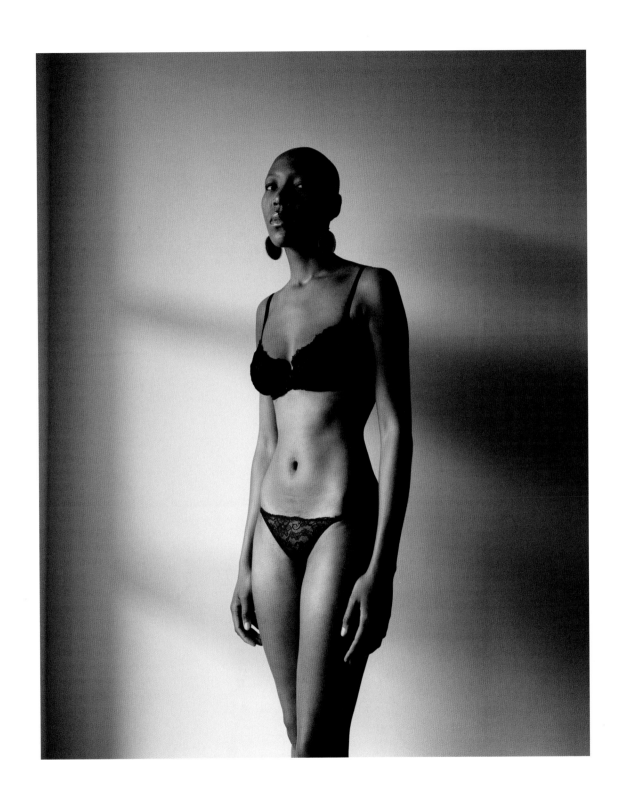

Kudzanai
Chiurai

Born 1981, Zimbabwe
Lives and works in South Africa

Born in 1981 in Zimbabwe, Kudzanai Chiurai is an internationally acclaimed young artist now living and working in South Africa. He was the first black student to graduate with a BA (fine art) from the University of Pretoria. Regarded as part of the 'born free' generation in Zimbabwe because he was born one year after the country's independence, Chiurai's early work focused on the political, economic and social strife in his homeland. Seminal works like *Presidential Wallpaper* depicted Zimbabwean president Robert Mugabe as a sell-out and led to Chiurai's exile from Zimbabwe.

 Chiurai's large mixed media works now tackle some of the most pertinent issues facing southern Africa such as xenophobia, displacement and black empowerment. His paintings confront viewers with the psychological and physical experience of inner-city Johannesburg, the continent's most cosmopolitan melting pot where thousands of exiles, refugees and asylum-seekers battle for survival alongside the never-ending swell of newly urbanised South Africans.

Kudzanai Chiurai
The Minister of Finance, from the series 'The Black President', 2009

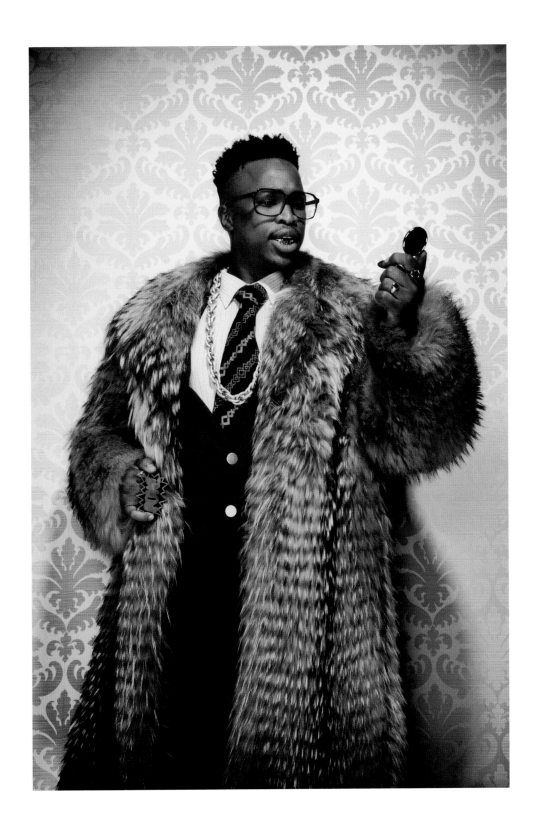

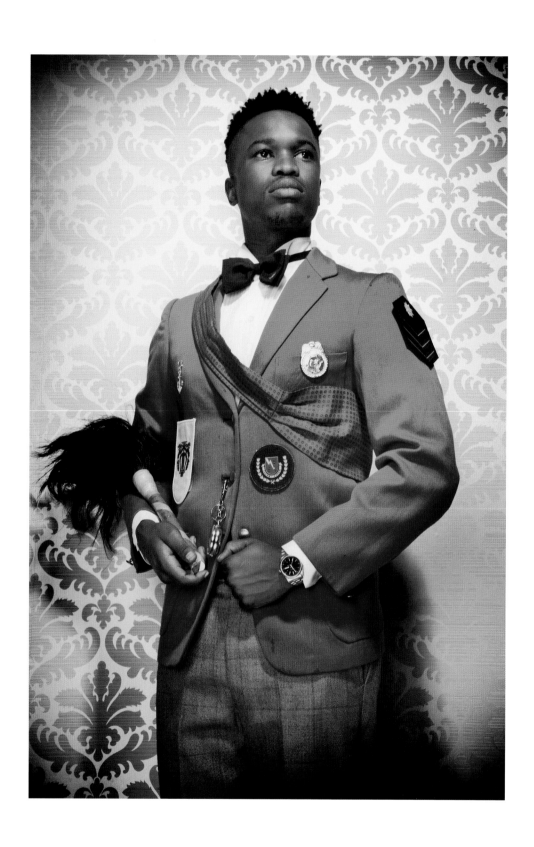

Kudzanai Chiurai
The Black President, 2009

The Minister of Education, 2009
(both from the series 'The Black President', 2009)

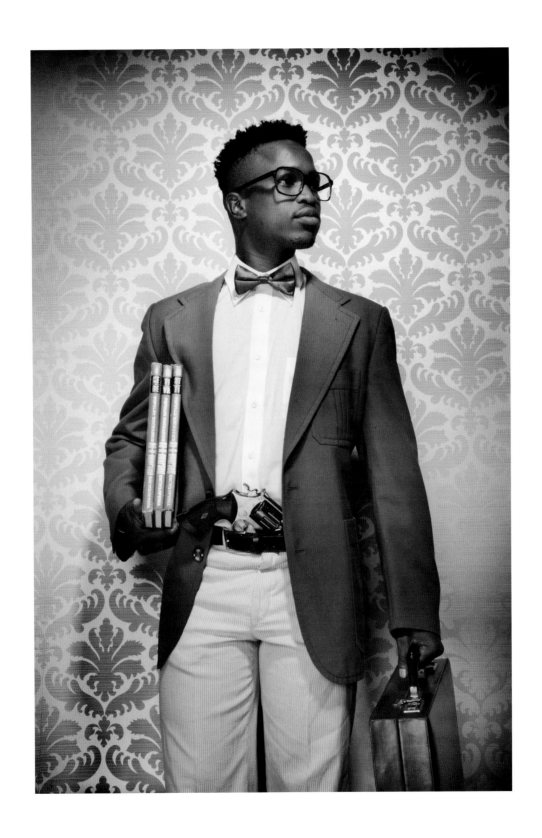

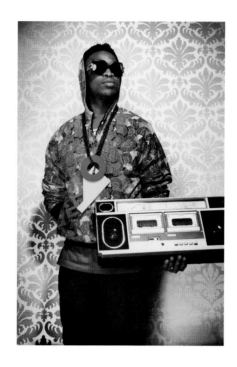
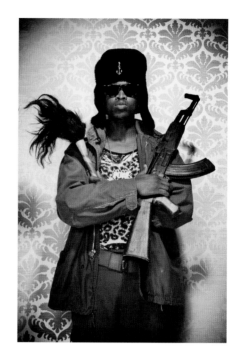
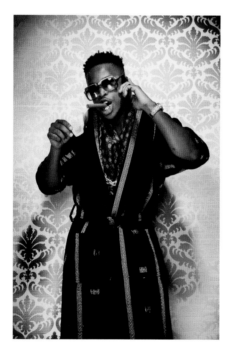
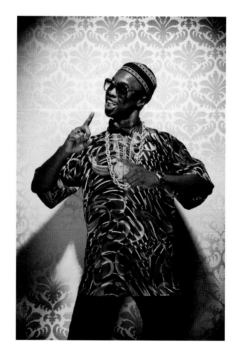

Kudzanai Chiurai
The Minister of Arts and Culture, 2009
The Minister of Enterprise, 2009
The Minister of Defence, 2009
The Minister of Foreign Affairs, 2009

The Minister of Health, 2009
(all from the series 'The Black President', 2009)

102

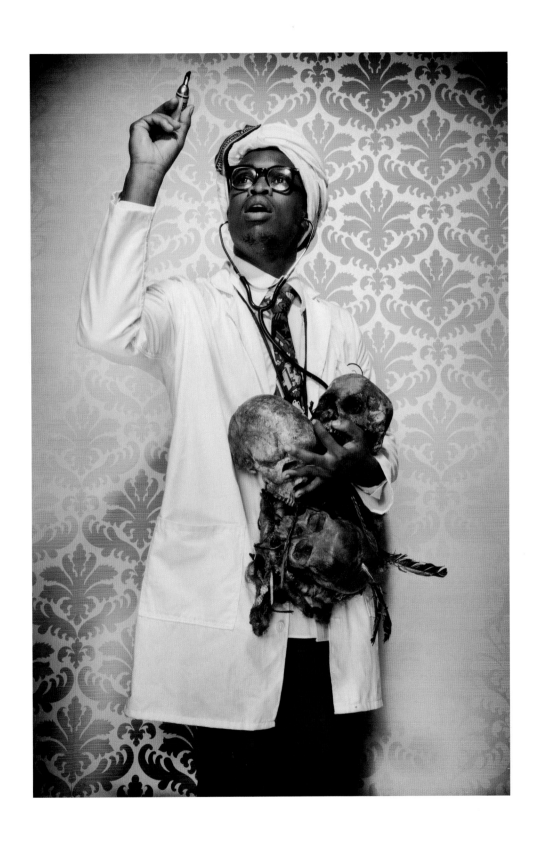

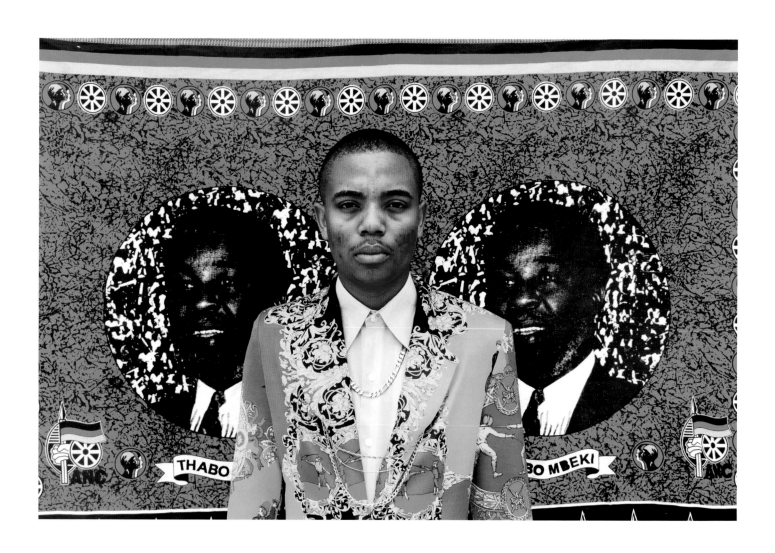

Kudzanai Chiurai
Untitled I, 2010

Untitled III, 2010

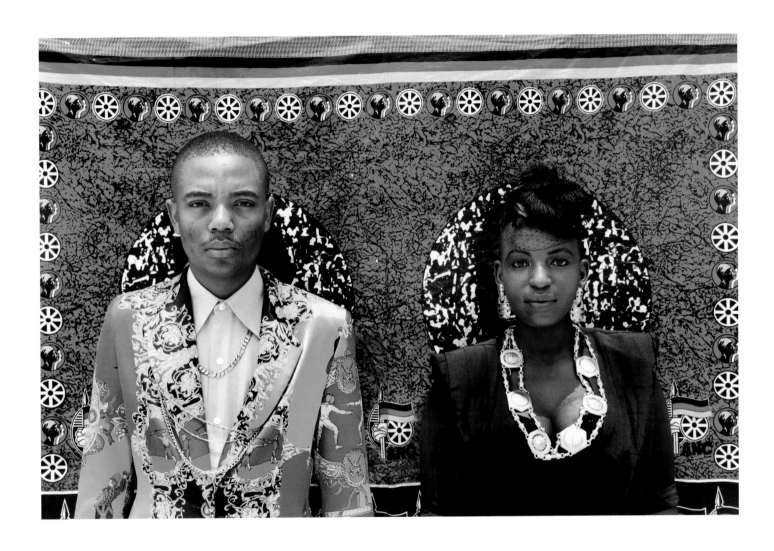

Hasan
& Husain
Essop

Born 1985, Cape Town, South Africa
Live and work in Cape Town, South Africa

Hasan and Husain Essop have been collaborating since their graduation from the University of Cape Town in 2006. Staged scenarios in which they perform varying roles are then photoshopped to explore a range of conflicts and convergences. Their work has appeared in several group shows, including *Integration and Resistance in the Global Age* at the Havana Biennale, *ABSA L'Atelier* in Johannesburg and *Power Play* at Goodman Gallery Cape, as well as in various private and public collections, including the Durban Art Gallery and the South African National Gallery.

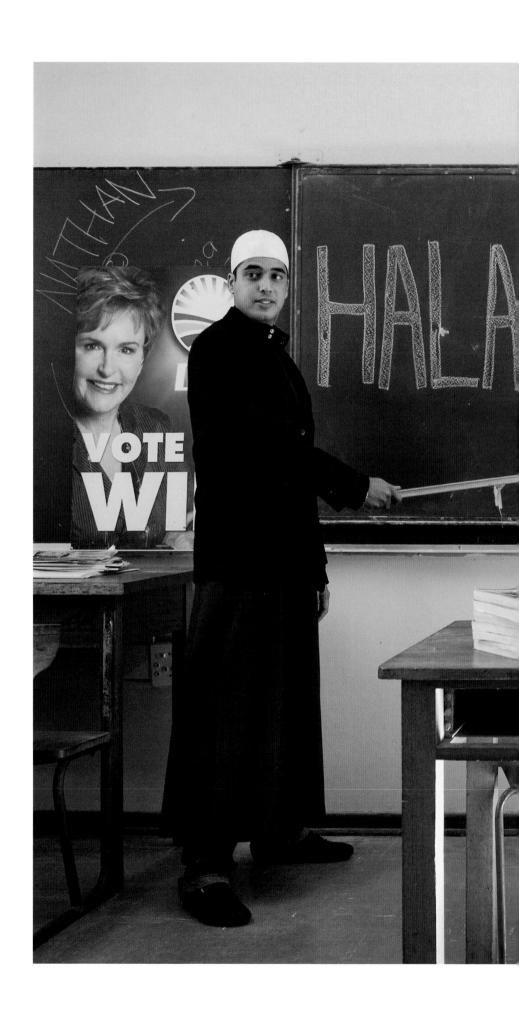

Hasan & Husain Essop
Halaal Art, from the series 'Halaal Art', 2009

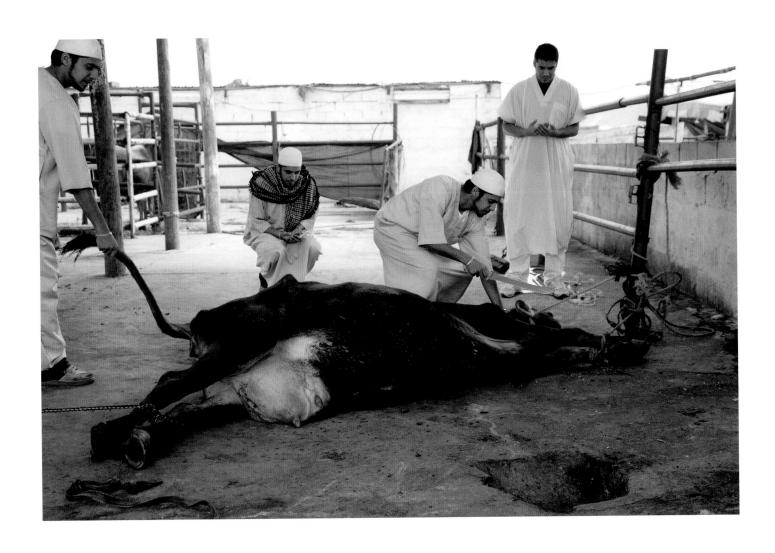

Hasan & Husain Essop
Blessing Meat, 2009

Sunrise Farm, 2009
(both from the series 'Halaal Art', 2009)

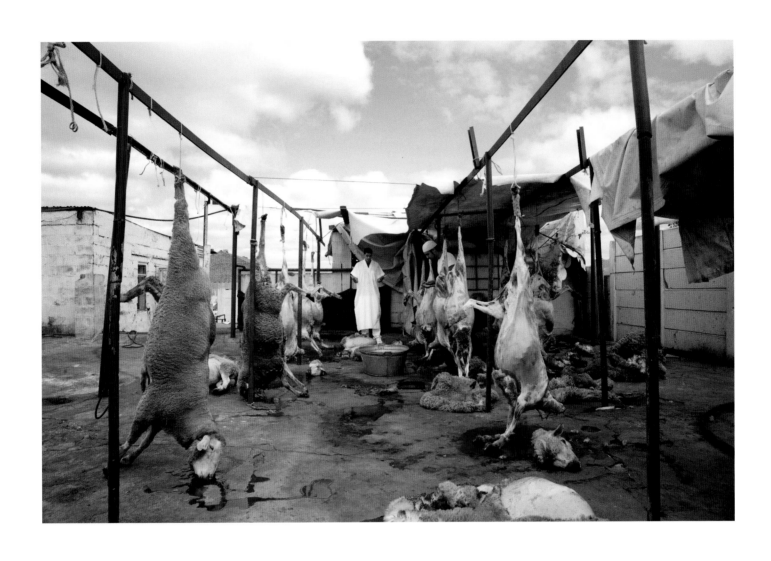

Hasan & Husain Essop
Night Before Eid, from the series
'Halaal Art', 2009

Hasan & Husain Essop
Feeding Scheme, from the series
'Halaal Art', 2009

David
Goldblatt

Born 1930, Randfontein, South Africa
Lives and works in Johannesburg, South Africa

Goldblatt is sometimes described as 'the father of South African documentary photography'. His role as mentor to younger generations of photographers is unquestionable. But Goldblatt himself resists any straightforward 'documentary' label. Professional since 1963, and based for many years at *Leadership* magazine, Goldblatt founded the progressive Market Photo Workshop in Johannesburg in 1989. His work encompasses the impact of mining, the class and race fragilities of whiteness, the homogenisation of South African towns, and the effects of Bantustan policy on African commuters (for the Carnegie Commission). His great long-term thematic project on structures and environments, and the values inscribed in them, surfaced with remarkable coherence and timeliness after apartheid's end with *South Africa: The Structure of Things Then* (1998). In 1998 he was the first South African to be given a solo exhibition at the Museum of Modern Art (MoMA), New York. Goldblatt received an Honorary Doctorate in Fine Arts at the University of Cape Town in 2001. The same year a retrospective exhibition of his work, *David Goldblatt Fifty-One Years*, began a tour of galleries and museums around the world, travelling to New York, Barcelona, Rotterdam, Lisbon, Oxford, Brussels, Munich and Johannesburg. He was one of the few South African artists to exhibit at Documenta 11 (2002) and Documenta 12 (2007) in Kassel, Germany. Goldblatt received an Honorary Doctorate of Literature from the University of the Witwatersrand in 2008. He recently held solo exhibitions at the Jewish Museum and the New Museum, both in New York and is currently exhibiting alongside photographers such as Walker Evans and Bruce Nauman in *The Original Copy: Photography of Sculpture, 1839 to Today* at MoMA. Goldblatt's photographs are in the collections of the South African National Gallery, Cape Town; the Bibliothèque Nationale, Paris; the Victoria and Albert Museum, London; and MoMA. He has published several books of his work. Goldblatt is the recipient of the 2006 Hasselblad award, the 2009 Henri Cartier-Bresson Award and was recently announced as the 2010 Lucie Award Lifetime Achievement Honoree.

Errol Seboledisho

Born in Soweto in 1979, Errol Seboledisho was brought up by his parents and grandparents. He matriculated in 1996 and had almost completed his training as an electrician when the money ran out. In 1999 he joined friends who were doing housebreaking, shoplifting and 'pavement robbery'. In the latter he would see a woman coming and, with knife in hand, say to her, 'Would you please give me your wallet and your phone so that I will never hurt you. Ja I would say please' he laughs, 'Ja, I asked so nice, 'cause I … was a nice person and I used to go to church.' In 2002 he was caught shoplifting in this store and went to prison for two-and-a-half years. Now he seeks work and is asked whether he has a criminal record. 'So, eish that stigma, sometimes it's what prevents us from working'. He has a son, 'And I'll always encourage him to go to school, never do wrong, never take somebody else's property.'
 Soweto. 13 February 2010

David Goldblatt
Errol Seboledisho, from the series 'Ex-Offenders', 2010

Blitz Maaneveld

Blitz Maaneveld ('Blitz', meaning lightning, because he was so fast with the knife) disappeared shortly after this photograph was taken and was then murdered before I was able to interview him. However I spoke with 'H', who became his girlfriend in 2007 when she was 21. This is an excerpt from what she said:

He was born in Bontheuwel in 1959. He had four brothers and two sisters. He was criminal since he was young, He was about nine when he stole from shops, then he started breaking into cars, then stealing cars, then more serious crimes like robbing people, then attempted murder, then murder. All his life he was in jail. All his life he was on drugs – dagga, tik, cocaine, mandrax, everything, and then he still drank on top of it. He had four children that I know of... He didn't improve his life and he didn't want to improve his life. He was just satisfied with what he did. ..Blitz and his younger brother, Kapou, were doing the same crimes, they looked after each other...and were in the same gang in jail, the 26s. Blitz was a general...His father was also a gangster...abusive towards his mother...Blitz believed a woman should be beaten in order for her to listen. He beat me. A lot. I made a case against him and had an interdict against him because he just didn't want to stay away from me. I was afraid of him. Then he came here to my mother's house for one week and was hitting me every night...Mommy called the cops and he disappeared. That was November 2008. Five months later the cops asked me to identify the body. But I couldn't, it was too decomposed. They had to show me a photograph of when he was brought into the morgue...He was shot twice in the chest, once in the back. By gangsters. He robbed one of the merchants. Everybody had a reason to kill him. I wanted to kill him. Part of me was happy to see that he's dead and he can't hurt me anymore, but another part of me was very hurt because I loved him.

Aside from other convictions, Blitz went to gaol for two murders. Here, at the Terrace in Woodstock, Cape Town, he killed a man with whom he quarrelled while gambling.

7 October 2008

David Goldblatt
Blitz Maaneveld, from the series 'Ex-Offenders', 2010

Hennie Gerber

Born in 1948, Hennie Gerber was 16 when he joined the South African Police. He became a dog handler working with Security Police on the Botswana border and then served with the Murder and Robbery squad, where he 'experienced ... techniques of interrogation which included various forms of coercion and torture'.* After 8 years he resigned and joined a private security company, Fidelity Guards, as Group Security Manager. On March 27, 1991 men with AK47s robbed the company's Joburg premises of R4.5 million. Gerber believed that this was a PAC operation and an inside job. He suspected an employee, Samuel Kganakga, for this and an additional theft of R60000. When he didn't yield to questioning Gerber had Kganakga taken to a remote gum plantation next to a mine dump where he was suspended from a tree by his feet. His genitals and hands were electrically shocked and a fire was lit beneath his head so that he would inhale smoke. Gerber, two other White ex-policemen and two Black employees questioned him. With brief respites he was suspended for about 8 hours without refreshment. 'There was liquor in my car and we started drinking. During these ... interrogations alcohol is always used. No right-thinking person can act in this way without your conscience plaguing you.'* Kganakga denied all knowledge of the robberies. He was eventually taken down, shot in the shoulder by Gerber's colleague, Oosthuizen, and then shot and killed by Gerber. The body was burnt. Gerber was sentenced to 20 years imprisonment for murder. He applied for amnesty to the Truth and Reconciliation Commission on the grounds that he had acted in pursuit of the fight against terrorism. The application was refused on the grounds that there was no evidence of a political motive for the killing. Gerber served 14 years and is now a private investigator.

*Gerber in the Truth and Reconciliation Commission, Amnesty hearing, Pretoria, June 1996

David Goldblatt
Hennie Gerber, from the series 'Ex-Offenders', 2010

David Goldblatt
Erickson Ngomane's advert, Republic Road, Darrenwood. 17 February 2000, from the series 'Tradesmen', *2000*

David Goldblatt
Peter Mogale's advert at the corner of 11 Avenue and 3 Street Lower Houghton, Johannesburg. 20 November 1999, from the series 'Tradesmen', 2000

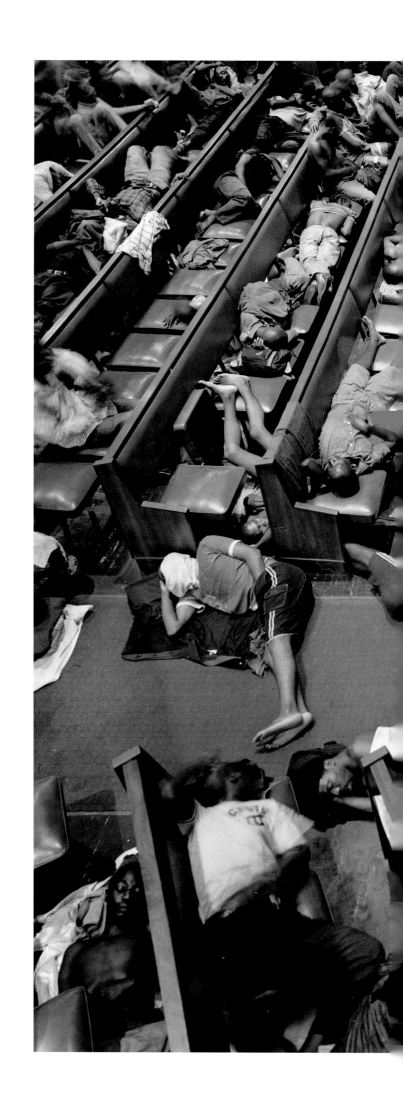

David Goldblatt
Refugees From Zimbabwe Sheltering in the Central Methodist Church on Pritchard Street, in the city. 22 March 2009, from the series 'Zimbabwean Refugees', 2009

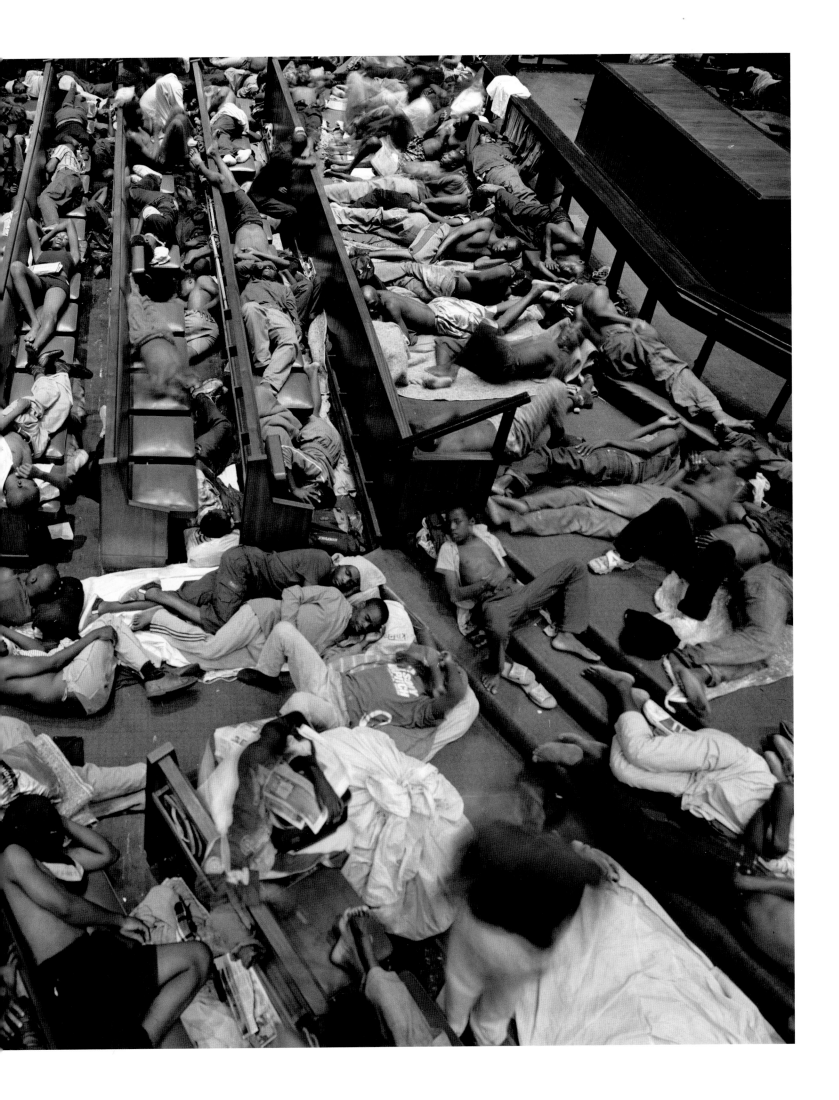

Pieter
Hugo

Born 1976, South Africa
Lives and works in Cape Town, South Africa

Pieter Hugo grew up in Cape Town, where he continues to live. He underwent a two-year residency in 2002-3 at Fabrica in Treviso, Italy. Recent solo shows have taken place at Yossi Milo Gallery in New York (2010); Le Chateau d'Eau in Toulouse, France (2010); the Australian Centre for Photography in Sydney, Australia (2009), and Foam Fotografiemuseum Amsterdam (2008). Group exhibitions include *The Endless Renaissance*, Bass Museum of Art, Miami Beach, Florida (2009); *Street & Studio: An Urban History of Photography* at Tate Modern, London (2008); *An Atlas of Events* at Calouste Gulbenkian Foundation, Lisbon (2007); and the 27th São Paulo Biennale (2006). He won first prize in the Portraits section of the 2006 World Press Photo competition, and was the Standard Bank Young Artist for Visual Art 2007. In 2008 Hugo was the winner of the KLM Paul Huf Award and the Arles Discovery Award at the Rencontres d'Arles Photography Festival in France, and in 2007 the Standard Bank Young Artist for Visual Art.

Pieter Hugo
Mallam Galadima Ahmadu with Jamis, Nigeria, 2005
Mummy Ahmadu and Mallam Mantari Lamal with
Mainasara, Abuja, Nigeria, 2005

Abdullahi Mohammed with Mainasara, Lagos, Nigeria, 2005
(*all* from the series 'The Hyena and Other Men', 2007)

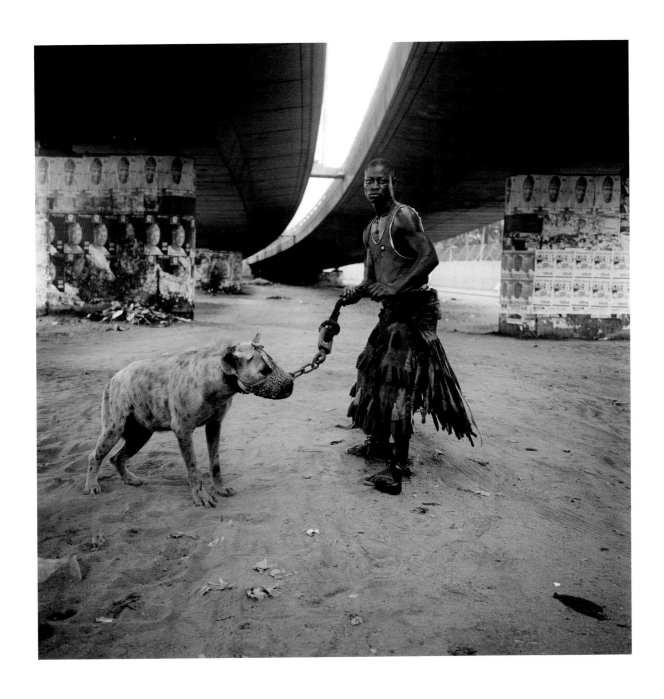

Pieter Hugo
Loyiso Mayga, Wandise Ngcama, Lunga White, Luyanda Mzantsi, Khungsile Mdolo after their initiation ceremony. Mthatha, South Africa, from the series 'Homelands', 2008

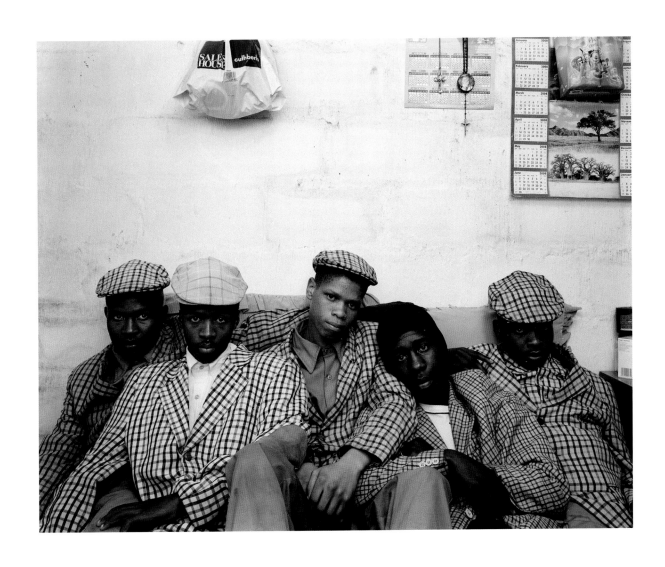

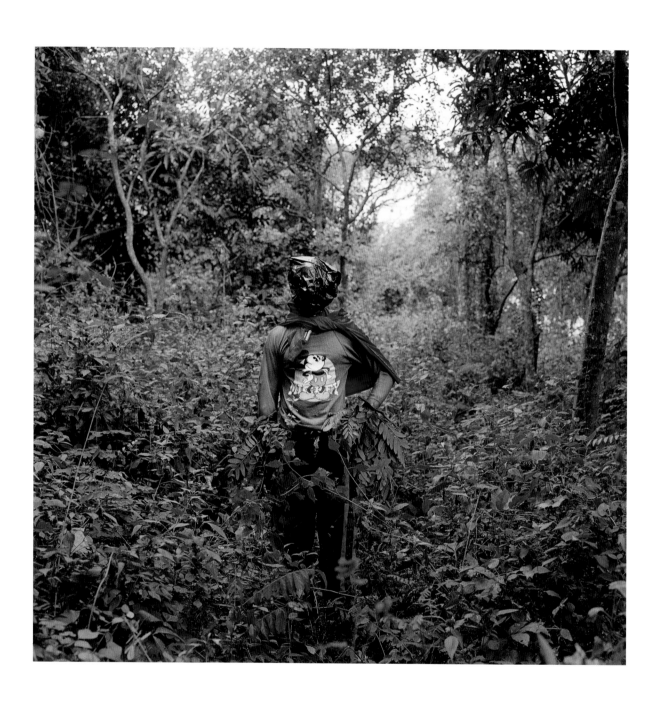

Pieter Hugo
Kwadwo Konado, Wild Honey Collector, Techiman District Ghana, 2005

Takyi Isaac, Wild Honey Collector, Techiman District, Ghana, 2005
John Kwesi, Wild Honey Collector, Techiman District, Ghana, 2005
John Kwesi, Wild Honey Collector, Techiman District, Ghana, 2005
(all from the series 'Wild Honey Collectors', 2005)

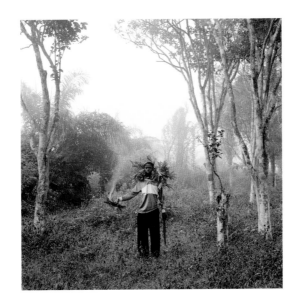

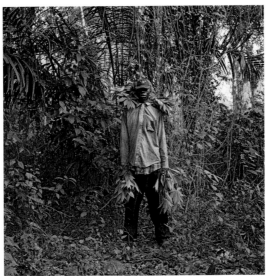

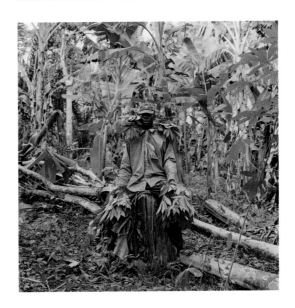

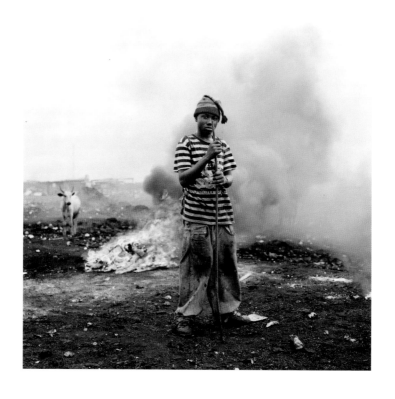

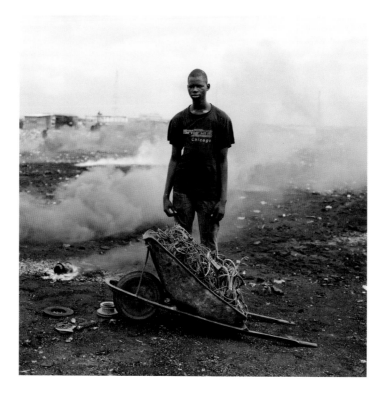

Pieter Hugo
Ibrahim Sulley, Agbogbloshie Market, Accra, Ghana, 2009
Al Hasan, Agbogbloshie Market, Accra, Ghana, 2009

Yaw Francis, Agbogbloshie Market, Accra, Ghana,
(all from the series 'Permanent Error', 2009)

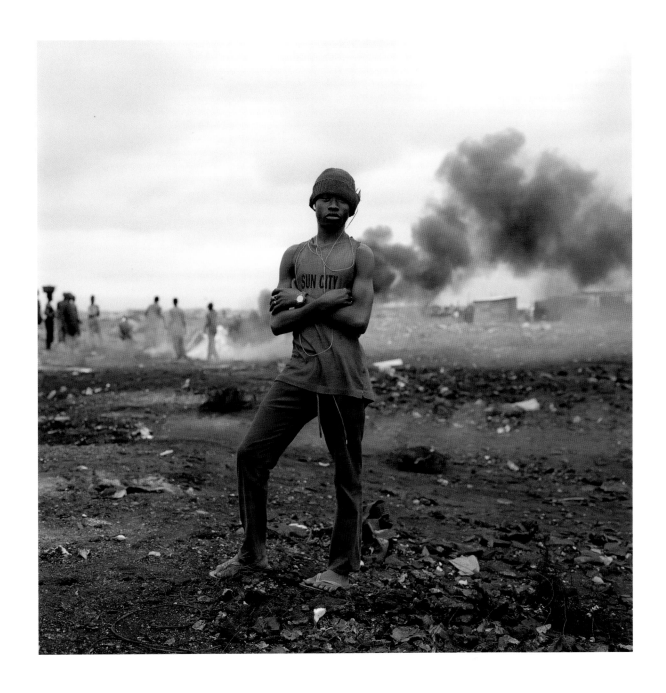

Terry
Kurgan

Born 1958, Cape Town, South Africa
Lives and works in Johannesburg, South Africa

Terry Kurgan is an independent artist who lives and works in Johannesburg. She began her career in drawing and printmaking but gradually became more interested in the photographs she was using as her primary source material. Currently, her work embraces a broad range of media and her primary artistic interest is in photography; in photographs as material for interpretation, and in the complex and paradoxical nature of all photographic transactions. Kurgan won the prestigious South African FNB Vita Prize for contemporary art in 2001 and has been nominated with her client and collaborators for Business Art South Africa/Business Day awards in 2004 and 2005, winning in 2009. Kurgan studied Fine Art in South Africa and the U.S.A., has taught at South African universities and often consults to media and social communications companies. She has exhibited broadly, nationally and internationally and her work is represented in most major public and corporate South African collections and art publications.

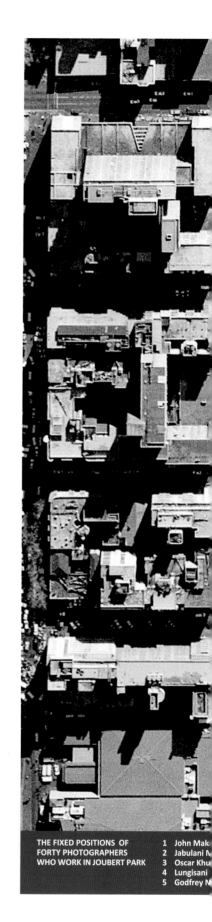

THE FIXED POSITIONS OF
FORTY PHOTOGRAPHERS
WHO WORK IN JOUBERT PARK

1 John Mak
2 Jabulani N
3 Oscar Khu
4 Lungisani
5 Godfrey N

Terry Kurgan
*Aerial map showing the fixed positions of forty
photographers working out of Joubert Park in 2004,*
from 'Park Pictures', 2004

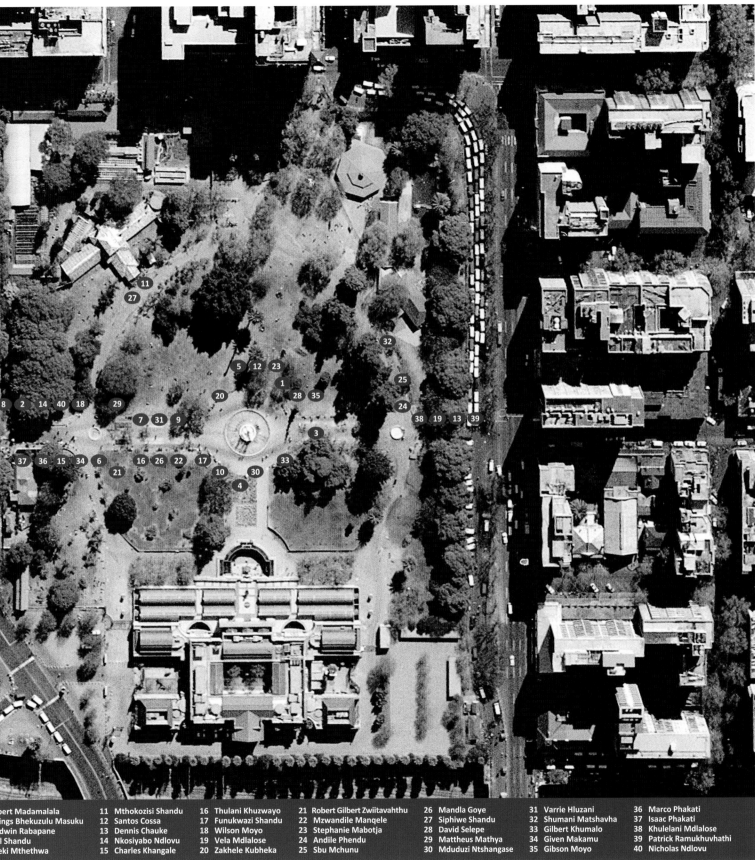

5
NAME: GODFREY NDLOVU
DATE OF BIRTH: 15 JUNE 1974
PLACE OF BIRTH: KWABULAWAYO, ZIMBABWE
RELOCATION TO JOHANNESBURG: 1999
CURRENTLY RESIDES: HILLBROW
OCCUPATION: PHOTOGRAPHER
WORKING IN JOUBERT PARK: SIX YEARS

Terry Kurgan
Godfrey Ndlovu, 2004

John Makua, 2004
(both from the series 'Park Pictures', 2004)

1
NAME: JOHN MAKUA
DATE OF BIRTH: 15 FEBRUARY 1950
PLACE OF BIRTH: LIMPOPO, SOUTH AFRCA
RELOCATION TO JOHANNESBURG: 1969
CURRENTLY RESIDES: HILLBROW
OCCUPATION: PHOTOGRAPHER
WORKING IN JOUBERT PARK: TWENTY THREE YEARS

23
NAME: STEPHANIE MABOTJA
DATE OF BIRTH: 5 AUGUST 1971
PLACE OF BIRTH: LIMPOPO, SOUTH AFRCA
RELOCATION TO JOHANNESBURG: 1993
CURRENTLY RESIDES: BEREA
OCCUPATION: PHOTOGRAPHER
WORKING IN JOUBERT PARK: THREE YEARS

Terry Kurgan
Stephanie Mabotja, 2004

Santos Cossa, 2004
(both from the series 'Park Pictures', 2004)

12

NAME: SANTOS COSSA
DATE OF BIRTH: 9 NOVEMBER 1961
PLACE OF BIRTH: MAPUTO, MOZAMBIQUE
RELOCATION TO JOHANNESBURG: 1990
CURRENTLY RESIDES: JOUBERT PARK
OCCUPATION: PHOTOGRAPHER
WORKING IN JOUBERT PARK: THREE YEARS

6
NAME: ROBERT MADAMALALA
DATE OF BIRTH: 6 JULY 1968
PLACE OF BIRTH: VENDA, SOUTH AFRICA
RELOCATION TO JOHANNESBURG: 1989
CURRENTLY RESIDES: DIEPKLOOF
OCCUPATION: PHOTOGRAPHER
WORKING IN JOUBERT PARK: THIRTEEN YEARS

Terry Kurgan
Robert Madamalala, 2004

Shumani Matshavha, 2004
(both from the series 'Park Pictures', 2004)

32

NAME: SHUMANI MATSHAVHA
DATE OF BIRTH: 1 DECEMBER 1970
PLACE OF BIRTH: SOWETO, SOUTH AFRICA
RELOCATION TO JOHANNESBURG: 1994
CURRENTLY RESIDES: JOUBERT PARK
OCCUPATION: PHOTOGRAPHER
WORKING IN JOUBERT PARK: ELEVEN YEARS

Sabelo
Mlangeni

Born 1980, Driefontein, South Africa
Lives and works in Johannesburg, South Africa

Sabelo Mlangeni was born in Driefontein near Wakkerstroom in Mpumalanga. In 2001 he moved to Johannesburg where he joined the Market Photo Workshop, graduating in 2004. He won the Tollman Award for the Visual Arts in 2009. His first solo show, *Invisible Women*, took place at Warren Siebrits, Johannesburg (2007). Group exhibitions include *I am not afraid: The Market Photo Workshop, Johannesburg*, Johannesburg Art Gallery (2010); *Obsession*, PhotoZA Gallery (2004); *Johannesburg Circa Now*, Johannesburg Art Gallery (2005); *Gender & Visual Exhibitions*, District Six Museum (2005); and *Positive: Pulse* at Sun International, Sun City (2003).

Sabelo Mlangeni
Bigboy, 2009

Madlisa, 2009
(both from the series 'Country Girls', 2009)

Sabelo Mlangeni
Innocentia aka Sakhile, 2009

Xolani Mgayi, eStanela, 2009
(both from the series 'Country Girls', 2009)

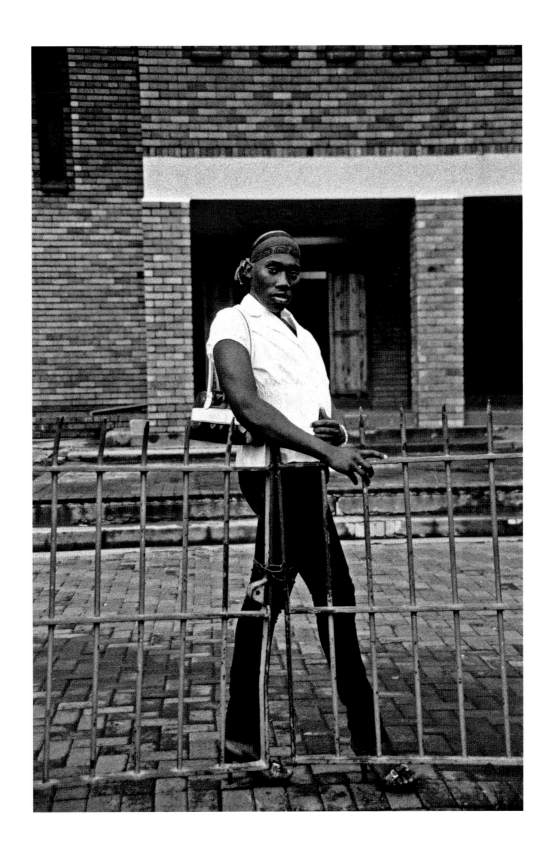

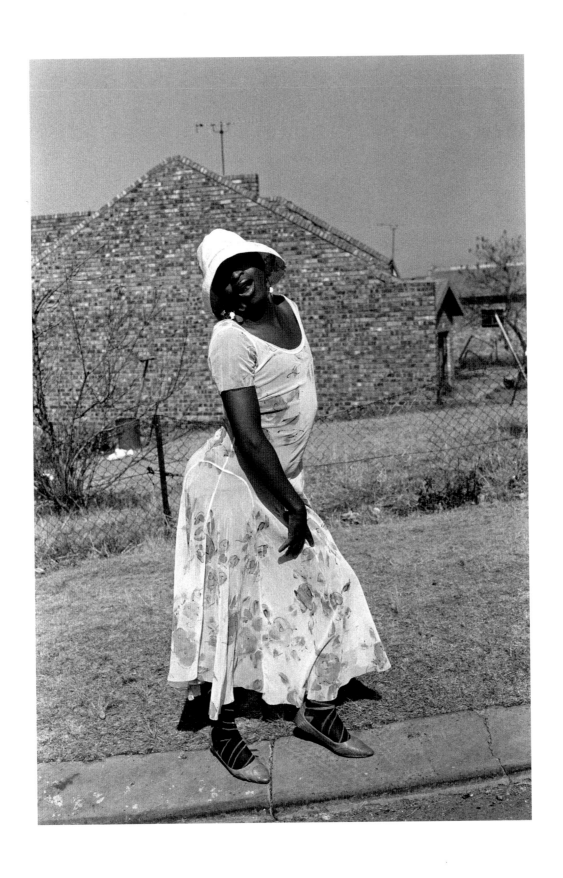

Sabelo Mlangeni
Lwasi Mtshali, 'Bigboy', 2009

Palisa, 2009
(both from the series 'Country Girls', 2009)

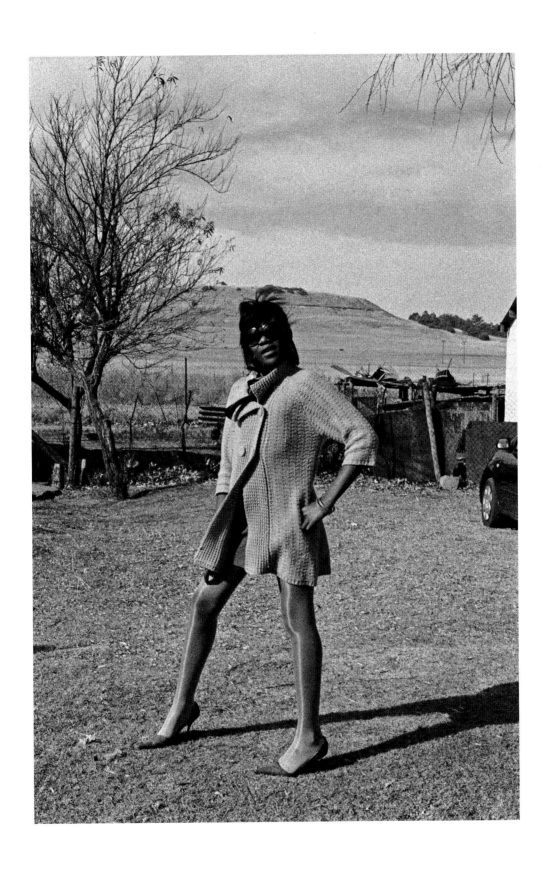

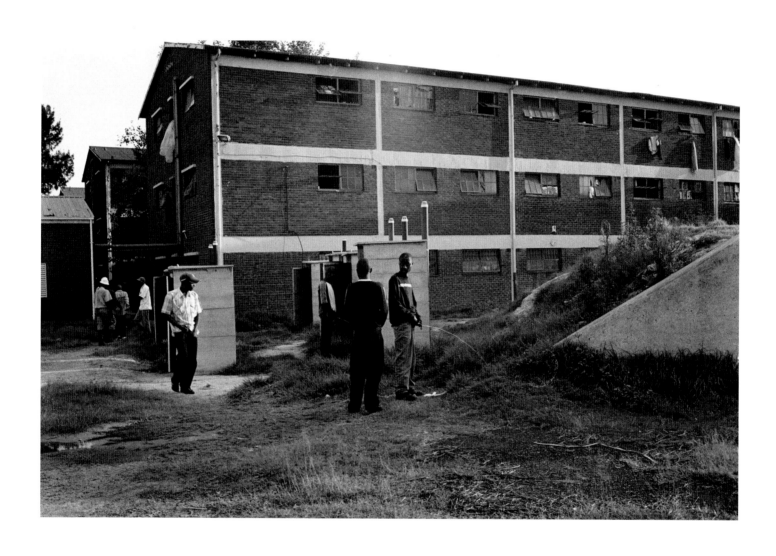

Sabelo Mlangeni
Men Only, 2009

Abangani, 2009
Dry Pipes, 2009
(all from the series 'Men Only', 2009)

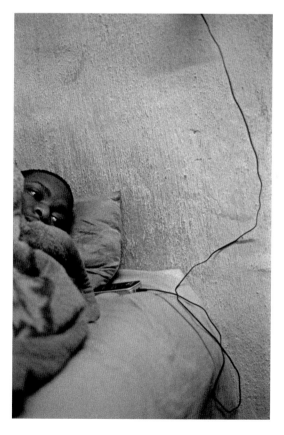

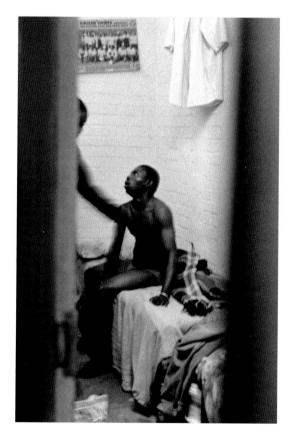

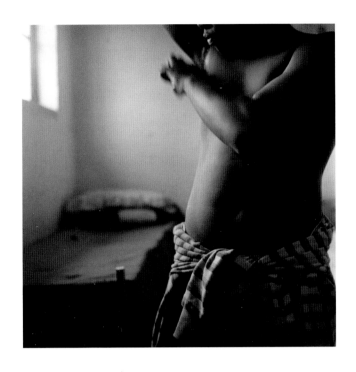

Sabelo Mlangeni
Nipple, 2008
Morning Blue, 2009
Mshana, 2009
Usbali visits the hostel, 2008

Rolling On, 2009
Room Visit, 2009
(all from the series 'Men Only', 2009)

161

Santu
Mofokeng

Born 1956, Johannesburg, South Africa
Lives and works in South Africa

Born in Johannesburg in 1956, Mofokeng won the Ernest Cole Scholarship in 1991 to study at the International Centre for Photography in New York. He also spent a year on 'sabbatical' in Bremen, Germany. Mofokeng held the position of researcher and documentary photographer for the Institute for Advanced Social Research for ten years at the University of the Witwatersrand. He has won many awards and fellowships in Africa, the United States and Germany.

In 2011 he will be the subject of a major solo respective at The Jeu de Paume, Paris.

Santu Mofokeng
Christmas Church Service,
Mautse Cave, from the series
'Chasing Shadows', 2000

Santu Mofokeng
*Mthunzi and Meisie making supplications to the ancestors inside
the Motouleng Sanctum – Free State*, 2006
*Prayer Service at the altar on the Easter weekend at Motouleng
Sanctum – Free State*, 2006

Inside Motouleng Cave, Clarens, 1996
*Sangoma sisters Gladys and Cynthia leading initiates in the
afternoon 'Ingoma', Clarens*, 1996
(all from the series 'Chasing Shadows')

Santu Mofokeng
*Ishmael after washing with
holy-ash at Motouleng Cave
- Free State*, from the series
'Chasing Shadows', 2004

169

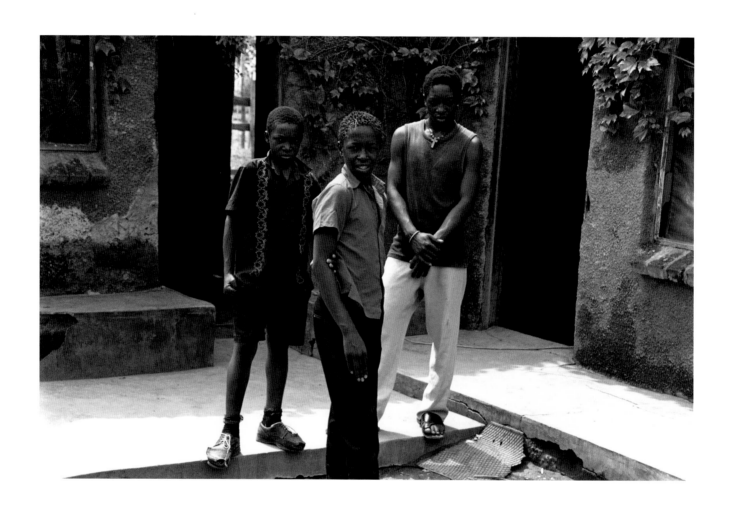

Santu Mofokeng
Nousta, Rister and Noupa Mkansi at home in Dan, Tzaneen
their parents Richard and Onica are both dead, 2007

Santu Mofokeng, Rister Mkansi in the family kitchen, 2007
(all from the series 'Child-Headed Households')

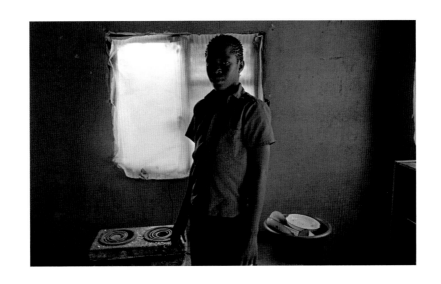

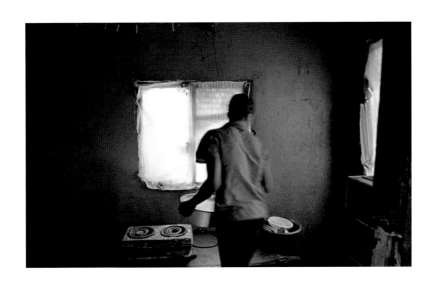

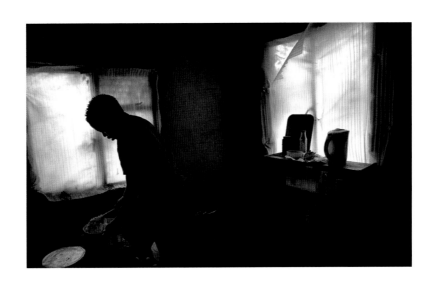

Zwelethu
Mthethwa

Born 1960, Durban, South Africa
Lives and works in Cape Town, South Africa

Zwelethu Mthethwa was born in Durban and lives in Cape Town, South Africa. He received a Fulbright award and studied at the Rochester Institute. Mthethwa was first recognized in the 1980s when he began to photograph the start of informal squatter camps around Cape Town. The pastels and paintings he completed early in his career were also well received. In more recent years Mthethwa has worked a great deal in large format photography and his photographic works have been included in major exhibitions in international galleries. He has had solo exhibitions at commercial galleries in South Africa, Europe and New York.

Zwelethu Mthethwa
Untitled, from the series 'The Brave Ones', 2010

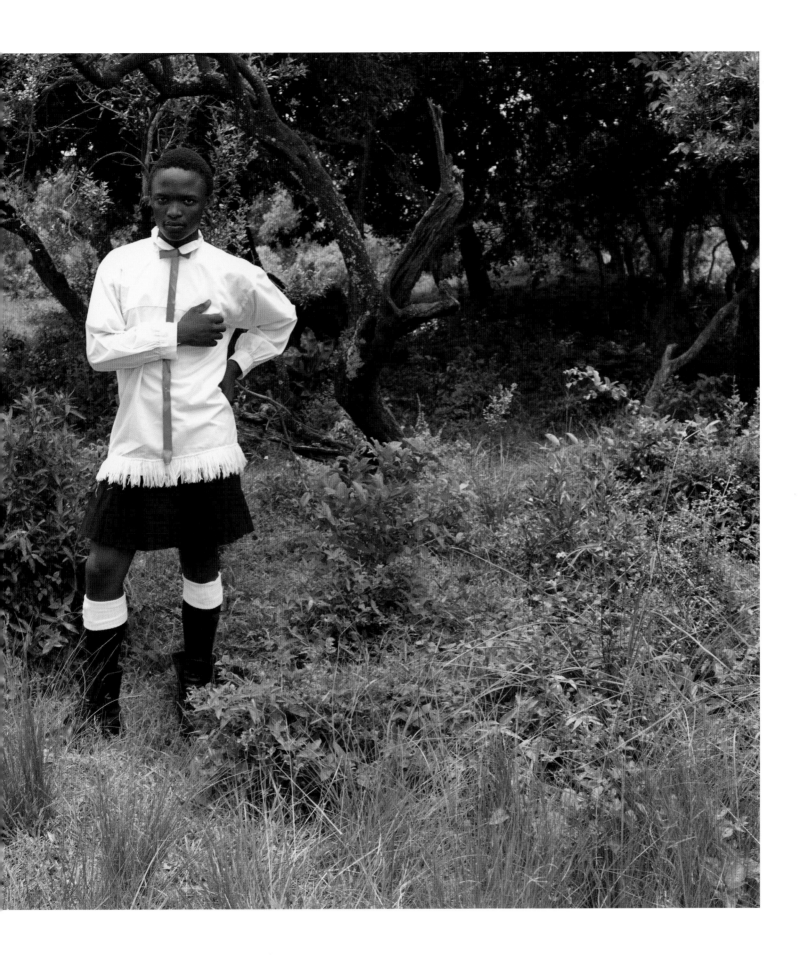

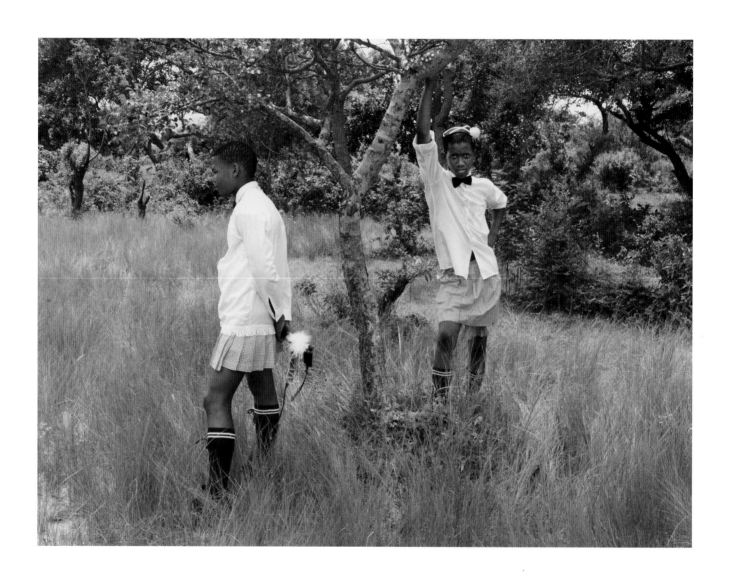

Zwelethu Mthethwa
Untitled, 2010

Untitled, 2010
(both from the series 'The Brave Ones', 2010)

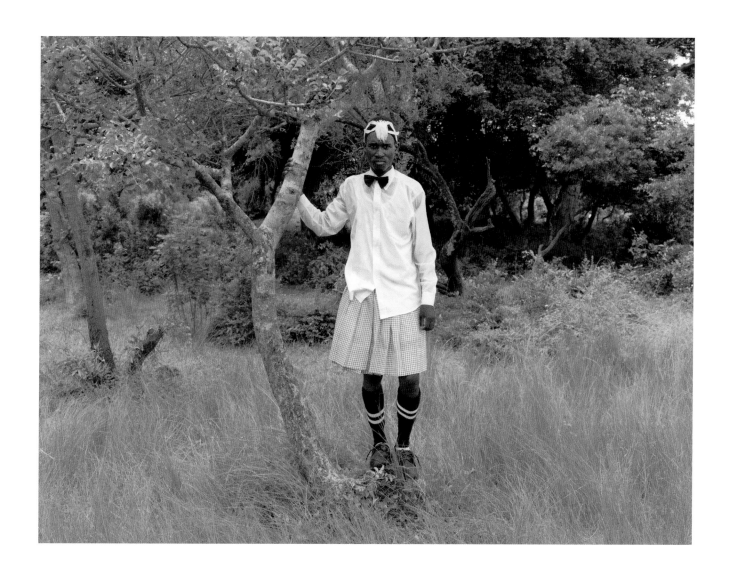

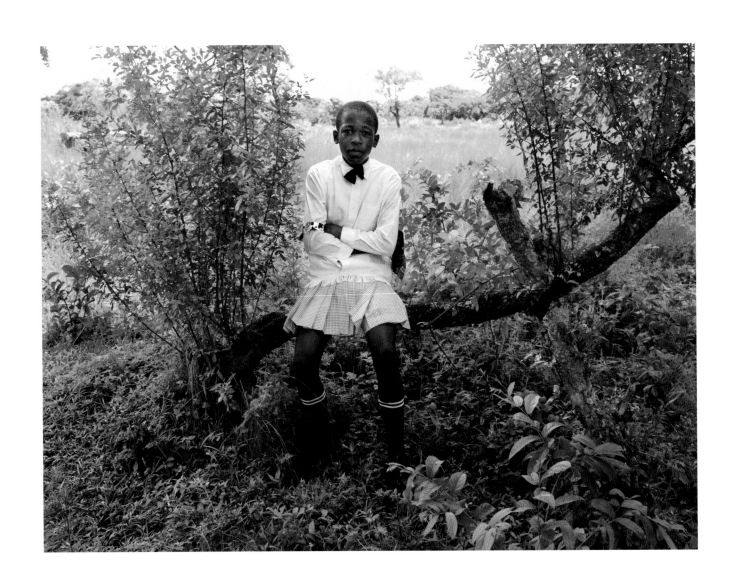

Zwelethu Mthethwa
Untitled, 2010

Untitled, 2010
(both from the series 'The Brave Ones', 2010)

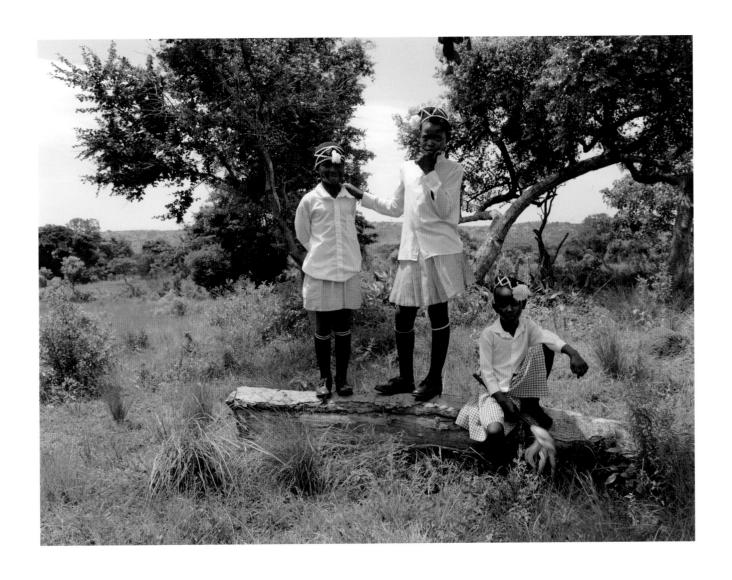

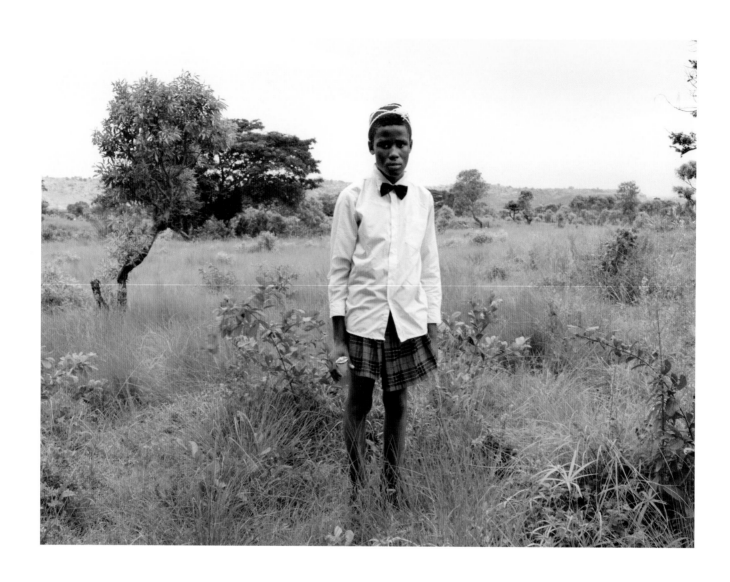

Zwelethu Mthethwa
Untitled, 2010

Untitled, 2010
(both from the series 'The Brave Ones', 2010)

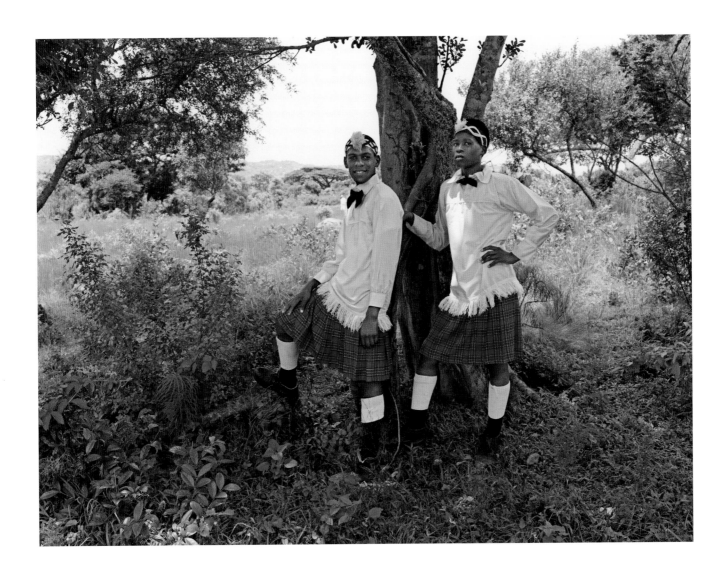

Zanele Muholi

Born 1972, Umlazi, South Africa
Lives and works in Johannesburg, South Africa

Zanele Muholi was born in Umlazi, Durban, in 1972. She completed an Advanced Photography course at the Market Photo Workshop in Newtown and held her first solo exhibition at the Johannesburg Art Gallery in 2004. She has worked as a community relations officer for the Forum for the Empowerment of Women (FEW), a black lesbian organisation based in Gauteng, and as a photographer and reporter for *Behind the Mask*, an online magazine on lesbian and gay issues in Africa. She was the recipient of the 2005 Tollman Award for the Visual Arts, the first BHP Billiton/Wits University Visual Arts Fellowship in 2006, and was the 2009 Ida Ely Rubin Artist-in-Residence at the Massachusetts Institute of Technology (MIT). In 2009 she received a Fanny Ann Eddy accolade from IRN-Africa for her outstanding contributions to the study of sexuality in Africa. She also won the Casa Africa award for best female photographer and a Fondation Blachère award at *Rencontres de Bamako Biennale Africaine de la Photographie*.

Zanele Muholi
Martin Machapa, from the series 'Beulahs', 2006

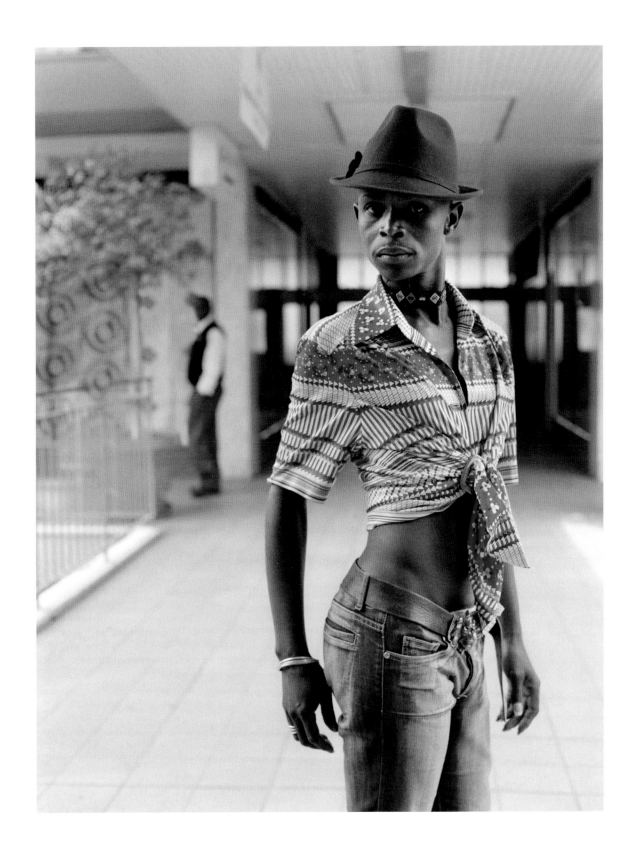

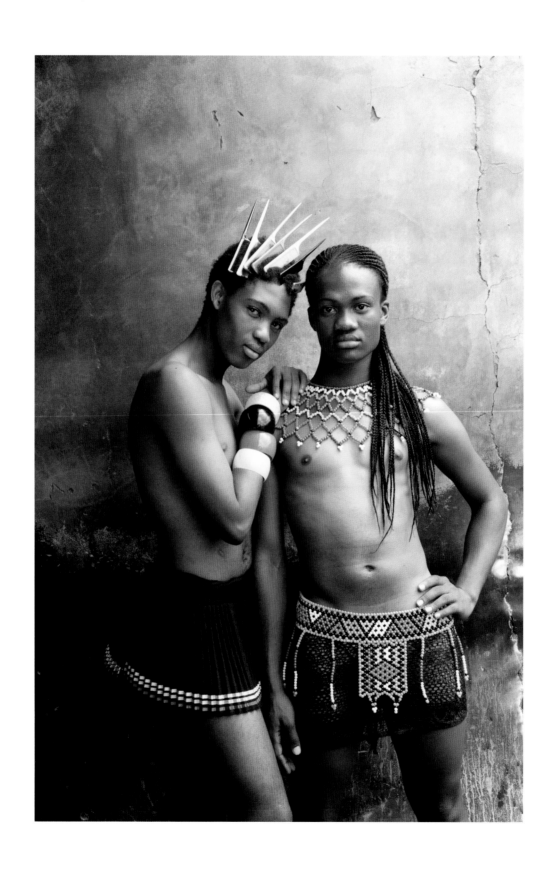

Zanele Muholi
Mini and Le Sishi, Glebelands, Durban, Jan. 2010

Ms Le Sishi I, Glebelands, Durban, Jan. 2010
Mini Mbatha, Glebelands, Durban, Jan. 2010
(all from the series 'Beulahs', 2010)

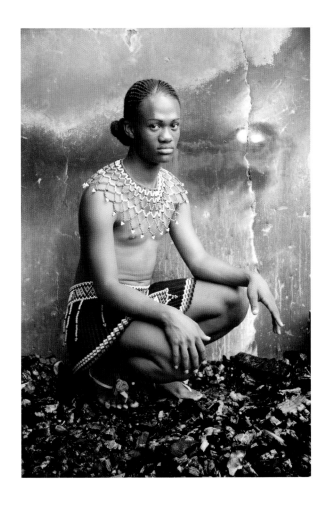
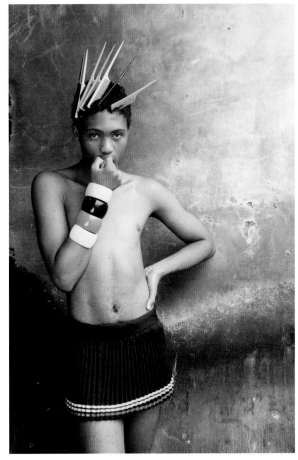

Zanele Muholi
Nosizwe Cekiso, Gugulethu, Cape Town, 2008
Lerato Marumolwa, Embekweni, Paarl, 2009
Bakhambile Skhosana, Natalspruit, 2010

Tumi Mokgosi, Yeoville, Johannesburg, 2007
Nosipho 'Brown' Solundwana, Parktown, Johannesburg, 2007
Sosi Molotsane ,Yeoville, Johannesburg, 2007
Refilwe Mahlaba,Thokoza, Johannesburg, 2010
Amogelang Senokwane, District Six, Cape Town, 2009
Tumi Mkhuma, Yeoville, Johannesburg, 2007
(all from the series 'Faces and Phases')

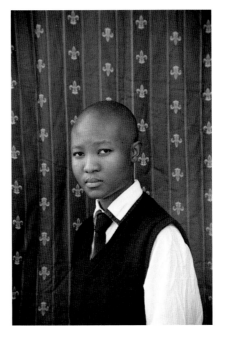
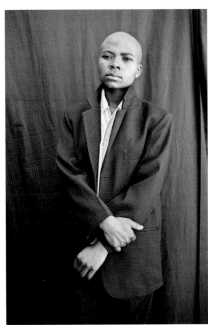
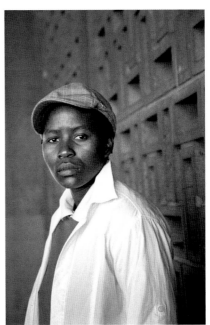
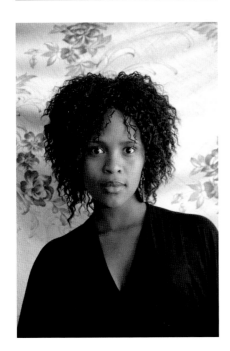
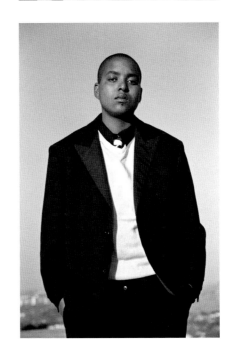

Zanele Muholi
Puleng Mahlati, Embekweni, Paarl, 2009

Sisipho Ndzuzo, Embekweni, Paarl, 2009
(both from the series 'Faces and Phases')

Jo
Ractliffe

Born 1961, Cape Town, South Africa
Lives and works in Johannesburg, South Africa

Jo Ractliffe was born in 1961 in Cape Town and lives in Johannesburg. She completed her BAFA and MFA degrees at the University of Cape Town. In 1999 she was the recipient of the Vita Art Prize. Solo exhibitions include *Terreno Ocupado* at Warren Siebrits Gallery, Johannesburg (2008) and *As Terras do Fim do Mundo* at Michael Stevenson Gallery, Cape Town (2010). Recent group exhibitions include the seventh Gwangju Biennale, Korea (2008); *Snap Judgments: New Positions in Contemporary African Photography*, International Centre for Photography, New York (2006), and *The Unhomely: Phantom Scenes in Global Society*, Second International Biennial of Contemporary Art (Biacs 2), Seville, Spain (2006).

Jo Ractliffe
Vacant Plot near Atlantico Sul, from the
series *'Terreno Ocupado'*, 2007

194

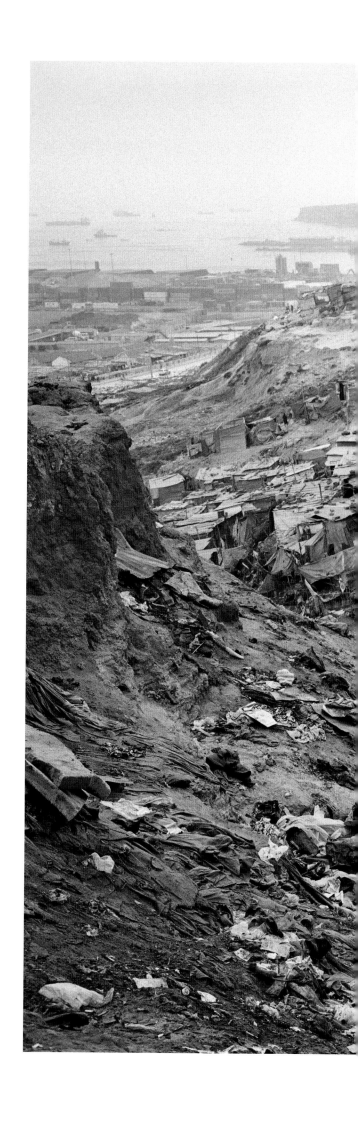

Jo Ractliffe
*Woman on the Footpath From Boa Vista
to Roque Santeiro Market*, from the series
'Terreno Ocupado', 2007

196

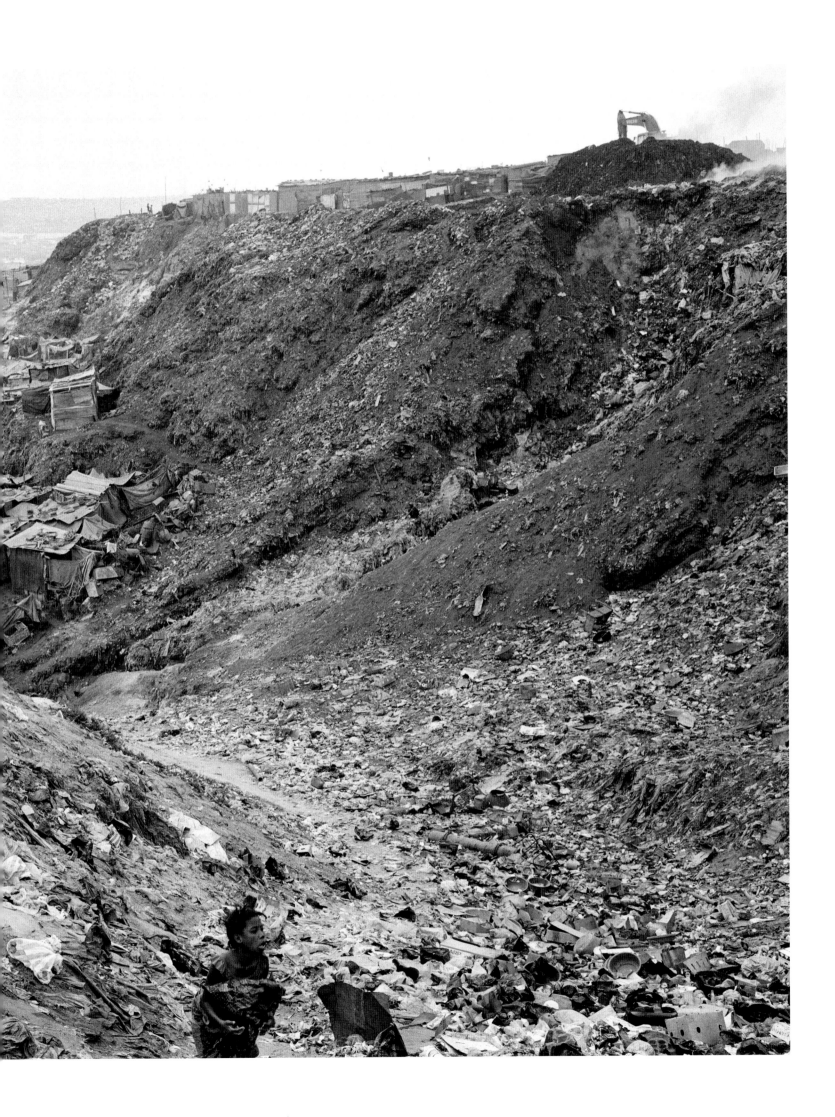

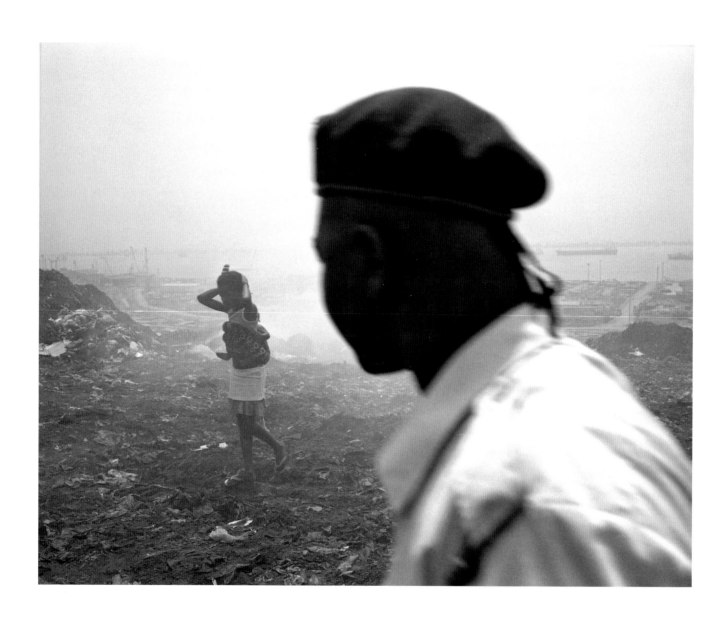

Jo Ractliffe
Woman and her baby, Roque Santeiro Market, 2007

Schoolgirls' uniforms, Roque Santeiro Market, 2007
Flour Seller, Roque Santeiro Market, 2007
Video Club, Roque Santeiro Market, 2007
Proprieter of a Video Club, Roque Santeiro Market, 2007
(all from the series *'Terreno Ocupado'*, 2007)

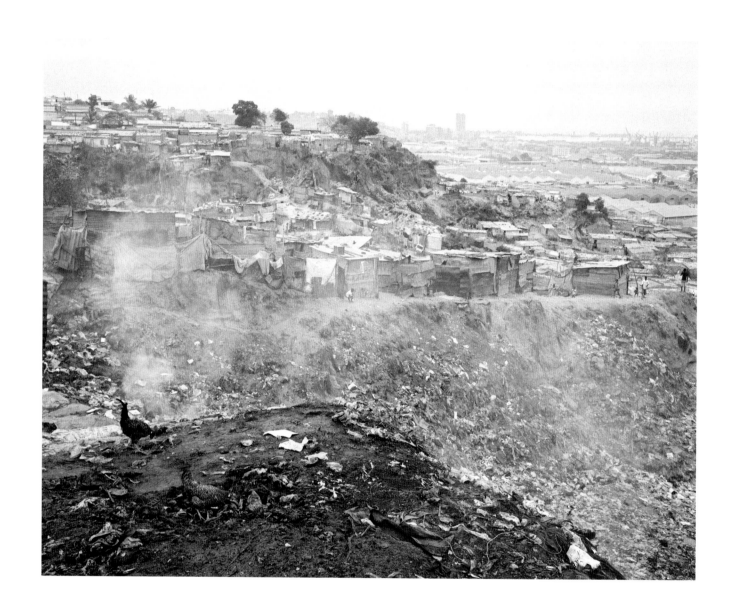

Jo Ractliffe
View of Boa Vista from Roque Santeiro Market I, 2007

View of Boa Vista from Roque Santeiro Market II, 2007
(from the series *'Terreno Ocupado'*, 2007)

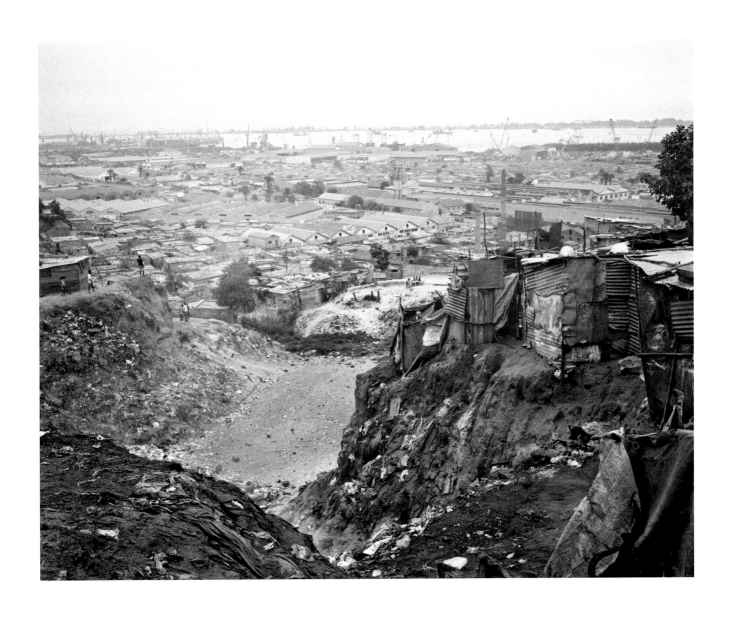

Jo Ractliffe
Details of tiled murals at the Fortaleza De São Miguel,
depicting Portuguese explorations in Africa, 2007,
from the series *'Terreno Ocupado'*, 2007

Berni
Searle

Born 1964, Cape Town, South Africa
Lives and works in Cape Town, South Africa

Berni Searle earned an MFA from the University of Cape Town after receiving a BFA from the same institution. Exploring South Africa's complex history, Searle creates photos, films, and multimedia installations in which her own body and identity figure prominently. Though her works are aesthetically alluring in their quiet simplicity, they are politically strong in their address to a nation still coping with its past. Searle's work has appeared in exhibitions at The Museum of Modern Art; the Brooklyn Museum; the Kunsthalle Vienna; the Istanbul Modern; and the Smithsonian National Museum of African Art in Washington DC. Her work was included in the 49th and the 51st Venice Biennales in 2001 and 2005; and the Dakar Biennale in 2000, where she won the DAK'ART 2000 Minister of Culture Prize. She has also been awarded a Standard Bank Young Artist award for Visual Art.

Berni Searle
Once Removed (Head I, II, III), 2008
Once Removed (Lap I, II, III), 2008
(from the series 'Once Removed', 2008)

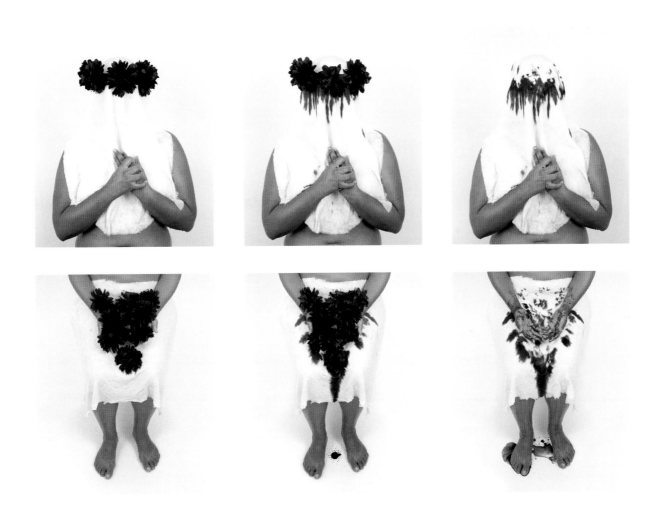

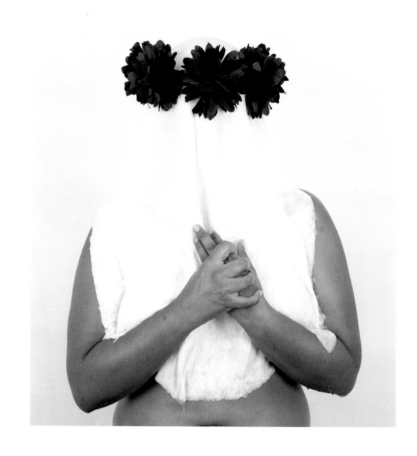

Berni Searle
Once Removed (Head I), 2008

Once Removed (Head II), 2008
Once Removed (Head III), 2008
(from the series 'Once Removed', 2008)

208

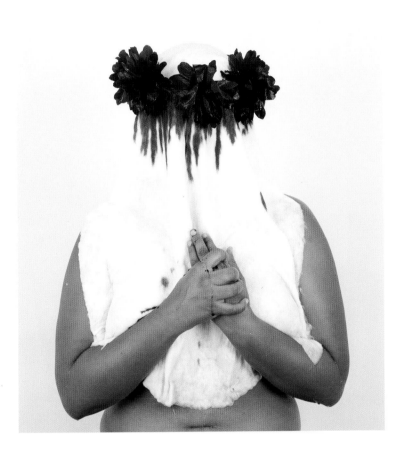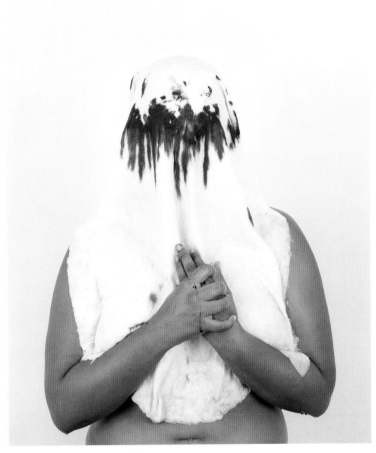

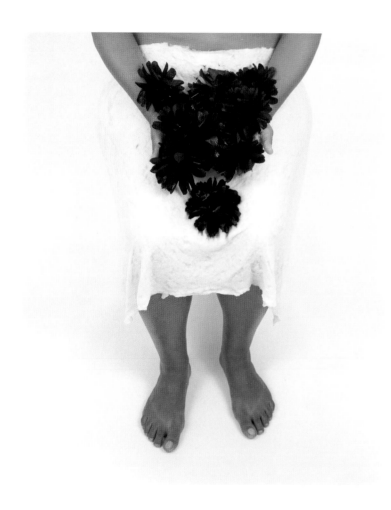
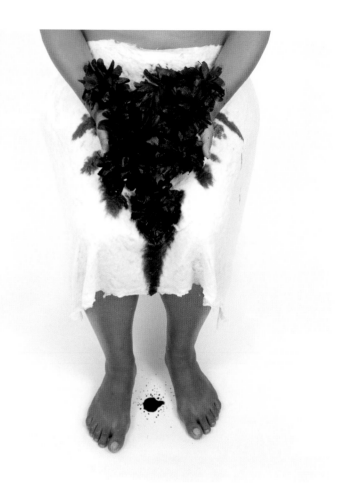

Berni Searle
Once Removed (Lap I), 2008
Once Removed (Lap II), 2008

Once Removed (Lap III), 2008
(from the series 'Once Removed', 2008)

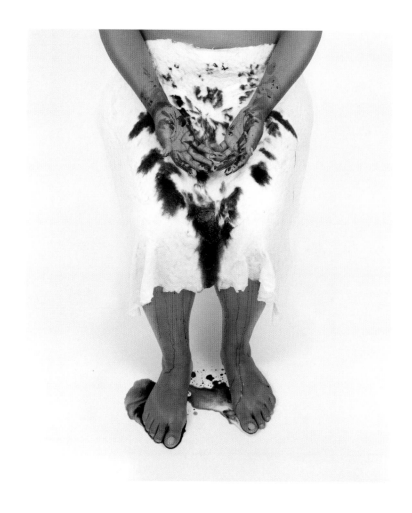

Mikhael
Subotzky

Born 1981, Cape Town, South Africa
Lives and works in Johannesburg, South Africa

Mikhael Subotzky studied at the Michaelis School of Fine Art at the University of Cape Town, and now lives in Johannesburg. His first major project was 'Die Vier Hoeke', a hard-hitting photographic essay about life in Pollsmoor Prison, which won him wide acclaim. He went on to complete the series and book 'Beaufort West'. These two projects – the one a careful portrait of an infamous correctional institution and the other an in-depth analysis of people and life in the town of Beaufort West in the Northern Cape – reveal many of Subotzky's concerns and themes. In 2007, Subotzky became one of the youngest members of the international photographic agency Magnum. He has participated in a number of international group shows, including *Snap Judgments* in New York and *Rencontres de Bamako Biennale Africaine de la Photographie*, and has had a number of solo exhibitions at Goodman Gallery in Johannesburg and Cape Town. He is the winner of the 2009 Oskar Barnack Award, the 2008 W. Eugene Smith Grant, and the 2008 ICP Infinity Award (Young Photographer).

Mikhael Subotzky
Wendy House VI, from the series 'Security', 2009

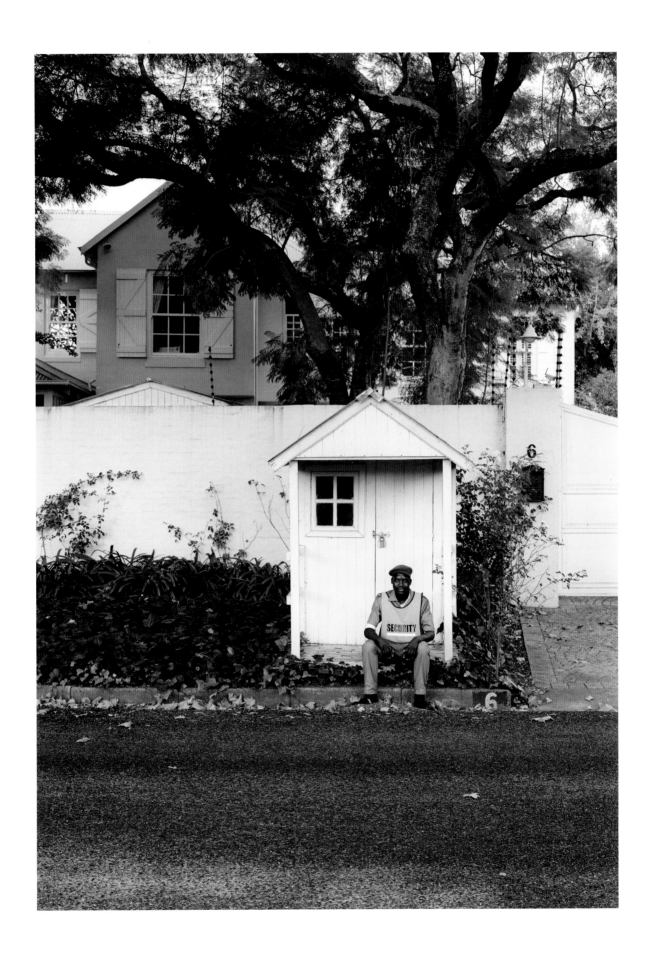

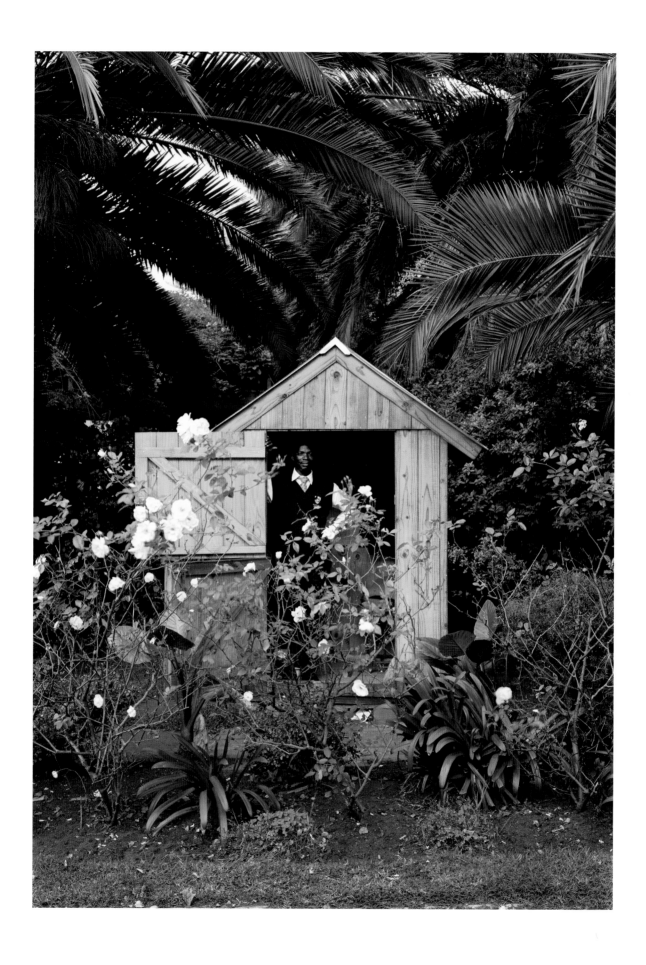

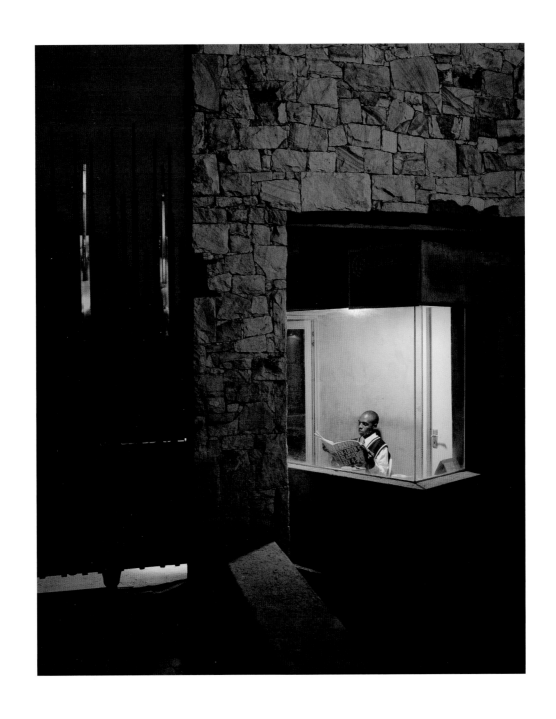

Mikhael Subotzky
Wendy House II, 2009

Gatehouse, Illovo, Johannesburg, 2008,
(both from the series 'Security')

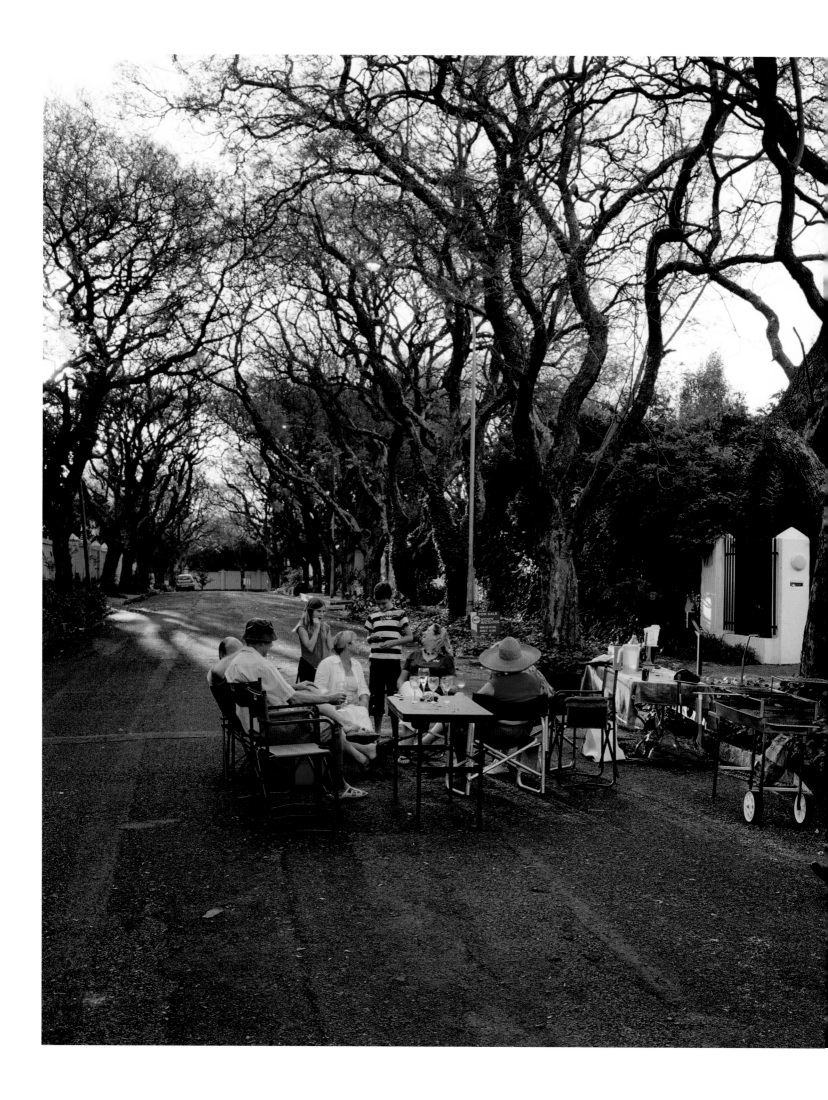

Mikhael Subotzky
Street Party, Saxonwold, from
the series 'Security', 2008

Guy
Tillim

Born 1962, Johannesburg, South Africa
Lives and works in Cape Town, South Africa

Tillim was born in Johannesburg in 1962. He started photographing professionally in 1986 and joined Afrapix, a collective of South African photographers with whom he worked closely until 1990. His work as a freelance photographer in South Africa for the local and foreign media included positions with Reuters between 1986 and 1988, and Agence France Presse in 1993 and 1994. Tillim has received many awards for his work including the Prix SCAM (Societe Civile des Auteurs Multimedia) Roger Pic in 2002, the Higashikawa Overseas Photographer Award (Japan) in 2003, the 2004 DaimlerChrysler Award for South African photography, the Leica Oskar Barnack Award in 2005 and the first Robert Gardner Fellowship in Photography from the Peabody Museum at Harvard University in 2006. He held solo exhibitions at Haus für Kunst, Altdorf, and Haunch of Venison, Zurich, in 2008, and in 2009, his project 'Avenue Patrice Lumumba' showed at the Fondation Henri Cartier-Bresson in Paris, The Photographers' Gallery in London, Foam Photography Museum in Amsterdam and the Serralves Museum in Porto.

Guy Tillim
Petros Village, Malawi, 2006

Petros Village, Malawi, 2006
Petros Village, Malawi, 2006

Guy Tillim
Chimombo Chikwahira, Petros Village, Malawi, 2006
Rayina Henock and Masiye Henock. Petros Village, Malawi, 2006

Petros Village, Malawi, 2006
Neri James. Petros Village, Malawi, 2006

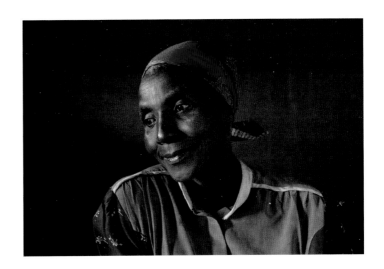

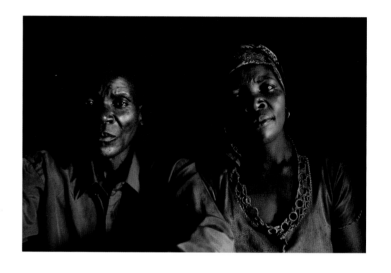

Guy Tillim
Petros James and Enelesi James. Petros Village, Malawi, 2006

Petros Village, Malawi, 2006
Petros Village, Malawi, 2006

226

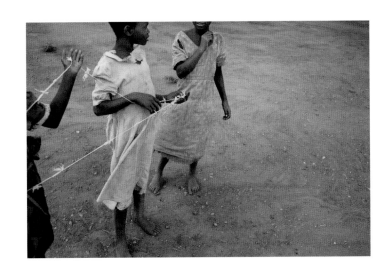

Roelof Petrus
Van Wyk

Born 1969, South Africa
Lives and works in Johannesburg, South Africa

Roelof Petrus van Wyk is currently completing the documentary photographic project: 'Young Afrikaner – A Self Portrait' and an accompanying, self-published, artist's book. The project documents the reclamation of Afrikaner identity by young Afrikaners, and the shift from a state-owned and sanctioned national identity during apartheid, to a self-determined, narrative, plural and personal identity, steeped in culture, which has occurred during the last decade.

A second body of work, a series of constructed photographic landscapes, 'Kimberley', is under way dealing with the memory of the Afrikaner tribe through documentation of the manmade marks on the landscape around the city of Kimberley. The Groot Trek, the discovery of diamonds, the resultant Anglo-Boer War together with the 'scorched earth' and 'concentration camp' narratives, the architecture of separate development during apartheid, and finally the contextualising of 2000 year old San drawings, have created a clear historical narrative on the Land.

van Wyk has been shortlisted for a number of awards including the 2010 International Photo Awards, Lucie Foundation, and the 2010 Spier Contemporary award. Previous exhibitions include *After A*, a group show curated by Federica Angelucci at the 2010 Atri Documentary Festival, Italy.

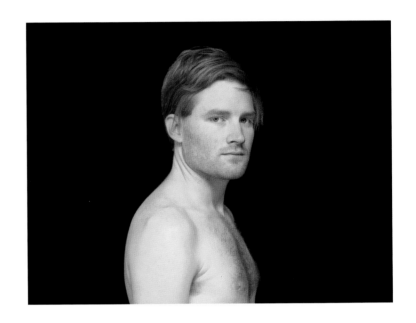

Roelof Petrus Van Wyk
Young Afrikaner – A Self Portrait, Koos Groenewald Fig. 1

Young Afrikaner – A Self Portrait, Koos Groenewald Fig. 2
Young Afrikaner – A Self Portrait, Koos Groenewald Fig. 4
(from the series 'Young Afrikaner', 2009)

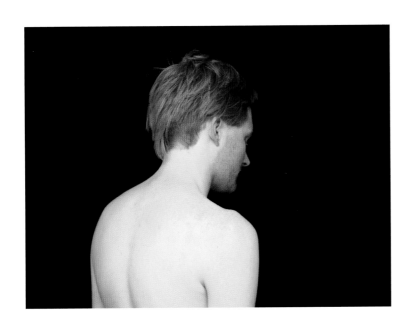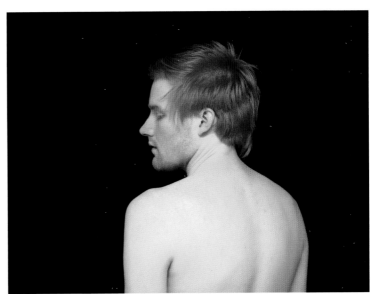

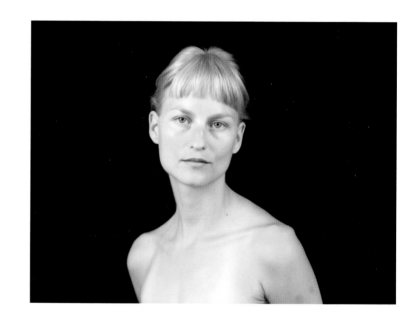

Roelof Petrus Van Wyk
Young Afrikaner – A Self Portrait, Jeanna Theron Fig. 1

Young Afrikaner – A Self Portrait, Yo-Landi Vi$$er Fig. 1
Young Afrikaner – A Self Portrait, Natasja Fourie Fig. 1
(from the series 'Young Afrikaner', 2009)

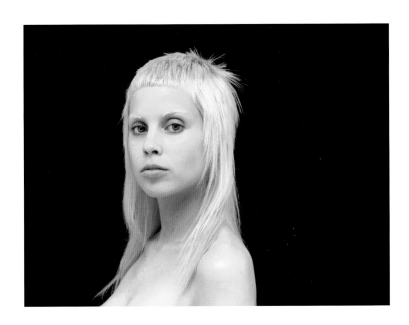
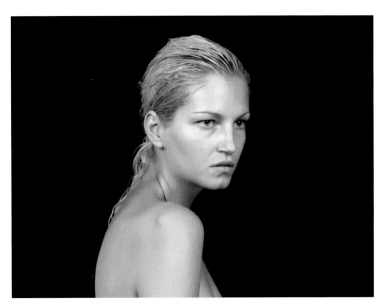

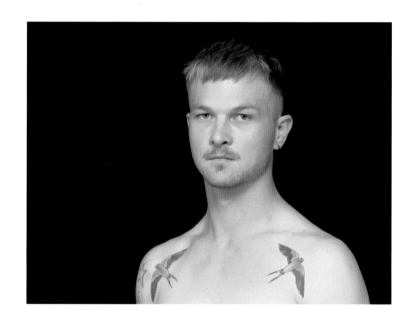

Roelof Petrus Van Wyk
Young Afrikaner – A Self Portrait, Daniel Swanepoel Fig. 3

Young Afrikaner – A Self Portrait, Daniel Swanepoel Fig. 2
Young Afrikaner – A Self Portrait, Daniel Swanepoel Fig. 1
(from the series 'Young Afrikaner', 2009)

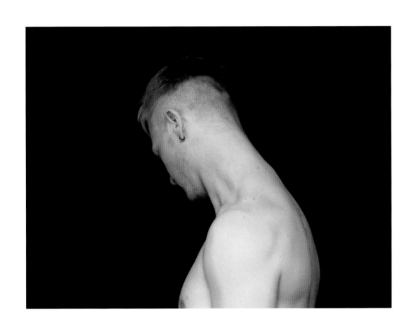
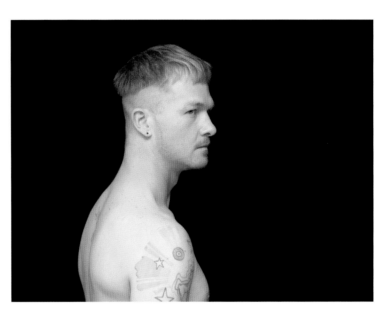

Roelof Petrus Van Wyk
Young Afrikaner – A Self Portrait, Llewelleyn Fig. A,
from the series 'Young Afrikaner', 2010

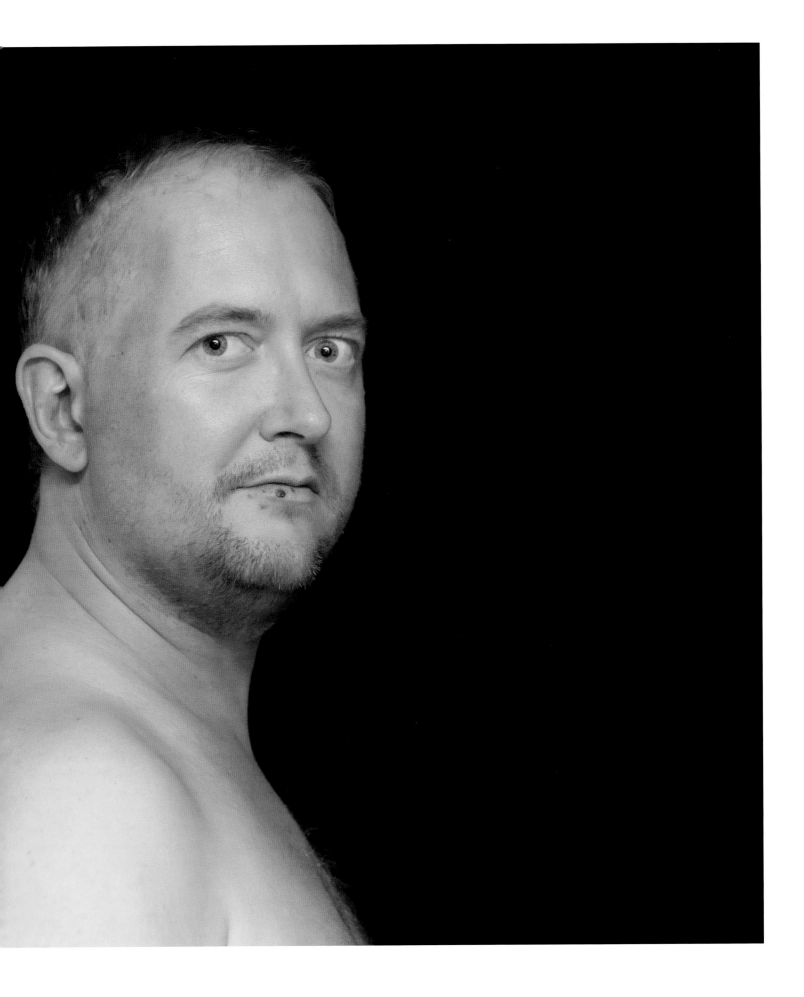

Nontsikelelo 'Lolo' Veleko

Born 1977, Bodibe, South Africa
Lives and works in Johannesburg, South Africa

Nontsikelelo 'Lolo' Veleko was brought up in Cape Town and studied photography between 1999 and 2003 at the Market Photo Workshop. In the last couple of years Veleko has attracted a great deal of attention with her striking work *Beauty is in the Eye of the Beholder*, a depiction of South African street style. Defying the clichés of what life can be like in South Africa, Veleko captures young people dressed in unique outfits, often with handmade elements. Nontsikelelo Veleko was a nominee and finalist of the MTN New Contemporary Artists in 2003 and has since participated in prominent local and international exhibitions. In 2006 her photographs were exhibited in the landmark exhibition *Snap Judgments: New Positions in Contemporary African Photography* at the International Center of Photography in New York. Most recently she held a solo exhibition *Welcome to Paradise* curated by Elvira Dyangani Ose for Casa Africa, Las Palmas, Spain. Veleko was the 2008 recipient of the Standard Bank Young Artist Award for Visual Art.

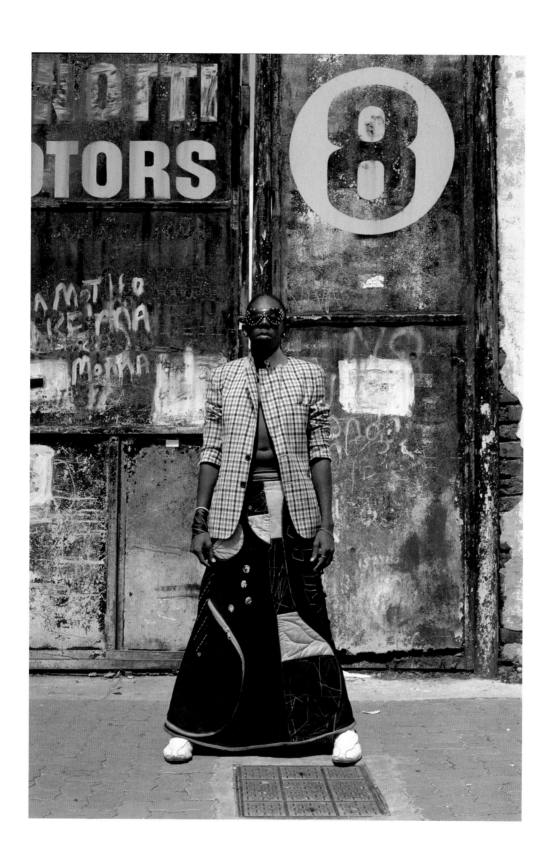

Nontsikelelo 'Lolo' Veleko
Sibu IV

Sibu VIII
(from the series 'Beauty is in the Eye of the Beholder', 2003-2007)

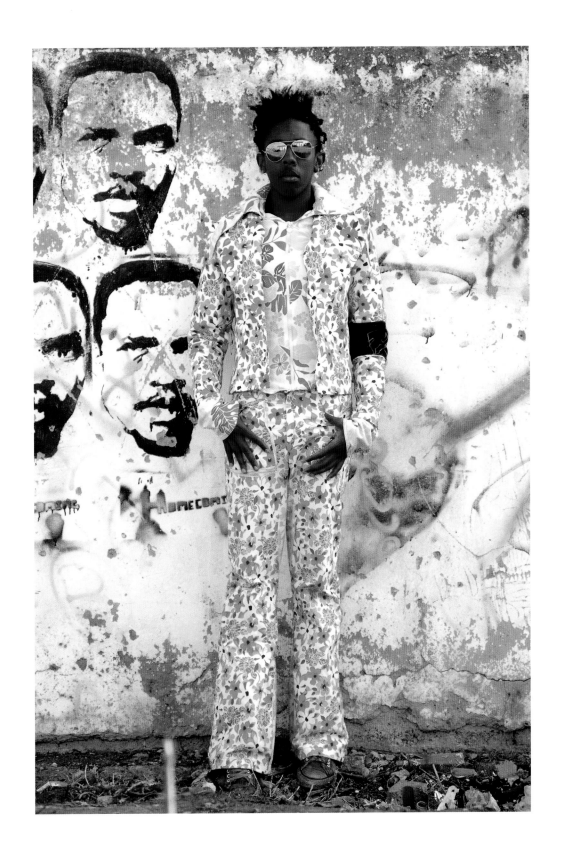

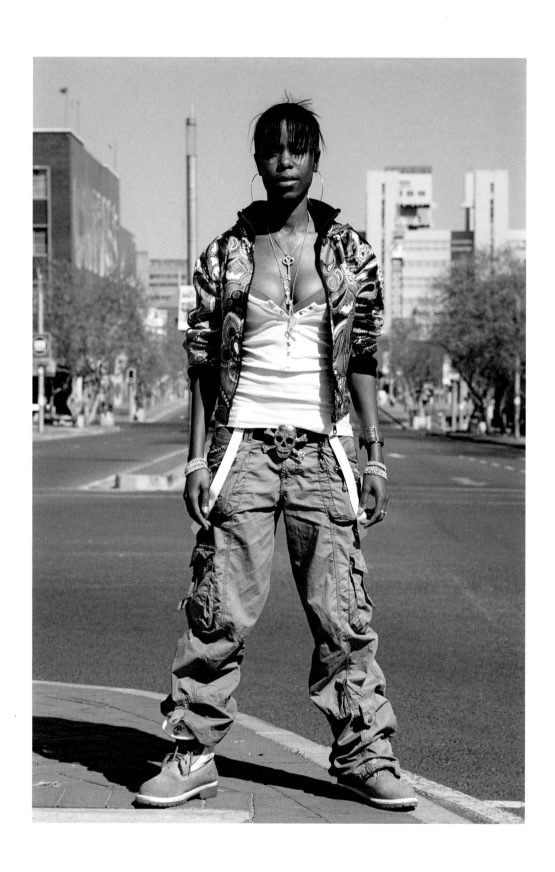

Nontsikelelo 'Lolo' Veleko
Lesego, Miriam Makeba Street, Newtown, Johannesburg

Cindy and Nkuli
(from the series 'Beauty is in the Eye of the Beholder', 2003-2007)

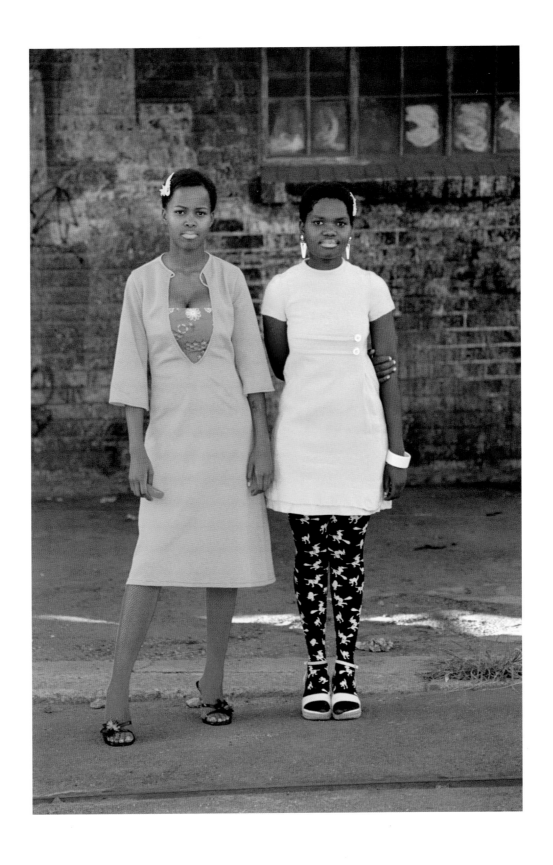

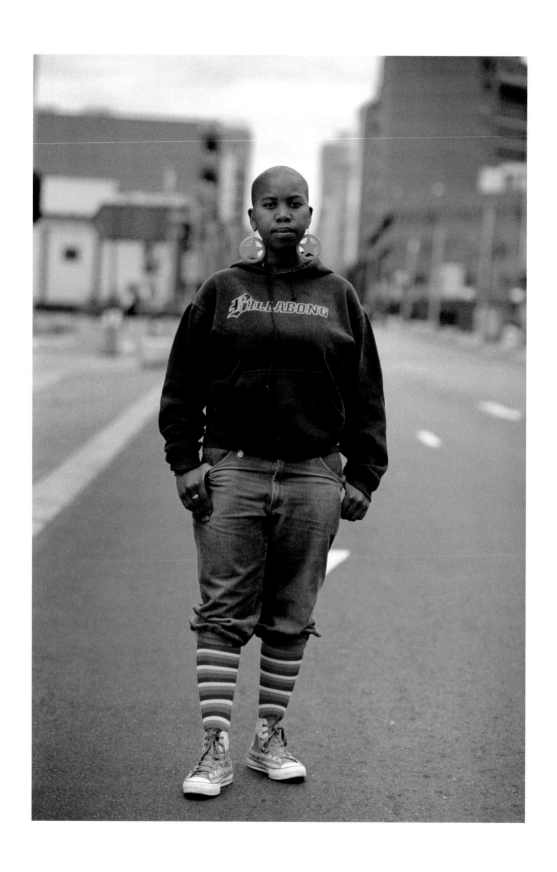

Nontsikelelo 'Lolo' Veleko
Vuyelwa

Katlego
(from the series 'Beauty is in the Eye of the Beholder', 2003-2007)

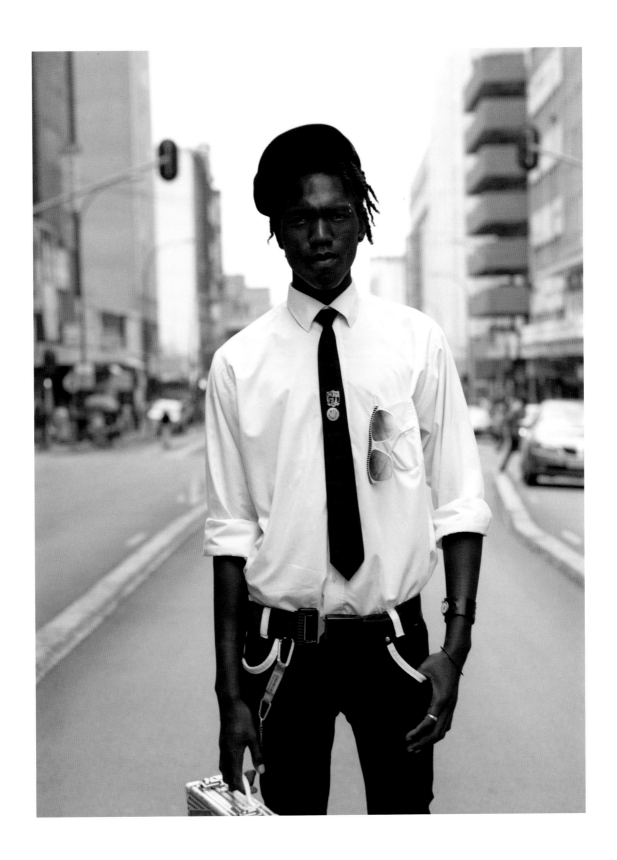

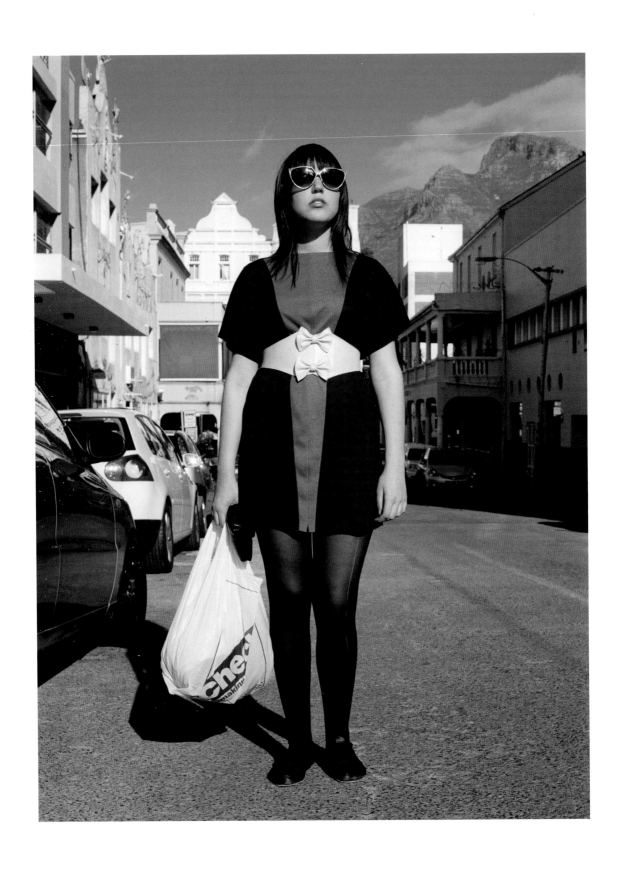

Nontsikelelo 'Lolo' Veleko
Girl on Long Street, Cape Town, Western Cape

Kepi I
(from the series 'Beauty is in the Eye of the Beholder' 2003-2007)

246

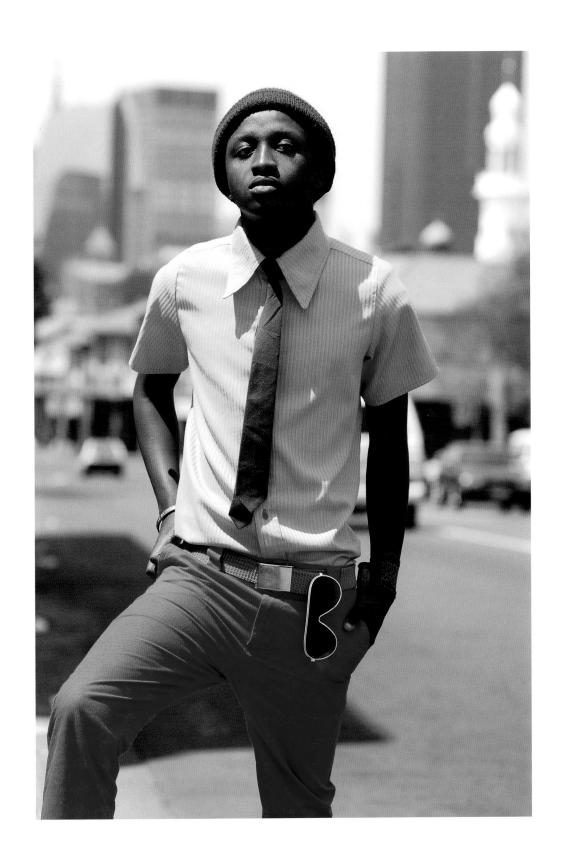

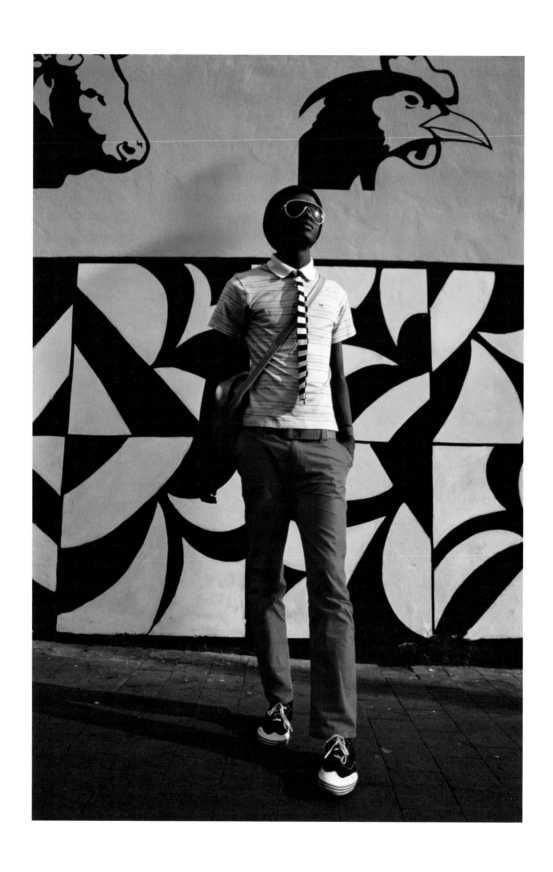

Nontsikelelo 'Lolo' Veleko
Kepi II

Nonkululeko
(from the series 'Beauty is in the Eye of the Beholder', 2003-2007)

248

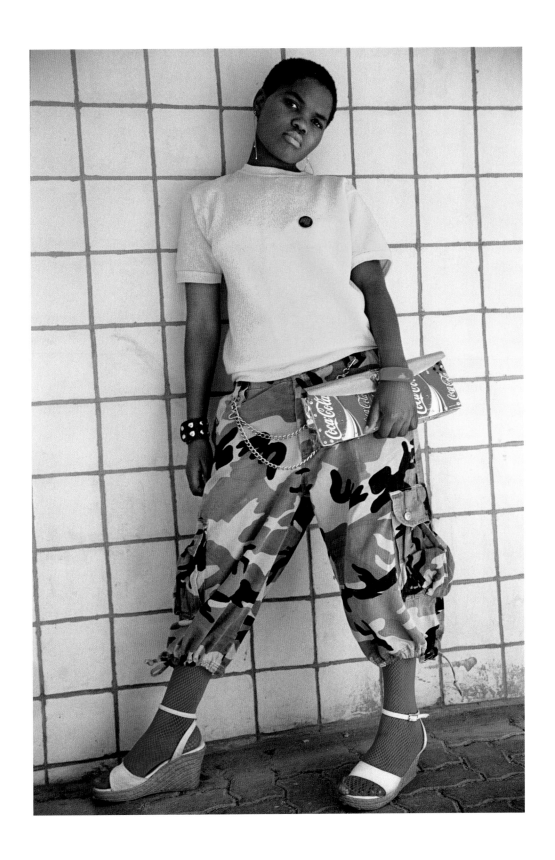

Graeme
Williams

Born 1961, Cape Town, South Africa
Lives and works in Johannesburg, South Africa

Graeme Williams began photographing in his teens after completing a Bachelor of Science degree (majoring in geology and statistics) at the University of Cape Town. He began to take on freelance assignments for local magazines and advertising agencies and then worked in London for a year before returning to South Africa. In 1989 Williams began working for the Johannesburg office of Reuters, covering the transition to ANC rule. In 1991 he started to contribute to the South African documentary collective, Afrapix, and later went on to become a founder member and manager of the South Photographs Agency. Since the late '80s he has worked as a freelance photographer and picture editor taking on regular commissions from a cross-section of local and international clients, as well as on his own photographic projects. His work is housed in the permanent collections of The Rotterdam Museum of Ethnology, and The Apartheid Museum in Johannesburg, amongst others. He has staged thirteen solo exhibitions and has contributed to numerous group shows.

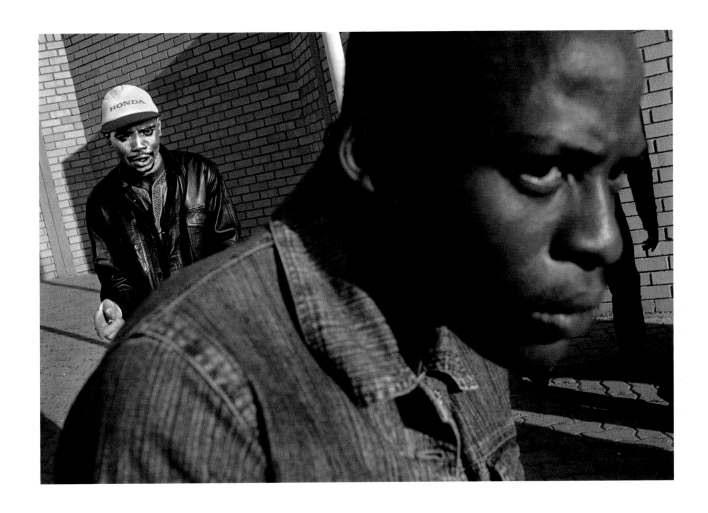

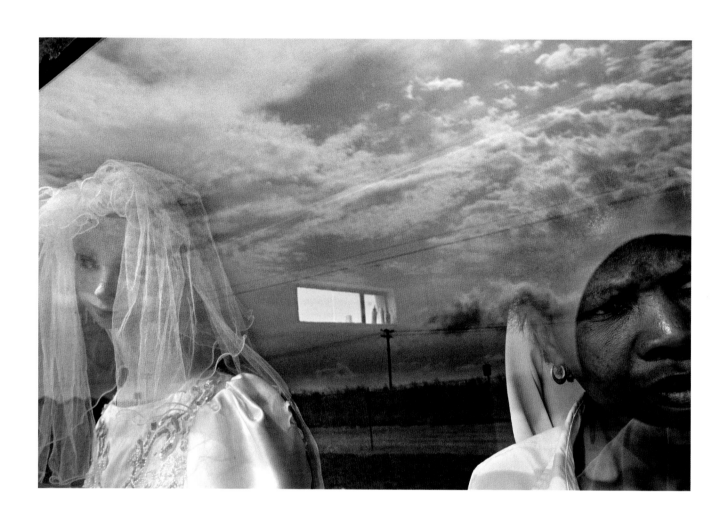

Graeme Williams
Glen Cowie, 2006

Marquard, 2006
(both from the series 'The Edge of Town')

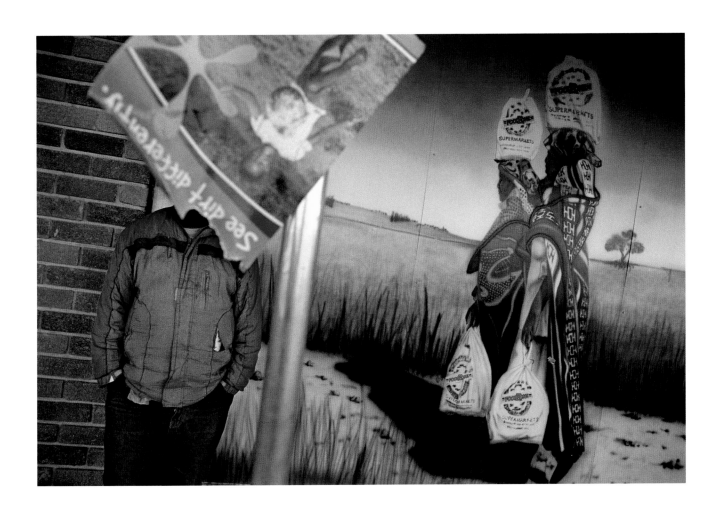

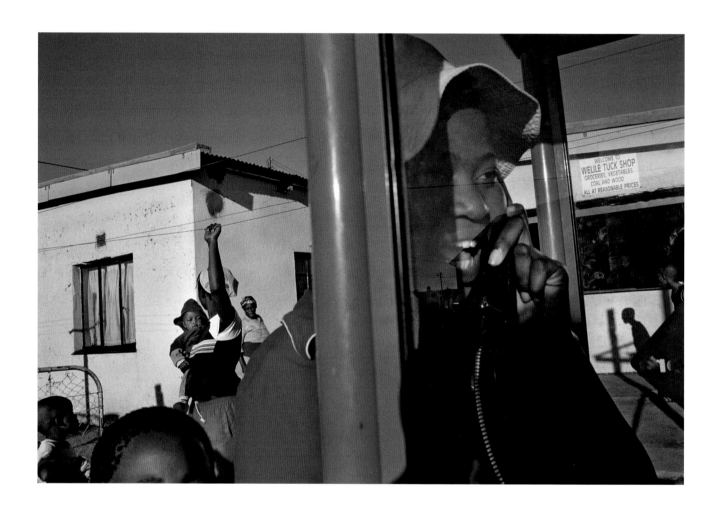

Graeme Williams
Springfontein, 2006

Victoria West, 2006
(both from the series 'The Edge of Town')

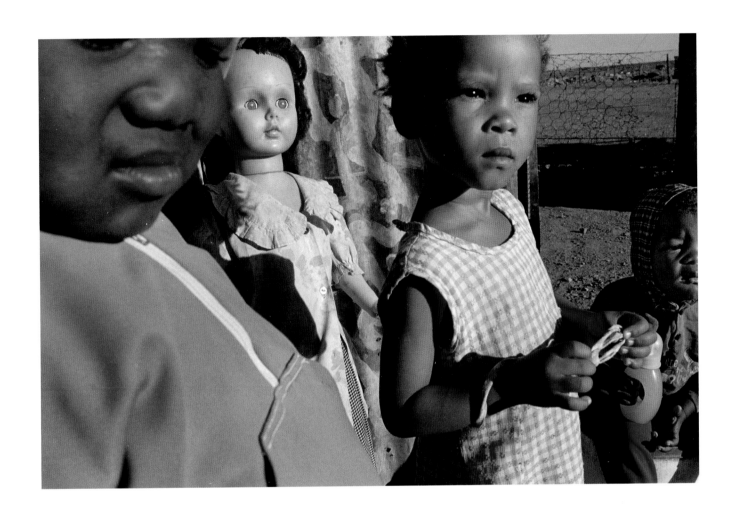

Graeme Williams
Intabazwe Township, Harrismith, 2006

Khayelitsha Township, Graaff-Reinet, 2006
(both from the series 'The Edge of Town')

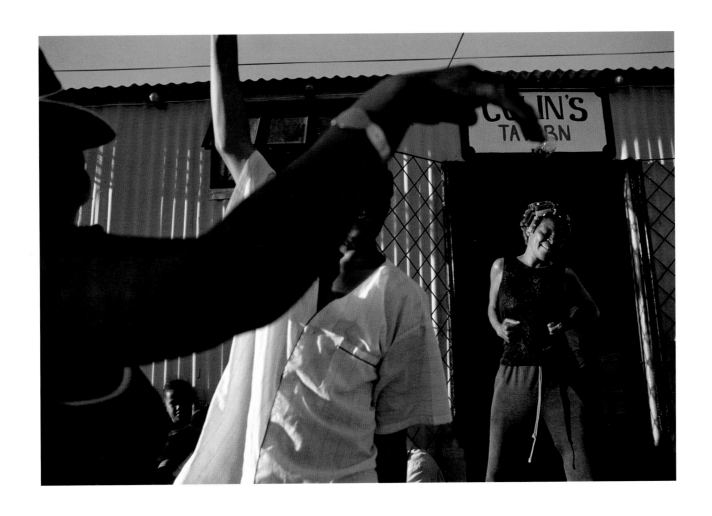

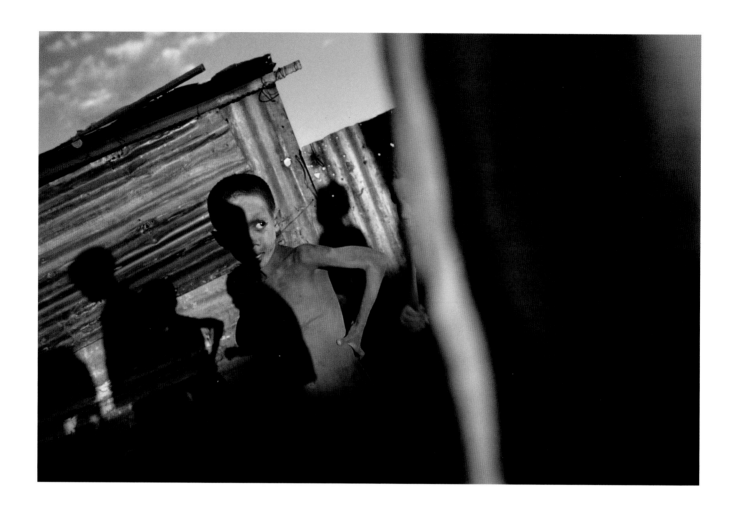

Graeme Williams
Hanover, 2006

Cape Town, 2005
(both from the series 'The Edge of Town')

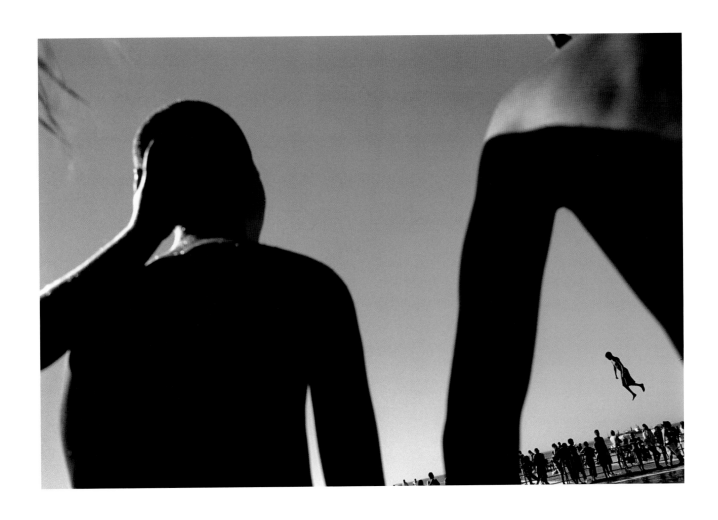

Interviews and Artists' Statements

Jodi Bieber

My new body of work entitled 'Real Beauty' has been inspired by a number of events, the primary being my own life. My forties have brought a feeling of more comfort within my own skin than when I was younger, even though my body shape has shifted. This project is an extension of a Dove billboard advertising campaign in London showing ordinary women in their underwear advocating and speaking up for real beauty. Advertising campaigns don't usually draw my attention, but this one did. A model sitting next to me on the way from London to Paris emphasised the extent to which Photoshop is used to enhance beauty. She was not in the least bit concerned about the rings under her eyes, as these imperfections would easily be erased after her photographic shoot. A BBC radio documentary spoke about an increase in the cases of black anorexic women in South Africa, as the full-figured body that was once more favourable is no longer as desirable as western body shapes.

I felt a strong need to create a body of work that goes against what the media has depicted as beautiful. Even within a complex society such as South Africa, across all communities, women hold unnecessary perceptions of self-doubt around themselves and their beauty from an early age. The work deals with reality and no Photoshop has been used to remove blemishes, scars, cellulite and any other form of 'imperfection', but also touches on fantasy.

The photographic shoot was a collaboration between myself and each woman, whom I photographed at their homes. The setting within their surroundings was my choice but each woman's pose was pretty much self-directed. I wanted each woman to project their personality or their fantasy into their shoot. The shoot created a space for each woman to explore their own identity in relation to beauty and to live for a couple of hours in an environment of elements of fantasy.

One of the issues that came to the fore in 'Real Beauty' was that, in general, South Africa is conservative as a nation. At times I felt people thought I was recruiting women for a pornographic shoot. I did not discriminate against anyone who approached me. I photographed each and every woman. Three main reasons that people used for saying no to being photographed (besides body privacy rights) were: 'my' husband wouldn't agree to it, religious views, and just feeling uncomfortable with their body shapes. Most of the women that participated in the shoot did so because they believed in the project and supported my concept of real beauty. A second issue that arose from the images produced from 'Real Beauty' is the different belief systems held amongst different communities. Very thin and tall women might be perceived by their communities as being sick, possibly with HIV/Aids, and more full figured women as healthy. In other communities thin women are often more desirable.

From the interviews I carried, out most women believe that there is no real perfect body shape and it is more about being healthy and feeling comfortable in one's own skin. The general trend was more accepting of thinner and curvaceous women and less accepting of the ultra thin models we see in the media. It is said that Tswana and Xhosa women are the most beautiful; the lighter your skin, the more beautiful you are.

The common ground for my work is that both myself and the women I photographed wanted to make a stand for real beauty.

Kudzanai Chiurai

Tamar: You are originally from Zimbabwe and trained there. Can you tell me a bit about your background and what led you to come to South Africa?

Kudzanai: I did art as an A-level subject at school in Zimbabwe and took a gap year after school when I just painted. I then applied to study art formally at Pretoria University in 2000. I didn't know anyone in Cape Town or in Johannesburg, but I have an uncle in Pretoria and could stay with him.

Tamar: What kind of an education did you get there?

Kudzanai: It was quite conservative — form and function was important. They offered traditional mediums such as painting and sculpture and I specialised in painting. After that I looked for other ways in which I could express myself and my practice became more multi-media. Initially my intention was to make pretty pictures but after a trip back to Zimbabwe in my second year and with the theory we were getting at the university, I became more engaged with the political situation there. I did some design work for an NGO in Zimbabwe and started getting access to more information through various development agencies. It gave my art a political function – I started making posters and T-shirts and stickers to give away.

Tamar: The late '90s was a time of immense tension and anxiety in Zimbabwe but you were living in South Africa after the transition to democracy. How did you negotiate that position? Did you feel like an exile or did you feel like you had relocated and found a new home?

Kudzanai: I found a new home. I had a lot of friends in South Africa, and after my second year at university, I didn't really go back to Zimbabwe. It became difficult because of the activist work I was doing and I became a South African resident. In my practice I looked at these countries separately, scouting the margins or the borders of these identities.

Tamar: When did you start using photography as part of your practice?

Kudzanai: I've always wanted to work with photography and did a bit of that at university. And I am really interested in popular culture — always flipping through magazines and newspapers. I started working on a magazine called *Yellow Lines* and began thinking about a series of photographs on the theme of the 'Black President'. I conceived of the series as representing a kind of a collective psyche of how we in Africa see our leaders. I think that Africans look at people in power or heads of state with a vivid imagination – there's a lot of projection; they become larger than life and we tend to look up to them. But, at the same time, it's also a bit like a soap opera with predictable story lines, characters and plots. Of course the question then becomes what does it say about ourselves if these are the stereotypes with which we identify.

Tamar: Can you say more about the stereotypes and icons that you invoke in the series.

Kudzanai: In the one entitled *Minister of Education* I wanted to use a stereotypical image of black empowerment like a Malcolm X figure. The glasses, the hair, the bow tie signify the intellectual or the

David LaChapelle, *The Rape of Africa*, 2009

scholar. But then we added a gun to this image to register the levels of violence in South Africa. At schools teachers were coming to work with guns to defend themselves and we were thinking about how education itself has to be defended, not only teachers. It's almost as if one is forced to be educated now with a gun to your head. In another image, that is not from this series but is related to it, with the man and woman against the Sheshe backdrop with Mbeki's face on it (*Untitled III*, 2010), I wanted to explore the link between politics and crass materialism. These characters appear to be very exhibitionist and loud and I am asking where this generation is coming from. Mbeki and his new South Africa are about political empowerment but the wealth of a new generation is linked to the political structure and a particular political party, the ANC, which acts as a source of new wealth. This figure with the red blazer and the feather duster is a Head of State. His pose is based on 18th-century aristocratic male portraiture but he has a fly swat. It has to do with how the African media portrays English aristocratic ideals and how many Heads of State follow this. For example, Robert Mugabe loves cricket and, even when the country is in turmoil, he makes time to go and watch cricket and is a patron of one of the sports clubs. But I also wanted to point to the fact that liberation is not without bloodshed, that is why I chose the red jacket. An exploration of masculinity is central to this project. African politics is quite patriarchal, the head of government is essentially the father of the state, the liberator — Nelson Mandela or even Robert Mugabe is called father of the state. And if you have this father, you must have a family structure so the question becomes what role do the citizens play and what do they learn from this father figure, what is imparted to them? As you grow up you learn your masculinity from your father, by interacting with him.

Tamar: It is interesting that image production around black masculinity often seems to centre on one of two opposites: on the one hand there is the hyper-masculinity of popular culture and sport set within a context of ostentation and consumerism. On the other hand there is the afro-pessimistic vision of starving youth and helpless, vulnerable people. It's as though the image of black masculinity is stuck between these two extremes of total macho empowerment or complete impotence. Your pictures seem to represent the first strand with its references to bling, consumerism, exhibitionism and materialism. Your images tap primarily into American rap culture, gangster culture, and popular imagery. Where do you draw your image bank from in terms of costume, pose, mode of address? Is it from magazines and media?

Kudzanai: Yes, from magazines, movies, hip-hop, style, fashion. I am interested in how hip-hop culture infiltrates other cultural domains and so we added certain nuances to these works — the gold chains, the phones, the Blackberry, the guns — to see how it interacts with ideas of 'Africanness'.

Tamar: Would you agree that your works register not so much the lived experience of African men but the image culture of African masculinity that circulates globally? It's about representation more than anything else.

Kudzanai: Yes. But it's also about how we construct images of ourselves. These media constructions are powerfully influential. At a recent exhibition, so many kids loved this work, they are able to identify a lot of the images and sources without me having to explain the work to them.

Tamar: I guess that kids growing up in cities and rural areas and townships are literate in hip-hop culture, but I wonder if any of them felt vaguely uncomfortable or thought of it as a parody of 'Africanness'. To what extent do you think you reinforce that sense of a globalised masculinity at the expense of the complex differences that the continent can potentially project?

Kudzanai: I think the point is to ask who creates these images, where are they generated? If it is another white kid who produces these images it is more problematic than when they are produced by Africans who open up or expose the culture. Asking where these images are coming from is essential – are they coming from the BBC or news or radio, or are they coming from Africa? Do we have an influence over the images that are being produced? I work with media constructions, images popularised through movies, music videos etc. It is important to ask how the images are used. How do we relate to them, what is their function, their purpose? And if these images are influenced by our culture, how can we change them, how can we make them more constructive? By creating these cinematic, large-scale, hyper-exaggerated, saturated constructions, I am hoping to render them open to criticism and discussion.

Tamar: The theme that comes out above all is materialism.

Kudzanai: Materialism is very prevalent — everyone wants to live better, get out of the township and live in the city, own a BMW and go to the right clubs. It's not the majority but perhaps it is the first generation that can have these things and the aspiration exists. With the influence of MTV and the internet and blogging black youth in South Africa have developed their own popular culture and their own idols, very different from their parents' generation. But even in this generation there are the kids who are critical and realise how fortunate they are, but crass materialism does exist.

Tamar: Can you tell me how you make the works? You don't actually take the photographs but conceptualise them?

Kudzanai: Yes I conceptualise them and start with the idea. It's like art direction, and mostly someone else takes the photographs — I wrote the briefs for the series and started working with stylists and a photographer and borrowed clothes from people. The looks in this series of photographs are based on actual people. In one of them, for example, I saw a friend at a party who I thought would look interesting as a Minister of Arts and Culture and so, instead of styling him, we used him wearing the same clothes he had worn at that party. But then we used him in another work dressed differently, almost like a mannequin. So we set up the shoots in a studio with certain props like costumes or a briefcase or books or a gun.

Tamar: Studio photography has been around in Africa for a long time. When you are staging these works in a studio, how aware are you of that tradition, of the work of someone like Samuel Fosso or Malick Sidibé?

Kehinde Wiley, *Napoleon Leading the Army Over the Alps*, 2005

Kudzanai: Well, I try intentionally not to look at people like Fosso or Sidibé. I worry that their work will subconsciously enter mine so I refrain from looking at it too much. Anyway I am much more influenced by movies and magazines than by African photography. I particularly like the work of American photographer David LaChapelle. He is a fashion photographer and his work is very theatrical and large-scale. I like the way he uses colour and saturates the image. I also look at the work of the American painter Kehinde Wiley, who uses portraiture to restage important figures like Napoleon in terms of black masculinity. It's not that I am uninterested in the tradition of African photography, I have just been exposed more to European and American art historical influences both in libraries and on the internet.

Tamar: You use the word portraiture, which is interesting — are your works portraits?

Kudzanai: Yes, I see them as portraits. I think for me they are theatrical portraits because often it's the same person but with a different gesture, posture, costume, style and character.

Tamar: What is your relationship to the characters that are being performed — do you feel a sense of identification or distance? Are you part of this community of posers or are you outside of it?

Kudzanai: The person I use for many of these portraits is essentially a performer, he's a pop icon in South Africa who everyone knows from television and radio. His name is Siyabonga Ngwekazi and it was important to use him as he works in popular culture – a South African audience would immediately recognise him. He is a popular icon himself and people look at him as a model for style and fashion. So to see him outside of that TV context is to be aware of the artifice of the roles he adopts, of his performance of black masculinity and popular culture as image.

Tamar: And why do you think photography is a good medium through which to explore these ideas?

Kudzanai: Photography allows me to bring these worlds together. Photography works across popular culture, art and different visual media. It's versatile and open. One can use it either as a critical tool or simply read it as reproducing popular culture. It has a dual purpose. I like its ambiguities.

Hasan and Husain Essop

Tamar: I want to start off by talking about how you became artists.

Hasan: It started from a very young age. Throughout primary school we were known as the boys who loved to sketch cartoons. If there was a food fair or something and they needed a banner painted, the teachers would call one of us.

Tamar: Did you already work together as brothers from a young age?

Hasan: At primary school we were very competitive, so we never worked together.

Tamar: You are older, Hasan?

Hasan: They took me out first: we were a Caesarean birth, so the doctor chose one of us first.

Tamar: So you are twins?

Hasan: Identical twins.

Tamar: They took you out first, Hasan, so you still speak first?

Hasan: Yes, and, growing up, people always asked that question, so I have adopted that rule. But back to primary school: we were obsessed by drawing, and how well you could capture reality. In the area we lived, we applied to a high school that did art (there was only one high school out of four in our area, in the Cape Flats, that offered art). We weren't fortunate enough to go to a private school so we went to a government school and we went there with the intention of doing art. Teachers saw potential in us doing other subjects; art wasn't seen as a career, but we persisted. We were harnessing our passion and we had a really nice teacher who introduced us to Surrealism, Realism, Fauvism, Dadaism, and that type of art. We were introduced to new mediums like oil and pastel. In high school we studied dead artists and I think our understanding about art was very romantic. We never had an idea of how we were going to make money; all we knew was that if we could do this for the rest of our lives we would love it.

Tamar: When you got to university, did you feel that there was a conflict between the culture in which you were brought up, the very romantic idea you had about what an artist might be, and negotiating a university art education?

Hasan: Completely. We hit rock bottom: there was just obstacle after obstacle. We were put in a class with students from private schools who painted on canvas, and we came from a background where we did watercolour painting on cardboard, not 'new media', sculpture or photography. We learned everything for the first time. The lecturers were trying to push us, but they were pushing us in the wrong direction because we also came from a traditional background. We were brought up with certain morals and ethics and we tried to stay true to that. Other students were quite open-minded and that was also new for us because they were atheists and we come from a community where atheism is taboo. So we tried to be open-minded and still keep our own beliefs. It was tough because at times we also stepped away from our background through that peer pressure, but in our final year we had the opportunity to explore the beauty of our beliefs and the challenges we faced.

Tamar: So you had to deal with coming from an education system which didn't necessarily prepare you for art school and from a religious community that was not necessarily very sympathetic to being in the art world. At the same time you were entering into a

space in which you met people with many different views. At which point did you realise that you could turn your own background and experience into the subject of your art so that you could make something meaningful out of it?

Husain: I think a lot of art students do that, not only us. If we were given a simple self-portrait sketch, in the beginning we used a bit of text from the Koran, but our parents were very disappointed with that part. You have to be careful how and what you are depicting and what you are using as subject matter.

Tamar: Did your parents think that was a kind of betrayal of a holy text?

Hasan: Yes, you are not allowed to do it. That is why art is shunned in the Muslim world.

Husain: Because it is very easy to step on people's toes. Especially in the Islamic world, representation is a very sensitive topic.

Tamar: How do you deal with those taboos, those restrictions and turn your language into something productive? At which point did photography become the medium that seemed to do that for you?

Hasan: I majored in print media and Husain majored in photography. Being so close, we were always together on campus. I hung around with the photography students so I started to really see the beauty of photography, although still loving print and the aesthetic you get from it. I explored photography because it was very 'what you see is what you get'; it's a modern medium. Also, everyone has a camera and I also thought that people would be more accepting within photography. Husain and a friend of mine, William Esposito, helped me. Husain would take me to the studio and shoot me in different characters, different clothing, different expressions, and then William would help me shoot landscapes. Then I would Photoshop them and create this kind of dialogue within the image, which spoke about that cultural conflict. I would be dressed first in really fashionable clothes and then afterwards as a character with Islamic garb and they would be fighting each other. I was trying to share what was happening with people around me who didn't know about Islam.

Tamar: Dramatising the conflicts inside you through photography?

Hasan: You know, I would come to campus and I would be this popular, fashionable guy – up-to-date, open-minded – and then go home and change into my Islamic garb with my parents and try to be that type of son to them. All my friends and people around could relate to that because it was something they were also experiencing; there was a real conflict that was happening with people of all types of religion. I think the worst experience was while growing up, in that sensitive phase in high school and university. The family around us, not my immediate family, I'm talking about uncles and cousins and acquaintances and people you're surrounded by within the community, they were the ones putting us down from the get-go.

Tamar: Husain, were you using photography more traditionally at that point or were you also interested in the idea of using photography via computers and Photoshop, as something that is the end product of a performance?

Husain: Well, the first time I picked up a camera I was in second year at art school and we were introduced to black and white photography. That's what actually caught me; that's where the passion grew – documentary-type photography. When it came to third and fourth year I was experimenting with new media as well, Photoshop and colour digital photography. I was trying to deal with the war in Iraq and

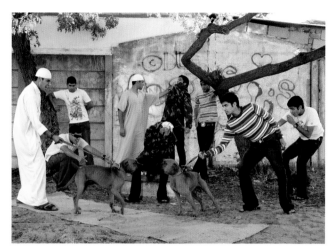

Hasan & Husain Essop, *Pit Bull Fight*, 2007

I was creating works with a mosque and the American flag next to it, trying to come up with some kind of dialogue between found images. Then when I looked at Hasan's work and, the way he interacted with himself, I was like 'Wow!' I suggested he shoot on site; it didn't even occur to me that I was helping him when I saw the final product.

Hasan: After we graduated we were in a rut for some time. We had pressure from our family, who were like, 'OK, you have your degree, we have invested in you. What's your plan?' We didn't have a plan, but things just fell into place. The Goodman Gallery phoned us because they saw our graduate work and they asked us to come in for a meeting, and we said that Husain and I never had had a chance to work together and we wanted to do it. We started with the pit-bull fight, the very first piece we did together. We spoke about our conflict with each other, our competitiveness, by representing a pit-bull fight, but it's the same pit-bull cloned. Husain had on Islamic garb and I was dressed in a smart jumper with jeans, also bringing that east versus west conflict in. You know, that photograph is where it all stemmed from: we looked at things that were happening around us for inspiration, so people couldn't tell us we are sucking this out of our thumb! We became observers; we went into our community looking at social problems and issues, asking friends, 'What do you feel about this, what is the problem with that?' We thought about how we could use things metaphorically. And it started from there. Violence always appealed to us strangely; the work started a bit violently but also we've got a sense of humour, so we also used humour within the first photographs. We love Hollywood at the same time as we hate Hollywood; it's a contradiction that exists within us, you know. It's such an obvious contradiction, but I think people live these contradictory lives.

Tamar: So how did you work out your technique, using Photoshop and drawing on fiction as well as real situations into which you insert yourselves?

Hasan: Being twins: that was our weapon! Growing up simultaneously, we experienced life together, so what we saw, we saw at the same time – our visual dictionary was being created simultaneously. Husain will know a place and he just needs to mention it and I know exactly, visually, what he is speaking about. That's where our being twins came into play because Husain will have an idea and then he will speak to me about it and we will argue and debate it. We understand it in our minds, so we come to the site as if we had prepared how we were going to do things.

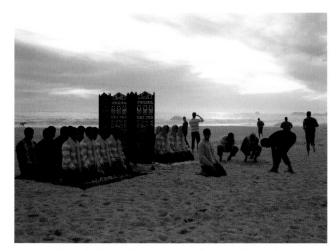

Hasan & Husain Essop, *Tayamum*, from the series 'Halaal Art', 2009

Tamar: So once you have gone out there and you've shot yourselves in situ, you bring the material back to your studio and start working with Photoshop, duplicating, multiplying, adapting?

Husain: Yes. With me, black and white really attracted me; the manual aesthetic of it or how true you stay to photography, and I still wanted to do that with digital photography, so people couldn't tell me, 'You are not a real photographer'. When we do the photographs we shoot manually: everything is manually done. Each character is placed exactly where they were photographed. So that's how we try to work, and when we are Photoshopping, we don't play with colour or anything, everything is as photographed.

Tamar: Okay, so let's take an image where you have got a lot of different characters; this one of the prayer meeting on the beach. How did you make it?

Husain: Yes, that is called *Tayamum*. This was in 2007. It was just me, I was still working alone without Hasan.

Tamar: So you took a photograph of yourself and then you Photoshoped all these duplications?

Husain: No, they are each individual shots: we never duplicate ourselves. It's against the whole principle. It's like there are forty-five photographs in one. There is a photograph we did in a mosque where we filled up the mosque and we are in position and we photographed it in every block in the mosque, so when we put it all together – over two hundred photographs – it looked like it was Friday, a wave of people. That's the tricky part with this; it's nice when the characters aren't overlapping because it's easy then to Photoshop.

Hasan: Yes, it's crazy. The more clean you do it – the more clean you edit the photographs – the more real it is. The more convincing it is.

Husain: And that's what we wanted. Artworks create a reaction and emotion within the viewer, and for us that was the reaction: stepping forward to see whether there are only two people in the photograph.

Tamar: Do you describe yourselves as photographers or as artists?

Husain: As artists.

Tamar: But your use of photography is tied to the traditional notion of the photograph as witness, the idea that a photograph is in some way a record of an actual event or an actual situation. You incorporate that into this adapted, manipulated environment.

Husain: We set up a photograph, but in the end we are actually setting up a moment that we are experiencing. So it becomes as if we are documenting what is happening to us. Like when we were in Cuba on our residency, we had no halaal meat available so we ended up going to a farm and buying a sheep and chickens and slaughtering them ourselves. And I was saying, 'We have to document this; this is a shot'. It was like buying a prop for a photograph, but it was also something we were going to use to feed ourselves, to sustain us.

Tamar: With your work you get the sense of it being a kind of ethnography from the inside, looking at the self from within. But, at the same time, you are addressing a wider audience?

Hasan: Yes, we are making work that needs to appeal to everybody, Muslim or non-Muslim. We were searching for a visual language that not only artists would be able to read but also so that anybody could get the basic essence of it. That's why we turned to Hollywood, to look at their sign vehicles, but in the end we try to look at reality and take exactly what we see.

Tamar: Do you sometimes feel that you should be censoring yourselves because you are exposing your community to scrutiny?

Hasan: That's why we use only ourselves in the photographs. We never ask anyone to be in the pictures because if there was going to be any judgment or any attack on anybody, it should be us and we would take sole responsibility for it.

Tamar: Does anybody ever say to you that your depiction of human figures is in itself transgressing Islamic law?

Husain: In the beginning they did, but then they started seeing what the work was doing and how we were tackling an issue. Today you have this fight against Islam, this war on terror: people are getting the complete wrong idea of what Islam is about. They don't understand that it is people that are corrupt and not the religion. We are using art to describe our religion and show the beauty of it. So people realise that we have to resort to this; it is a new day and age, and this is a new way. If the media is going to fight us, then we also have to fight the media with the media.

Tamar: Describe to me what the project 'Halaal Art' is about.

Hasan: It was something that started during our trip to Cuba. It was about the way we were living, the challenges we faced as Muslims in a country that didn't have Islam. It started with finding meat, a lamb, and sacrificing it halaal; making something that's impure, pure for your body to eat. We tried to explore that: what does that mean? We take where our food comes from so for granted. We went to the abattoir in Cape Town where we get our halaal meat and we shot in a kind of alley, to show the abundance of nutrition here. It is horrific to some extent, but it is also a beautiful ritual if you understand it and you respect it and you respect the animal.

This was a photograph made right before Eid; this is a mosque in Cape Town and the night when the fast has completed, people in your community, like, say, five of our friends, would all put money together and then buy all the ingredients to make a pot. And then at this mosque, they would sell the ingredients with pots and everything; you just need to make it and during this night, about eighty pots were being cooked. One pot fed one thousand kids and this happens once a year. It's something special. These photographs are tricky because they take a lot of planning. At the scene we set up the tripod. I will test the light. I will look at Hasan and say, 'Do you like this angle?' and he's like, 'Maybe you shift it like this' and we have

that discussion. This happens so quickly you know, because that's the beauty of the work, it has to happen quickly, the light changes all the time and you want to stay true to what you are photographing. And then he will do a series of acts where I will photograph.

Husain: So we don't have to go, 'OK, on three: one, two, three'. We passed that phase a long time ago. A lot of the time we shoot on a shutter of sixteen or eighteen and you can get easy movement of the body, and it's quite hectic because sometimes we have to act it. If it's a small shot we will try to shoot on a roll, but when it's big work, when you are using a lot of characters, we keep it on large format, it's much easier to work with. After doing the series of photographs, we will do another series of photographs but just at a different angle because you never know, and that's when we take it back home and go through them. In the still frame we look for the moment, the killing moment, excuse the pun, where it's him dishing up, or it's him stirring the pot or it's him praying with a knife, about to cut.

Tamar: It's like a stage set in a way, isn't it? It brings in theatre, film, modelling, advertising?

Husain: Because that's what we live with, that's everyday life. A lot of the time we try not to really model, in a way. We kind of go back into the past in our mind to create a shot. For example, like with the cooking of the pots. We were watching the cooks for maybe two hours, learning their movements, and when it was our turn to act, it's like you get into character and you just do it.

Tamar: You come with this whole image culture informing your view both overtly and subliminally.

Husain: We are true believers in Surrealism. Dadaism and Surrealism is what sparked everything for us, when our teacher taught us about that in high school. A lot of these things happen subconsciously; we don't even know we are doing them. It's amazing: it's like a sixth sense — we have that twin thing.

Tamar: Are you at all engaged with either Islamic cinema or Bollywood or Asian visual traditions, or is it mostly western or Hollywood culture, would you say?

Hassan: It was an attack on Hollywood in the beginning, but our parents are from an Indian heritage. So I trace our forefathers from India and that's our culture, so Bollywood has been part of us. If my sisters want to wear a fashionable garment, they put on a sari. We are Capetonian, we are of Indian descent, we are Muslim and we are South African. There's so many identities within us that we are proud of. The work comes out of all of that.

David Goldblatt

Tamar: You've been engaged with photography for a long time; what has it meant to you in the past and what does it mean to you now?

David: My whole life revolves around taking photographs, looking at photographs, absorbing them, pulling them apart. It's very difficult to disentangle it and say, 'this is what it means to me', but I suppose if I had to give a one sentence answer, it means the ability in myself to reflect on, analyse, and bring together in some kind of synthetic way, aspects of the reality around me.

Tamar: Do you experience the world as filtered through your photographic imagination?

David: No, I don't think so. I'm not deluded by the possibility of encompassing the world in a photograph. That is the ultimate unattainable ideal, but I'm not in any way deluded by that idea. No, it is a fairly immediate and commonplace sort of thing.

Tamar: Has your relationship to photography changed over time?

David: I think – and I'm not being facetious – I think I am very boring; a straight-line graph. If you look at what I did fifty years ago and what I'm doing today, the variations have simply been in the aspects of reality that I have chosen to look at. But I don't think there has been any kind of change in the fundamentals; in the manner of looking and the way of trying to dissect reality.

Tamar: But of course your work is always permeated by different historical developments, and the relationship to history is key.

David: Yes, my relationship to history is key; as I have gone along, so I have absorbed new insights. During my university years, economics and economic history were enormously important to me. And every now and then I read something that suddenly gives me new ways of looking at old things. At the moment I am re-reading W.G. Sebald's *Rings of Saturn*. I am astonished by what he reveals, and I suppose that some of that percolates through into my being and into my way of seeing. This is true too for the poetry of Ingrid de Kok.

Tamar: It's very interesting that you mention those two literary figures, Sebald and de Kok. I know of your relationship with Nadine Gordimer and Ivan Vladislavić, whom you've worked with and written with, and it was you who introduced me to the extraordinary work of Marlene van Niekerk. So what is your relationship to text and to the literary?

David: I think that it's a complex and intimate one. Photographically, I was hardly influenced by South African photography over the years, except for Sam Haskins, whose influence was key at one particular stage. But I have been influenced in a very fundamental way by South African literature; J.M. Coetzee, Herman Charles Bosman, Ivan, Nadine, Marlene, Lionel Abrahams, Barny Simon, Athol Fugard. These have all been very important to me; they have written about this country so powerfully.

Tamar: When you say they have been influential, is that in terms of a critical relationship to the country, or is it to do with their subject matter? Do they alert you to certain kinds of images? How does that translate photographically?

David: I think it's both, and some of them are very elusive. I think Marlene van Niekerk has penetrated to new levels in South African writing. I don't think she has been influential in a particularly visual way, whereas Nadine Gordimer was. I wanted to find ways of putting into photographs the qualities of her observations, which were so elucidating for me in my own observations. With Bosman too, in a different kind of way.

Tamar: It might also be because they are both very graphically descriptive writers, but Marlene van Niekerk has a more stream-of-consciousness way of trying to articulate memory and trauma and guilt. Those litanies of words are just amazing; they have their own kind of music. I'm interested in the role text plays in your own work and the texts that you yourself generate. When you write those, do you self-consciously craft them or do you feel they just provide information that is very 'straight'?

David: I sweat blood when I write. I try to articulate in words information that is complementary to the photograph – expansive

of the photograph and yet not an attempt to put words and thoughts into the reader's or the viewer's mind and eye that would prevent the photograph from being itself the main source of the experience. It's a very difficult thing to do. In the case of the 'ex-offenders', I have tried not to interpolate my own judgements. I've interviewed each of them and I've tried to generate a short piece of text that will be faithful to what they told me.

Tamar: And then you craft that into a piece of prose that you feel relatively comfortable with, that can sit next to the photograph?

David: I think you are being generous when you say craft it: I bully it!

Tamar: When one sees these texts in relation to the images, do you feel that they are captions, or could they exist as complementary objects?

David: I see them as captions. The photograph remains, for me, the main source of the experience. At times I will write a very short caption and expand on that particular subject in an ancillary piece of text at the back of a book, if I am publishing one. Also, I have to say that the captions change over time, both with my re-experience of the photograph and depending on the context in which I am showing the photograph. It's an ongoing process, because the photographs are not static and nor is the information.

Tamar: So there is something about the viewing situation, the temporality within which the thing is viewed, that allows one to interpret it?

David: Exactly.

Tamar: You do photograph landscapes but they are always in some ways inhabited, if not directly by people then by structures, by words, by traces of lived experience. It seems to me that being human, and registering something about human experience, is central to your relationship to photography.

David: Yes, I think that is broadly true. I am not greatly interested in trying to replicate or interpret nature in itself, but I have to say, when I drive down from Johannesburg through the Karoo, there are parts where I am really so moved by the land and by what I am looking at that I am strongly tempted to photograph it as it is. But somewhere inside, I am very wary of that approach. It's probably a kind of insecurity – to be so presumptuous as to photograph a huge mountain and to put it into a minuscule photograph. Perhaps I need that evidence of human traces. It brings it down to human scale.

Tamar: There is also always the danger with landscape that one ends up in a rather romanticised vision of the world.

David: Yes, I am very sceptical of that and tend deliberately almost to 'scratch' the reality in order to reduce its romantic possibilities. But, having said that, I have always yearned to be able to be lyrical in photographs. I find the photographs of Edward Weston extremely beautiful and I envy the ways in which he was able, apparently without guilt, to photograph the land – having no thoughts about who owned it and how it came to be that way. Simply photographing what he saw because he was moved by it. So I have a kind of unrealised yearning in that direction but whether I will ever succumb to it, I don't know.

Tamar: It's both the price we pay and, in a sense, the privilege that we enjoy of having grown up in this place: the land is never just the land, and people are never just people because everything is so over-determined by history and our place in it. It's in everything we see

and do; there is the double-take, the guilt, the slightly traumatised relationship to people and places. Viewing your work, there is always that sense of unease that takes it away from the purely beautiful to this profound sense of ambivalence and loss.

David: Yes, that's true; I think it goes quite deep. Having said that, I yearn to be lyrical; privately I find a lot of lyricism in the things that I've done. To the un-South African eye, I can be photographing things that seem ugly but I don't find them ugly. Or they might be ugly but I find within them much to be lyrical about.

Tamar: What is it that thinking and working from this space in the south tells us, not only in relation to our experience here, but in terms of the wider world?

David: This is a question that has often bothered me. At first, I wanted to tell the world about this place until I realised that what I had to tell was almost unintelligible to anybody outside this place. This goes for politics, but also for a great deal else – things that people who have grown up here know, almost without knowing it, are very foreign to people outside. But I think that increasingly, probably through film and television, a greater awareness of things here and some sense of our contrariness has percolated.

Tamar: Just to invert that, South Africans are also inheritors of all sorts of things from the rest of the world; photographic, literary, cultural... One of those early moments of encounter was the phenomenon of 'The Family of Man' exhibition which came to South Africa in 1958. Do you remember anything about that?

David: Yes, that was a very important experience for me. It brought together a great deal of photography in very stimulating and provocative ways. It was only many years later that I realised that there was within it an ideological twist that was in some senses – not sinister; that's overstating it – but not all together admirable. But it was an exhibition that boldly and even dramatically put photographs into our lives where they hadn't been before: where I knew they should or could be, but it made it manifest.

Tamar: It's interesting because, from what I have managed to track in the archives, it seems that it was a profoundly important experience for local audiences and photographers. Of course the exhibition has been subject to a lot of criticism but it seems that there is another important story to be told about it. While it might represent a kind of generalised humanist fantasy, in a country in which most of the population was not allowed their humanity, humanism might not have been such a bad thing. Humanism actually comes to serve a purpose.

David: Exactly. I think you are quite right and it had that effect; it drew very big crowds. Photographically, it was a very rich experience for me because it showed quite eloquently what could be done with photographs. That it was also propaganda in many ways is another matter. It was a remarkably effective exhibition.

Tamar: Thinking historically about photography during the apartheid years, what did you feel that photography could achieve in relation to the broader political culture of that time?

David: I think photography achieved a great deal. The work of *Drum* magazine and the photographers working there, people like Jürgen Schadeberg, Peter Magubane, Ian Berry, Alf Kumalo and Bob Gosani. They did very important things: revealing what was happening in prisons, in farm labour, and gang culture in the townships. For the first time, *Drum* magazine made the world of the townships visible to

outsiders, and to the people in the townships themselves. Then there was Ernest Cole, with his seminal but in South Africa hardly known book because it was banned, *The House of Bondage*. And then the younger generation of photographers who became active in the 1980s – Omar Badsha, Paul Weinberg, Guy Tillim, Giselle Wulfsohn, Gideon Mendel, Lesley Lawson, Ben MacLennan, Santu Mofokeng, Gill de Vlieg, Chris Ledachowski and others. The work of these photographers in exposing apartheid was, in my opinion, critical. I don't think my work had any significant influence on anyone. It was mostly oblique to the situation. It might have had a percolating effect on some consciousnesses. I hope it did, but I doubt it ever moved anybody to do or not to do anything that they would have done otherwise.

Tamar: Was your work mostly mediated through publications during the 1960s and 1970s or were there also exhibitions that showed your work within South Africa?

David: To begin with I hardly showed my work – it was in boxes in our house. But as I became more proficient and more ambitious, I began to show some of the work in a local photographic magazine which was at that time owned and run by a man called Mannie Brown, who became an unacceptable person to the South African government. He eventually ended up in England and ran safaris to South Africa which were done in big 4x4 trucks and he built into the sides of these vehicles hidden compartments for arms.

Tamar: He was a smuggler for the ANC?

David: Yes, and Mannie Brown published some of my earliest work. And then there was the South African *Tatler,* which was very important to me. The South African *Tatler* was originally a kind of local clone of the old English *Tatler*, which was basically a magazine for the 'mink and manure' set; gossip and high society, the hound and the fox and things like that. But in the early '60s there were two magazines in England that were very influential; *Queen* (mainly regarded for ladies' fashion) and *Town. Town* was a cultural magazine, quite avant-garde – extremely so, in fact, with regard to design, typography, photography, writing – it was a very lively magazine. I submitted some work to them about South Africa, just on the off-chance, and got a reply that was very positive from an assistant editor, Sally Angwin. She was a South African working in England and the magazine commissioned me then to be a photographer for a written story they had commissioned on the Anglo-American corporation, which they published. That was a major stepping stone. Sally then came back to South Africa, and she was commissioned as editor of the South African *Tatler*; the owner wanted to turn it into a kind of local version of *Queen* and *Town*. Sally commissioned me to do all sorts of things, and that was the critical moment when I turned to full time photography. That was 1964.

Tamar: Growing up here, what I remember about this place was a culture where images were carefully policed and only certain images were allowed to be reproduced. It interests me to think about what it must have been like to be a photographer in such an iconophobic culture.

David: There was a great deal of censorship, but at the same time we had a great deal of freedom, strangely. Because one developed ways around the system, within it, that were illicit but expressive. I think that was quite influential on South African photography. It's hard to pin it down, but newspapers, magazines, photographers, writers, we all learnt, as it were, to wiggle and squiggle; doing what

we had to do and, in the process, I think we developed ways of being and seeing that were enabling within that. Of course, a lot couldn't be done or said and couldn't be photographed, and I think that was influential too, because it denied us experience. We were denied the experience of knowing what Nelson Mandela looked like. We were denied the experience of each other's lives; that was perhaps the most tragic effect. But in terms of our work, yes it was restricted, there's no question, and you kept looking over your shoulder to see whether you were being followed or if your phone was being tapped, or how the regime would react to this or that.

Tamar: Thinking about the relationship between the political context and making images, do you have any feelings about the ethical responsibilities of the photographer? Do you think it is an ethical project?

David: Yes, certainly. I think it derives from precisely the same ethic that guides or influences one's life in general. However, I think that there are particular ethical considerations that apply to photography that might not apply to writing or to doing carpentry or anything else, that relate specifically to the way you bring into being images of other people or their lives. There's no question that there are ethical considerations there. It's quite a complex process; one learnt not to do certain things, or to do them in ways that were revealing, I suppose ethically. I hesitate to use that word, but I suppose that's essentially what's at stake. I mean, at an elementary level, I learnt very early on not to photograph people without their permission or at least to be very circumspect about that. I can't claim to be lily-white in that regard; there would be times that I've done that but usually because I needed to make some particular point about a situation for which I was prepared to sacrifice that principle. But broadly speaking I don't photograph without permission because ethically I think we are all entitled to privacy and there's no question that the camera is an invasive instrument in some situations.

Tamar: And do you think that, in the particular demographic of South Africa, where subjectivity and identity have been so circumscribed by legal strictures and structures, there are political imperatives that are specific to this place?

David: Yes. It was particularly so during the years of apartheid as a white person coming to a black person and saying, 'I'd like to take your photograph, please'. I am asking, I am saying 'please', but there is a certain relationship between the white and the black person at that particular juncture. Particularly if that black person was economically at a humble level in life: they would not refuse you, simply because you were the boss. You had white skin and they presumed you had rights that they didn't have. So one had to be very careful about that, and one tried not to take advantage of that.

Tamar: This makes me think of the body of work, *Tradesmen*, in which you have people offering their services. What is this project about?

David: In post-apartheid South Africa, I became acutely aware that little signs were mushrooming on our sidewalks and on our trees and poles advertising all kinds of services: painting, building, tiling, carpentry. Often these were very crudely drawn, often misspelt, but there was no question of what was happening. Suddenly black people were able and willing and wanted to offer their services in the suburban life in Johannesburg in ways that were not only unknown but once forbidden because black people were not allowed to trade within white group areas. And so to me this was an indication, at a very day-to-day level, that liberation had come. It means that a man

who had a certain skill or even aspired to some skill, with a cell-phone and a paint-brush or a roller, could offer his services and enter the marketplace. It was a way of clawing his way into the economy, and I think it was enormously important. And so I started photographing some of the signs, and the obvious move then was to phone these people who offered services and ask if I could come take photographs.

Tamar: So they are offering their services and you are buying their services, but you are buying their services for a different purpose than that advertised?

David: Yes, but I didn't buy their services, I didn't pay.

Tamar: You didn't pay them?

David: No.

Tamar: So you phoned them, you took up their offer to be called, but for a different purpose. That's also very interesting in terms of how this sign functions because what it elicited in you is different to what was intended.

David: Correct. And I had to explain why I was interested in it. I said, 'I think you are very important. What you are doing is very interesting and important.' But, a couple of them refused – they didn't want me to photograph them.

Tamar: What is also interesting about these is that the name of the person becomes part of the image.

David: But that's very much in the South African context, because they would carry over the old nomenclature traditions or protocols of previous years. They didn't say, 'Please call P. Mogale', they said, 'Phone Peter'. It's a strange transmission, transmutation almost. I think this was largely a consequence of the old way of thinking of themselves, and of whites thinking about blacks.

Tamar: So they are translating themselves into their market, because the target audience is white consumers who want services. Do you see these as portraits?

David: Well, I try not to get involved in the semantics of the photograph. I see them as photographs. Whether you choose to regard them as portraits or as ethnographic types or whatever, I'm not really worried about that. But there have been at least two photographers of great importance who have photographed the trades. One was the Frenchman Eugène Atget, who photographed on the Paris streets all kinds of people – lamp sellers, messengers, launderers – and Irving Penn did a magnificent series of photographs of people – firemen, butchers, nurses, a whole host of them – and really very fine photographs. My photographs, to me, were in-between. I wanted to make the connection between Peter the painter and his advert. To me this man's photograph is unquestionably a portrait of that man; there is something about him that comes though, but then there was also a question of what the person was prepared to give me. So I am afraid I can't answer that question in an unequivocal way.

Tamar: What about August Sander?

David: I think he combined these things – portraits and types – because his great project was to photograph a German nation and he regarded these people as exemplars of certain types, but in the process he unquestionably made portraits.

Tamar: It's a very slippery thing, isn't it? There is a lot of writing about how ethnographic work diminishes the humanity of subjects by turning people into types, but there can be something about the humanity of individuals that exceeds the conventions of ethnography.

David: Absolutely. I have to say that I've become very impatient with this attempt to load you with guilt because you choose to look at the other. We're all looking at the other all the time, otherwise we'd be inside our heads all the time! If I look at you to photograph you, you are other. There's no question. And if that otherness is in some way related to your trade as lecturer and professor and writer, whatever it is, then so be it. I can't change it, that's you.

Tamar: I suppose historically, though, the issue is when the relationship to the other has been invested with power relations that position certain subjects in a subjugated way.

David: Yes, and that's certainly a factor in South African photography. So we come back to this question of the ethics. There was a very interesting development in this area with Steve Hilton-Barber's photographs of a North Sotho initiation school in the 1990s. At that time we had a magazine here called *Staffrider*. We had a competition for a photographic essay and Andries Olifant, who's a writer and critic, and Santu Mofokeng and I were asked to be the judges, and we selected a group of photographs by a photographer, Steve Hilton-Barber, who's now dead. Steve was a young man whose father owned a farm in the Northern Transvaal and he did an amazing set of photographs of this initiation school, which we selected as the winning essay. We had a little photographic gallery in the Market Theatre in Johannesburg and we displayed it there. And all hell broke loose. How could he – and we – expose these sacred rites? I mean, he had photographs of a whole group of these young boys standing in a sort of arc and all of them with their penises exposed as well as other photographs of the initiation. Of course, we had taken the precaution of ensuring he had permission to do this work. He had a letter from the principal of this school giving him permission to visit and to take photographs. He was then singled out for criticism that this was because he, being white and the son of the owner of the farm, couldn't be refused. It was very presumptuous of the person making the criticism, because you presumed that this principal, who was a school teacher, was incapable of making up his own mind and writing a letter. Anyway, the debate raged on and one of the criticisms was that women coming into that gallery, particularly the cleaning woman in the Market Theatre, would see these photographs. These were mostly older African ladies and it was one of the proscriptions of this ritual that women should not be allowed to see it. So we then put up screens with a notice board, saying if you are offended or likely to be offended by these pictures, please avoid them.

Eventually, we knew that either we had to take down the exhibition or keep it up in the face of this barrage of criticism, particularly from African men. And we had a young woman running the gallery and I phoned her in the evening and I said, 'Well, tomorrow we will have to decide.' When I phoned her in the morning she said, 'It's all been solved: the pictures have been stolen.' The whole exhibition had been swiped.

Tamar: That's extraordinary. The resolution was taken out of your hands. Let's look at the 'Ex-Offenders' series. It raises different ethical and political issues.

David: Crime has become a very important part of life in South Africa for all of us. For blacks, whites, everybody. People in the townships, people in the suburbs and on farms. We all have to take account of crime in our lives, from burglar bars on our windows to various devices

to protect our motorcars so that they can't be driven off, gear locks, insurance premiums loaded, radio burglar alarms on our houses, electrified fences, all kinds of things. There are very few people, I would venture to say, living in South Africa who have not been directly affected by crime or who wouldn't know people close to them who have been affected, from violence to petty theft and robbery. And I felt that I needed somehow to take cognisance of this in my personal photography. So I decided that I would try to photograph people who had committed crimes at the scene of crime. I thought that in doing this, firstly, I would perhaps generate within them a certain kind of consciousness, because the scene of crime must be of some importance to them. And, secondly, I hoped to make portraits of people in the sense that I've often wondered who they are. I've personally been at the receiving end of crime in three or four muggings, men with knives, and on one occasion armed robbery, and I've often wondered, who are these guys, you know? How could they come to be doing this? Are these monsters, are they ordinary citizens?

So I began to look around and made contact with an organisation that deals with the rehabilitation of offenders and restorative justice, and through them I have made contact with a number of people who have offended and who have been to prison. And so I developed an approach that I can't claim to be ideal, but it seemed to me the only practical one. You've committed forgery, I ask you to go back to the scene of the forgery so that I can do a portrait of you there. I then, with a voice recorder, ask you to tell me the story of your life. I ask you to sign a release giving me permission to publish and exhibit the photographs and your story. I pay you R800 and I undertake not to make money out of this. Any proceeds from this work above my basic costs, will be donated to an NGO dealing with the rehabilitation of offenders.

At first I tried to interview people and I found it just interfered with the flow. Now I put the recorder in somebody's hands and say, 'Just tell me the story of your life, from the beginning. Where you were born, your parents, your childhood and so on, and go right through to the time you were in prison'. These people come out of prison very often with very little and there's no question that they are putting themselves in a very vulnerable position. This interview and photograph that I make might come to be published ten years down the line and might affect them in a job or in a relationship. There are all kinds of possible consequences. And so I take cognisance of this and I don't try to persuade anybody. I explain in a very clear and unambiguous way what might be the consequences so that there's no question of deceit. I've learnt a great deal in the process about South Africa and about people and it's what I'm at present working on.

Tamar: So you are accumulating a whole series of images on this theme?

David: Yes. And I've decided to accept anybody who's committed any kind of crime. At first I was picky. I was interested in certain kinds of crime. But I've realised that it's the act of doing something illegal and what it is that tips somebody over into doing it, that is of most interest to me. Having served sentences, sometimes of years, some still maintain their innocence and it's not for me to judge. I simply take the story as they give it to me and try to tell it.

Tamar: A whole genre of prison photography has recently emerged within South Africa; all those Pollsmoor prison photographs, and the tattooed men. You've obviously made a conscious decision that that's not what you want to do; you don't want to look at incarcerated people.

David: Correct, though I would find that very interesting. I've visited two prisons and it was a very powerful experience. But first of all other people have done this – I think Subotzky has done extraordinary work – and secondly, it's not what I want to do. I want to meet ex-offenders not as cyphers in an institution but as individuals. But I want to meet them photographically in a place of special significance: the scene of crime, or possibly, that of arrest. Few of the ex-offenders that I have photographed had been back to the scene of crime before I went there with them. It was possibly a place of life-changing importance and for some this was a moment of powerful cognition.

Tamar: The experience is both captured in the photograph and exceeds the photograph in some way. There's also a sort of moment of potential rehabilitation or encounter with a conscience, as you described it.

David: I have to say I have had moments of doubt about this whole project because I am putting these people in a position where this could bite them, even though I've explained to them what it's about and what the consequences might be. I don't want it to bite them but it's possible that it could. And yet, what's emerging for me from this is that many of these are ordinary people. But for circumstance and good fortune they could be my kids, or me.

Tamar: But what also then becomes very interesting is that reintegrating the person into the life situation in which they transgress also provides the possibility of the restoration of the humanity there. So there's a potential to act differently within that situation. They're not doomed or it's not over-determined. I find the image of Errol Seboledisho very moving from that point of view; you get the kind of gleam of the commodity that surrounds this person, almost like temptation. This one is also extremely moving, there's something about the face – this is Osmond Thembu outside his shack – and right in the first sentence you describe that he accidently shot his friend. There is the juxtaposition of this incredibly tender, light-bathed face, and then this impoverished surrounding of shacks and litter. Do you think that in constructing these kinds of scenarios there is a way in which you feel you are making an argument about poverty and about criminality?

David: Yes, I don't think that *I'm* making an argument but what I think is emerging *is* an argument. And the argument is fundamentally that we have failed a whole generation of people in this country. That is a tremendously depressing and important indictment. The fact is that they find themselves in situations that are essentially hopeless. Their ability to be upwardly mobile is extremely limited and so the temptation to go into crime is very strong. For me that's what's emerging from these photographs.

Tamar: Do you feel then that the photographs help to articulate a collective responsibility? That these people have paid for their crimes but the guilt is a shared guilt?

David: Absolutely. That's certainly what for me is becoming apparent. But, as before, in the way I work, it's oblique. I'm putting it together and in my opinion it has the possibility of a certain kind of weight. But first of all one must always bear in mind that these are minute samples and it's very dangerous to generalise from them.

Tamar: A completely different order of criminal to the murderer and gang member, Blitz Maaneveld, is the politically motivated violence of Hennie Gerber. Obviously he's personally responsible but he represents a certain kind of institutionalised violence, doesn't he?

David: Yes, he was part of a culture of criminality and how police dealt with criminality because he was an ex-policeman. He was involved in an almost mutual relationship that existed in South Africa between the criminal and the opposing forces of law and order. A kind of mutuality that is frightening.

Tamar: This makes me think more about the TRC and political crime and institutionalised crime. It seems to reference a whole different body of testimony as well as to invoke those people who didn't necessarily come back to the scenes of their crimes, but had to face their victims. There's something about that in this photograph of Hennie Gerber, which is slightly different to the others. It seems to speak of the institutionalised crimes of the past. It seems to me to tell a bigger story.

David: Well, I don't know how I'm going to do it, but I want very much to bring this into this essay; people who are committing crime in this country at a much higher level. I mean, with Maaneveld it was plain murder, but then with Gerber we have corruption to an extraordinary extent and depth. I don't know how I'm going to do this.

Tamar: Your photograph showing Zimbabwean refugees sheltering in a Jo'burg church suggests crime of another order still. Can you say a little bit about the circumstances in which this photograph was made?

David: The manner in which Africa has produced refugees is the subject of history – although this is not altogether history, it's still ongoing and fraught – but the way in which we have handled it here contains within it the elements that make up some of the criminality that we are talking about. Our whole attitude in this country to the manner of treatment of people who have come in, has to me been a terrible descent from the high level of morality in which the new order was conceived. There's no question to me that we had a moment of grace in the early 90s; the transition from apartheid into the new democratic movement. That held the possibility of a society in which there were principles to adhere to relating to the ethics of social engagement that we have now lost. A lot of that is contained for me in that photograph. It relates to Zimbabwe first of all, which has become an appalling dictatorship really. And the hopelessness of people who, escaping that, come here and are treated in a way that is simply not describable.

For these images, I phoned up the minister, Paul Verryn, who had opened his church to accommodate refugees, and told him I would like to visit his church and to take photographs. So I attended a Sunday morning service and then told him I would like to return in the evening when people come here to go to bed, and he facilitated it. There's a gallery running around the church, and so I stood in the gallery and then took photographs.

Tamar: I'm thinking that these people are asleep, but there is a fine line between sleep and death and it's a very disturbing photograph from that point of view. Do you feel that looking at the sort of photographs of catastrophic human destruction of the 20th century – holocaust photographs, genocide photographs – informs your sensibility at this point? And here's the difficult question: do you think there's something about being a Jew that's relevant here?

David: Firstly, I have to say that I don't entertain even the idea that there's a kind of generalisation endemic in this: I think that's a very dangerous route to go down for a photographer. I'm always concerned with the particular, the particularity of the particular. It's the attempt to be intensely engaged with the particular that propels me, because that's essentially what the camera does, and I think it's presumptuous

and dangerous to think that you are making universal statements. But the other question you asked has always been, in some deep recess of the mind, a critical factor. To me, what happened to Indian people in the group areas of Johannesburg and other parts of the country was a replica almost, except at a gentler level, of what happened to the Jews in Germany. People were thrown out of their homes and their shops, simply because, in this case, they were of a different colour, they were Indians. They were not whites and to me that was monstrous and certainly as a Jew that related very strongly to the way I feel. I suppose in this picture too that awareness is a part of me; I can't deny it.

Tamar: In a way we've come back to where we started with *The Family of Man*. On the one hand, there is a necessary caution about a generalising humanist vocabulary of suffering and experience; the need to assert the particularity, the historicity of the local, and the camera's capacity to capture that. But at the same time, the particular is always haunted by our own sense of our humanity.

David: There is a dynamic there, yes. But essentially the photographer has to be concerned with what is directly in front of him – if, out of that, something emerges that has relevance to broader dilemmas, that's a bonus, but it's not something you can assume or even try to capture. In my opinion, that's the only way to operate.

Pieter Hugo

Tamar: What motivates you as a photographer and what kind of photography do you most admire?

Pieter: Photography for me is very much about engaging with the world. It's enabled me, growing up as a white South African in this very strange, complicated place, to make sense of who and where I am. I have been very influenced by documentary photography, like Robert Frank's *The Americans*, Joel Sternfeld's *American Prospects* and Richard Misrach's *Desert Cantos* series. When I came of age, just after 1994, photography in South Africa was still very politically based. But when I saw their work and also David Goldblatt's, especially the *In Boksburg* book, I realised photography could be political and powerful but it didn't have to have the urgency of photojournalism. I think part of being a good photojournalist is being an alchemist; you have to transform a situation. I haven't been particularly good at that and I actually work very slowly. I'm a documentary photographer. I feel comfortable with it but the term 'photojournalist' riles me.

Tamar: What does being a documentary photographer mean for you?

Pieter: I see it as Werner Herzog sees it. It's about looking for new ways of conveying truth. I'm not particularly interested in giving an itinerary of facts or recording reality but more in capturing something that's really engaged. A type of ecstatic experience where one looks at the pictures and one experiences truth, even if it's not the truth of an accountant.

Tamar: So what's the relationship between your own personal sensibility and the material that's out there in the world?

Pieter: I like to think a lot of it is visual literacy. One absorbs by osmosis. I've never been a person to sit down with a book and analyse it; to some degree I experience things viscerally. In the past I've gone out with very clear, preconceived ideas of how I want to handle a project and that's always failed. But I've always been

engaged with art. The last thing I looked at that completely blew my mind was the Lucien Freud retrospective in Paris.

Tamar: Is that to do with the quality of realism in Freud's work?

Pieter: Well, there's realism of course, but there's also the central issue Freud faced: how to make the person in the painting not a rendition of a person, but a person him or herself; how to make a painting flesh. The capacity of painting to do this either makes me feel like a failure as a photographer or it really highlights the limitations of photography. I think Freud shows you why it's important that painting continues.

Tamar: Your relationship to colour is very important; do you work only in colour?

Pieter: At the moment, yes. I'm not averse to black and white. I collect photography and most of the photos I collect are in black and white. But my working in colour came about when I switched to medium and large-format photography. That was when I saw the capacity of the medium to render a tangible likeness. And it's been a really interesting process, deciding on the colour palette. For each project I choose what that palette will be and what best suits the subject. Then I try and work back to what I remember it looking like at that time. These are decisions that are made during the process of printing.

Tamar: So memory and recollection and the atmosphere of an experience or place are distilled and come into focus at the point that you print the work?

Pieter: Yes, very much so. In a way it's very similar to 'the moment' when one takes a picture; there's this intersection of chance and predisposition, and your time and place in history. It's the same with printing; it is very much of the moment. I am interested in the point when the print becomes an object in its own right.

Tamar: Decisions around scale also happen at that stage?

Pieter: The first thing that happens with photographers when they switch from printing for magazines to printing their own work is that they get seduced by being able to make large prints. I've done that but I've learnt that each work is different; if the print is too big, it starts pushing you away. I've stopped printing work and immediately showing it. I like having it in my studio for a while and living with it, deciding whether this one looks better than that.

Tamar: Do you make a distinction between the work you do in South Africa and on the rest of the continent? Do you inhabit those different spaces equally comfortably?

Pieter: The way I work in South Africa is definitely different. When I've gone to Nigeria to photograph 'The Hyena and Other Men' or 'Nollywood', I've set myself a very clear timeframe. I've got three months where I can do this, or a month, and that's all I do. I wake up, I go to work, I shoot, I get back, sleep, shoot, whereas the South African work is much more dependent on impulse. Another thing is that in Nigeria I tried working in large-format, in the same way that I work here, and it was just impossible. Large-format camera and tripod: thirty seconds later you have a very problematic situation. So I work with a medium-format camera that is handheld. I can move around and it's just lighter.

Tamar: So for the 'Messina/Musina' project you worked with a large-format camera on a tripod, you situated yourself within this community, you stayed there for a while and you lived amongst people?

Pieter: Yes. But one of the things I found enticing with the Messina project is that the term 'community' doesn't really apply there. For a start, everyone's transient. It's a mining town, a border town. Everyone who comes through there is either a miner or works for the border police, or is a refugee. There are very few permanent residents. And there's a pretty mixed population, which is reflected in the book. In the portrait of *Pieter and Maryna Vermeulen with Timana Phosiwa*, they're Afrikaans and Timana is Tswana.

Tamar: How did this photograph come about?

Pieter: I saw a boy standing in a field shooting birds and went up to him and asked what he was doing. The area where this photograph was taken is in a part of South Africa called Blikkiesdorp, which means Can Town. It would previously have been the poor white area where railway workers lived. What's interesting is that now, in this neighbourhood, there's a white working class that's becoming much poorer because they don't have the benefits of apartheid, and there's an emerging black middle class buying properties because the land is cheap. Most of them work as customs officials or on the border. I asked the boy if I could shoot a portrait of him, and then I met Pieter and Maryna in the back garden of his house. I noticed they were very close to a boy called Timana. It turned out that they were renting a room from Timana's father, so they were lodgers in the servants' quarters of a black house, which is a complete reversal of how one pictures the situation of whites in South Africa. Timana's father had been shot during an armed robbery in Johannesburg and was in prison. They had, in a way, adopted his son and were looking after him. I saw the incredible affection they had for Timana. This seemed to me very much a picture of the new South Africa, warts and all. And there's an honesty and a tenderness in this picture if one looks beyond the dysfunctionality of the family unit, which is redeeming.

Tamar: What I see here in your relationship to this group seems to emerge out of a real closeness and proximity. There's something very intimate here. It seems a very different feeling from the relationship of you as a photographer to the subject in images like those shot at the recycling dump in Ghana.

Pieter: Well, the circumstances in which these pictures were taken are very different. The 'Permanent Error' series was taken on a burning rubbish dump in an environment that I'm not accustomed to. It's physically dangerous, and dangerous to one's health. The 'Permanent Error' series shows the necessity of labour and the experience of labour under very particular conditions. Also, as opposed to the Messina environment that is relatively familiar, in Ghana I'm the tall white guy, I'm the outsider. It's complicated.

Tamar: How did you come to be in this place?

Pieter: I had read an article in *National Geographic* and seen a photograph in *The New York Times* about this site. In both cases it was in relation to what happens when the world's technology gets recycled. The photographs I saw were made in a standard photojournalistic way, as contextual pictures. It immediately struck me that there was something incredibly interesting about this place where computer monitors and hard drives come to die. I was aware that many photographers had been to this place and photographed it, but often in a very obvious and clichéd way.

Tamar: So what distinguishes the way you approach this world?

Pieter: Well, I didn't just go for two days and photograph it with the intention of having a photo essay for the World Press Photo. I knew

this would eventually be a book and I could work on it for years if I wanted to. I worked on it for two years in the end, so I got to know the place pretty well. The dump is in the middle of Accra. These teenagers live there and strip the computers down to salvage what they can and the rest gets burnt, or they burn it to get the copper out. They've come from rural villages and work for about two dollars per day. They send the money back to their families in the north. Computers arrive in the harbour from Europe or from the US; some of them get stripped and some get salvaged – a tiny proportion for use in schools and offices in Accra. The rest gets sent to a market where certain parts are stripped out. Then these guys take the remains to a dump where they burn it, they get out what they can and sell this back to Nigerian businessmen who have weighing scales on the side of the dump, and they in turn sell stuff on to larger recycling companies.

Tamar: Did you feel obliged to pay the kids to pose?

Pieter: In this instance yes, because they were all busy working when I took the photographs, so they had to stop and stand for a few minutes. They were losing money by posing for my photographs.

Tamar: And do you pose them or do they pose themselves?

Pieter: It works quite organically. What makes it to the final edit of a sequence is a very small proportion. Sometimes if there's something that really bothers me I might ask them to change the angle a little bit. There are many variables at play: there's the energy between myself and the subject; there's their own comfort, the pose they assume, and then there's the rest of what's happening in the frame.

Tamar: So here you come, a tall white guy with a camera as you describe it, in this space. Is that a comfortable or an uncomfortable position to occupy?

Pieter: I definitely feel more comfortable doing it than I used to. I've been photographing this way for ten years now.

Tamar: And do you ever worry about it and think, what am I doing here?

Pieter: Oh, every day.

Tamar: Do you think about the ethics of it?

Pieter: No, I've never had an issue with the ethics of it. I think every photographer has taken pictures and at that moment felt they were committing some kind of transgression. If I feel that then I don't use those pictures. I don't want to produce pictures of anything I personally don't want to look at.

Tamar: So what would constitute a transgression?

Pieter: Invasion of privacy, an imbalance in the dynamic. For instance I find it incredibly difficult photographing people who are mentally handicapped. It bothers me because there's no agency there. What's important is that I'm looking but also that I'm being looked at.

Tamar: This raises the question of the ethnographic. What is it to come in from the outside, to situate people in environments that tell us stories about communities, lives, politics, relationships of power? Are we in the realm of anthropological or ethnographic photography here?

Pieter: Well, as an artist I find that question very hard to answer. The term ethnography has become so loaded. There might be merits in it, but, especially being South African, one immediately wants to avoid being categorised like that. But maybe there's a bit of throwing the

baby out with the bath water. There's something very condescending in assuming custodianship of other people's representation. Of course, that's the nature of photography: the photographer has the final say in which picture goes out, but I question whether there's no reciprocity between subject and portraitist. In a way it's a recording of a collaborative event. So you can't assume that the subject of a photograph is passive and has no agency. And the way power is played out in photographs is complicated. If one looks at the 'Permanent Error' series, 'The Hyena and Other Men' and 'The Honey Collectors', one theme that keeps coming through is the issue of power and submission and domination – whether it's to do with the geopolitics between the first and so-called third worlds, whether it's between man and animal, or man and environment.

Tamar: Let's talk about 'The Hyena and Other Men' in this context. Who are the subjects and what are they doing with those animals?

Pieter: They are a group of travelling minstrels who have pet hyenas, baboons and pythons. They're a family from Kano, which is in the north of Nigeria, and they travel from town to town playing their drums and doing street performances. They also sell fetishes and charms and medicines. They wear ceremonial dress based on Islamic African garb, but they have totally urbanised it. So there's an interesting hybridisation that's happened here between something that's very contemporary and something traditional. When I travelled with them over a period of two years they never stayed anywhere for more than a night or two. They kept on moving around. They catch the hyenas in the wild, as pups, and then they train them and subdue them with drugs and sticks. It's quite brutal. I felt very conflicted while making the series. On the one hand I became very good friends with these guys and felt very comfortable hanging out with them, and on the other hand the way they treated animals was appalling to me.

Tamar: How did you decide where to position them in the photographs?

Pieter: We just kept on travelling and whenever I found a moment to do it I photographed them. Initially I tried photographing them doing their performances when crowds would gather and they would be playing, but I found that too journalistic, too ethnographic in a way. What was more interesting to me was the dynamic between these guys and the environment and of course the animals. And so I started shooting individual portraits of them, trying to instil some sense of calm and quiet in between these moments of chaos.

Tamar: The mood is very different from the 'Honey Collector' series, even though a certain 'taming' of nature is at stake in both.

Pieter: These are wild honey collectors in northern Ghana. They harvest honey by setting fire to the area around the tree where the bees have settled and the smoke chases the bees out. But the bees get quite vicious, so they have discovered that if they wear cassava on their hands and around their necks and a black bag over their heads they can protect themselves. To get the honey they have to set fire to the ground, and soot sometimes settles inside the honey, which means they can't sell it on the international market; they have to sell it on the local market for a pittance. They are desperate to start taming bees.

Tamar: And these black plastic bags, they've presumably cut some holes in them?

Pieter: Just for their eyes. This picture was just one of those moments where it came together. The guy with his red cape and his Mickey Mouse shirt – we were walking around in the morning and there

he was. You couldn't have styled it if you tried. That picture was taken just after sunset. It was very difficult, a six-second exposure or something. They had just cut the tree down and were busy sitting on it. The whole process can sometimes be quite frustrating and tormented. If one comes from the photojournalistic 'decisive moment' school then the thrill is in the shooting. But for me a lot of the work happens afterwards.

Tamar: Also when you are shooting, you're dealing with your own physical engagement, with dangers, you are watching over your shoulder?

Pieter: The physical dangers one gets accustomed to, I think, but a big part is learning – for me at least – to let go sometimes and let things run their course. There are possibilities everywhere, all around you, all the time, it's just about relaxing and opening your eyes to them.

Tamar: But also maybe it is the sense of your own vulnerability – psychological, physical, emotional – that produces the imagery that you then go home to work with? If you were just out there feeling comfortable and confident it wouldn't be generative in the same way.

Pieter: Oh no, absolutely not. And I wouldn't be working in the first place.

Tamar: What I find interesting is listening to you talk about being in these unfamiliar situations, and hearing your own sense of ambivalence and unease. There's a mixture of bravery and timidity. That's very different to the image one gets looking at many of the pictures, which are so spectacular and confident and almost macho. But when you describe the process of living and working and moving within these environments, it feels to me like it's a little more fraught.

Pieter: It is definitely more fraught and I am conflicted about it. And I am also interested in moments of vulnerability, both my own and my subjects'.

Tamar: Let's talk about the portrait of the Xhosa men after circumcision through which you participate in a long tradition of such images. I am thinking of Zwelethu Mthethwa, for example.

Pieter: Yes, and there's a powerful picture by Bonile Bam too. My picture depicts a very tender moment between a group of young men who have gone through an intense physical and psychological ritual. There's this moment of emergence and pride that they have managed to survive. There's a period after the initiation when they wear suits as a signifier of having gone through it; the whole ritual is marked by different garb. In the first part you're painted and you wear a blanket to renounce your worldly positions; you get stripped of everything. Initiation happens and you are naked, and then afterwards you get washed and you wear a suit. The suit is part of the symbolism, you are now a man, you are no longer a boy. You don't wear short pants anymore, you wear long pants. You wear a hat on your head and hats have always been signifiers of status.

Tamar: You convey something very intimate about this shared experience. It seems like you have been allowed in to something quite private. Are you as comfortable in Umtata as you were in Messina?

Pieter: They are about the same to me. I feel comfortable in the topography of South Africa. I know it pretty well; I've travelled here extensively. You know, I love the process of just wandering around and following my nose. This is my country. I am not a stranger or a foreigner here.

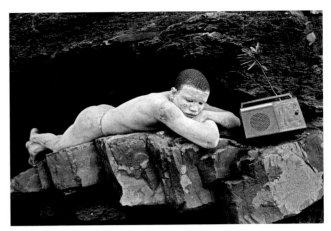

Bonile Bam, *Abakhwetha*, from the series 'Initiation of the Mind', 2000

Tamar: This takes us back to your position as a 'white man in Africa' and to your way of dealing with the strangeness and vulnerability of your position as a photographer in Africa, given the history of colonialism.

Pieter: I sit and you sit in a kind of strange precarious position. We are white South Africans, so then you have to start asking yourself what defines being an African and whose definition of this is the authentic version. If you asked me, I would say: I am an African. If you asked 90% of the people on the continent, they would say, no, you're not African. But I'm part of this colonial experiment. I have become a piece of colonial driftwood in a way. What I find interesting is when I show work at Bamako to an audience of African photographers there's a cameraderie, there's support, there are people engaged with it.

Tamar: And you feel you're an African photographer?

Pieter: Yes, to some extent. I mean I'm also not a big fan of nationalist identity because I come from a past where I have seen what it can do. I'm very cynical about it. And there's the danger of being pigeonholed or ghettoised. That I really don't want. But this is my home. I feel I belong here.

Terry Kurgan

Tamar: Can you tell me a bit about the park photography project and how it started?

Terry: This was my second project with the photographers in Joubert Park. The first was produced just after I moved to Johannesburg in 2001. 2000 was the beginning of what has been an extraordinary decade of urban renewal and regeneration in Johannesburg. Joubert Park is in the middle of the inner city. It's a rare green lung in the middle of what used to be Johannesburg's central business district. In the late 1980s, as the Group Areas Act began to informally dissolve and black people began to move into the city, white business left the city centre for the office parks and malls of the northern suburbs. Over the last decade and a half particularly, black migrants from the continent and from rural South Africa have moved into the inner city close to where they could find work, but into mothballed former office buildings that were never intended to be residential. Today, many people are living in stressed circumstances in bad buildings, often without running water and other basic services. Joubert Park remains pretty derelict too. In this context, the arts have been mobilised in

the interests of urban regeneration and many unusual projects have emerged. One of these, curated by Bie Venter, Dorothy Kreutzveld and Jo Ractliffe was called *The Joubert Park Public Art Project*. They invited fifty local and international artists to make works in relation to the economy and the culture of the park, the adjacent Johannesburg Art Gallery or the present surroundings of both.

Tamar: So how did you respond?

Terry: One of my preoccupations as an artist has been with photographs and what they mean in the world. Sometimes I make photographs as the objects of my work but often I make work that explores photographic meaning, most particularly with regard to family and domestic images. I walked around the park and discovered, to my delight, that the park was full of street photographers. At that time, in 2001, there were thirty to forty photographers in the park, each occupying their own fixed position; they sat in the same place every day. The brief had been to make a work that had some relationship with the economy and/or the culture of the park, and photography seemed to be at the very heart of the economy of the park. Also, this extraordinary image culture was being produced right next to the Johannesburg Art Gallery. This gallery was built by the Rand Lords in 1911 to assert British and European cultural superiority. Right from the beginning, when Johannesburg was nothing more than a Wild West mining town, the gallery had an awkward relationship with its surrounds. I became very interested in the disjunctive relationship between park and gallery. Here was this Eurocentric art gallery, or museum really, built at the same time as the city came into being, but 100 years later, the people who inhabit the park and the buildings adjacent to this gallery are absolutely not the public who enter the gallery. I did some research on the Johannesburg Art Gallery and its history of collecting at the same time as I explored the park as a space that has produced countless photographs that people have commissioned of themselves.

Tamar: So who were the photographers in the park and how did you come to work with them?

Terry: I discovered that the photographers in the park had an organisation called the Joubert Park Photographers Association, headed up by John Makua who, in 2004, had occupied the same spot in the park for about twenty-two years. He was the longest serving photographer in the park. Speaking to Makua and some of the organisers of the photographic association, I discovered that they had long been trying to use an empty building in the park as a studio and they just didn't have the connections, the authority, the self-confidence that it takes to push something like that through the city of Johannesburg's authorities. So, as part of my project, we approached a local bank and they funded the production of a temporary, waterproof, marquee-like studio. We managed to wire it up and even plug it into the Johannesburg Art Gallery! I took a group of photographers to a commercial image bank and they chose eight images to use as printed backdrops. The photographers had been using the Johannesburg Art Gallery as a backdrop for many of their images. Their clients would pose in front of sculptures in the gallery courtyards, and inside the gallery in relation to paintings and art works. But by the time of my first project, a locked gate had been erected between the park and the gallery and they were not allowed to do this any more.

Tamar: Studio photography is so important in Africa. Was that relevant to you?

Terry: Yes, that was my reference. This was my take on the African photo studio. Some of the images that came out of it are so lovely because you have a 'sunset at the beach' backdrop and you see the sand and then you see the grass in front of the backdrop. The photographers used the backdrops very creatively but it was also important that it enhanced and increased business for them. It ran for a long time until the studio shredded. After the studio itself fell apart the canvas backdrops used to be hung between trees and eventually the whole thing disintegrated.

Tamar: So how does this feed into the second project?

Terry: I had become very interested in the theme of migration and how migration was transforming the city. I was trying to find a way of showing those demographic shifts and I remembered that the photographers held on to photographs that were never claimed by their clients. I thought this could be very interesting. Looking back at photographs unclaimed over ten years, one would get a sense of who was coming to the city in 1990 and who was coming to it in 2000 and in 2005. Another part of the second project was to map each photographer's position in the park, because I was so struck by how inviolable those positions were. You couldn't just walk into the park, pick up your camera and begin to work there. You had to find your way there through very complex networks that in many cases began far away from Johannesburg: Zimbabwe, Ghana, Mozambique. I was interested in how life moves past the photographers in the park. There's this constant flow of pedestrians that interested me in terms of migration, just as an image. When I first began to think of a project it was something to do with capturing this movement, and the first ideas I had, which I threw out, were to do with video, and then the notion of how intense these positions, these fixed positions were, became even more interesting to me. So I interviewed each photographer and I tried to establish where they had come from, where they were living at the moment and how long they had occupied their particular positions. This brief history forms part of each portrait image I made of the forty park photographers. It's included in the image, it's not a caption. Each image includes name, date of birth, place of birth, date of relocation to Johannesburg, and the number of years each person had worked from their spot in the park.

Tamar: Are they all immigrants?

Terry: Very few of them come from Johannesburg. I was very interested in their stories. Part of the process in each of my interactions with the photographers would be to go over their informal archive of photographs that had never been claimed, and these also became very interesting to me. They agreed that I could buy them at the same price that the client would have done, had they returned.

Tamar: The mythology around the park is that it is a very dangerous place full of petty criminals, but you actually get quite a bucolic vision in your photographs. And all your sitters look fairly in control of their lives. They all have expensive cameras, they're nicely dressed, they've flowers and trees around them.

Terry: I think that's mostly white anxiety about a space full of poor black people. As for the photographs, you know, they're my images, my eye, I pressed the shutter, but I tried to get the photographers to collaborate with me in the representation of themselves. What was interesting is that they imitated each other in pose and attitude. I used a very shallow depth of field so the backgrounds are a little bit out of focus; it was a decision I made, that was very deliberate. I didn't want them to look like documents of the park, t

Terry Kurgan, *Photographer in the studio in Joubert Park with clients*, 2001

portraits and I used a close-up lens, hand-held. I wanted it to be quite relaxed. I really wanted to get very close up to each individual photographer. I wasn't that interested in showing the detail of their context as much as the sort of verdant park life. It was a lovely time of year so you often see the purple bougainvillea that I like so much dropping onto the ground. I tried to involve the photographers as much as I could. I didn't move them around. They all knew I wanted to make a formal portrait but I didn't dictate their poses. I shot the pictures over many weeks. I would have to make appointments. Sometimes people would be too busy to take a break.

Tamar: How did you explain the project to your sitters?

Terry: I tried to explain that I was making a project about the work that gets produced in Joubert Park and the work that is produced for the Johannesburg Art Gallery and the things that they have in common, and also that I was interested in the work they had produced over so many years in the park. They all came to the opening at the gallery, and I gave each photographer a copy of their own portrait. I showed their work alongside my own. Here, for example, is one of the photographs that was produced in the temporary studio of my first project. This woman is lounging on the grass but she's against a backdrop of the Lost Kingdom in Sun City that in itself was so interesting as a backdrop choice because the place is a complete fantasy, the whole place is made up. It was the longest lasting backdrop; I love images like this you know, where a mother and daughter are performing their relationship. This is a very old photograph. They're standing on the fountain. It's one of my favourite images because of the way the mother and daughter are performing their relationship, you know, it's just so tender. I have always been fascinated by domestic photographs, and how they mean very different things when you look at them ten years after you originally made them. I'm interested in how unfixed, unanchored the meanings of these images are and yet how important they are, there's so much about presence and absence. Sometimes a mother would come into the park with her baby and a plastic bag and there would be five or six different outfits and the baby would get changed and changed, and she would be producing this happy, pretty mother-child relationship and posing in a way that may or may not have anything to do with her life experience but she was producing the image and relationship that she wanted to produce.

Tamar: Staging and posing is so crucial to photographic portraiture, isn't it?

Terry: Absolutely; people pose. There's the distinct language of the pose. You'll see if you look through the photographs that there are a range of ways in which people pose, and they unconsciously imitate these sorts of conventions. I have always been interested in portraiture and performance. One of my favourite pieces of writing about portrait photography and performance is by Richard Avedon, called *Borrowed Dogs*. Avedon writes that when he was growing up the Avedons made a formal family portrait every year, and each year, in each portrait there was a borrowed dog, and a borrowed car. But the Avedons in fact never owned a dog or a car.

Tamar: The fiction of photography?

Terry: Yes, but it was very important to their notion of who they were in the world, and it was very important in terms of the kind of family story that they wanted to tell. The essay is all about truth and lies in photographic portraiture, the commissioned portrait and performance, and it has always just completely fascinated me, particularly because it's to do with family photographs, the choices that people make, the tension between fiction and reality and the kinds of stories that families tell about themselves.

Tamar: What you are describing in relation to portraiture comes from a very personal place and I know you have worked a lot with your own family photographs, but here in this particular project you are an outsider. How do you feel about that?

Terry: Well I feel myself very much to be an outsider. But there was a discipline to the project and there was a frame to the project and I feel that with all my projects there's a framing brief that determines the medium that I use, and my approach to the project. Here the frame was the park and the Johannesburg Art Gallery, the subjects are photography and the city. I felt as though I had to get past my discomfort as an outsider and make the right work in relation to a particular physical space and its social and economic circumstances.

Tamar: You go into the park as a white woman with her camera to do a kind of pictorial essay on a group of black photographers who inhabit this space. I'm interested to know how that feels.

Terry: It felt like I was cataloguing the photographers in the park, and using my camera to engage and get to know them, but at the same time I was very self-conscious of the power relations. Being white, being a white woman, I felt disempowered in this largely black male environment. But turning the camera on people, I'm never comfortable with that relationship. I felt uncomfortably more powerful than my subjects. It also felt like a mode, a documentary photographer mode that I was employing as an artist, to make a project about lost and found images, and what these images mean in the world, and also what we learn from them about people migrating to the city.

Tamar: Are the images that the photographers take just as important as the images that you take of them?

Terry: Yes, certainly, in terms of my intention with this body of work. This project is wedged in between two projects that explore the same sorts of issues, but in very different ways. In the project that I'm busy with currently, I am really an outsider. I don't pick up the camera at all and nor do I collect photographs that belong to anyone else. The project is being made with migrants from the continent and I am working around themes of migration, xenophobia, love, loss, loneliness. People are invited to document themselves. They step into the privacy of a photo booth to make their own images, or the privacy of a video booth and make their own short videos about their lives.

Tamar: Do you think that photographs have some sort of reparative role in people's lives? Can they help to piece together what is a very fractured and fragmented existence?

Terry: Yes, hugely. I look at my own family's photographs made in South Africa when they first came out here in the early 1930s from Lithuania. The images they sent back home. They are dressed very elegantly, but my father always tells me how poor they were and that as a small child he didn't own shoes. In the end it's very hard to know where the story that the photograph tells begins and ends. Photographs help people produce stories about themselves and their lives. For me it's so much about the melancholy of making that object in the first place. And then, too, the fact that it has an independent life long after.

Sabelo Mlangeni

Tamar: How did you become a photographer? Was it through the Market Photo Workshop?

Sabelo: Yes, I came through the Market Photo Workshop, but I started photography in 1997. While I was at high school, I met a woman who's a street photographer, but she couldn't take the photographs, walk around, deliver the images and collect the money, so it became my work. That was back home in Driefontein. And from then on I was hooked! After I started working with her, she taught me how to use a camera. Her name is C.S. Mavuso; she is still taking portraits and has been working for more than thirty years. Even now we still connect.

Tamar: So photography was part of the culture in which you grew up?

Sabelo: Yes. After working with her, I started to ask about photography, which was difficult because I was still in high school. When people asked me, 'What do you want to do?' I used to say, 'I want to do photography.' And they'd say, 'You can't have a career as a photographer. If you want to be a photographer, you have to go through journalism.' But moving to Johannesburg, I was like everyone else who moves from the rural areas to the cities looking for a job. Then I saw the Market Photo Workshop and I said to myself, 'I want to study photography!' That's where everything started, and in my beginners' course I was given a bursary and then in my intermediate course too, so I was able to continue.

Tamar: At this point did you already have a sense of what your subject matter could be or what photography could allow you to represent, or was it something that emerged gradually?

Sabelo: As a street photographer you think you know a camera, you understand photography in your own way. But going to a school, that's where you start to look at photography not just as a box and as papers. You start to look at photography as something very powerful. You can use it to tell a story. When I finished at the Market Photo Workshop, I started to assist the most famous fashion photographers in South Africa. I felt like at the Market Photo Workshop you were just taught about documentary photography. But I was always fascinated about how fashion photographers control light, creating your own light. So at the same time, I would go around and do my own personal projects.

Tamar: And you've stuck with black and white for your personal projects – that was something that was very much part of the aesthetic that came out of the Market Photo Workshop?

Sabelo: It was something that I started from. I have recently started to work in colour, but I find it very difficult; I prefer to work in black and white. With a black and white photograph, you can't just pass it without looking: it takes your attention. And there's more mood in a black and white photograph. Sometimes I hear people talking about my subjects as 'very heavy', and it's because I am using black and white. But I have come to an understanding that black and white adds to the stories that I tell.

Tamar: In most of your work, you make a visual essay around a theme. What is it that you think photography can capture in relation to those sub-cultures or communities you photograph?

Sabelo: Most of the people and spaces that I work with are forgotten in our fast-moving society. I look at those things that people shy away from in the world, and use that to tell my stories. For example, *Invisible Women* is about women who clean the streets of the city of Johannesburg at night. I saw them working at night and after that I started to notice that when you go to a city in the early morning, the city is still asleep and people don't care who cleans the streets at night because when you wake up the streets are clean. I thought I could use photography to give a face to these women. When I look at them I see a mother. First thing when she wakes up she has to clean the yard, not for herself but for the community.

Tamar: So who are these women, and how did you first notice them as a community?

Sabelo: These women come from different backgrounds. Some of them are from here in Johannesburg, some of them are immigrants. Some of them are from Soweto. I was working at the Market Photo Workshop at night, and then I would walk to Troyville, where I live. When I passed, I saw a group of women sitting on the street before starting work, and then I began to notice them every day. And then I started to look at them in a broader way; I started to ask people, 'Who cleans the streets?', but they didn't know. Being around them was at first difficult and the city of Johannesburg is not an easy city. But after I developed trust with them, it was very easy because they started to be interested in me, who I am and where I am coming from. In some of the photographs, there's a woman called maNkosi – she is from the next town close to mine, so I found that the women are also like my mothers. In the end we had a good trusting relationship. When they came to the exhibition, I bought them some presents to say thank you; because if they had refused to work with me, I would not have had these documents.

Tamar: So they came to the exhibition at the Market Photo Workshop – it must have been a very moving experience for you to have them there.

Sabelo: It felt great, and it was my first solo exhibition. And they were very happy with the pictures.

Tamar: So how did the actual process of taking the photographs happen?

Sabelo: It was not easy because at first the group of women didn't want to talk to me. I was lucky that one woman started saying, 'This boy was here yesterday, and even today he is here again.' And so she started to talk to me and ask me about photography and if I worked for a newspaper or something. And the other women wanted to know more about me and who I was, and sometimes I would leave my camera at home and just get to know them, help them to clean. So after that process they started to see that this person was not

coming just to take something from them and then leave. I started to develop that trust with them. And then, after two or three months, I was able to start to photograph them.

Tamar: And how long did you work with them?

Sabelo: Eight months. At first, it was every day, and then it was two or three days a week. When the photographs look like a drive-by, it is because sometimes I would give them a lift back to the depot if I got a car from a friend. That blurring in some of the images is because I was shooting from inside the car and sometimes the figures were also moving. Even when I wasn't shooting in a car, I would find something to frame my photograph. So it's not just a photo that anyone is able to photograph. The idea was to make them invisible, but have portraits of them moving, because I wanted to show them in action.

Tamar: So you get the contrast between seeing the features and the individuality of the person while sometimes they appear like blurred ghosts in the street. And you are obviously using the street lights; the lights that are available to you.

Sabelo: Yes, I use those that are available to me. And I do my own processing because I still find it fascinating. If you start to print all your photographs in a dark-room, then when you go out on the street you understand exactly what you want.

Tamar: So that was the first big sustained body of work you produced?

Sabelo: Yes, that was my first and I must say it taught me a lot! To spend eight months on the streets including through the winter… You have to walk outside and start working at half past ten at night when everyone goes to bed!

Tamar: Did you feel it was dangerous?

Sabelo: Yes, sometimes it was because sometimes I would walk quite a distance to town.

Tamar: And are they under any physical threat, women in the streets at night?

Sabelo: Yes, I mean not much direct threat, more the things that they witness in the city of Johannesburg at night; the things that happen around them. Sometimes you are with a woman working on the street and suddenly there's a car that's hitting another, or you are witnessing people robbing. It's not really an easy job.

Tamar: So you hold some of the city's secrets?

Sabelo: Definitely. Walking in Johannesburg at night you witness so many things, even when you think there's no people in the city!

Tamar: Let's contrast that with another project, 'Country Girls'.

Sabelo: Well, the 'Country Girls' started in 2003; it was the wedding of my friend Arthur to Thando, his boyfriend, in Ermelo. When I was invited there, I saw there was a group of gay guys living in different small towns in Mpumalanga, from Piet Retief to Ermelo, Standerton and Secunda and Bethal. From 2004 sometimes I would go visit them once a year, but from 2008 I started to visit them more often. Because in the time that I've spent with them, the one thing that I've noticed is their 'togetherness'. They are very close to each other; it's like a small community of gay men where, even if they have problems and issues from the community about their sexuality, they are still able to push it! Because for me, coming out as a gay man with a dress is a very political thing.

Sabelo Mlangeni, *Invisible Woman I*, from the series 'Invisible Women', 2006

Tamar: Would you say they live in tension with the broader community in these small towns or is there a certain degree of harmony?

Sabelo: It depends on the different cultural communities and the religions too… sometimes there are issues or attacks, but lots of them work in the town's hair salons, so it gives them a bit of status. Most of them work as hairdressers. After spending some time with them, I started to go around with them to the shebeens and sometimes they would have a beauty contest. Even before same-sex marriage was allowed in South Africa, there were already these guys in 2003, like Arthur, getting married. So they're always pushing the boundaries.

Tamar: It's really interesting, the way that they negotiate their positions in the broader community. It's a sub-culture, but it's also interacting in some kind of fragile but fairly peaceful truce with the broader culture. And cross-dressing is part of this sub-culture?

Sabelo: Yes. This title, 'Country Girls', it comes from there, because they don't want to be called men, they call themselves *amantombazana*, which means 'girls'. With this body of work, you have to move carefully. At first, when you approach them, you have to explain because you can't just come with a camera and click and go. At first they didn't know me, but, as I've said, from 2003 to 2009 I had enough time to get to know them: that's why when I look at the images now, they feel like very positive images. If you work from within, your body of work doesn't become about you or your story: it becomes our story. The way they are free around me with my camera makes it easy for me; I prefer to be very close to my subjects and that reflects in my work.

Tamar: What determines how you pose people? Are you looking at other photographs? Some images from this series resemble fashion photographs. Is that intentional?

Sabelo: Fashion is very important, yes: even though they are in the countryside, they dress themselves up. They love fashion, and some people look at gay life as fashionable.

Tamar: So there's a lot of performing for the camera?

Sabelo: Yes, performance is important here.

Tamar: Are these costumes ones that they would be dressed in anyway, or do you ask people to dress for the photograph?

Sabelo: No, I find them dressed like this.

Tamar: And they don't provoke hostility walking down the street dressed like this?

Sabelo: You know, as much as I would say yes, we do have those kinds of incidents, it's just a small part of the community I'm showing. In South Africa we are trying, and the communities are starting, to understand gay people. These men definitely challenge a stereotype, yes, they challenge everything around; growing up as a boy you are expected to act as a boy and then you dress as a woman. It makes some people angry. The stereotypes are shifting a little bit, and will shift even more if gay people like these are not scared to come out and say, 'This is who we are, and we like it, and this is how we present ourselves'.

Tamar: Do you see yourself as an artist, as part of a broader collective of gay black men? I'm thinking of Nicholas Holbo, Moshekwa Langa – there are a number of people in South Africa who use art as a forum for rethinking questions of sexuality. Zanele Muholi is an obvious example. Do you think of yourself as part of that community of younger artists?

Sabelo: I think of myself as a cameraman, sometimes not even as an artist.

Tamar: When I think of a cameraman, I think of somebody who works to somebody else's brief. But when I think of a photographer I am thinking of somebody who is more likely to be in control of their own vision, which strikes me as who you are.

Sabelo: I don't look at it in such a deep way: I am a person who works with a camera. I just think of how to make a good picture, one that tells mine and our shared story.

Tamar: So the camera is an extension of who you are. You walk around with your camera, and you know a good picture when you see one?

Sabelo: Exactly. Sometimes I won't have a reason to photograph a certain scene. Sometimes I just walk in the street and it's what I see. For me, I prefer to be a 'cameraman': I don't mind when someone says I'm an artist, but at the moment I find myself very young and I still have a long way to go! Most of the time my work is influenced by my background, where I'm coming from. It's a journey where I learn every day. My camera is a way of seeing the world and also being able to record my surroundings. There is something different about photography, because it's not just something you could say in words; it also challenges your thinking and your emotions. If I don't have my camera on me, there's something that I don't have, it's like I'm naked. That's why most of the time I have my camera in my pocket.

Tamar: You mentioned you've recently started to look at other people's photographs. What sort of photographs are you looking at?

Sabelo: Most of the time I like people who are working with a theme in a body of work; spending time sitting in a community. When you look at Goldblatt's *Some Afrikaners*, that's the kind of way that I'm working. And also the work of Santu Mofokeng and Andrew Tshabangu has been influential to me. At the moment I'm working on a new body of work that is quite autobiographical. I am looking at myself and how I feel about certain things. You know, when you are a documentary photographer, especially the way I work, its quite tiring. I am always working. I leave my house and stay with people for two or three weeks, and sometimes I only go to my house once a week. Sometimes it feels like it takes a lot from you. So my new project is about when you are

feeling lost and empty; when you come back home, and have to start again fresh. I want to make pictures out of those feelings.

Santu Mofokeng

Tamar: Let's start with talking about 'Chasing Shadows'. How does this series fit into your work?

Santu: When I began working on 'Chasing Shadows', I was working on a metaphorical biography about what life was like under apartheid. Basically, in the beginning it was difficult to justify this kind of work. It's almost like what Marx says about religion, like it's a false consciousness. My first project with a camera was to look at people praying in the church, on the trains, on their way to and from work. So I've been interested in religion and spirituality for some time. That was 1986. After 1994, I wanted some kind of closure about the work I was doing in the townships; basically saying 'I'm done with social documentary'. I could not continue to justify invading other people's spaces, because if you show social maladies the benefit accrues to the photographer but it doesn't change anything. That's why I'm now working on landscapes: the work is still political but I don't foreground how people live, whether they're poor or living in shacks. Looking at this consciousness that is religion, it makes me wonder about the reasons that apartheid lasted so long, but this kind of sensibility could help sustain people even during hard times. That's why I say that 'Chasing Shadows' was meant to give some kind of closure in my work.

Tamar: Can you describe what the photographs represent? What is being enacted in these scenes?

Santu: This series and the 'Child-Headed Households' series are related because both have to do with AIDS in some way. I have been photographing in the caves from 1996 and have returned there many times. I am interested in the rituals and the costume and ceremonies that take place there. But I also made a portrait there that has to do with AIDS, and one reason I did this is that it is my own brother, who is actually in the photograph. He had gone to the caves for healing. When I was doing 'Child-Headed Households', it was really difficult to make those images because I'd arrive in a place in the northern Transvaal in Limpopo where the parents are suffering from HIV, and then get told that one of the kids has been studying at Wits University for years doing mechanical engineering. I didn't know what to do with that information. It becomes very difficult to photograph the mother who is suffering from AIDS when you know her child has ambitions to move up in the world. How do you photograph her? There is this stigma attached to this kind of work. I could do it with my brother but I found it hard with other people.

Tamar: So you turned to picturing the bereaved children?

Santu: Yes, I have become interested in the families that are left behind after a parent dies of AIDS. Look at this portrait: what I find interesting about this – these three boys – is that you can see the parent has died, you can tell this by the look of the youngest child. He is angry and very confused about why the parents are not there. You can see this is the older boy, one who's trying to win bread for his two siblings. The second older boy actually does the cooking and housework. You can tell by his body language, there's some gender ambiguity about the way the boy is carrying himself. For a while I didn't understand why I felt uncomfortable with the images. I found it curious how gender roles can have an effect on posture, carriage

and looks. He is the mother figure whereas his elder brother is very macho; he is the breadwinner. If you find yourself in rural areas, roles like these where you find the boy is the one that's cooking, are looked at as taboo, in the same way that not too many people accept gays or lesbians in rural areas where patriarchy is an institution.

Tamar: So it was your brother's illness that got you thinking about AIDS and its effects, socially and culturally. Can you expand on his place in the 'Chasing Shadows' series?

Santu: What happened is, when I tried to take my brother to a clinic, a private clinic, he said to me, (because my brother was a sangoma) that western medicine did not apply to people like him, it doesn't work for 'us' and he says, 'Can you take me to Mmantsoupa?' And I am looking at him and then I say, 'Do you know this person?' Many people believe Mmantsoupa's bones were interred in this cave.

Tamar: And who was Mmantsoupa?

Santu: Mmantsoupa was basically the Basotho King Moshoeshoe's advisor; we are talking about the mid-19th, early 20th century.

Tamar: She is your ancestor?

Santu: Ancestor, yes. We are not related. What made her famous is that when Moshoeshoe was having trouble with the Boers (they were fighting over land. Lesotho, the land of the Basothos, was a sprawl that spurned the bounds of the Free State). Mmantsoupa predicted that, if Moshoeshoe went into war with the Boers, he was going to win. That's the battle of Viervoet in 1851, where the Boers were defeated by Moshoeshoe.

Tamar: So your brother wanted to go back to the site where her bones were interred because he thought that would heal him?

Santu: Yes, and then I said, 'No, no, no: before we do that, I am going to take you to a doctor who's going to bomb you with antibiotics, and basically rehydrate you, because you don't even know how far it is. It's 350km!' And I took him to the cave and at some point he couldn't walk; a friend of mine was using a wheelbarrow just to carry him to the cave. When we came out he actually thanked me for bringing him to the place. When he came out he was walking and he felt strong, but he didn't live long after that. And so, I now believe faith and belief can sometimes move mountains. My brother had the belief. It gave him strength. I only discovered after the year 2000 that, actually, Mmantsoupa's bones are buried some sixty kilometres from this particular cave.

Tamar: Is the community that worships in the caves a Christian community?

Santu: You have Christians, sangomas, traditionalists who worship ancestors: basically even the word 'Christian' is really funny because these people still believe in sacrifice, an old testament practice. In the pantheon of ancestors, Christ can be viewed as an ancestor.

Tamar: Can you talk more about your interest in capturing the spiritual and the mystical? Did this emerge for you as a counter rhetoric to social documentary?

Santu: It became a project on the side, on its own. During apartheid, when all the resistance movements were banned in this country and people had gone into exile and some were imprisoned, you ask yourself what was happening to ordinary people between 1964 and 1976. Where did people find solace, or maybe a crutch? Perhaps it was in church or in mysticism or millenarianism.

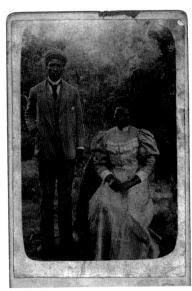

Santu Mofokeng, *Joel and Jane Maloyi, c. 1890s*, from the series 'The Black Photo Album / Look at Me: 1890 – 1950', 1990

Tamar: But during that decade, during the '60s and '70s, that is the decade when photography became one of the few vehicles for countering various myths and offering alternative views than those offered in the official versions of events. One thinks of Ernest Cole and David Goldblatt and Alf Khumalo, for example.

Santu: Yes, you can say things begin with *Drum* more or less. Before, if you had photographers, you had studio photographers. Gentlemen or ladies who plied their trade, making money covering social things like birthdays and weddings. But social documentary begins with Bailey. He introduced this method of narration into *Drum*; addressing social things about black life.

Tamar: Yes, in *Drum* you have Schadeburg and Bailey and others. And they also provided a forum for black photographers and writers to publish their work for the first time. And in that context the documentary mode made a lot of sense?

Santu: Yes, it made sense; but also it didn't make sense. It made sense because it was based on a myth. You believe that photography, because it is a positive medium, tells the truth. There was this myth that has its beginnings in the 1900s in America with people like Jacob Riis [a missionary priest of Danish extraction] and Lewis Hine [a sociologist]. Photography and writing about social issues could affect government policy then. That myth is still with us. But, yes, during the height of repression, one way you could percolate social problems was through photography.

Tamar: Particularly in this culture of censorship and, almost, iconophobia. There was a kind of fear of images during apartheid, wasn't there?

Santu: It's about controlling the images. You could say after *Drum*, the old *Drum*, ownership of media was still in white hands. It is only after 1976 when Peter Magubane went on to win the Thomas Pringle award and became famous, and Ernest Cole's book was banned here, that social documentary photography comes into fashion.

Tamar: So your formation was within that culture?

Santu: Yes, but as a journalist, I was lousy because I don't drive,

and I could never meet deadlines. Also, I had no insight into this fictional biography; making photographs about life in Soweto in the naive belief that apartheid was based on ignorance. That if I showed that black people want the same things that white people do by photographing everyday life in the township, maybe it might change things. That's naivety. I can't say I was a big political activist. My approach has always been based on poetry and philosophy, in standing back. I don't believe in one truth: I like to look at things from many sides.

Tamar: So how did you develop a photographic language that allowed you to move from that social documentary mode to a different kind of visual language? For example, in 'Chasing Shadows' the use of blurring and the very dark contrast is a sort of tonal poem.

Santu: Before I came into photography I was going to go into pharmacy. When I came into photography what I did was to learn the chemistry, to learn the optics, because in terms of technique I try to make it like a science. If I couldn't make it as a photographer, at least I could print. In 1991, I went to study at ICP in New York and I had one teacher who pushed me away from editorial work, works whereby you think that all the information is already in the frame. And I went into a hiatus. That's why you have 'The Black Photo Album'; the project came about in that period of my spiritual crisis. I started seeing photographs for what they are; as representations and not as substitutes for reality – meaning, they are already a fiction.

 I began collecting old photographs. If you went to libraries or museums you'd never find pictures of black people portrayed as a wholesome human, family or communal beings. And so sometimes you'd ask yourself if Mandela or John Dube were prodigies, if they did not belong to any community. Were never nurtured and groomed. There must have been many people around them and like them but you couldn't find that narrative; that's not what you were taught at school. I remember when I went to *The Star* to look at the archives and I said, 'Why don't you have old images of black people?' They said, 'Black people could not afford to be photographed'. I must confess, I was also ignorant at the time I started to work on the project.

Tamar: So 'The Black Photo Album' is to some extent an historical act of reclaiming a visual past?

Santu: It's an archaeology, an excavation.

Tamar: And this is when you came back from ICP? You're trying to reconfigure who you are as a photographer, trying to understand your relationship to the photography of the past, and this is the product that comes out of that hiatus?

Santu: The hiatus comes from the question of 'Where do you begin to point your camera after such "knowledge"?'

Tamar: So this is a way of managing that difficulty, because here you point your camera at different images?

Santu: We were trying to uncover who these people are and where they are coming from.

Tamar: It's an act of retrieval?

Santu: In a sense. If you go to libraries, you'll find ethnographic images of black people like you do with flora and fauna. Sometimes Duggan-Cronin made a photograph that looks like a science drawing: you have front elevation, side elevation and back elevation. Or else you'll find pictures of black people next to machinery on the mines or whatever. Either you are a worker or you are flora and fauna. I was

doing this project not to deny other stories, other narratives, but I was trying to insert this work within the body of knowledge of the past.

Tamar: But of course the 'ethnographic' encompasses a whole range of images, from crass tourist postcards to quite sophisticated portraits. Are they all just the same? Are they all in the same continuum of objectification, or do you think that there is any point in trying to see whether some of them exceed the stereotypes and actually articulate a subjectivity that is not just objectifying?

Santu: It's very difficult to place one meaning to a photograph. And it's not only the photograph, it's also the writing, the text, the context, and of course the intentions. The meaning shifts. You could look at some of Duggan-Cronin's work and have a completely different reading if you don't know about Duggan-Cronin. You are just looking at a portrait, and some of them are really beautiful. Duggan-Cronin was an ordinary guy on the mines who had a fascination with all these men who were working around him. But it's only later that he begins to do what you call anthropology. To me, photographic meaning shifts. I'm living now. I can go back and look at what happened before me but it's not fixed in time. When I look at the photographs from 'The Black Photo Album' I am curious about the people and their lives and their clothes. Sometimes I say after looking at the photograph, 'Who owned those clothes?' Because there are some photographs where everyone has a fob-watch, and you just wonder if they all could afford one. Or, are they just the photographer's props?

Tamar: But isn't that part of the history of studio portraiture? In the tradition of studio portraiture people wear their best, or there is a series of clothes in a wardrobe which they put on for studio portraits.

Santu: Yes, they do; they ham it up! But also some of these portrait photographers had clothes and painted in backgrounds. You see some wonderful gables, eaves or columns or whatever. And then there is an animal rug thrown on the floor. Maybe it's a leopard skin or something like that. There's so much you can read just looking at photographs.

Tamar: And 'The Black Photo Album' helped you to shift your focus as a photographer from being a social documentary photographer to being this kind of poet with a camera?

Santu: This was in 1992, and the project 'Chasing Shadows' begins in 1996.

Tamar: It's a very important hinge that opened up all sorts of possibilities afterwards.

Santu: Yes. Also, doing the project, you can imagine if you are going to say, 'I am going to photograph spirituality', you are talking about something you can't photograph: you are trying not to fix the thing. You have a feeling but not necessarily an image.

Tamar: And you always shoot with film, not with digital?

Santu: With film. But I'm starting to use digital as a kind of diary. Because it's very easy and sometimes if I think that colour will give more information I will photograph in colour.

Tamar: Now that's a new departure.

Santu: It's not a departure. Every time people say to me, 'Are you always photographing in black and white?' I say, 'Well I'm a photographer: it's that I choose.' It's not like I don't photograph in colour. I choose, or maybe this is what I show; black and white.

283

Tamar: But the thing about black and white is that it has its own history and conventions and a particular relationship to the documentary tradition, and the 'struggle', especially in South Africa. So it seems to me that in this work you remain in dialogue with the tradition. Using black and white keeps you in that conversation.

Santu: My work is political and always was. After '94 I couldn't justify invading other peoples spaces. People would come to me and say 'This is sensitive.' or 'This is one of me not them.' And if I go to landscape, it's still about who owns the land. It's about memory, it's about the past, it's about ownership. It's about the stories we tell about the past. After 1994 you won't find anyone who supported apartheid. Even black policemen were working against apartheid; they were fighting apartheid: That's the narrative. But the land tells its own story.

Zwelethu Mthethwa

Tamar: Can we start by talking about the relationship between your practice as a photographer and as a painter?

Zwelethu: Well for me the main distinction between photography and painting is that in painting you add things onto your support and in photography you have to edit when taking the photograph and after taking the photograph. So photography for me is all about editing and when you edit you retell stories and create new stories. So many things happen in the process of editing. The main picture that is in front of you can be changed into something else. But really, I think that painting and photography are very interchangeable and for me there hasn't been a great distinction between them. Actually, when I paint I use a lot of photographic material, so I think for me somehow they synthesise.

Tamar: Your photographs seem to me to be very painterly.

Zwelethu: I'm aware of that, but I think that's because of the nature of my education. Because I've studied painting, I see a lot of colour and texture. That's why I hardly ever take black and white photographs. My world is very, very colourful. But when I was studying at the Michealis School of Fine Art in Cape Town, I took black and white photographs. Looking back I think that was because we didn't have colour labs. It was those limitations that drove me to do black and white. So when I went to Rochester Institute of Technology I started to work with colour because they offered colour photography, and I started to enjoy the colour and find meaning in it.

Tamar: And were there particular colour photographers you were looking at whose work was informing yours at that point?

Zwelethu: No, but I have been informed by the whole history of photography, starting with all the early processes of photography: daguerreotypes, salt paper, glass negatives. And in a way, it was just looking at the chronology of photography that informed me, the thinking behind photography; what made photography popular. With the practice of painting it was only rich people that could afford to commission painters to do portraits of them, but when photography came along, everybody who could sit still – because at that time the daguerreotype exposures were long – could have their photograph taken. And then photography became very popular because of travel, people learnt to travel through photographs. People that were in America or in England and who couldn't afford to go to Egypt, for example, to see the pyramids; they could buy those photographs so they learnt to travel through those images.

Tamar: And what about the figure? Portraiture seems to me to be very important in your photography, right from the start.

Zwelethu: The figure for me always starts with portraiture because portraits signify that a person lived. It's important that it is a kind of official document. That's why in official books, passports, identity books there are photos, because it's like an official statement that says, 'this is me'. It's an assertion of a life lived. But it also has to do with storytelling. Culturally I come from a storytelling family. My mum would tell me stories every night before I went to bed. It was the equivalent of reading a book to your kids. Through my photographs, I tell stories, I tell different stories.

Tamar: That brings up the question of the relationship between photographic truth and fiction: on the one hand you've got the assertion of a life lived, which one can assert as a fact, and on the other hand you have the elaborate ruses, disguises, fictions and narratives that coalesce around the figure.

Zwelethu: I think that in a very funny way photography can manoeuvre between or amongst different realities. That's why I find it so fascinating. People often believe that the photograph is the truth but there are tricks in photography; you can create the truth. So I really enjoy the many layers and realties that photography presents to us.

Tamar: Are there particular stories that you feel you want your photographs to tell? And, if so, where do those stories come from?

Zwelethu: Of course the stories will always start with me as the narrator because it's me who actually looks and it's me who edits. I choose the stories but the stories that I tell are about contemporary culture, meaning, what I see every day. So I tell stories that are evolving in front of my eyes. Sometimes I read about them in books, sometimes I read about them in newspapers, sometimes I hear stories being told by my friends, sometimes I see these stories unfolding in front of me when I watch TV news. The story always starts with a detail but I somehow choose stories that have an international link to them, that are universal. When your stories are too limited, you tend to lose your audience because there is no point at which they can plug in, but when the stories are universal you find people from different cultures understanding the kinds of stories you are telling. Any good composition will have many layers to it. You know, it's like a song: a song will have drums, sometimes violins, guitars, sometimes there is a solo of a trumpet – all this makes up a band, which creates melody and then harmony. So for me telling stories has got to be like that. I have got to come up with different mechanisms for making the stories good ones, in order to grab people.

Tamar: What interests me is your own relationship to those stories and the subjects they picture. Do you feel that you are working from within communities or are you an outsider who visits the communities that you portray?

Zwelethu: I think if you look at yourself as an outsider it becomes just too difficult because you are very conscious of the fact that you are coming from the outside. But if you 'psych' yourself and believe in and work together with the people from the inside, it becomes easier to tell the story and people will warm to you. They drop the mask and they become very honest and that's when you can actually take your photograph, when people completely trust you. But when they don't trust you there is that facade. It might be invisible, but when you look at the photograph afterwards, you think, 'Wow, this person really

wasn't relaxed'. A portrait will deceive you if you come unarmed and unprepared. You will think it is a great photograph, but when you blow it up you will realise that there is something very odd about the sitter, and it's because you are not on the same wavelength and you are not connecting with the sitter.

Tamar: What happens when you photograph outside of South Africa? Can you still establish that kind of trust?

Zwelethu: Two weeks ago I was in Mozambique, where there is a huge landfill that municipal trucks use to dump their garbage. I have always been fascinated by garbage, what we throw out and the fact that most of the stuff that we throw out is actually reusable. Now I don't speak Portuguese and most of the people there speak Portuguese (although some of them speak the Shangaan language, which is similar to Zulu, my mother tongue), so language is the first step in my negotiation. To prepare the ground I asked a journalist friend, Frederico Jamisse, to accompany me there. Now this worked in two ways: one, he speaks Portuguese, but, two, people know him because he is always on the news and so it became very easy to talk to people in that dumping ground. The barriers I encountered as a visitor fell down because they knew him and they trusted him. So we went there and I told them exactly what I wanted to do and I started taking photographs, initially of just the dumping ground without people, or with people in the far distance. But there was a group of youths between the ages of eighteen and twenty-five who decided to come with us and I told my guide, who was my friend, to let them come and that if we got good access I would pay them up front – just for them to be around us. It is illegal to take photographs in this dumping ground and there are always cops around because the municipality in Mozambique cannot grant access to people to salvage the dump because of health hazards, but they know that people recycle stuff and they get money out of the stuff that they recycle. So it's a catch-22 for the municipality, it is a political thing so they don't allow photographers to go in there. And so these teenagers worked as my guides; they would tell me, 'Don't go over there because the police are over there'.

Tamar: And did you actually photograph these kids in situ?

Zwelethu: I chose to photograph younger kids. I will tell you why: there are families there, but younger kids, for me, represent the future. These kids, they collect metals and plastics, they sell them and then that money doesn't go only to them, it goes to their families. That's what fascinated me, so I chose to photograph kids more than grown-ups. I didn't photograph grown-ups. The contemporary role of these kids has evolved into a dual role in the sense that they are still kids, but they also work and look after their families, which is a role usually reserved for adults. They also play a meaningful role in recycling, which is also a big political issue.

Tamar: I'm very interested in the question of what it is to be a stranger and what it is to be at home in the place that you photograph. Your own position, politically, in relation to that is interesting in comparison to Pieter Hugo, who photographed in a recycling dump in Ghana. It's true that you are not a white man in Africa but you are also not a Mozambiquean. There are differences of class, there are differences of access to resources and wealth, and so you are a stranger in other ways.

Zwelethu: In Mozambique I have done many series because – and you will be surprised – most people in Mozambique knew me because I appear on TV there and one of my best friends, Moreira Chonguiça is

Zwelethu Mthethwa, *Untitled (Gladiator 5)*, from the series 'Contemporary Gladiators', 2008

a musician there; that's how I get access to Mozambique. I work with an intermediary. It was the same when I photographed the Shembe. Although I'm not a member of the church, I have a very close friend, Hlengiwe Dube, who took me there. So I try to go in through a person who understands the system and knows the community. I try to break down those boundaries of being a stranger. That's how I work. That's why it's been very difficult for me to photograph overseas. If you look at the work that I did in Common Ground in New Orleans, I had to find a conduit to link New Orleans with my reality in Cape Town. In New Orleans I knew that I was very lucky in the sense that I was there three times before Katrina, then I was there twice after Katrina, so I somehow knew the neighbourhood. I still had to find ways to make things make sense to me, because I am, I will always be, the first audience of my work. I've got to educate, entertain and critique myself first. If stuff doesn't make sense to me then I put it aside. That's why I took photographs in Cape Town and photographs in New Orleans and fused them together, because I am very much aware of the inside-outside.

Tamar: Let's talk about the Shembe series.

Zwelethu: I don't like to over-direct people when they are looking at these. When people see these photographs they say, 'Wow, what is happening here?' It is a fusion of many identities, it's like real fiction. They see the bowtie, they see the pith helmets, they see the kilts, they see the shirts, blouses, soccer socks and then they formulate their own stories. It's great when people come with their baggage; I love that.

Tamar: What you seem to be proposing is a kind of counter-ethnography. You don't go there as an expert on Shembe culture or as someone looking to find out the truth about Shembe culture. Your photographs seem to me do something different.

Zwelethu: I was not interested in the ritual. What fascinates me is how and why people clothe themselves in these different ways. That's why the setting is a forest, the landscape, because I love the KwaZulu-Natal landscape, I love the greens, I love the hills. For me, by separating them from the ritual and anchoring them in that landscape, I am telling you a story. I am not interested in the church per se – that's why I found the women boring because they are wearing their traditional gear and I am accustomed to traditional hair, traditional skirts. For me the young men were just amazing because of the clash of identities. You know,

where does the bow-tie come from, why are they wearing the bowtie during the day? Because in the western tradition it's considered formal evening attire. Why do their shirts look like women's blouses with frills? Where do the pith helmets fit in – do they still signify a soldier's uniform? It's fascinating.

Tamar: So how did it come about that you started photographing them?

Zwelethu: Actually, I started by photographing them in the city centre in Durban and then I photographed them in a township in Umlazi and then I photographed them in the small village just outside Umzinto. So I had the city, I had urban, and then rural. At that time I was looking at the ritual, because that was my entry point, but the more I spent time with them the more I got excited and saw new possibilities. When I saw these ceremonies where they wear these very fascinating kilts, that's when I said, 'Wow, this is the way I want to present them,' because I have documented the church but I am more fascinated by this other identity, I'm not interested in recording the rituals. I'm interested in the chemistry between two individuals, that's what it is for me. You know, I'm aware that some ethnographers have amazing photographs but I'm interested in the complexity of a situation and the aesthetics of a photograph. Some people will criticise me and say I am beautifying the subject. I understand that, but what's wrong with taking aesthetically pleasing photographs?

Tamar: It's a decontextualisation.

Zwelethu: Exactly. They're portraits. It's portraiture because you are not aware of the ritual. When you look at the photographs, it's just like portraiture.

Tamar: But also there is a scrambling of codes: sartorial codes, fashion statements and traditional associations.

Zwelethu: I think that it's largely about how we recreate identities, you know, because I think that culture is always evolving and this is about playing different roles. When you are at work you perform, you are a different person to who you are when you are at home. When you are with your friends, again there is a different persona. It's fascinating to see these kids wearing elements from different worlds, you know, from different realities. But it's also about communities. In my eyes, my scheme of things, we are one, we are communities, we function as cogs in a wheel. I don't see a kid as an individual, you know; a kid is always defined by the parents or by what the parents do because I come from a collective culture. That informs my images. It's always about groups and collective identities.

Tamar: And was it difficult to gain the trust of this community?

Zwelethu: The first time it's always a bit difficult, but I have been going back and forth, back and forth, so I understand the codes within the community and when I take photographs I always ask people, 'Is this OK?' and then I go back with a bunch of photographs for them. Then people understand that I am not doing something that is against them. If you don't give people a reason to trust you, they will always be suspicious, but I understand the codes and it's been really great working with them.

Tamar: Are there any particular shots in the series that you would like to talk about?

Zwelethu: There is one I particularly like, with the kids in the tree. It's something about the leaves and the way the leaves obscure the view of the kids. I enjoy the playfulness of that. It reminds me of Seydou

Keita, who photographed the backs of people instead of the fronts. When I work I'm just in that crazy mode, it's like I don't really think in a linear way, and when I got back and looked at the photographs of that particular tree and the leaves hiding one of the kids, I was really fascinated with that play. It's like you're revealing, you're hiding, you're revealing, you're hiding.

Tamar: I am interested that you bring up Seydou Keita and the whole tradition of portraiture within Africa, because that's very powerful. Do you feel that you create your own outdoor studio here, a kind of controlled environment?

Zwelethu: Yes, it is controlled. I think once you point your camera at people, you are controlling, you are the producer, you are the creator and you are the editor as well. And then there's that give and take that happens between you and the sitter, you know, there's that chemistry that happens. You have a certain power over the people that you are photographing. They are in front of you and you have to direct them.

Tamar: What about the scale? Why are they so big?

Zwelethu: These have to be big because there's landscape in them. And with most of the portraits I prefer it if people look at the camera because then they are returning the gaze. That for me comes from the fact that in South Africa the gaze is a political thing. In South Africa, where black people were seen as non-citizens, they were not allowed to return the gaze, but for me when they stare back it's like they are saying, 'I am here, I have the power to look at you. You are looking at me, but I am also looking at you.' For me, that's the whole psychology of the interaction and if the photographs are small the subjects will be seen as objects because of the scale, but when they are big they match your size and they have presence. So it's very important to show those photographs big. It's crucial for the encounter. The other thing is that we are taught to believe that when something is small, that is when it is intimate because you can hold it close to you, but I find large-scale photography very intimate because you can enter the photograph, so you can see the details, you can become part of the image.

Tamar: The argument is that large colour photographs are associated with spectacle and the relationship between intimacy and spectacle is interesting.

Zwelethu: I think it's like when a guy looks at a girl, sometimes a girl will say, 'I don't like the way he looks at me because it's sexual.' My point is that just looking can be very intimate because there is a way that we look, there's a way that we find the detail and that is intimate, because the girl in the picture is not small, she's your size.

Tamar: But there is also power involved in that, surely?

Zwelethu: The power is in returning the gaze. Even when I photograph kids in that garbage dump they are still very strong individuals. And in the pictures of interiors, you can see all the little odds and ends and they become very intimate. I don't think that all photographs work well in large scale, it depends what the intentions are, you know, it's not just making a grandiose statement. It depends what the intentions of the author are.

Zanele Muholi

Tamar: Can we start by talking about 'Faces and Phases', and how it fits into your work in general?

Zanele: 'Faces and Phases' is a group of black and white portraits that I have been working on from 2006 until now – it has become a lifetime project. At the same time, I have also been making a series showing couples in different positions; embracing intimately. That's how I look at life, that's how I see my world: that's where I'm at. The project is about me, the community that I'm part of. I was born in the township: I grew up in that space. Most of us grew up in a household where heterosexuality was the norm. When you grow up, you think that the only thing that you have to become as a maturing girl or woman is to be with a man; you have to have children, and also you need to have *lobola* or 'bride price' paid for you. For young men, the expectation for them is to be with women and have wives and procreate: that's the kind of space which most of us come from. We are seen as something else by society – we are seen as deviants. For young women who are in same-sex relationships, they find themselves in harsh spaces where you are put in a position where you are being fixed: you have to be made to become a straight woman and work according to the heteronormative culture that is there. If you refuse, and say, 'I am not what you think I am', you are more likely to experience 'curative' rape, where a woman is raped in order for her to be changed and put in her place. That is one of the harsh realities of our lives. Then for young boys, sometimes you find that young men are raped by other men who want to prove a point to them: 'That's not what men are supposed to be'. South Africa has the best constitution in the world – that is supposed to guarantee us our protection, but in reality a lot of people have suffered because of who they are.

I see myself as a visual activist. We're not going to be here forever, and I want to make sure that we leave a history that is tangible to people who come after us. We are part and parcel of bigger structures: we are voters in this country, we are citizens in this country and we pay taxes just like anyone else. So if we are refused our rights to express ourselves, it means that we do not have full citizenship in our country. My approach to my work is to try and capture that reality without looking too much to the negative, without entertaining that violence, without letting the perpetrator know that we are losers. Because we can't lose this battle: this is ongoing. Until these atrocities come to an end, I won't stop.

Tamar: What role do you think photography plays in this visual activism?

Zanele: Visual material really helps people have an understanding that something exists. You can feel it, you can touch it: it's there. It's an opportunity to take that image and to freeze those moments, and for people to process it later on. So if we just write about the existence and the resistance and the struggles of lesbians, gays, bisexuals and transgender groups in South Africa, it won't make sense without presenting and projecting those lives as images.

Tamar: So they are testimonials to an existence of a culture and people; they are witnesses, in a way?

Zanele: Yes, we as photographers witness something and then we become presenters and projectors to others. People have misconceptions about queers' lives: they don't understand that we live the same lives as any other person. The way you conduct yourself, the way you live your life, your politics, these tend to be misunderstood by those who refuse to understand, regardless of the laws that are in place. It's a struggle around the globe, but it is something else within the African continent. We know the harsh realities of our friends and lovers in places like Uganda, Malawi, Botswana, Zimbabwe; people have to deal with double stigmas. In South Africa, they have to fight against queer attacks but on top of that they also have to fight xenophobic attacks that they encounter in the very same spaces where they come to seek refuge.

Tamar: Can you talk some more about your reponse as an artist and an activist to the rise of violent homophobia in Africa in general? Of course this is not only Africa's problem, and questions about asylum are very alive in Europe. I'm interested in how you negotiate that.

Zanele: In talking about negotiating a space, it depends on where you are, who you are, and what level of education you have, because there are class issues as well as racial issues in place. How many people who are from Africa, who are black, who do not have professions, who don't have access to funds or resources, can even *get* to those European spaces? When we talk about seeking refuge or citizenship or being in the diaspora as an African person, we need to talk about how you get there, who allows you access, and, if you get there, whether you can conduct your life like you did before. What I've seen with most people that I know who are abroad is that you kind of lose your sense of being an activist because you are in a comfortable space and there is nothing to fight for. And then there are those who are in dire straits who really can't even access a thing, unlike if they were professionals in Africa. When you get abroad you end up doing a minor job – not a decent job like one that you had at home. But 'at home' you couldn't express yourself freely, so you were like a person in exile again.

Tamar: Can you talk more about the role of photography in your work as an activist?

Zanele: For me, photography is not a luxury. I am not doing photography because I think it's beautiful or so on. I want to make a statement and I know there are many people who don't understand, but tough. For me it's really not a luxury.

Tamar: Was it always like that for you?

Zanele: No, I started photography very late. I had my first solo show in 2004. I looked at a number of shows that were done by a number of different people, some who were tackling similar subject matter to me. I think I needed to ensure that we are visibly part and parcel of this history, because if we don't do it for ourselves we can't complain and expect other people to do it for us. We cannot complain and say that we are being 'othered' and that people do not present us in the manner that we want to be presented. Somebody had to do something. We can't shy away, because this is our *lives*. This is not a choice. It's risky; there's so much to lose.

I look at my projects and use the constitution as my reference document. Right now I am interested in how it would be perceived if I as Zanele Muholi, as a black lesbian woman – those three identities – were to have four or five wives and be the main person. For me it's a kind of performance, something theatrical, but yet it's real because it's based on a true story.

Tamar: It's interesting because you use very varied visual languages. On the one hand, you use the black and white conventions of a certain kind of documentary tradition in work that is designed to make people and communities visible. Then, on the other hand, you use the, rich, dense colour vocabulary of a certain kind of fashion photography to stage different (often marginalised) subjectivities. Now in the work you're doing with the wives or the lesbian beauty queens, photography becomes this arena for you yourself to perform a number of identities. How do you move between those different modes of working?

Zanele: I don't like to deal with conventions; I don't want to be fixated

around one thing. I just wake up and I think this is what should be done and this is how I want to approach it. And looking at fashion, you know, fashion is queer, sport is queer, everything is queer, everything around us is queer! The food that we eat, how we think and so on. I just try to disorganise and disrupt what is out there.

Tamar: So is it a conscious decision for you when you decide which means to use in order to communicate one or another set of ideas, or do you work quite intuitively?

Zanele: I spend a lot of sleepless nights thinking about how to project it and how to achieve it. A lot of my work is not done in any studio format: I'll work under a bridge in District Six, I'll work in Johannesburg. I like the rough backgrounds because that fully represents the background where I come from. And then in front of this background I have this beautiful face. I look at this young, cute lesbian person or gay person, and I think that person is me. Because when I was young, nobody was interested in photographing Zanele. But you don't want to look at queerness as a trend. You just want to project real lives and also to present how people look at themselves differently. So, with the young lesbian couples, really each and every image is about the people in the photographs, but also it's about me; an interplay between fantasy and the real.

Tamar: So even in these that look like fairly straight documentary photographs, there is an aspect of play and fantasy that's at stake there?

Zanele: Just like in any straight community where you look at different people, different faces, those pictures are more than just faces. For me, they are about me, as Zanele celebrating my community, celebrating any individual who is surviving, or who has once lived and identified as black and lesbian in South Africa or within that space in the township. We commemorate those who are no more, and also acknowledge the fact that there are so many challenges that each person is facing.

Tamar: In that sense the portrait becomes a sort of tribute to their survival, to their existence. It's a kind of homage to that person. Let's talk about some specific examples. Tell me a bit about Nosizwe.

Zanele: Nosizwe was in my class when I taught basic photographic skills in Cape Town. I met her in 2008. Nosizwe has since passed; she died in October 2009 when she had an asthma attack. She was a lesbian mother and she left behind a five-year-old. She is not the only person that has since passed from the pictures that I have taken in the past few years.

She was one of the first people that I started photographing at the time when I realised the need for black and white portraits of lesbians, not with their partners but as individuals, because their backgrounds were different. So, as these youngsters die, you get affected if you care about the people that you have photographed. You can't just say 'These are subjects; life goes on, I'll get other ones.' You get involved with the people when a tragedy like that happens in their families. You get involved with their family and it means that you have to bring back that picture, because as black people we have our own notions of what a photograph is. We don't only look at photographs, but that's somebody's soul: taking somebody's photo means a whole lot.

When Nosizwe passed, this particular photograph really helped the family to have something that made people remember this young person as a living person, as a beautiful person. So I had to give the family that photo and get permission from her mother to have it

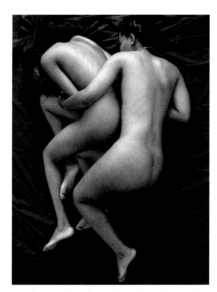

Zanele Muholi, *Being I*, from the series 'Being', 2007

included in *Faces and Phases*. You are not only a lesbian alone, a gay person alone, or transgender or intersex person alone: we come out with our families because *they* are the ones who have to explain to those who do not understand what's going on, and also educate others. The families get opportunities to see the pictures and get an understanding that it's not only their daughter that is like this, but there are many people like her. That tangible document serves as a memory for many. Which is why for me this is beyond taking photographs for the fun of it: it's expensive and you have to take risks. And when you shoot queer people you are putting them at risk as well. You are making them visible.

Tamar: Yes, there's the sense of danger and vulnerability involved. What is it to say that the soul is somehow embodied in the image, and how does that effect – do you think – what is appropriate and what isn't appropriate to photograph?

Zanele: I grew up in a space where people associated witchcraft with photography, taking an image of a person but also capturing the soul of a person. Which is such a powerful thing, because people do not always understand the mechanical exchange that exists as the process is taking place.

Tamar: So is there a taboo about photographing them in case you steal something from them, deplete them?

Zanele: It's a complex thing because, if you talk about 'stealing' and 'stolen glances', it depends on how and by whom it is done. I find it difficult to capture other people within different communities, but you find that some white people have easy access to black communities – I don't know why. For me, with most of the people I photograph, I know them very well. It might be easy for a white person to capture a black person, but for me I find it difficult to just go into a community where I don't know who the people are and just invade their space and take their images and produce a book. I have seen there is this trend over a period of time, how the othering and politics of representation has been going on for decades, for ages. So maybe the capturing of the soul doesn't apply if it were a white person shooting a black person, but then I find it's those spaces that I still can't access as a black person trying to take pictures of other black people.

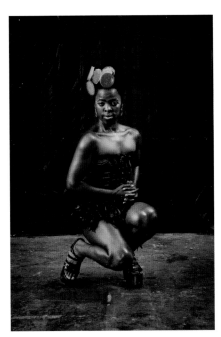

Zanele Muholi, *Miss Lesbian V. Amsterdam*

My principle over the past few years has been to capture those who I know; people who I know by names and surnames. If you look at the history of African photography or African anthropology you hardly have the names and surnames of the people. It's very important to know the people that I photograph. In the work that I do, I go and travel to different spaces, and I just freeze when I come across a community that I don't know. So it means I'm delayed for a week or two weeks just trying to understand who these people are before I take photographs of them, because then it makes life easier.

Tamar: When people take up poses, to what extent do you direct them and to what extent do you allow people to occupy body positions that feel natural to them?

Zanele: The basic rule – if you see my pictures – is just be yourself: you don't have to try hard. In the work that's been produced in which I'm the participant in the project and where I take the director's role, everything is set up and it takes a *whole* lot of time. But in those other spaces I take minimal time: one, two, grab that moment and that's that. I am very careless. I always say to people it's like having sex without a condom. I have tried shooting with a tripod, but it's just time consuming. I know it's very important but honestly, by the time you set up a tripod the person is off already!

Tamar: And you almost invariably in these images have very plain backgrounds. You don't want too much information there; you want the focus on the person.

Zanele: I want whoever is looking at these images to say to himself or herself, 'This could be anywhere'. One thing I do deliberately is undo the sense of place and naming – it could be Durban, it could be Johannesburg – because as soon as we start looking at spaces we start making judgements. You look at a person and say, 'That looks like a Zulu person': space takes on a lot of categories that sometimes can become dangerous. And also, the minute the people are known to be in this or that particular place, you never know what might happen to them. So I just diffuse the background altogether. Under the bridge in District Six is my favourite place. This is where my studio is, *here*, and

I don't need any luxuries or any artificiality to capture these images. The light most of the time is always great; no tripod, nothing. No special lighting because I don't *have* it. I'm capturing these individuals as they are, now, and as they go through phases in their life.

Jo Ractliffe

Tamar: Can you tell me a little about your development as a photographer?

Jo: I came to photography somewhat by accident – although looking back, I did my high school art project on photography, which should have told me something. At art school I initially majored in painting – I was terrible at it. Then in 1982 I bought my first camera, a second-hand Nikkormat. Seeing those first images, just the fact of them, was enthralling. It was as if someone had turned a light on. I felt I had found a language with which to comprehend the world.

My first images were taken around Cape Town and on road trips up the West Coast. Much of my childhood was spent in semi-rural and industrial spaces; my father managed a brickworks just outside Cape Town and I would go to work with him every Saturday. The factory was half an hour's drive out of Cape Town, up the West Coast; a journey that took you past the docks and the refinery, into a landscape of factories, quarries and smallholdings. There was something in those spaces that I felt strongly connected to; something about labour and loss and an intractable landscape. So when I started photographing, I went back to places that resonated with those childhood experiences: abandoned factories, junkyards and industrial wastelands – and the brickworks, which had by then become the site of Cape Town's large waste dump, Vissershok.

Tamar: In South Africa at the time there was of course a strong documentary tradition, but also people seem to have been looking a lot to American and European photography. At what point did these worlds collide or come together?

Jo: There's a tendency to talk about 'the tradition' of documentary photography in South Africa as if it was a coherent practice that progressed in tandem with events that shaped the country during the course of apartheid. And also, as if it grew out of western documentary traditions – or at least defined itself in relation. I can't speak to the history of documentary in South Africa, but at the time we're talking about – the early 1980s – I would say it was emergent rather than established. Sure, there were precedents, people who might, in retrospect, be considered pioneers of documentary; and there was also the era of *Drum* magazine, which produced a distinctive group of new photographers. But generally, I think the photographic field was much more dispersed and fragmentary than we imagine. What distinguishes the photography of the late 1970s and 1980s is that it was inextricably bound up in the surge of political activity and mass mobilisation that was triggered by the 1976 Soweto uprising. It was embedded in activism. But many photographers working at that time had come to photography relatively recently and primarily through their involvement in the struggle as activists. Also, they came from very different cultural, educational and professional backgrounds and with quite significantly different aims and objectives. So while there was a very strong sense of common purpose, the photography of that period was not a homogenous or cohesive practice either. We forget that; we think of it as this singular, almost monolithic entity. But it wasn't; it was new and exploratory, shaping itself in the making, as it were.

I don't mean to imply that photographers worked naively, without awareness of photography's histories, but I would argue against the idea that it was self-conscious or emulated other traditions. Approaches varied according to individual interests and what people had access to. If I think back to my early influences – Walker Evans, Manuel Alvarez Bravo, Josef Koudelka and Robert Frank in particular – they were photographers whose work I saw in books. I knew little then about South African photography, apart from my interactions with local photographers. Only later did I get a real sense of our photographic history.

Tamar: Were you aware of social documentary and the political photography associated with *Staffrider* and Afrapix in the '80s?

Jo: Yes, absolutely – there was a strong sense of community as artists, photographers and a whole range of cultural practitioners responded collectively to the imperatives of the time. And, while I shared similar concerns and was part of a visual arts group that did work for various organisations, when it came to my own work I didn't fit the mode of social documentary or its direct political address. I wasn't comfortable with advocacy. I was interested in a different language, one that was less didactic, more analytical perhaps. Certainly I questioned the limits of the frame and tried to explore ways of working that drew attention to what I saw then as the limitations of documentary; I didn't want my photographs to be constrained by the particulars of time and place – 'Crossroads squatter camp on the 30th May, 1986', for example. I wanted to move beyond the specifics of a particular subject or event towards something more metaphorical or emblematic – to evoke a larger narrative about the state of things; a world seemingly gone mad.

At least that was how I thought about it then. I've been having this debate with David Goldblatt for over 25 years now – whether photographs can, in fact, transcend the particularities of their moment. I still want the emblematic, but I think a little differently about it now.

Tamar: It must have been quite difficult in the '80s to assert that your work was not simply about this place but about a larger vision of a world gone mad, given the fact that photography in South Africa at the time was so wedded to the particular and to the project of photography as a socially transformative tool.

Jo: Yes, it was; I felt somewhat on the outside of things and a great part of me wanted to belong, wanted my work to be seen as 'relevant', or at least, committed. But I was also struggling with an inner conflict about my own place in things: my heritage and what it meant, and what position I could take in relation to it.

My other struggle was with the photographic medium itself; my creative interests seemed to go against the grain of photographic possibility and my attempts to realise them led to much frustration and intense exploration – the photomontages of *Nadir*, the plastic camera fragmentary 'stills' of *reShooting Diana* and later, the filmstrip-like sequences of *Vlakplaas: 2 June 1999 (drive-by shooting)*, for example. All these works, I would argue, responded directly to the social and political landscape of South Africa – and they were very much anchored in the real. But they were equally an attempt to interrogate the constructs of photographic representation; to destabilise the status of veracity attributed to the photographic image and open up a space for other imaginings. They seem to have found a place over time, but they didn't resonate with the kinds of work that was being done then.

Tamar: Is that perhaps because there wasn't a language to understand

conceptual photography here at that point? The documentary mode was just so pervasive?

Jo: I don't think of my work as particularly conceptual, or rather I wouldn't define conceptual as something necessarily in opposition to documentary. I was simply trying to find a way to speak. And despite my sometimes quirky approach, I would argue my work has always been rooted in documentary and shares similar concerns. But I suppose during a time when the prerequisites of photography were so clear-cut and unambiguous – to expose the workings of the apartheid state and to mobilise political change – there wasn't much space for that kind of analytical reflection on the medium itself.

Tamar: Do you think, then, that the end of apartheid allowed for the opening up of possibilities for new pictorial languages? Do you think this has allowed you as a photographer to emerge and to gain visibility?

Jo: Yes, very much so; it ushered in new ways of thinking about ourselves, our past and how it had been narrated – and with a kind of self-reflexivity, which previously had not seemed possible. Also in the 1990s we became part of an international art world and this expanded the field – and it coincided with the global rise of photography and video in contemporary art. I think that had quite a profound effect on photography here; I remember in the mid-1990s there was much debate about the 'crisis in photography', an anxiety that, with the advent of democracy, photographers had 'lost' their subject. But I think it was more intricate than that and, on reflection, as much as it was a euphoric time, it was also a difficult and painful one. I felt quite liberated at first, like I could begin to assert my place as a photographer as opposed to some eccentric 'in-between'. But by the end of the 1990s I began to have my own crisis with photography; I felt I had lost something of 'seeing' and needed to go back to a more direct way of working – careful looking, clarity, focus and the acknowledgement of a 'subject' in its own right.

Tamar: So let's talk a little about these issues in relation to 'Terreno Ocupado'.

Jo: Briefly, 'Terreno Ocupado' explored the urban landscape of Luanda in the aftermath of civil war. It lasted nearly thirty years and was one of the most protracted and convoluted ever fought in Africa. It was also a war that was fuelled by external interferences, secret partnerships and undeclared political and economic agendas, and which ultimately converged into a proxy Cold War. To add another layer, Angola was also the stage of Namibia's war for liberation against South Africa – what we, as white South Africans, knew as the 'Border War'.

I had first read about Angola in *Another Day of Life*, Ryszard Kapuściński's book about events leading up to independence. Until then, in my imagination, Angola was simply 'The Border'; that unnamed place where brothers and boyfriends were sent as part of their military service. I was very struck by how that book resonated with what was happening here in South Africa and it also gave me a sense of how I could work metaphorically in photography. There's a wonderful passage about the dogs in Luanda, abandoned when the Portuguese left, which inspired the dogs of the *Nadir* series.

All this was very much in my mind when I first went to Luanda in March 2007. It was five years since the war had ended, and also the year of Kapuściński's death. My first impulse was to embark on a search for Kapuściński's 'lost dogs', and I made a list of places from his book, starting with Room 47 in the Tivoli Hotel, which was where he had stayed in 1975 (it's still there). I was not looking to produce a

commentary on the 'state of things' in Luanda now. I went in search of something else: traces of that imaginary Angola. So working on 'Terreno Ocupado' took me right back to a landscape (real and imaginary) that had occupied me twenty odd years ago.

Tamar: How did you feel being there? Were you uncomfortable as an observer or did you find a kind of freedom or mobility that one never had in South Africa as a white person?

Jo: I was concerned about a number of things; I hadn't been to Angola – in fact I had photographed very little outside South Africa – and given South Africa's history there, I was a little anxious about how I was going to engage in that context. Luanda is also not an easy place when it comes to photographing and doing so involves intricate processes of negotiation. But generally, and in spite of this, I was received with openness and warmth. I was probably the only white person in Roque Santeiro, but ironically I wasn't seen as such. It was quite curious, unexpected: people assumed I was local, or, when they realised I was foreign, Brazilian.

Tamar: Do you speak Portuguese?

Jo: No, but I picked up enough for basic communication and I worked with an ex-soldier who facilitated all the negotiations necessary for taking pictures – and also a young schoolteacher, who was my translator. He was very interesting; he had taught himself English out of a dictionary and we were constantly debating about language. I was lucky; they were wonderful to work with.

Tamar: How do you think South Africa and South Africans' relationship with the rest of Africa has changed? Africa used to be a no-go zone for most white South Africans during apartheid, a world beyond borders that few people knew anything about. Has it become more accessible?

Jo: I'm not sure; my experience is limited here. Obviously, with the ANC coming into power, there have been fundamental shifts in the ways South Africans both engage with and are received in other African countries. But I also suspect that we may be less open than we would like to imagine, that the isolation of the apartheid years continues to haunt us.

My connection to Angola came through my interest in the war and a desire to explore the ways Angola has figured in South Africa's history — and in my imagination. That did give me something of a 'way in', but it also raised the question of my own position, as a photographer, in a place that wasn't 'mine', and how I would reflect this in the images. Which is also why I don't often photograph people; the relationship is just too complex for me.

Tamar: But there are people in these photographs.

Jo: Yes, they are there; Luanda is now home to over 5 million people – a third of Angola's total population – and I didn't want to evacuate them from my photographs. But they were not my primary focus. In the entire series there are two images with people looking directly at me: the man at the gasoline station and the proprietor of the video club. Often people would ask me to photograph them; they thought I was there to record their living conditions and they were keen to have themselves and their homes photographed. Others took it as a definite sign I was from the government and were fearful of being photographed. And then we would have a conversation and I would explain that my project was not something that could serve or harm them in that way.

Tamar: Do you feel uncomfortable photographing people in this environment? Why do you not want to photograph them head-on?

Jo: It's both simple and complex for me, particularly in contexts like this. I can't reconcile the taking of someone's portrait if I don't have a relationship with him or her, if it's not a mutually beneficial and equal exchange. And in this situation, I don't think it could have been. It's not a moral issue or anti-portraiture thing; it's very personal, and the question for me is always who does this picture serve? I took the photograph of the policeman in Roque Santeiro because he represented a certain militarised masculinity that I found very present in Luanda, and it was heightened by his stance in relation to the woman carrying the baby behind him. So he became an emblematic figure of sorts, not an individual. There are exceptions, but generally it goes back to difficult questions about intention and accountability.

Tamar: I find it interesting that you say you don't photograph people, because one has a very strong sense of these environments being inhabited.

Jo: Yes, that's true, and that landscape of inhabitation became my primary interest; how people were making their way in this wild chaotic sprawl of a city, full of post-war energy and enterprise and the contradictory promise of a new future. I remember my first experience of walking through Roque Santeiro: the livestock section with tethered goats and pigs, the avenue of video clubs housed in old military tents, showing Brad Pitt and Angelina Jolie in *Senhor e Senhora Smith*, hairdressers, tailors and coffin makers – and everywhere all this wonderful crazy shredded paper adorning all the poles. There was something strangely festive in all of it. I felt I was entering a world that was simultaneously post-apocalyptic and medieval — where *Mad Max* meets *The Canterbury Tales*.

Tamar: What is really interesting about the whole project is the sense that there is a dialogue between all the layered representations of historical occupations and migrations and travel and journeys. This teeming, lively location that you are recording and encountering situates the present in a strange and rich dialogue with the past.

Jo: Yes, that's partly why I chose the title 'Terreno Ocupado', which translates loosely as 'occupied land'. It conjures up all those layers of occupations and migrations, as you say, but it also asserts the present: new occupations since the war. In all the time I've spent in Angola I have been acutely aware of the past within the present, as if what I am looking at is a screen for something else. And the challenge is how to register all that depth, those layers, in something as thin as the surface of a photograph.

Berni Searle

Tamar: Let's start by talking about the role of photography in your practice.

Berni: I come from a background in sculpture but I found the medium of photography to be something through which I could express my ideas more directly. I also work with the moving image in video and film, and for me the photographs are almost extensions or parts of that process. Often the photographs explore a different aspect of a body of work – they're not simply video stills, but are also able to viewed independently.

Tamar: To what extent are you involved in making the actual photographs?

Berni: I have a sense of what I would like to achieve when starting off with a project — for instance, how an object might be framed in relation to the body. But I am also the subject of my photographs so I rely on other people in the production of the work. In the process there are all kinds of happy accidents that become part of the work. There are also unanticipated disappointments; either way, one works with them. So it is a process that develops very organically. We work with Polaroids so I have a sense of the framing as we go along – even though an instant Polaroid photograph doesn't compare with the final product of course.

Tamar: As you say, you invariably use your own body in your work. This seems to me to constitute a personal and a political gesture. Are you trying to negotiate the history of the representation of women in particular? *Berni:* In some ways, yes. My earlier work such as the 'Colour Me' series and the 'Discoloured' series are very much about asserting visibility and dealing with aspects of representation and classification, particularly in relation to apartheid South Africa, but as a woman, it speaks to gender as well. In the photographs, I look back, as a means of challenging what is seen. This is an important intervention for me. By reworking modes of representation, one is able to question certain assumptions, and there's a trajectory that one builds on, and/or that one contradicts.

Tamar: So how do you understand the relationship between the ethnographic past and the use of your own body in your work?

Berni: I became aware of aspects of ethnographic practices while I was studying, but there were also more concrete examples around me, like the diorama displays of indigenous people at the Natural History Museum, at the time. Challenging or drawing attention to such static modes of representation, in terms of classifying, studying and exhibiting indigenous people, was central to part of an installation, titled *Re-present*, that I did in the Castle of Good Hope as part of the show *Life's Little Necessities*, for the 2nd Johannesburg Biennale in 1997. I encased photographic transparencies of these dioramas and various objects in resin. I also created an installation in which I used spices to outline the plan of the Castle, drawing attention to its historical significance in terms of trade. As my work developed, I used my own body in relation to some of these ideas, particularly how ethnographic and even more immediate political factors manipulated and limited certain ideas about identity. From here I developed an interest in aspects of heritage.

Tamar: So your own family history and the use of history and memory functioned as a kind of counter to those broad classificatory mechanisms?

Berni: Yes, I think exploring aspects of personal history was a counter-strategy. The period after 1994, after the first democratic elections, seemed to offer this opportunity. While I have drawn from personal histories in my work, I don't see the work as being autobiographical. My presence in the work itself, and the fact that I draw from personal memories and histories, doesn't mean that the work can simply be reduced to my set of personal experiences. Aspects of the imaginary also feature in the work, for example, which extends the specific boundaries of the 'personal'.

Tamar: To what extent do you feel that you are still negotiating apartheid structures and systems in your work?

Berni: Probably less obviously so than in my earlier work, but this is not to say that one can simply put things in the past. There are many, more nuanced ways in which we live with a legacy that still permeates people's sense of self today. We've now surpassed Brazil in having the biggest gap between rich and poor in the world, and race still factors strongly in that equation. I think that the xenophobic attacks on foreigners in May 2008 is another case in point. So even though my work is informed by this place, there are other contexts in which one can question similar relations of power. My work in the south of Spain, in a piece called *Home and Away* (2003), deals with aspects of migration and xenophobia. This is a good example of where the particular circumstances of one context triggers off a dialogue with other kinds of historical, political or cultural experiences elsewhere.

Tamar: How do you situate your own practice in relation to global contemporary art?

Berni: I think that, with the lifting of the cultural boycott, the sense of isolation that artists felt was somewhat eased. Seeing the works of artists that I had only ever read about, like Lorna Simpson, Carry Mae Weems and Pat Ward Williams, whom I exhibited with in the 2nd Johannesburg Biennale, was inspiring. I was struck by how certain aspects of representation were effectively challenged in their practice as well as the strategies that they used to challenge the 'gaze'. Going back a bit, my own practice and development as an artist was hampered somewhat by the fact that I had not had the opportunity to study art at school. Art education was virtually non-existent in non-white schools at the time. So there was a sense of isolation that I initially experienced on this level as well. Having said that, and in retrospect, this may not have been such a bad thing – there was, after all, a big wide world out there!

Tamar: The artists you mentioned use the body as a political medium in a way that engages feminist practices from the '70s onwards. Do you see yourself as working within that tradition? I am thinking of key works like *Snow White*, for example.

Berni: Yes, in *Snow White* there is that aspect of the work, though my intention is not to make solely feminist work. At the time that I made this work, in the '90s, race was an important issue to address, and maybe aspects of gender didn't seem as urgent an aspect here at that particular time, but these issues are always interrelated and co-exist in a very complex way. I suppose I really want to resist classifying the work in one way or another, precisely because of the complex way in which many of these aspects of identity intersect.

Tamar: It's interesting though that, in the work of so many young South African photographers working now, sexuality is up for question – not even gender so much but rather sexuality and sexual choice.

Berni: It's not surprising. For many communities, being gay is still a taboo. Being openly gay has also had drastic and traumatic consequences for some, and so there is an urgency to give voice to these experiences. But also to create visibility, to simply say, 'We exist'.

Tamar: Let's talk about 'Once Removed' now.

Berni: 'Once Removed' consists of two sets of photographs, two triptychs really. One set features the torso and the other a lap, shown from the waist down. The work is informed by ideas of veneration and ways in which we remember and commemorate, in this case, through the incorporation of flowers or garlands. The white material that I used is wet paper pulp, that hugs and accentuates the contours of the body, emphasising its three-dimensionality. I am still interested

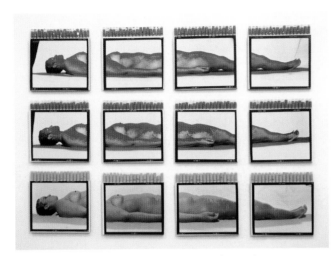

Berni Searle, *Girl*, from the series 'Colour Me', 1999

in the transformation of the body through strategies of revealing and concealing – similar to when I covered the body in spices in 'Colour Me' – and in this work it is the idea of the veil that facilitates that interest. We tend to think of the veil only in a Muslim context, but it has a tradition in Christianity and in various ancient Roman civilisations where garlands and heavily draped head-dresses and head gear were common. I have also worked with colour and contrast, not only on a formal level in the way the bleeding and the seeping of colour is absorbed by the body and the draped pulp, but also on an emotive level where the black flowers seem to suggest something quite ominous. Although these are quiet works, there is a suggestion of suffocation, particularly in the way in which the hands are clasped, even clenched.

Tamar: So, if we take them as two triptychs, there is a sequence where in the first one the paper is wet but the seepage hasn't begun.

Berni: Yes, even though they are photographs or still images, the title seems to suggest a sense of sequencing or something developing over a period of time. Once removed, could suggest twice or thrice removed, etc. So there is a sense of progression.

Tamar: And the third image in each sequence is just the stain, the residue?

Berni: It's what is left, the traces. And that which remains is once removed from what was previously. But also there is another layer, the paper pulp, that can potentially be removed. So it plays with the power of suggestion too, of what may still come.

Tamar: Does the staining reference body fluids, particularly in the bottom panels, suggesting menstruation?

Berni: Yes, in the *Lap* series.

Tamar: And is that important or is it just a by-product, a 'happy accident'?

Berni: Everything within the frame is important – the black flowers are too strategically placed to be a 'by-product'. The suggestion of bodily fluids is there, but again, it's a suggestion rather than a direct reference to menstruation.

Tamar: How important is it for you that this is a performance that you produce using your own body?

Berni: The body is the most immediate thing that one can work with

and it is also the receptacle of one's experiences in that there is a lot that is held within one's body – memories, dreams, fears etc. In some of my works there is a more direct link to myself, and in some cases less so. In *Snow White*, for example, it's about a particular tradition of making roti that has been passed down from my maternal great-grandfather, to my grandmother, to my mother. But it doesn't describe how to do it, it's more a symbolic representation or re-enactment, like a ritual. In this work there may have been a more direct reason for using my own body because of these personal connections. On the other hand, in 'Once Removed', one isn't entirely sure whether it's my body or not.

Tamar: And is there an ethics at stake in putting your own body in the picture – especially given the history of how the body has been used for classificatory systems?

Berni: It certainly makes it easier, using my own body, since I don't need to negotiate with anyone else in terms of how I represent them. A lot of my earlier work raised questions in relation to the body and classificatory systems, not only experienced by myself.

Tamar: So on the one hand there's the other – that is the other of culture and of the history of representation of public discourse – which you embody and perform. But there is also an internal dialogue that requires no one else to be present. In that sense there is a strong performative element in your work

Berni: Yes, but I'm not a performance artist. In a live performance there's always the possibility of being objectified and it's hard to get away from creating a 'spectacle'. Although the work often involves a degree of staging and performance, through the medium of photography and video I am able to intervene formally, for example, by controlling the angle from which I am viewed, the framing and composition of the body in relation to the background etc. The creative process that happens between the performative act and how it is presented allows for a greater degree of mediation, on my part. It allows me to be present but also somewhat 'removed'. I like that distance, for now, anyway.

Michael Subotzky

I first read the story *Thoughts in a Train* in 2007. I was amazed that a story that was written before I was born could be so resonant in my twenty-sixth year. Since then, I have first experienced, then worked in, and now lived in these suburbs – the suburbs of Mr Tshabangu's 1970s story, and South Africa's thirteenth year of democracy. When I was a child, Wendy Houses lived in the suburban backyards for children to play in and imagine themselves in a castle or a mansion. By 2007, they had found their way past the houses and out through the front walls onto the suburban pavements. Stationed there like little models of the real houses behind them, they are a constant shelter to a succession of guards who travel from far-off places to inhabit them and watch the night through. These 'Wendys' or 'Zozos' as they are known are simple in design, just as a child would draw the most essential of houses. They are also one of the few direct visual manifestations of the fear that is implicit in the surroundings. The very same fear that Mr Tshabangu so eloquently brought to life in his story of the '70s has found form in these small wooden sketches of the quintessential home.

Thoughts on a Train, by Mango Tshabangu

When we ride these things which cannot take us all, there is no doubt as to our inventiveness. We stand inside in grotesque positions – one foot in the air, our bodies twisted away from arms squeezing through other twisted bodies to find support somewhere. Sometimes it is on another person's shoulder, but it is stupid to complain so nobody does. It's as if some invisible sardine packer has been at work. We remain in that position for forty minutes or forty days. How far is Soweto from Johannesburg? It is forty minutes or forty days. No one knows exactly.

We remain in that position, our bodies sweating out the unfreedom of our souls, anticipating happiness in that unhappy architectural shame – the ghetto. Our eyes dart apprehensively, on the lookout for those of our brothers who have resorted to the insanity of crime to protest their insane conditions. For, indeed, if we were not scared of moral ridicule we would regard crime as a form of protest. Is not a man with a hungry stomach in the same position as a man whose land has been taken from him? What if he is a victim in both ways!

We remain in that position for forty minutes or forty days. No one knows exactly. We, the young, cling perilously to the outside of the coach walls. It sends the guts racing to the throat, yes, but to us it is bravery. We are not a helpless gutless lot whose lives have been patterned by suffering. The more daring amongst us dance like gods of fate on the rooftop. Sometimes there is death by electrocution but then it is just hard luck... He was a good man, Bayekile. It is not his fault that he did not live to face a stray bullet.

We remain in that position for forty minutes or forty days. No one knows exactly.

We move parallel to or hurtle past their trains. Most often my impression is that it is they who cruise past our hurtling train. Theirs is almost always empty. They'll sit comfortably on seats made for that purpose and keep their windows shut, even on hot days. And they sit there in their train watching us as one watches a play from a private box. We also stare back at them, but the sullen faces don't interest us much. Only the shut windows move our thinking.

On this day it was Msongi and Gezani who were most interested in the shut windows. You see, ever since they'd discovered Houghton golf course to be offering better tips in the caddy business, Msongi and Gezani found themselves walking through the rich suburbs of Johannesburg. Their experience was a strange one. There was something eerie in the surroundings. They always had fear, the like of which they'd never known. Surely it was not because of the numerous policemen who patrolled the streets and snarled in unison with their dogs at black boys moving through those gracious thoroughfares.

Msongi and Gezani were young no doubt, but bravery born of suffering knows no age nor danger nor pattern. Fear of snarling policemen was out for these two young black boys. Nevertheless, this overwhelming fear the like of which they'd never known was always all around them whenever they walked through the rich suburbs of Johannesburg. They could not even talk about it. Somehow, they were sure they both had this strange fear.

There was a time when they impulsively stood right in the middle of a street. They had hoped to break this fear the like of which they'd never known. But the attempt only lasted a few seconds and that was too short to be of any help. They both scurried off, hating themselves for lack of courage. They never spoke of it.

In search of the truth, Msongi became very observant. He'd been noticing the shut windows of their train every time he and Gezani

happened to be in ours. On this day, it was a week since Msongi had decided to break the silence. Msongi's argument was that the fear was in the surroundings and not in them. The place was full of fear. Vicious fear which, although imprisoned in stone walls and electrified fences, swelled over and poured into the streets to oppress even the occasional passer-by. Msongi and Gezani were merely walking through this fear. It was like walking in darkness and feeling darkness all around you. That does not mean you are darkness yourself. As soon as you come to a lit spot, the feeling of darkness dies. Why, as soon as they hit town proper, and mixed with the people, the fear the like of which they'd never known disappeared. No, Msongi was convinced it was not they who had fear. Fear flowed from somewhere, besmirching every part of them, leaving their souls trembling; but it was not they who were afraid.

They did not have stone walls or electrified fences in Soweto. They were not scared of their gold rings being snatched for they had none. They were not worried about their sisters being peeped at for their sisters could look after themselves. Oh, those diamond toothpicks could disappear you know... Those too, they did not have. They were not afraid of bleeding, for their streets ran red already. On this day Msongi stared at the shut windows. He looked at the pale sullen white faces and he knew why.

He felt tempted to throw something at them. Anything... an empty cigarette box, an orange peel, even a piece of paper; just to prove a point. At that moment, and as if instructed by Msongi himself, someone threw an empty beer bottle at the other train.

The confusion: they ran around climbing on to seats. They jumped into the air. They knocked against one another as they scrambled for the doors and windows. The already pale faces had no colour to change into. They could only be distorted as fear is capable of doing that as well. The shut windows were shattered wide open, as if to say danger cannot be imprisoned. The train passed swiftly by, disappearing with the drama of the fear the like of which Msongi and Gezani had never known.

Taken from Hirson, D. and Trump, M. (eds), 1994, *The Heineman Book of South African Short Stories, From 1945 to the Present*. Oxford, Heinemann Educational/UNESCO Publishing.

Guy Tillim

Petros Village

Petros Village is situated in Central Malawi, about 50 kilometres north of the capital Lilongwe. Rural, but not remote, the villagers rely on a local market for sale of tobacco and beans for cash, and grow maize as a staple food.

In 2004 the rains didn't fall and their crops failed, but a famine was averted because they were given food by the Italian community of Sant'Egidio, amongst others. This year, as in all years, they face the same engagement with the climate. It is an opportunistic and marginal existence with an uncertain harvest.

The village takes its name from its chief, Petros James. In accordance with Chewa law he inherited the chieftainship not from his father, but from his uncle, his mother's brother. The son of his sister Neri will inherit the title from Petros and take his name just as Petros did from his uncle. As Petros said, the sons and daughters of your sister are your real relatives, your real home is where your mother comes from.

I met Petros with Dr Piero Bestagini and Moses Chigona from the Saint'Egidio feeding centre and laboratory at nearby Mtengawantenga. Within a few minutes of meeting him, he had agreed that I could spend a week in the village. Piero asked where I would stay and without hesitation Petros took us to his homestead and showed us his sleeping quarters. He and his wife would move into the room where they prepared food.

It is only a day or two later that I realise the significance of this concession. The hospitality I receive is so open-handed, so otherworldly, that it's almost impossible to imagine it in the place I come from. I try to place it, this generosity of spirit. I think in clichés of traditional rural hospitality, custom, things time-honoured and unmolested by city life. But the sense of it is elusive, muted by prejudice, obscured by ignorance.

The sun is setting, hiatus before the deep village dark, a whispering group of children gather around me in the twilight just to stare.

Guy Tillim, 2006

Roelof van Wyk

Tamar: Let's start by talking about 'Young Afrikaners'.

Roelof: 'Young Afrikaners' is a meditation on being white in Africa, on being white Africans, in fact.

I am interested in the transformation of a singular, National government-sanctioned identity, to something more personal and plural. It's about mapping that and seeing how much the 'tribe' has really moved forward. Collaborating with these individuals and hearing their stories, I start to weave a certain Afrikaner narrative relating the specimen to the species, which really interests me.

Tamar: So, what does being an 'Afrikaner' mean for you?

Roelof: The strongest bond we have as a group is located in the language, Afrikaans. However, within that we have a very specific historical role as the oppressor, which is what differentiates an Afrikaans-speaking Afrikaner from an Afrikaans-speaking 'Coloured' person, who was on the receiving end of the apartheid system, the oppressed. That is how I start defining it. Exploring how we as a group carry forth that difference, that history, perhaps that guilt, into our current and future identity.

Tamar: Do you think that a shared language could define inclusiveness and exclusiveness, rather than old outmoded notions of race?

Roelof: Yes, absolutely, and I can see that happening already. What we share culturally is becoming stronger than what differentiates us racially. It's definitely about a shared language, and within the shared language there are shared experiences and a shared culture. Language is what I think allows us to grasp, understand and trust others.

Tamar: To what extent do you think that traditional Afrikaners will embrace this expanded idea of Afrikanerness and a shared, transforming language?

Roelof: Afrikaans is, and has always been, a complex, dynamic, constantly adopting and adapting language. It's a mixture of various other languages. It has a very strong Dutch base but also French and German and indigenous African words, including traces of Malay from the imported slaves. These have shaped the language over four hundred years, so the roots of this language have been, historically,

Roger Ballen, *Die Antwoord*, 2009

inclusive. It is changing as we speak. Various words have been breaking into a shared mainstream vernacular like the words 'gees' (spirit) or 'vuvuzela'.

Tamar: It's interesting then, that 'Young Afrikaners' remains locked to the traditional notion of 'Afrikanerness'. And you have not wanted to expand beyond a white cohort of characters. At the same time it subjects this group to a kind of pseudo-scientific scrutiny that would not have happened to them in the past.

Roelof: The project began with straightforward documentation. However, I was searching for a method that would give me not only a relatively scientific/objective end result, but also reveal something of the inner life of the subjects. I admire the scientific approach of the photographic work of Muybridge, as well as enjoy the pseudo-scientific appeal of police mug shots. It was only when I saw the anthropological photographic work of Gustav Fritsch, and Alfred Duggan-Cronin, that I felt I had finally found my reference. As I photographed, I realised a kind of unconscious performance was taking place. The subjects started revealing themselves in this performance in front of the lens; the way they held their heads, the way they looked into or at the camera; I was surprised at the emotive result. Which made me look again, and harder at the earlier anthropological images of South African indigenous tribes, and I started seeing real people; not only specimens of a group or culture, but people with names and lives beyond the frame of the photograph. A wonderful discovery that in turn enriched this project immeasurably.

Tamar: So what's the role of the studio in creating this intimacy?

Roelof: Firstly, it's a constructed space and it is a very simple construction; a length of black velvet, a tripod and camera and some flash lights. Secondly, this construction allows me to travel easily across South Africa and create the exact same setup wherever a subject finds themselves. Because it's so simple and intimate, it contributes tremendously towards a comfortable, trusting relationship between me and the subject.

Tamar: So on the one hand there's this intense encounter between you and the sitter – which unleashes something that allows you insight into the interiority of this person. At the same time the whole thing is overdetermined and overlaid by the history of photographic practices – mug shots and criminological or anthropometric practices that are about surface appearance.

Roelof: Yes, but there are also more art historical references that I overlay, even if it's obscure, or simply a current obsession. Photographically, August Sander, Thomas Ruff, David Goldblatt, Roger Ballen, the Bechers, all contributing some reference to the work. I also reference portrait painting: Bacon, Rembrandt, Fra Filippo Lippi, Irma Stern. Monumental South African propaganda sculpture – cast men on horses, the frieze in the Voortrekker Monument – lurks in the back of my memory, and creates an image bank against which I develop a singular vision for my own work.

Tamar: Why are your figures unclothed?

Roelof: I want each image to be like a butterfly on a pin. It's literally looking at the 'thingness' of the subject: hair colour, eye colour and skin colour, and all the flaws, blemishes and tattoos – traces of a personal history written on the body, a map of sorts. Even though these marks on the skin speak about the history and the memory of an individual, in a way it becomes symbolic of this group's own four-hundred-year-old history.

Tamar: As you say, they become like specimens. At the same time they are very groomed and are marked, in a way that is highly culturally specific. Then there are also the cold sores or pimples or scars.

Roelof: To be specific, this cancer sore belongs to Llewellyn; the image was taken days after the removal of a cancerous brain tumour. Today he is in remission, however, through this cathartic experience he started engaging with traditional herbal medicinal practice. He is now being initiated into becoming a traditional African herbal healer, an Inyati. It's very interesting in his case that a stereotypical white Afrikaner male can transform and engage with a traditional African archetype. He is adapting and shifting, becoming part of Africa, becoming part of the land.

Tamar: What is your relationship to all these individuals? How well do you know them and their stories?

Roelof: A prerequisite is that I already know them or am getting to know them personally. They're friends, they're friends of friends, they're lovers, they're family, I know their stories well. I shoot some subjects three, four times, it's an ongoing engagement directed at not only building a trusted artistic relationship for the portrait project, but also at building a collaborative foundation for the other projects of my bigger South African body of work, of which 'Young Afrikaner' is the first.

Tamar: Your relationship as a photographer to this community is interesting. It's not at all like anthropologists or criminologists who were photographing from outside.

Roelof: The project is also a self-portrait, of myself and of the group. The anthropologists were 'looking at' the tribes, even David Goldblatt (*Some Afrikaners*) and Roger Ballen's photographs (*Platteland*) were from the outsider perspective – even voyeuristic. I am on the inside. I am representative of the group.

Tamar: And there's a trust because you are part of this community?

Roelof: Yes, and no one I have invited to be part of it has said no. I believe that there's a mutual understanding of the importance of this project too. An opportunity to be heard. A voice.

Tamar: Is it just a personal intersubjective negotiation or is it also about a kind of shared reckoning with self, and history? How does your own self-questioning relate to a broader culture of Afrikaner self-examination, for example in the writing of Marlene van Niekerk and others?

Roelof: Both. It's also dealing with an inherited history. The work of Marlene van Niekerk and Antjie Krog has set a scene for this generation of Afrikaner writers, musicians and artists, questioning our identity and our past, but I don't believe any photographer is currently dealing with Afrikaner identity as explicitly as I am.

Tamar: How do you feel about the way in which Afrikaners have been represented in the past? By David Goldblatt in *Some Afrikaners*, for example? How would you relate that project to your own project? Does it have any relation to it?

Roelof: It definitely has, yes, the subject matter is obviously related. Goldblatt's is a relatively literal documentary body of work reflecting the ideological complexities of the time, photographing working-class Afrikaners. My project is more than a literal documentation. It has become, in a way, a constructed documentary project, and it's engaging quite differently with the subject matter. Goldblatt also looked at Afrikaners as an outsider, and although he has expressed empathy with these individuals and his pictures reveal a certain humanity, I believe his gaze was perhaps less sympathetic and perceived as harsh commentary at the time. However, it's reached a near mythic status at this point. It most certainly wasn't a self-portrait, like the *Young Afrikaner* project. I am the Young Afrikaner, and we collectively are defining our identity.

Tamar: I'm interested in comparisons and putting things in the context of South Africa's broader photographic history. I'm thinking of the other visual representations of Afrikaners, like Roger Ballen's photograph of the rock group Die Antwoord. He also photographed Afrikaners in his projects *Dorps* and *Platteland* for example. What do you make of them?

Roelof: Goldblatt had empathy, Ballen made monsters. However, the monsters are still my people and it's hard to accept that that's how people see us. Part of this project is undoing that. I am undoing that on a deeply personal level too, having grown up in a small, conservative Afrikaner community or 'dorp' on the 'platteland', by doing this project. It's kind of balancing out the scales.

Tamar: You have inherited a whole history of visual representations of Afrikaners in relation to which you have to position yourself, and most of them don't represent how you see yourself.

Roelof: Yes, and I include here a plethora of sensational media images that graced the covers of newspapers and magazines everywhere. An image of three shot AWB members in 1993, slouched dead against their car – bullet-ridden, khaki-wearing, bastardised swastika logo on the shoulder, overweight white males. I am also an outsider when I look at these images. I wonder, 'Who are these people?'

Tamar: Let's compare what Roger Ballen did with Die Antwoord and what you do in this particular project. He concentrated on the artifice of their performance and reproduced it in his own highly fabricated reconstruction. Or perhaps they 'mimicked' his visual language? You too have photographed the singer Yo-landi who is your friend.

Roelof: Yo-landi doggedly pursued Ballen to photograph Die Antwoord. She has a very strong visual instinct, and wanted to take Ballen's original image and own it in her own right; the video to the song 'Wat kyk jy?' (What are you looking at?) takes Ballen's aesthetic to a whole other level.

Tamar: What about the sexual politics of your project? Does that matter to you? Does the opening up of ideas around sexuality post-apartheid affect you?

Roelof: South Africa's post-apartheid constitution was the first in the world to outlaw discrimination based on sexual orientation, and it's the first in Africa to legalise same-sex marriage. That said, sexual politics in South Africa is a loaded gun. It's still a conservative society at heart, homosexual and cross-race relationships still turn heads. For a young Afrikaner to come out to their family is an anxious event, loaded with fear of rejection and outright discrimination. It takes a certain conviction and belief in the self to go against the grain. I think, however, that 'resistance' to the status quo has been a marked characteristic of the Afrikaners throughout history, and is now only showing itself within individual behaviour, in step with the changing times.

Tamar: Is there anyone else for you who, in a critical or self-critical, imaginative way, is rethinking the image of the Afrikaner, the visual image of the Afrikaner? I can see it in literature and there it is very powerful.

Roelof: I can think of various young Afrikaner artists who are making waves in their work: Wim Botha in fine art, Johan Thom in installation and performance, Suzaan Heyns in avant garde fashion, Inge Beckmann in music. Strong, boundary-shifting, conceptual and highly crafted work. The rock-and-roll scene has been leading the way during the last decade with the likes of bands like Fokofpolisiekar (Fuck off police car), true to the spirit of that particular style of music.

Tamar: So in a way you are participating in these cultural self-reflections and explorations?

Roelof: I think I am part of a larger growing South African cross-cultural wave of a conscious questioning of what constitutes our particularly defined culture, and the adventurous exploration of the very rich texture this southern place offers us as artists including [non-Afrikaner] people like Athi Patra-Ruga and Dineo Bopape. The subjects I photograph are each and every one part of this wave, but they are also real, normal, flesh-and-blood people.

Tamar: But they are also very beautiful, and young. It's a self-selecting community and it's a kind of sub-culture in itself.

Roelof: Their ages vary between 15 and 45 years of age, so 'young' is a relative term. The 'young' in 'Young Afrikaners' refers to the living generation of a group whose origins can be traced to 350 years of existing on this land. The 'beauty' in the images I assume refers to my formal approach. As I said earlier, I reference traditional portrait painting that allows the artist to paint a more 'idealised' picture of the individual. Perhaps creating a 'new' mythology... I do this by carefully selecting a final representative image, which is the most flattering and kind to the eye, out of a possible batch of 100 to 300 photographs. I agree, though, that the complete album of images is a specific subset of individuals, chosen by, and with whom I surround myself, reflecting facets of myself.

Nontsikelelo Veleko

My journey in photography arose from an interest in exploring identity. In earlier ongoing projects, for example, *www.notblackenough.lolo*, I have profiled prejudice and reductive stereotyping. 'Beauty is in the Eye of the Beholder' is an ongoing celebration of the South African 'Born Free' generation and their expression of identity through dress and fashion. *Wonderland* takes this project a step further in investigating the social and emotional states of my surroundings – South Africa is my place of departure, by experience and location, but conceptually I am interested in the discovery of the world.

More than just documenting fashion and style, I am interested in how we read fashion, and how my subjects use their clothes to construct, and often deconstruct, their guises of identity. My subjects are rarely mainstream individuals. Many of them are characters that take risks in the ways that they declare themselves in the world, and in so doing are often vulnerable within the domains they inhabit, often at the edge of society.

Graeme Williams

Tamar: How did your interest in photography begin?

Graeme: I started by working for the main evening newspaper in Cape Town. My job was to photograph houses for the property section; very basic stuff. This was in the mid-'80s. On one particular day, there had been a lot of fighting in the townships on the outskirts of Cape Town. I quickly finished photographing my houses and headed for the trouble spots. I had no clue what I was doing and I just wandered straight into a battlefield. I found myself in the middle of a war zone with no back-up.

Tamar: Did you see yourself as a photojournalist at that point?

Graeme: Not really. It was so unconscious. I didn't think that photojournalism was my future. In fact I was drawn towards longer-term documentary projects at that time. But I think when you're confronted with something as exceptional as apartheid, which is affecting one's society so powerfully, one feels compelled to react to it. I didn't have a long-term view of what I was going to do with the images. I just took them to the editor of the newspaper and every now and again they were published.

Tamar: Were they published as your authored photographs?

Graeme: Yes. There was so much happening at this stage in South Africa's history. The country was in a State of Emergency, which involved strong clampdowns. I remember once there was a protest march happening outside parliament in Cape Town. A woman and a child got shambokked; there was tear gas and the usual kind of chaos. Afterwards, a white woman came up and hugged the black woman and I photographed the scene. I gave the picture to the editor and he published it. A week or two later, I walked past someone's cubical in an office building and saw that they had cut out this photograph and stuck it onto the wall. It made a real impact on me that someone had reacted so strongly to one of my photographs.

Tamar: Did you see yourself as a witness?

Graeme: As a photojournalist, I have never really felt entirely comfortable with my role, especially when I was photographing people who were experiencing extremes of emotion or violence. Often during the time when I was photographing for Reuters, between '89 and '94, I had a very strong feeling that I was invading people's privacy and crossing lines of reasonable behaviour. It's very easy to get fired up by adrenaline and lose perspective. At the time, I thought that what I was doing was really important and that the end justified the means, but that's not true.

Tamar: Were there documentary photographers whose work you particularly admired?

Graeme: Yes, David Goldblatt's work, and particularly his extended documentary projects, had a very strong influence on a large number of photographers from my generation. And my Afrapix [photographic collective] colleagues were doing in-depth bodies of work, really taking an interest in a particular subject and exploring it photographically. This era really defined my photography and I started working on extended projects from the late '80s and haven't really stopped since.

Tamar: Was your work predominantly in black and white until the transition to democracy?

Graeme: Black and white fitted the apartheid era, you know; they were the obvious shades. It just fitted the sort of gritty, grubby side of South African life. At that time, South Africa was so closed off from the rest of the world and it felt almost sacrilegious to do something so flighty as to photograph in colour. I think apartheid was such a huge dark cloud that hung over us all, and black and white was the only way to go. Then after the end of apartheid there was this hazy patch where as photographers we struggled to find a clear source to our work. Up until then, the source had always been the presence of apartheid. But, on the other hand, I also felt a huge relief when apartheid was over and I could sense that photographically there was a freedom beyond its constraints.

Tamar: At which point did you start using colour?

Graeme: That came later, in the late '90s. It feels like there were distinct stages to the way I photographed social change in South Africa. In the '80s, with Afrapix my work was quite contemplative, and there was time and space to explore subjects. Then there was the transition period between '89 and '94, which became dominated by extreme violence and political positioning. There wasn't the time to do in-depth work because things were changing at an extremely fast pace; people were dying, sometimes 50 per day. It's very difficult to focus on something, such as rural vegetable farming when there's such dynamic change happening on one's door step. There was a sense that the whole way one approached photographs had to change and it had to be immediate. It was more like war photography. For five years that became my life. I began to crave the intensity of those encounters and it became very difficult to be able to separate out what was real life and what wasn't. One lived very much for the day so it was an unconscious approach to documenting change, and I think a sense of the broader picture was missing. Only in retrospect can I step back and look at what I actually photographed and what it meant. At the time I was too involved and emotions were too high to reflect on what I was doing.

Tamar: Did you feel at the time you had an ethical responsibility to tell the world what was happening, or was it more of a professional commitment?

Graeme: That's a complex question. I would say a bit of both, but also a real desire to be a part of such a dramatic period of change. Prior to the beginning of this period, I had spent a year living in London. I was at the Nelson Mandela 75th Birthday concert at Wembley Stadium and remember thinking that big things were about to happen in South Africa and that I wanted to be a part of this change. There was this sense that Mandela would soon be freed and there was a growing anticipation. I came back to South Africa at the end of 1988 and the violence started soon after. I chose to work as a freelancer for Reuters because I wanted to get close to everything that was happening.

When Nelson Mandela came out of prison I was waiting outside, and, for almost all the big events that happened, I was present. But what I hadn't foreseen was how seductive and all-consuming photographing violence can be. How it is extremely difficult to remain objective. I just lost my sense of balance, and got too involved. After five years doing this work, I felt that I had to stop. In 1994, when Mandela was inaugurated, I sat at home with my pager turned off, and that was the end of it. It took a while to detox from news. It's an addiction, and adrenaline is a very strong drug; it took quite a while to re-adjust.

Tamar: So then 1994 comes; how did you negotiate that transition?

Graeme: I think there were so many transitions happening at that point. On a social level South Africa had gone from an apartheid white government to a black government. No one knew what the outcome would be. I think that, for a time, South Africa ricocheted from one crisis to the next. On a personal level I was trying to adapt to a life less driven by adrenalin. On a photographic level, I tried various things and nothing really worked, so I just let it be for a while. I think it took three or four years before I sensed that I could approach a new subject.

Tamar: Would you say you went back to a more essayistic, contemplative mode of working?

Graeme: Yes, I did, but what wasn't working anymore was my old approach to a subject. The idea of following a defined theme or creating a social document no longer interested me. I think what freed me up photographically was discovering that I could isolate a feeling that I had towards something and communicate it on a visual level. So in post-apartheid South Africa what I have really tried to do is to change my starting point. I've got to feel something before I can photograph it. Also, on a worldwide photographic level, the boundaries between documentary and fine art photography were blurring. It just happened to coincide with the major changes within South Africa. I think it was an incredibly valuable process for me to learn that actually there are no rules, and that I could venture wherever I wanted. The move to colour was initially a way of testing these boundaries, but maybe it was also a rebellion against the past.

Tamar: So how does 'The Edge of Town' fit in to this moment?

Graeme: 'The Edge of Town' is made up of 41 photographs shot over a four-year period during which I visited over one hundred towns or townships. My approach was very much 'hit and run'. I chose never to photograph in the same place twice. I would keep moving from town to town, township to township. I could only photograph for about two or three hours per day because I needed strong early morning or evening light which gave me the harsh impact and long shadows. The physical aspects were difficult, but the most demanding element to how I was working was that I no longer followed a clear set of defined parameters. I was photographing a particular feeling, sense, or mood, rather than a subject. I had to find a situation that had the right visual and emotional aspects to it. Days would go by without getting anything that approximated what I was feeling, and that's why I think it took four years to complete. When I started with the project I didn't have a clear picture of how the images should look visually; it was a process. I started photographing in black and white but then I moved on to colour It took another few months to work out that I could only photograph in extreme lighting conditions in order to get the right feel. Then I realised that I wanted to break down the distance and the 'objective' feel of documentary photography and I wanted to break the barrier that I as a photographer often set up between myself and

my subjects. This demanded that I get really close to my subjects within a very short period of time. I am not sure if this work could have been done in many other countries. Paradoxically, there is quite an openness to strangers within South African society. I was often amazed by how welcoming people were to me, allowing me into their homes and activities.

Tamar: Did they see you as a tourist or a photographer? Did they ask why you were interested in them?

Graeme: Yes, we would often chat, but usually after I had photographed. Initially, my interaction with my subjects had to be brief or else I would lose the natural tension that was present at the time. If I waited too long or became too familiar, my presence would be felt in the photographs. Whenever that happened the photograph lacked the feeling of edginess that I wanted.

Tamar: Do you see yourself as a kind of latter day ethnographer?

Graeme: I think that I was trying to transcend the barrier that early 20th century photographers had created for themselves by putting their tripods down and bringing out a person and photographing them. I wanted to break down this separation that restricted the ethnographer to the position of observer or visitor. I think these photographs only work when I am able to gain access to the subjects lives on an intimate level.

Tamar: Can you talk about some of these issues in relation to a specific image? The man with the painted face wearing the Honda cap, for example?

Graeme: This image was taken at a football game, and the subject was a mime artist entertaining people outside the stadium. The image was captured while he was performing and I was part of the crowd. I think this is a good example of what I was trying to achieve. I wanted viewers to be slightly unsure of what was going on in each photograph, and this reflects how I felt about change in South Africa at the time. So one could get a sense of what was happening in one corner of the photograph or one corner of the country. But one could seldom work out how all the elements of the photograph worked together or how the country as a whole was faring. In this particular photograph there are three points of focus: there's the mime artist on the left; a chap who's completely ignoring him and walking past – he is slightly blurred in the foreground; and then a shape in the background that is fairly intimidating. The result of not getting the whole picture leaves one with a slightly uneasy feeling.

Tamar: And that's true of a lot of the photographs. There's something quite vertiginous about the angle from which some of them have been taken, so it's quite difficult to work out what's falling, what's standing, what's real, what's pictured.

Graeme: Yes, that was intentional. The hope is that the viewer is attracted by the colour and the dynamic framing on a surface level, and then they are able to explore further.

Tamar: So you never stage or set up anything, it's always something you stumble upon?

Graeme: These moments would always be stumbled upon. I found early on in the project that if I tried to influence things and hung around too long, the elements might come together but there would be no real edginess or energy to the photograph. They had to work spontaneously or they never really worked at all.

Tamar: There's quite a surreal fascination with dolls and children in the photographs. Where does that come from?

Graeme: The white doll and black kids thing comes from growing up in apartheid South Africa, where there weren't many black dolls around, so poor black children would pick up an old white doll and would, because of their youth, be oblivious to the race issues. I'm drawn to troubling juxtapositions in which the subjects are seemingly unaware of a deeper significance.

Tamar: Tell me about the image of the guy diving into the swimming pool?

Graeme: This photograph was taken at the Sea Point pavilion in Cape Town. The person on the right-hand side floating in the air had actually just jumped off the high board. At the time the pool was still very white-dominated, but on New Year's Day people coming from the townships arrived in large numbers and it becomes a whole different social space. It was fantastic, the place was packed, and I think in a way this image illustrates the way I approach each photograph. The person jumping off the board wasn't interesting as a singular element, but the frame becomes broken down into various fragments. It was important for me to remove their original purpose of the elements and create something new out of the combination.

Tamar: They're very wonderfully composed. What I think is very fascinating about them is the sense of the choices you make which lead to a rupture in the visual field.

Graeme: What I drew on was the way in which some photographers have discarded the formal or frontal way of framing a scene. Photographers like Antonin Kratochvil or Paolo Pellegrin from the photojournalistic field have completely broken down the conventional frame. I would often travel with some of their books in my car in order to entice myself to look beyond conventional ways of framing. I suppose what's happened is that I incorporated these looser ways of framing into my photography. I am especially interested in the idea of the 'edge', both socially and in the way I frame an image. It's a word that comes up a lot, especially in its capacity to make one lose one's footing or become off-balance, so the certainties of life and meanings become blurred. Many of the situations that I found myself in didn't produce results because the elements just didn't come together, the light wasn't right or people reacted too directly to me. But most often, the restriction was my own confined viewpoint. It is extremely difficult to break the habit of formal framing. I had to force myself to let go of those conventional approaches to the photograph and whenever I was able to relax these learnt formulas, there was a chance that the photographs could work. It's the sense of vertigo or imbalance that interests me.

Over a 12 month period in 2010—2011, Tamar Garb interviewed thirteen of the photographers in 'Figures and Fictions'. The remaining four were not available for interview. To register their voices, each has supplied a statement to accompany their work.

Editorial assistance was provided by Orla Houston-Jibo, Amy Halliday and Liese van der Watt.

Thinking from the South: Reflections on Image and Place

Tamar Garb in conversation with:

Achille Mbembe
Sarah Nuttall
Riason Naidoo
Colin Richards
Cape Town, July 2010

Tamar: Why don't we start with the idea of thinking from the south. What does it mean to think in, of or from the south?

Sarah: I think it can mean different things. It can emphasise a literal place, a location. This assumes that there is something about a specific location that enables you to think in a particular way. But the invocation of 'thinking from the south' can also infer a particular kind of politics, a geopolitical reading of the south as being dispossessed, materially and theoretically. The third strand (of course there may be overlaps between them) would put the emphasis on a critical theoretical project that could make ideas travel; to find a way of thinking which is not provincial, which lets the world in, and that opens onto other places, in the south but also in the north, insisting on producing global epistemologies (so that the way we think about Johannesburg, say, or São Paulo, or Cairo, changes and becomes part of the way in which we think about New York, and vice versa). It does seem useful to think about 'thinking from the south' but then also to be alive to the limits of such a rubric, the points at which it becomes confining, rigid, less than capacious.

Achille: Personally, I'm sympathetic to the idea of thinking from a specific location, although, as the Chinese critic Ackbar Abbas is fond of saying, in this age of globalisation, locality is itself dislocated. I think of the question too in relation to my own biography. I have spent my entire life moving from one place to the other. Now, I happen to be in South Africa and I take South Africa seriously. I take the continent seriously, but I keep moving. I spend time in the USA too, but from a cultural point of view, I am a mixture of African and French. So in that kind of logic of circulation the question of locality becomes very problematic. Therefore thinking from the south is a polemical statement, but with political as well as intellectual potential. So the question is: how does one take it seriously at the same time as one exercises critical distance from it as a spatial assignation? I think I find it very productive to think in the interfaces of various places that have come to define who I am, but perhaps this is a product of my own personal biography.

Tamar: If we think of the south as a location, on the one hand, and the south as a politics or a state of mind, on the other, does this mean one can think from the south in the north, too? As we know, cities everywhere now are made up of people who come from all over the world, and ideas as well as people circulate. So the idea that there is a clear separation between the construction called the north and the construction called the south is extremely problematic. And is it possible to think from the north when you live in the south too?

Sarah: Yes, I think one can think from the south in the north, and vice versa (though beyond a certain point such formulations point to the limits of these dichotomies of north and south).

And yet there is something specific about place. South Africa is an interesting case in point. In a city like Johannesburg, one is living in the midst of extremely poor people, which I think does count for something in the way in which one negotiates and thinks about everyday life. It's simply not the same in London or New York. White people in South Africa are a minority living under a black-led government so this means that we are engaging with black perspectives of place and politics, past and future each day, and confronting whiteness in a somewhat more demanding way than I think often happens in the cities of the north. I think Aboumaliq Simone may be right when he suggests that Bangkok or Johannesburg or Jakarta or Phnom Penh, different as they undoubtedly are, do seem to share something about the relationship between living and space and a certain kind of urban contentiousness which might simply not be there in Copenhagen or Quebec.

So one wants to assert certain kinds of experience. But that may or may not enter into our thinking in productive ways and so, in and of itself, it may count for nothing. It depends on how it helps us to think about situatedness. Arjun Appadurai asked a question in Johannesburg the other day that I found compelling: What counts as theory? Can theory be somewhat different or somewhat more capacious here than it is in the north? Might it be involved in a project of reconstruction, of finding bits and pieces that might constitute the beginnings of something else, a future, in a way that it doesn't do in the north?

Colin: These are difficult issues. I would also want to hold on, from a political position, to the idea of an emplaced place, a material locale in all the meanings of 'material'. I don't think I'm at all comfortable with the possibility – theoretically and politically – of just dissolving or tipping the emplaced part of experience (however provisional) into some other kind of ever-spinning circuitry in a kind of cosmopolitan free fall. So, as a 'southerner', I would probably want to take issue with thinking from the south in the north as if these were definite localities of some sort. But, at the same time, there's a long history within South Africa of claims to exceptionalism, and I would want to avoid overstating this too much and gesture towards re-territorialisation. One wants to maintain the specificity of the place one inhabits, but without making a case for exception beyond the recognition of distinction. The other thing is, like probably all of us here, I've been privileged enough to travel quite widely. And it is the experience of distance and proximity in different registers that has become vital to my thinking and experience. How we negotiate 'distance' spatially, temporally and conceptually takes a variety of forms within and outside 'the south'. What, for example, is it to be 'face to face'? What is it to face perpetual contradiction in the proximities of your ordinary lived life at a level and on a scale that renders life palpable in extraordinary and sometimes anxious ways. There is something in all this that must remain insistently particular, even peculiar, the fertile, motile strangeness of emplacement. Even being in Cape Town is so very different to being in Johannesburg, so to speak of the south can become a bit thin. An entire discourse on the relation between these two metropoles has developed in our thinking. Funnily enough, Cape Town is the south of the south, the historical contact point between the African south and the European west, which raises its own kinds of dilemmas. But the distance–

proximity elasticity, even the perversions of this elasticity, seems to me to be crucial to thinking from or out of this place. Let's take 'face to face' violence for example. We have very living, daily encounters with violence of many shades and shapes, and I have not found this to be so visible in the (admittedly) few cities I've been to in the United States, Western Europe, England or the East.

Achille: Well, there's a north in the south too. I live in Johannesburg, which is a concatenation of many different worlds: the first world, the second, the third, the outer world, if one wants to speak in those terms. What is really interesting is to think at the interface of the multiple worlds we inhabit, even if we are not moving physically through them. The first moment of theorising is about theorising from the self that is then translated into other gestures. I have spent all my adult life away from what one could term my homeland. But I don't define myself as an exile in the post-colonial sense. And spending one's adult life away from one's homeland doesn't mean one is homeless. So for me, if thinking from the south has any meaning, it means grappling with that tension between homeliness and homelessness. A proper, a good theory is a theory that is both grounded and at the same time homeless, one that can travel, one that is produced here but that can make sense to people living in Harlem or Jakarta. If it doesn't do that, it's purely a local thought.

Riason: The point is that the south has come to be defined as such, only in relation to the north. But there are ambiguities. When we talk about the south, we can, quite feasibly, restrict ourselves to thinking about the location of people who were previously dispossessed. But, the way I take the south is also as a space from which to think about possibilities for the future. And this in relation to the shifting global economics and politics of the present. We are in a new moment in relation to these issues. Now, we in the geographical south, have the potential to determine our futures, whereas previously the south did not have that power. Brazil, South Africa, China, India, Mexico have new possibilities. I think there is more of a possibility today to have the voices from the so-called south heard, to have these experiences shared globally. It could mean a much more enriching world with more appreciation for one another's cultures, with multiple centres of culture breaking down the hegemony of the north. It's important for us in the south to determine our own futures related to our own circumstances, an emancipation of the self one could say, without always looking for guidance and approval from the north. This ultimately means a world particularly receptive and open to suppressed histories of those dominated in the past.

Tamar: Can we invert the old top-down model that goes from a putative north to a receiving/exploited/manipulated/imagined south – however you like to put it? How does one turn these modes of thinking upside down without simply replacing one monolith with another? How can we productively think about the interstices between these constructions, so that something comes out of this that isn't just an inversion?

Riason: I'm not suggesting a shift in power from the north to the south; I'm suggesting a self-determination, a confidence to do new things, without it always being in relation to the north.

Sarah: I think what one does is to turn the axis sideways. So, one finds

oblique angles through which to revisit one's materials. For example, one can look at a set of photographs and map them onto the kinds of relationships that post-colonial theories suggest we should, and one can make a picture from that, but one can revisit those very same photographs with different questions. I'm thinking for instance of Omar Badsha's representations of Durban. We can read them through the lens of the Indian Ocean, of India, Mauritius, South Africa, China, and what emerges in the photographs is something entirely new. So I'm wondering if playing around with the geographical/political axes doesn't show us something different about the kinds of archives that we have and enable quite exciting new questions. When Badsha's Hari Krishnas walked down one of Durban's main streets as a multi-raced group, what kinds of affiliations across the Indian Ocean were being drawn into Durban and out again? So it just might be about shifting the axes and certainly not reversing them. That wouldn't help anyone at all.

Tamar: That's really interesting. The Badshas are more commonly thought of in relation to the history of documentary photography or images of the dispossessed and oppressed. By turning the axis in the way you suggest, new questions and meanings are made possible. The archive is remade. Even the most liberating insights of post-colonial theory might have become a straitjacket.

Sarah: What I think is quite interesting when you start shifting the axis into the south is that you open up the capacity for registers that an at times po-faced post-colonialist orthodoxy misses: registers of irony and humour, shared by, say, Indians and South Africans when thinking about the 'metropole and the margins' trope. With them come more oblique languages of the political. And, I think, a growing sense that post-colonial theoretical orthodoxies that in some essential ways have been born in London and New York are not offering critical vocabularies that necessarily speak in ways that we can actually use, in Johannesburg or São Paulo. In Johannesburg at present, the most popular cultural form is comedy, especially a comedy line-up called Blacks Only (in fact, a line up of young comedians of all races), which attracts audiences of 3000 people. Academics seem hardly to have noticed, but journalists have. What is interesting about this kind of comedy and satire is that it works by fixing 'race' and immediately unfixing it, drawing it in and then letting it go and finding a language which is generative and subversive.

Colin: Yes, the way in which representational practices can exceed the intentionality of the system that put them in place is critical in every way. Perhaps there are some – the crudest or most vile practices – which don't reproduce anything but system. But there are many occasions where people do perform subjectivities with irony and, importantly, humour. Humour and hurt go together. People do answer back, people stare down disciplinary gazes and the machinery of systems. To not fully see that is to deplete ourselves of the capacity to speak and to be agents. But I guess the point is obvious.

Achille: The dangers of simply inverting categories are enormous. The ones that were used to classify, hierarchise, violate. Reversing these and projecting them against the other, whoever that is, is really not very useful. Especially if one takes into account the fact that

there's a history before colonialism. One thing post-colonial theory does not take sufficiently into account is the fact that, whether we are dealing with Africa, Asia or Latin America, we are dealing with very old societies. There's a history before colonialism and the west doesn't exhaust the historicity of these societies. To come back to a point Riason was making in relation to the future, the fact that the future can be made anew, it seems to me that the moment we are living in right now can best be seen from places such as here, South Africa. If you want to think in terms of the future, maybe it's time to put the west to rest. I think the time has come to leave the west to itself and look elsewhere and look differently. I feel very strongly, as far as Africa is concerned, that the obsession with the west has made it impossible for us to explore various other potentialities written in our long history.

Riason: I really agree with that. Let me give an example, just in terms of museums and curatorial initiatives. Take the SA National Gallery, where so many of its shows have been determined by definitions of modern art from Europe. An exhibition like *Picasso and Africa*, for example, held at the South African National Gallery in 2007. As important an event as it was – claiming to be the first exhibition of Picasso in Africa, it is staged here a hundred years after *Les Demoiselles d'Avignon* was painted. What it shows is that we are still measuring our self-worth in relation to Europe. Our importance and cultural value is still pitted against the art of Europe. So we still operate within the western canon. As much as I appreciate the work of Van Gogh and Picasso and Matisse and a whole host of other modern European and American artists, the point is that we need to give people other options, particularly as we've emerged out of apartheid cultural boycotts and the Cold War scenario that have long isolated us from other ancient civilisations and cultures, particularly in the south. Now we are in a position to have an exhibition from China. We can talk to Cuba and Chile directly and have those kinds of discussions across the south without them always being mediated and determined via the north. So, I think if we shift the focus onto ourselves and our own strengths, we would get a very different scenario; where the emancipated self from the south engages, on equal terms, with partners in the north and with the rest of the world.

Tamar: It's a fine line, isn't it? Between, on the one hand, seizing the initiative and shifting the agenda so that you are at the centre of your own universe and, on the other, constructing a new form of parochialism.

Sarah: I agree that there is a very fine line. At Wits, Isabel Hofmeyr, myself, Achal Prabhala and others have been discussing the idea of living in the aftermath of the many metanarratives that have shaped twentieth-century Africa – colonialism, independence, third-worldism, apartheid, post-apartheid, in the 'wreckages' of a set of utopias and dystopias. The idea is that living in the wreckage, in the ruins, of these grand schemes, can constitute a productive place (Ackbar Abbas reminds us that ruins are always radically incomplete) to think from, enabling us as it does to work with bits and pieces in order to make something else, something less coherent but more complex. It is not a politics of hope, but it is about trying to make something with the assortment of things we have, which we have been left with.

Colin: Yes, and perhaps avoid the saturated melancholic register that one sees in so much 'western' writing. But also, we don't want to fall into a kind of self-satisfied turning inwards. I don't see how anything might be articulated coherently without thinking 'relation'. And open

relationality remains the challenge and the 'interface' (the face that is visible on two sides, with thickness between) is the place we need to theorise and explore. So, thinking about the issue of distance again, one can be simultaneously close and far, or between, but the interface is the figure that can articulate this condition. Otherwise you fall for stabilising the points and planes on either side, perhaps moving to a kind of parochial 'nativism' or, alternatively, submitting to an amorphous 'let's all float in a floating world' in which difference dissipates and almost any politics becomes eviscerated.

Achille: Yes, inhabiting what we are calling the 'interface' is not at all a comfortable position. In fact it's a very difficult position. What is comfortable is to inhabit one side of a coin, stable, fixed and almost immutable. Also, from a purely sociological point of view we mustn't forget that, when we look at the continent, millions of people are living far away from their homes. They are living in camps, some of them more or less permanent, some of them in transitory structures. Most of them are on the way to somewhere else. The destination is not always clear but the drive is there to go somewhere else. Homelessness is not a theoretical construct. It's a condition of lived experience. Being in transition is not the privilege of the elite, in the way in which we understand cosmopolitanism in classical Enlightenment philosophy. It's something else, it's a different order of experience. So I just wanted to make that point so as to bring us back to some clearly historical and sociological facts.

Tamar: Absolutely. And there are very different ways of being on the move. It's dangerous and inaccurate to conflate the cosmopolitan, the refugee, the migrant or the exile. Each has a different relationship to displacement and settlement.

Achille: What is interesting is the element of motion and circulation. Millions of people are not settled and the settler now is somewhat of an anachronism in a continent where millions of people are on the move, where settlement is always provisional. And the refugee or the stranger or the foreigner might now have come to represent a new version of the cosmopolitan.

Tamar: Can we think about some of the specific challenges and anxieties that face this place now, particularly its relationship to Africa and the question of the foreigner? The foreigner has become the unsettling figure *par excellence* here in this fledgling democracy. There are specific issues to be faced from here, about xenophobia and violence. The idea of the foreigner has been much theorised in the north – in the writing of Julia Kristeva for example. But what is the particular way in which the experience from within Africa allows us to theorise this?

Sarah: Each place will generate a particular set of discourses around sameness and difference according to what it needs. We need the concept of the Afropolitan, and we need a conversation about desegregation, but each of these must be fundamentally alert to, and allow themselves to be shaped by the question of xenophobia as well. Xenophobia represents a place where a democratic project falls apart. So, it's a question of finding critical concepts that are shaped from the strains of this sort of violence and can also give people alternative versions of what they want to be.

Colin: The struggle is to keep the worlds we make and inhabit open. That seems to me a very primary struggle because the forces of closure are all around us all the time. So, if one goes back to the metaphor of the interface, the struggle is to keep the faces open and alive and that's politically, theoretically and practically critical.

I also think the anxiety that suffuses much of our work here is very important. I think there's an opportunity in the anxieties of radical openness and estrangement; there is a vital, if rather shapeless energy here. Strangeness and openness have a critical relationship with one another. To go back to what Sarah was saying, there are mechanisms for dealing with anxiety, one thinks about satire, humour, irony, strategies that build on a certain kind of familiarity in the face often of a disturbing terror. There is something fertile here.

Tamar: It's interesting for me to reflect upon how ideas of the stranger – and anxieties around the term – have changed here. I left South Africa in 1979 during a time when there was a stranger around every corner because of the way in which the culture was segregated by law. The organisation of society produced a whole series of internal strangers and strangenesses. So you had a kind of schizoid population, a schizoid national identity, something that was riven at the source, which produced – I think at least for my generation – a deep, deep scepticism about notions of nation, because one knew the cost. There was no way one could identify with a national team, patriotism etc. Now I come back here thirty years later to see an attempt to construct a new notion of nationhood, multicoloured, post-racial, whatever. And there are new kinds of 'others': an African other on the one hand and a western or a European other on the other. There are new forms of othering and new forms of bordering that are going on now.

Sarah: I'm interested in your juxtaposition of the '70s and now. I think there has been a shift in relation to building something we might, even if sceptically, call a sense of South Africanness. We've been through some tough years, but in fact the recent World Cup provides a space from which to reflect on 1994 because it showed us that we have this generative capacity to be and inhabit quite a complex sense of 'South-Africanness'. I think of this as a rhetorical register that is quite precisely of this place and at the same time of being in the world. There are moments of lucidity that do point to the possibility of a shared public understanding of ourselves. They often recede as quickly as they arise, but they do come, are there.

Tamar: How do you feel that the event of the World Cup articulated these tensions and alliances? Something, it seems to me, happened here which confounded expectations, and new identifications and identities seem to have been generated. Was this a significant moment? Is there a shift, in terms of both a new construction of South-Africanness and its negotiation of itself in the global south perhaps?

Riason: I've dreamt about being at a football World Cup ever since I can remember. We only started to see World Cup games in this country very, very late. I saw my first World Cup live on TV in 1990 when it was held in Italy. With sanctions against South Africa in place, just to see it on television was considered a privilege. I come from a football family – three generations of footballers, club managers and club owners. I have been to numerous local professional and amateur games all over the country – from Qwa Qwa to Cape Town, from Tembisa to Laudium. My family was involved in a professional football club from Durban: Manning Rangers (founded in 1928). For me the thousands of football supporters who go to games on a weekly basis were glaringly missing. That silence was deafening. Almost as if the organisers intended it that way, with the access to tickets only being made available via the internet at steep prices, in a country where the vast majority of football supporters are the black working classes, and without internet access. And, I am sorry to say

that for me the World Cup resulted in very little beyond the actual games and a good public image abroad. It was a fleeting moment. We would need a World Cup every day of our lives to sustain this kind of feeling. It was as if people were on some kind of drug for a month. It gave a feeling of goodwill, but the next day people went back to their ordinary lives and closed their doors and put the alarm on. So for me it was a momentary dream when people came out of their realities but then they went back into them. Nothing more. But then again I did see five of the six games in Cape Town, where the majority of fans were white middle class that never frequent local football matches.

Colin: That may be true but there was an incredible feeling here. I had this sensation, just as in 1994, '95, '96, when there were moments of a certain energy, a certain capacity and a certain excess in the places I inhabited, with the people I encountered, to drive, strive and imagine beyond a particular sense of a crisis. And, despite my habitual scepticism, I definitely felt that the energy the soccer spectacle tapped into (whatever else it tapped into) reinvigorated that visionary excitement I recall from those earlier moments. That extraordinary sense of connection is a source of vitality. Even if we don't talk exactly about hope, one does want to see and draw on the extraordinary energy the event liberated.

Achille: For that whole month, I had the feeling of living something extraordinary, but in the full knowledge that it was unique in the sense that it could not be repeated. I felt an urge and willingness to be a part of it because I knew it would end and we would never see it again. And what I saw in Johannesburg, Cape Town, Rustenburg and on TV was the manifestation in the public of deep immense psychic reserves. Though we could have suspected they were there, we didn't know in what form, in what quantities, what densities or qualities. And suddenly they came into the open; I remember on the day of the opening, we drove into town. Johannesburg didn't look the way it usually looks. It was a totally different, almost a surreal space: people blowing their vuvuzelas, talking to each other, smiling, a cacophony of sounds and colours and expressions such as I had never seen in my entire life, anywhere. So, frankly, I would like to keep a memory of that moment, as a fragment of what this place is capable of. Its deep potentialities, in the full knowledge that these moments are indeed unique, in a sense that they are not currently repeated in everyday life. South Africa is struggling with the fact that it's becoming an ordinary country – that is, it's not exceptional. At that moment it felt unique, maybe because over the last few years we have gone through some hard times here. So the World Cup, I think, gave voice to something South Africa could be, but which it is not yet. The challenge now is how we translate that into a political project and cultural project as well.

Sarah: I felt, as Colin did, that there is a correlation between what happened around the World Cup and '94. Njabulo Ndebele made the point that '94 couldn't have happened if there wasn't something quite subterranean that bound people across the lines they so readily reinforced in daily life. It was unexpected, that this sporting event should have turned into a politically redolent moment. South Africa found a fragment of a dreamscape again, reignited some of that earlier sense of potential. I liked the way in which the big push in the newspapers was that if we can do this for sport, we can do this for poverty. So the thing is now, can we harness this energy into a social movement?

Tamar: But the irony is that the machine that it served was the machine of global capital. I think one can't forget that. How does

global capital function as the catalyst through which somatic, social and psychic potentialities become unleashed?

Achille: But that's the miracle of capital. I mean, seeing our ruling class here, which is still speaking about the national democratic revolution, wearing designer clothes and celebrating commercialism at its most extreme, is quite ironic. But it's part of all of that irony and those anachronisms, it's the combination of all of that that produces these psychic states.

Tamar: One of the other things that was produced was an extraordinary display of hybridity, going back to our north, south, east, west dichotomies. The spectacle of the World Cup seemed to provide a space in which those constructions just fell apart, so when one looked at France, one looked at a majority black team; when one looked at Germany, one saw Turks and Africans who were German. Momentarily, and perhaps naively, it seemed as though constructions of identity based on race and origin had collapsed in the interests of new collectivities and experiences shared by so many people.

Colin: Is it not a glimpse of a humanism, of the constant struggle to become human? Is it not that?

Tamar: That's interesting, and it's very relevant to the kind of language that is haunting some of our discussion. We are all the children of the critique of humanism; we know the arguments that have been made as to why humanism is compromised, why it has devalued difference in the interests of the universal subject 'Man', in the context of the Enlightenment project, etc. But is it something worth revisiting from this place and this perspective, and, if so, how?

Collin: I have been thinking a lot about 'humanism' (that awful word) in relation to the visual arts in particular. I am interested in registers of engagement with different kinds of content, different forms around the animal, around the machine, around waste, other things which for me suggests something about our efforts to being and becoming human in a very particular way. I go back to thinking about proximity and distance and face-to-faceness, as we were discussing earlier, and the energies liberated by the World Cup that provide a particularly vivid example of what it might be to be human. The human and what we understand by that seems to offer a centre of gravity here, but I have no idea where it will go, not only because there is this legacy of bad faith humanism that we struggle with, but our deep suspicion of big questions and shapeless big ideas. These lines of thought are congested with disappointment.

Sarah: I think that we are, collectively, hugely wary, as are many people who have lived with liberalism and its legacies. Liberalism produces the opportunity for everyone to speak and no one to bother to listen as long as someone has spoken. So I think it's a really ugly way to proceed. I don't think that we should use notions like the post-racial or necessarily a kind of humanism because it makes so many people so angry, but I think there's a project that we are engaged with around undoing difference and that is because of a very specific history which legislated for difference in this particular place. I think that in the wake of the failures of liberalism and the failures of nationalism, after Nelson Mandela, to offer a language of mutuality, it is part of the challenge of our generation to work at the limits of difference. We need to think not about sameness necessarily, but about the predicaments that fall to us in the wake of a critique of difference and get us into a place from which we might speak across race.

Achille: I think it's a very important question. The critique of 'humanism' is also an integral part of black diasporic thought. But it's a critique of a certain kind of humanism, a form of, in fact, provincialism that masquerades as universalism. That's what we find in Du Bois, in Cesaire, in Fanon, Senghor, all of them. But the other thing we'll find in this tradition of critical thought is a sustained attempt at salvaging some idea of the human or some political project of human mutuality which, in order to be salvaged, needs to take seriously the utopia of a world free of the burden of race. In fact, as long as we keep carrying the cross of race and racism, we won't be able to say anything meaningful about the project of human mutuality. What I find interesting in South Africa, and maybe that's what it means to think from here, is that for the first time in the history of modern societies the project of building a society that is free of the burden of race is being experimented with. The United States of America hasn't been able to do that. Europe is only awakening now to that problem. In Latin America it hasn't been done. This is where it is being experimented with for the first time, institutionally in the reform of the state and in relation to the law. Of course it's still just a project, but we can see it being translated into practice in all sorts of ways in everyday life. So what I saw during the World Cup was as if a little window opened and one glimpsed what it might look like. Some kind of promised land – and then the window closed again. But one wants to hold onto what one has seen whether one will be there to enter the land or not.

Tamar: Perhaps it's only from a space that is so traumatised by race that that kind of imagining can really develop. This remains a country living in the legacy of that trauma and so perhaps it's therefore particularly invested in this glimmer.

Colin: In some ways, it strikes me that the question is alive because the inhuman remains so very alive and present in our history.

Tamar: It interests me to think about the inhuman in a country in which crimes against humanity have been so publically perpetrated and exposed. What is the human in this context? How have the TRC [the Truth and Reconciliation Commission] and its legacies opened up patterns of thinking about this? The mobilisation in public discourse of the concept of ubuntu – of African mutuality and face-to-faceness, if you like – may be a response to this trauma of the inhuman which is still alive in the present.

Sarah: Yes, the drive may be here in the way it might not be in some other places because we have been to such a bad place. There's a connection between the darkness of where we come from and something that we are trying to do and the trauma is both there and not there, it comes back and recedes and reappears. There is also a generational aspect to it. Many people over 40 think in terms of trauma and wound, but the younger generation pushes back against that quite strongly and is looking for a kind of place of wellbeing that is oriented towards the future. Yet it's never that clear on either side of the generational shift, there is always a rising and a falling movement, a taking ownership of the self and then a falling back into wound at certain points. I do think, though, that we are now living in a post-TRC era, in terms of our language and politics.

Achille: Having lived here for ten years and observed what's going on, I am very aware of the TRC, the so-called 'miracle'. But post-TRC, post-miracle, society is facing a serious crisis of language. There is a crisis of language in the sense that society has ended up repeating the trauma in the language in which it wants to talk about it, speaking

in clichés about really significant historical achievements; or it has accumulated a series of dead-ends, a cul-de-sac of language that talks about the past but doesn't make sense of it in a meaningful way or in one that is powerful enough to project it into a new utopia. The challenge is how to move from clichés and noise to a real voice, a voice that speaks to this place beyond universalising generalisations. It's striking that in fact what has happened recently is that South Africa is trying to find a voice in the language of global capital, the World Cup being of course a prime example. The TRC tried to define a new ethics, but now we are in the realm of capital. I'm not saying that that is bad. I'm just saying that the stage has shifted. That now we are all kneeling at the altar of capital and what we are witnessing is that capital is capable of producing paradoxical results.

Riason: I want to link a few thoughts in relation to capital and revolution and a lack of catharsis or healing in South Africa. Frantz Fanon described revolution as being necessary in order to move on. Of course we did not really have a revolution here. So I think in many ways we are living in an experiment. I think we are living in this moment of something unprecedented. I think it will only be understood long into the future. I don't think we should downplay the achievements of what has happened here, but we also need to acknowledge what has not happened. The lack of a revolution and the consequent need for violence in overcoming a very oppressive history; and a black majority that still lives in poverty. How does it play itself out in South Africa? Violent crimes. How does that link to capital? In a very material country, some might interpret that as you are what you own. So if I take something from you of capital value then my own value and worth increases. Crime then becomes necessary in transferring a certain amount of power – the material object that is transferred also contains a power. I think there's a real connection between the excess of crime, necessitated by a desperate need for capital, and the absence of a revolution.

Sarah: Maybe that's right. But: was Fanon right? Do we in fact need violence in order to move on? If we say crime is 'the war that didn't happen', are we assuming too fully that there must be violence in order to constitute social change? It's so hard to read the brutal sociality of crime critically and in a way that's attuned to the complexities of this society.

Tamar: Can we relate some of the questions we've been thinking about in relation to language and sociality, to the issue of representation – and photography in particular? Photography bears the brunt of its particular relationship to ethics and language in this place. We have inherited a powerful narrative of the past. Through the apartheid years only a certain kind of photography was regarded as ethically defensible. This was the photography of witness and resistance set against the backdrop of an iconophobic culture and state censorship. It was a culture permeated by prohibitions against excess, pleasure and knowledge, and photography became the privileged medium of exposure and truth-telling with black and white as the favoured vehicle for doing this. So there's this very specific history – not only formally but ethically – that contemporary photography has to negotiate. And in addition there's the weighty legacy of objectification and ethnographic essentialism that permeates the long history of colonialism. So it's a huge ask, isn't it?

Sarah: I am not sure we've got over that yet. For example, white people continue to photograph black people and very few black people photograph white people. So, I find it refreshing when I look at Nontsikelelo Veleko's work to see that she sometimes

photographs young white women. I wish young people at the Market Photo Workshop would take a camera and go and photograph in the suburbs. And then I think we would start to get an interesting set of incendiary images pushing against the history of photography and the history of segregation in this country. It is striking, I think, the degree to which virtually every book of photographs which comes out is either about black people or it's about white people when there are, and have been, many social spaces in everyday life in which white and black people encounter one another, closely or remotely or both. There are images to be found in the work of Goldblatt, Badsha, Veleko, Muholi and others that do draw on and examine a rubric of racial entanglement, though we haven't yet put them together and considered them. I think there is work to be done, collectively, on a project of desegregation in curating our visual concepts. I also think that South Africans still get photographed as if they live only in the Cape Flats or only in Soweto, as if they somehow don't often move through multiple spaces in the course of one day, as if they do not, more than most perhaps, traverse space.

Achille: In a sense, photography here has a hard time dealing with motion and circulation. It knows how to deal with fixities and circumscriptions and single moments. So the question is, how might photography in South Africa inhabit those historical practices of migrancy and movement? The big thing in the history of South Africa is movement. The whole history of races in South Africa is around a history of movement, around who has the right to move and who should be mobilised. The challenge for photography is to negotiate that now, when we are no longer in the age of apartheid. I don't think it has worked out how to do this. The other crisis, it seems to me, is even more serious. It has to do with the crisis of the image in an age of spectacle in the ways in which Guy Debord tried to talk about it in the '60s. Some of the features he described have not materialised but many of them have – and in proportions he himself never imagined. So we cannot think of photography without critical reflection on the status of the image and the issue of spectacle at a time when the image is itself in crisis.

Tamar: I wonder if the area in which something profound has shifted is in relation to questions of sexuality. I think that there has been a real opening up of the possibility of photography as the space for articulating, shifting and shaping new subjectivities and sexualities. There are very young artists like Lunga Kama and Mary Sibande who play with identity and self-representation through photography, for example. Or Andrew Putter who takes on the painted ethnographic past and implodes it through mimetic restagings of putative historic subjects. Then there's Zanele Muholi's performative practice in which she enacts the role of a lesbian beauty queen or a female Jacob Zuma surrounded by his wives. Most recently she has parodied the excesses of the current political establishment in her *I'm Just Doing my Job* image, in which she represents herself semi-naked, covered only in offal and accompanied by two 'handmaidens' in reference to the much publicised and criticised birthday celebration of the Black Empowerment business man, Kenny Kunene, that cost R700.000, and included the serving of sushi off the naked torso of a hired model. All the registers of irony and parody that we talked about earlier are mobilised here. And of course, Sabelo Mlangeni in projects like *Country Girls* explores cross-dressing and transvestism in a documentary mode. Even an artist who is slightly older like Zwelethu Mthethwa plays with gender codes in his series *The Brave Ones* that harnesses the idea of spectacle and

theatricality to an image of feminised masculinity. All sorts of social and sexual taboos are mobilised in these practices.

Colin: Taboos are really interesting. And the relationship between iconophobia, scandal and subversive sexualities needs to be explored. It reminds me of the recent furore that surrounded Zanele Muholi's representations of lesbian intimacy (amongst other things) in an exhibition in Constitution Hill when the Minister of Arts and Culture Lulu Xingwana stormed out, offended by the scenes and actions that were pictured. But transgression and taboo don't only have to do with sexuality. I am thinking also of the recent scandal caused around the appearance of a rather indifferent painting (not a photograph) of a post-mortem of Mandela titled *The Anatomy Lesson*. The artist Yuill Damaso's reworking of Rembrandt's extraordinary *Anatomy Lesson of Dr Tulp* brought to the fore the anxiety that centres around the figure of Mandela, his body, his iconicity.

Achille: What I found interesting in the response to the representation of Mandela's death and autopsy was the reaction of the ANC. They likened it to 'witchcraft', which seemed at first to be really crazy, but we have to remember that, in some ancient African traditions, the image is something that is imbued with tremendous power and ambiguity. So I am wondering whether the term 'witchcraft' here is not a way of referring to the power of images and the idea that the handling of images has to be disciplined to guard against all sorts of dangers, especially in relation to death and the body.

Colin: It's almost a religious notion of what death is, and the tenacious power of the image. The long, clear and present history of iconoclasm, of course, comes to mind.

Achille: I'm interested in the moment when the artistic act turns into public scandal. For instance, when the Minister of Culture goes to the Muholi exhibition, which the Ministry itself has partially funded, and sees the pictures and walks away, as if to say these images cannot be seen in public or cannot be seen by certain kinds of people or do not really represent who we are or who we want to be. Or in the case of the representation of Mandela's autopsy. It's quite interesting to notice that scandal erupts whenever matters of the body, sex, sexuality and death are brought together in some form of relationship. So, I think that there's still some serious work to be done at this point in the history of power and politics in South Africa, and that maybe it is important to explore to what extent it is the space of scandal and outrage that can be expanded as a condition that liberates and frees language. As a response to the crisis of language, we might begin by responding to the moment language – photographic, musical, whatever – creates scandal. Maybe we need more of a scandalous, blasphematory set of practices in order to rethink the present. You throw a hand grenade and then everything explodes. So you throw it in the field of sexuality, in the field of this and that, and you jam the logics of closure, including linguistic closure, because it always starts from there.

Colin: One of the great things about these debates is that they do show the power of art to animate and undo, to violate, a whole range of practices and habits of thought. What is really heartening about these controversies is that they still happen, there is still power there, there's still a whole dimension of the image that troubles us to the point of direct action.

Riason: Fortunately we have a great constitution that can be used to embarrass those who may be out of tune with it. But of course, these controversies do raise other issues too. It's not only about the 'scandalous' content of the works. We are talking about a coded visual language here which all of us around this table are able to unpack and see in context. But I think we have to understand that the majority of the population in this country has not been through any form of art education; under apartheid it was non-existent in the Bantu Education schooling system. That's a really simple thing, but it's a key to understanding why, for example, most parliamentarians do not visit art galleries unless they have some official role, such as opening an exhibition. There's a whole generation for which modern western and contemporary art has been an abstract concept or is seen as foreign and elitist. This is fundamental because we are actually speaking in an esoteric language that is outside of the reference of the majority's education in this country. The lack of attention to art education in township schools has not improved since 1994, which is so necessary if we are to grow new appreciative art audiences, art educators, artists, critics and curators of the future.

Achille: I agree that we are dealing with sophisticated forms of art or language that may not be widely intelligible. So when they are presented in public they create friction, which suggests that there is still a set of boundaries, officially recognised or implicit, within which a legitimate photographic/musical/literary discourse is allowed. So what someone like Muholi is doing clearly falls outside of those boundaries and that's why it creates a scandal. So I'm interested in what those boundaries are, such that certain works are received without any problem while some other works might create polemics. I'm interested in those boundaries and how we identify them and how we make sure that they are destroyed, so as to allow for a multiplicity and diversity of languages, a sort of linguistic epiphany, which is a necessary condition, not only for the sustenance of the democratic project, but also as a condition for a greater aesthetic impact of South African cultural production. It won't have an impact if it's not part of that linguistic epiphany, or its impact will be limited. We have to resist the forces of closure.

Tamar: I am wondering whether, artistically, that is expressed in the irreverence of the younger generation. There is a kind of healthy disobedience towards political and artistic orthodoxies and ideas of taste. I am thinking, for example, of the series by Kudzanai Chuirai, based on African leaders, in which he's looking at stereotypes of African masculinity, deriving from African-American popular culture, icons from sport, the pop industry as well as the tradition of the African studio portrait. There's something very irreverent about the way Chuirai plays with icons and iconicity, with the photograph acting as a space for performance and a hyper or excessive form of display.

Sarah: And of course his process stands for the 'anti-document' in every possible way. It exemplifies the negation of the old apartheid categories and the ethical/aesthetic orthodoxies of the past. Because you can't pin them down and fix them eternally. I like that about these works. I think it's socially productive for us. The problem with the hold of documentary has been that it has only rendered certain things visible. And there was a way of seeing that documentary imposed on its subjects, so I think one can play around in numerous ways with the conditions of the not-seen. One can implode the tyranny of the visible. This is particularly important for us because the history of blackness in this country is caught between invisibility and hyper-visibility or spectacle.

Tamar: This of course returns us to the issue of the ethnographic gaze and the hyper-spectacularisation of the 'native' body.

Riason: I think that the ethnographic gaze is still with us. I think particularly in relation to South African photographers working on the continent, who come from a documentary background, and who, in my view, are producing images of the continent that conform to myths of the continent, intended for an elite, white audience in South Africa but also a western audience in general. I think that's a crucial aspect to South African photography right now which is gaining enormous international exposure and which links directly to photography produced a hundred years ago when white colonial photographers used the black subject as exotic objects for dissemination in Europe. South Africa has been isolated from the rest of the continent over recent decades and so in many ways South Africa is only starting to discover what the rest of the continent is about, and often via white South African photographers or CNN. In many ways it is a return to the cycle of old patterns of power and representation on the continent, as it was a century ago. Only this time white South African photographers are offering the new colonial gaze of the continent. And this is extremely problematic, especially if you think that the hunger and the markets that demand and consume these images are in North America and Europe.

Achille: For me such images are not very interesting either from a political point of view or even from an artistic point of view because, however hard they try, the terms of conversation are always determined by long-held stereotypes and I don't really see what kind of innovation one can introduce in that predictable narrative. We know it so well; it has been there for centuries, those representations of the continent as the dark place of misery, pestilence and witchcraft. I'm still waiting to see a serious disruption of that narrative. So I don't find it interesting. What I find interesting is a whole set of initiatives emerging in the field of writing, for instance in the journal *Chimurenga*, which is based in Cape Town, where a certain insurrectionary appropriation of language is going on in order to re-imagine what African sexuality, politics, ethics could be, outside of western colonial frames as well as outside of nativist ones. It seems to me that that is where the edge is and what is in gestation; what is emerging out of what otherwise people consider to be ruins. So the question is, how do we build on those fragments of the emergent in order to imagine a different kind of future? It seems to me that, as far as Africans are concerned, that is what is the demand of our times. Not really the recycling of stereotypes under a marvellous gaze.

Sarah: My feeling is that we haven't intellectually put enough pressure on photography in this country. I think it's important to allow critical encounters to happen across what are presented as discrete bodies of photography. If we put Zanele Muholi and Pieter Hugo alongside one another and allow them to rub up against one another in unpredictable and open-ended ways, it may be a way of seeing more clearly which bits of each speak (to and through the other) and are productive and which aspects fall into silence. I think there's got to be a push to rethink these things now, especially in relation to anachronicity. We have to question what should be relegated now to the past and to issue challenges to the received narratives of our history, whether it's to do with documentary or the ethnographic. We need to find a place from which to begin to do something different.

Achille Mbembe is a research professor in history and politics at the University of the Witwatersrand, Johannesburg, South Africa. He is the author of many books, including *On the Postcolony* (University of California Press, 2001). His latest book is *Sortir de la grande nuit. Essai sur l'Afrique decolonisée* (Paris, Editions La Decouverte, 2010).

Riason Naidoo is a curator and artist. He has a special interest in photography and is author of *The Indian in DRUM magazine in the 1950s*. Naidoo is director of the South African National Gallery, part of Iziko Museums in Cape Town.

Sarah Nuttall is Professor of Literary and Cultural Studies at the Wits Institute for Social and Economic Research (WISER) at the University of the Witwatersrand, Johannesburg, South Africa. She is the author of *Entanglement: Literary and Cultural Reflections on Post-Apartheid*, and co-editor, most recently, of *Johannesburg – The Elusive Metropolis* and *Load Shedding: Writing On and Over the Edge of South Africa*.

Colin Richards is currently Professor at the Michaelis School of Fine Art, University of Cape Town, South Africa. He is an artist and writer and has published extensively on contemporary South African art.

Exhibition Checklist

Jodi Bieber
Claire, from the series 'Real Beauty', 2008
Pigment print on cotton rag paper
Goodman Gallery, Cape Town / Johannesburg
80 x 100.5 cm

Jodi Bieber
Babalwa, from the series 'Real Beauty', 2008
Pigment print on cotton rag paper
Goodman Gallery, Cape Town / Johannesburg
80 x 100.5 cm

Jodi Bieber
Gail, from the series 'Real Beauty', 2008
Pigment print on cotton rag paper
Goodman Gallery, Cape Town / Johannesburg
80 x 100.5 cm

Hasan and Husain Essop
Blessing Meat; Sunrise Farm, from the series 'Halaal Art', 2009
Pigment print on cotton rag paper
Goodman Gallery, Cape Town / Johannesburg
All images 53.5 x 83.5 cm

Hasan and Husain Essop
Night before Eid; Feeding Scheme, from the series 'Halaal Art', 2009
Pigment print on cotton rag paper
Goodman Gallery, Cape Town / Johannesburg
All images 53.5 x 83.5 cm

David Goldblatt
Blitz Maaneveld, from the series 'Ex-Offenders', 2008
Gelatin-silver print
Goodman Gallery, Cape Town / Johannesburg
36 x 46.5 cm

David Goldblatt
Errol Seboledisho, from the series 'Ex-Offenders', 2010
Gelatin-silver print
Goodman Gallery, Cape Town / Johannesburg
36 x 46.5 cm

David Goldblatt
Hennie Gerber, from the series 'Ex-Offenders', 1996
Gelatin-silver print
Goodman Gallery, Cape Town / Johannesburg
36 x 46.5 cm

David Goldblatt
Refugees from Zimbabwe sheltering in the Central Methodist Church on Pritchard Street, Johannesburg, 22 March 2009, 2009
Gelatin-silver print
Goodman Gallery, Cape Town / Johannesburg
47 x 58 cm

David Goldblatt
Peter Mogale's advert at the corner of 11 Avenue and 3 Street Lower Houghton, Johannesburg, 20 November 1999, from the series 'Tradesmen', 1999
Pigment print on cotton rag paper
Goodman Gallery, Cape Town / Johannesburg
46.5 x 37 cm + 37 x 37 cm

David Goldblatt
Ericson Ngomane's advert, Republic Road, Darrenwood. 17 February 2000, from the series 'Tradesmen', 2000
Pigment print on cotton rag paper
Goodman Gallery, Cape Town / Johannesburg
46.5 x 37 cm + 37 x 37 cm

Pieter Hugo
Pieter and Maryna Vermeulen with Timana Phosiwa, from the series 'Messina/Musina', 2006
C-type print
Michael Stevenson gallery, Cape Town
170 x 136 cm

Pieter Hugo
Yaw Francis, Agbogbloshie Market, Accra, Ghana, from the series 'Permanent Error', 2009
C-type print
Michael Stevenson Gallery, Cape Town
82 x 82 cm

Pieter Hugo
Abdullahi Mohammed with Mainasara, Lagos, Nigeria, from the series 'The Hyena and Other Men', 2007
C-type print
Michael Stevenson Gallery, Cape Town
100 x 100 cm

Pieter Hugo
Kwadwo Konado, Wild Honey Collector, Techiman District, Ghana, from the series 'Wild Honey Collectors', 2005
Pigment print on cotton rag paper
Michael Stevenson Gallery, Cape Town
82 x 82 cm

Pieter Hugo
Loyiso Mayga, Wandise Ngcama, Lunga White, Luyanda Mzantsi, Khungsile Mdolo after their initiation ceremony. Mthatha, South Africa, from the series 'Homelands', 2008
C-type print
Michael Stevenson Gallery, Cape Town
100 x 125.64 cm

Kudzanai Chiurai
The Minister of Finance, from the series 'The Black President', 2009
Pigment print on cotton rag paper
Goodman Gallery, Cape Town / Johannesburg
150.5 x 100 cm

Kudzanai Chiurai
The Black President, from the series 'The Black President', 2009
Pigment print on cotton rag paper
Goodman Gallery, Cape Town / Johannesburg
150.5 x 100 cm

Kudzanai Chiurai
The Minister of Education, from the series 'The Black President', 2009
Pigment print on cotton rag paper
Goodman Gallery, Cape Town / Johannesburg
150.5 x 100 cm

Kudzanai Chiurai
Untitled I, 2010
Pigment print on cotton rag paper
Goodman Gallery, Cape Town / Johannesburg
60 x 90 cm

Terry Kurgan
Santos Cossa; Shumani Matshavha; Stephanie Mabotja; John Makua, Godfrey Ndlovu; Robert Madamalala, from the series 'Park Pictures', 2004
Pigment prints on cotton rag paper
Gallery AOP, Johannesburg
92.5 x 61 cm

Terry Kurgan
Aerial Map of the Joubert Park Precinct in the inner city of Johannesburg, marking the fixed positions of forty photographers who were working in Joubert Park in 2004
Reprinted in 2010
Collection of the artist
67.5 x 83 cm

Selection of unclaimed photographic portraits taken by the Park Photographers named below
1. Godfrey Ndlovu
2. Godfrey Ndlovu
3. Gibson Moyo
4. Gibson Moyo
5. Mduduzi Ntshangase
6. David Selpe
7. Jabulani Mpofu
8. Mduduzi Ntshangase
9. Khulelani Mdalose
10. John Makua
11. Robert Madamalala
12. Oscar Khumalo
13. Robert Zwitavahthu
14. Robert Madamalala
15. Varrie Hluzani
16. Stephanie Mabotja
17. Varrie Hluzani
18. Santos Cossa
19. Santos Cossa
20. Robert Zwitavahthu
Collection of Terry Kurgan
10 x 15 cm

Sabelo Mlangeni
*Madlisa; Innocentia aka Sakhile;
Xolani Mgayi, Estanela; Lwazi
Mtshali, 'Big Boy'; Palisa; Big Boy*,
from the series 'Country Girls', 2009
Gelatin-silver prints
Michael Stevenson Gallery,
Cape Town
36.5 x 24 cm

Sabelo Mlangeni
*Nipple; Mshana; Morning Blue;
Usbali visits the hostel*, from the
series 'Men Only', 2008–2009
Gelatin-silver prints
Michael Stevenson Gallery,
Cape Town
35 x 24 cm

Sabelo Mlangeni
Bheka's Room, from the series
'Men Only', 2008–2009
Gelatin-silver prints
Michael Stevenson Gallery,
Cape Town
27 x 27.5 cm

Sabelo Mlangeni
Rolling On, from the series 'Men
Only', 2008–2009
Gelatin-silver prints
Michael Stevenson Gallery,
Cape Town
26 x 26.5 cm

Sabelo Mlangeni
Men Only, from the series 'Men
Only', 2009
Gelatin-silver print
Michael Stevenson Gallery,
Cape Town
24 x 36.7 cm

Santu Mofokeng
*Nousta, Rister and Noupa Mkansi
at home in Dan, Tenzeen. Their
parents Richard and Onica are
both dead*, from the series 'Child-
Headed Households', 2007
Pigment print
Lunetta Bartz, Maker Gallery,
Johannesburg
110 x 160 cm

Santu Mofokeng
*Rister Mkansi in the Family Kitchen,
1, 2 & 3*, from the series 'Child-
Headed Households', 2007
Pigment prints
Lunetta Bartz, Maker Gallery,
Johannesburg
20 x 32 cm

Santu Mofokeng
*Ishmael after washing with holy
ash at Motouleng Cave, Free
State*, from the series 'Chasing
Shadows', 2004
Gelatin-silver print
Lunetta Bartz, Maker Gallery,
Johannesburg
67 x 100 cm

Santu Mofokeng
*Christmas church service,
Mautse Cave*, from the series
'Chasing Shadows', 2000–2006
Gelatin-silver prints
Lunetta Bartz, Maker Gallery,
Johannesburg
38 x 57.5 cm

Santu Mofokeng
*Mthunzi and Meisie making
supplications to the ancestors
inside the Motouleng Sanctum,
Free State*, from the series
'Chasing Shadows', 2000–2006
Gelatin-silver prints
Lunetta Bartz Maker gallery,
Johannesburg
37.9 x 57.4cm

Santu Mofokeng
*Prayer service at the altar on the
Easter Weekend at Motouleng
Cave, Free State*, from the series
'Chasing Shadows', 2000–2006
Gelatin-silver prints
Lunetta Bartz, Maker Gallery,
Johannesburg
38 x 57.5cm

Santu Mofokeng
*Prayer service at the altar on the
Easter Weekend at Motouleng
Cave, Free State 1*, from the series
'Chasing Shadows', 2000–2006
Gelatin-silver prints
Lunetta Bartz, Maker Gallery,
Johannesburg
38 x 57.5cm

Zanele Muholi
Martin Machapa, from the series
'Beulahs', 2006
Digital C-type print
Michael Stevenson Gallery,
Cape Town
100 x 75.5 cm

Zanele Muholi
*Mini and Le Sishi, Glebelands,
Durban*, from the series
'Beulahs', 2010
Digital C-type print
Michael Stevenson Gallery,
Cape Town
100 x 75.5 cm

Zanele Muholi
*Puleng Mahlati, Embekweni,
Paarl; Tumi Mokgosi, Yeoville,
Johannesburg; Refilwe Mahlaba,
Thokoza, Johannesburg*, from
the series 'Faces and Phases',
2007–2010
Gelatin-silver prints
Michael Stevenson Gallery,
Cape Town
76 x 50.5 cm

Zanele Muholi
*Lerato Marumolwa, Embekweni,
Paarl; Nosipho 'Brown'
Solundwana, Parktown,
Johannesburg; Amogelang
Senokwane, District Six, Cape
Town*, from the series 'Faces and
Phases', 2007–2010
Gelatin-silver prints
Michael Stevenson Gallery,
Cape Town
76 x 50.5 cm

Zanele Muholi
*Bakhambile Skhosana,
Natalspruit; Sosi Molotsane,
Yeoville, Johannesburg;
Tumi Mkhuma, Yeoville,
Johannesburg*, from the series
'Faces and Phases', 2007–2010
Gelatin-silver prints
Michael Stevenson Gallery,
Cape Town
76.5 x 50.5 cm

Jo Ractliffe
Left to right:
*Woman and her baby, Roque
Santeiro Market; Schoolgirls'
uniforms, Roque Santeiro
Market; Flour seller, Roque
Santeiro Market; Video Club,
Roque Santeiro Market*, from the
series 'Terreno Ocupado', 2007
Gelatin-silver prints
Michael Stevenson Gallery,
Cape Town
All images 36 x 45 cm

Jo Ractliffe
*Woman on the footpath from Boa
Vista to Roque Santeiro Market*,
diptych from the series 'Terreno
Ocupado', 2007
Gelatin-silver print
Michael Stevenson Gallery,
Cape Town
All images 60 x 75 cm

Jo Ractliffe
*Details of tiled murals at the
Fortaleza De São Miguel,
depicting Portuguese
explorations in Africa*, from the
series 'Terreno Ocupado', 2007
Gelatin-silver prints
Michael Stevenson Gallery,
Cape Town
All images 35 x 35 cm

Berni Searle
*Once Removed (Head I, II, III);
Once Removed (Lap I, II, III)*, from
the series 'Once Removed', 2008
Pigment prints on cotton rag
paper
Michael Stevenson Gallery,
Cape Town
All images 102 x 84.5 cm

Mikhael Subotzky
Street Party, Saxonwold, from
the series 'Security', 2008
Digital C-type print
Goodman Gallery, Cape Town /
Johannesburg
80 x 100 cm

Mikhael Subotzky
Wendy House VI, from the series
'Security', 2009
C-type print
Goodman Gallery, Cape Town /
Johannesburg
168 x 118 cm

Mikhael Subotzky
Wendy House II, from the series
'Security', 2009
C-type print
Goodman Gallery, Cape Town /
Johannesburg
168 x 118 cm

Guy Tillim
All images titled *Petros Village, Malawi*, from the series 'Petros Village, Malawi', apart from *Chimombo Chikwahira, Rayina Henock and Masiye Henock, Neri James*, 2006
Pigment prints on cotton rag paper
Michael Stevenson Gallery, Cape Town
All images 43.5 x 66.5 cm (except FF.78 55.5 x 83 cm)

Roelof Petrus Van Wyk
Koos Groenwald Fig.4, Fig.1, Fig.2, from the series 'Young Afrikaner – a Self Portrait', 2010
Pigment prints
Collection of the artist
100 x 133cm

Roelof Petrus Van Wyk
Jeanna Theron Fig.1; Yo-Landi Vi$$er Fig.1; Natasha Maria Fourie Fig.1, from the series 'Young Afrikaner – a Self Portrait', 2010
Pigment prints
Collection of the artist
100 x 133 cm

Roelof Petrus Van Wyk
Daniel Swanepoel Fig.3, Fig.2, Fig.1, from the series 'Young Afrikaner – a Self Portrait', 2010
Pigment prints
Collection of the artist
100 x 133 cm

Nontsikelelo 'Lolo' Veleko
Katlego, Johannesburg; Kepi I; Kepi II; Sibu IV, from the series 'Beauty is in the Eye of the Beholder', 2003–2010
Pigment prints on cotton rag paper
Goodman Gallery, Cape Town / Johannesburg
All images 38 x 25 cm

Nontsikelelo 'Lolo' Veleko
Subu VIII; Vuyelwa; Lesego, Miriam Makeba Street, Newtown, Johannesburg; Girl on Long Street, Cape Town, Western Cape, from the series 'Beauty is in the Eye of the Beholder', 2003–2010
Pigment prints on cotton rag paper
Goodman Gallery, Cape Town / Johannesburg
All images 38 x 25 cm

Graeme Williams
Soweto; Glen Cowie; Marquard, from the series 'The Edge of Town', 2004–2007
Collection of the artist
All images 54 x 80 cm

Graeme Williams
Springfontein; Victoria West; Intabazwe Township, Harrismith, from the series 'The Edge of Town', 2004–2007
Collection of the artist
All images 54 x 80 cm

Graeme Williams
Lower row, left to right:
Khayelitsha Township, Graaff-Reinet; Hanover; Cape Town, from the series 'The Edge of Town', 2004–2007
Collection of the artist
All images 54 x 80 cm

Zwelethu Mthethwa
Untitled, from the series 'The Brave Ones', 2010
C-type print
Jack Shainman Gallery, New York
124.5 x 170.2 cm

Zwelethu Mthethwa
Untitled, from the series 'The Brave Ones', 2010
C-type print
Jack Shainman Gallery, New York
124.5 x 170.2 cm

Zwelethu Mthethwa
Untitled, from the series 'The Brave Ones', 2010
C-type print
Jack Shainman Gallery, New York
124.5 x 170.2 cm

Photographic Credits

Page 6: courtesy of MAKER © Santu Mofokeng.

Page 10: courtesy of Michael Stevenson, Cape Town © Pieter Hugo.

Page 15: courtesy of Museum Africa, Johannesburg.

Page 16: Fig. 6, courtesy of the artist and White Cube; Figs. 7-9, courtesy of Michael Stevenson, Cape Town © Zanele Muholi; Fig. 10, courtesy of George Eastman House, International Museum of Photography and Film.

Page 19: © National Library of South Africa.

Page 20: © Duggan-Cronin Collection, McGregor Museum, Kimberley, South Africa

Page 23: courtesy of MAKER © Santu Mofokeng.

Page 24: Figs. 22/23, © Duggan-Cronin Collection, McGregor Museum, Kimberley, South Africa; Fig. 24, courtesy Michael Stevenson, Cape Town © Zanele Muholi.

Page 26: Fig. 25, © Pitt Rivers Museum, University of Oxford; Fig. 26, © Duggan-Cronin Collection, McGregor Museum, Kimberley, South Africa.

Page 29: © Tate, London, 2010.

Page 30: Fig. 28, courtesy of the artist; Figs. 29-31, courtesy of the artist and Goodman Gallery, Johannesburg.

Pages 33/34: © Constance Stuart Larrabee Collection, Eliot Elisofon Photographic Archives, National Museum of African Art, Smithsonian.

Page 36: Figs. 37/38/39/41, © Bailey's African History Archives, Johannesburg; Fig. 40, courtesy of the artist.

Page 37: Fig. 42, © Bailey's African History Archives, Johannesburg; Fig. 43, © Sunday Times – South Africa.

Page 40: © The Ernest Cole Trust. Image courtesy of the Hasselblad Foundation and the Ernest Cole Trust.

Page 42: Fig. 46, courtesy of the artist; Fig. 47, courtesy of the artist © Paul Weinberg; Fig. 48, courtesy of the artist © Gideon Mendel; Fig. 49, courtesy of the artist and the Centre for Curating the Archive, University of Cape Town; Fig. 50, © Paul Weinberg / CCA / UCT Library.

Page 44: Fig. 51, courtesy of the artist and Goodman Gallery, Johannesburg; Figs. 52/53, courtesy of MAKER © Santu Mofokeng.

Page 46: Fig. 54, courtesy of the artist © Gideon Mendel; Fig. 55, courtesy of the artist © Gideon Mendel / Mlungisi Dlamini.

Page 49: courtesy of Michael Stevenson, Cape Town © Sabelo Mlangeni.

Pages 50/51: Figs. 59/60, courtesy of Michael Stevenson, Cape Town © Jo Ractliffe; Fig. 61, courtesy of the artist © David Lurie.

Page 54: Figs. 62/63, courtesy of the artist and Goodman Gallery; Figs. 64/65, courtesy of Michael Stevenson, Cape Town © Guy Tillim.

Page 55: courtesy of Michael Stevenson, Cape Town © Pieter Hugo.

Page 57: courtesy of Michael Stevenson, Cape Town © Pieter Hugo.

Page 61: courtesy of the artist and Jack Shainman Gallery, New York.

Page 62: Figs. 76/77, courtesy of the British Library; Fig. 78, courtesy of the artist and Jack Shainman Gallery, New York.

Page 63: Figs. 79-82, courtesy of the artist © Paul Weinberg; Figs. 83/84, courtesy of the artist.

Page 66: courtesy of the artist and CCA/UCT Library.

Page 67: Figs. 88-90, courtesy Axis Gallery, New York, and the Mohanlall Family Estate; Fig. 91, courtesy the artist; Fig. 92/93, courtesy of Goodman Gallery, Johannesburg.

Page 69: courtesy of Terry Kurgan.

Page 73: Fig. 100, courtesy of the artist and Goodman Gallery, Johannesburg; Figs. 101/103/104, courtesy of Goodman Gallery, Johannesburg; Fig. 102, courtesy of the artist and Michael Hoppen Gallery.

Page 74: courtesy of the artist and Goodman Gallery, Johannesburg.

Pages 89-95: courtesy of the artist and Goodman Gallery, Johannesburg.

Pages 99-105: courtesy of the artist and Goodman Gallery, Johannesburg.

Pages 108-115: courtesy of the artists and Goodman Gallery, Johannesburg.

Pages 119-129: courtesy of the artist and Goodman Gallery, Johannesburg.

Pages 132-139: courtesy of Michael Stevenson, Cape Town © Pieter Hugo.

Pages 142-149: courtesy of the artist.

Pages 152-161: courtesy of Michael Stevenson, Cape Town © Sabelo Mlangeni.

Pages 164-171: courtesy of MAKER © Santu Mofokeng.

Pages 174-181: courtesy of the artist and Jack Shainman Gallery, New York.

Pages 185-191: courtesy of Michael Stevenson, Cape Town © Zanele Muholi.

Pages 194-203: courtesy of Michael Stevenson, Cape Town © Jo Ractliffe.

Pages 207-211: courtesy of Michael Stevenson, Cape town © Berni Searle.

Pages 215-219: courtesy of the artist and Goodman Gallery, Johannesburg.

Pages 222-227: courtesy of Michael Stevenson, Cape Town © Guy Tillim.

Pages 230-237: courtesy of the artist © Roelof Petrus van Wyk.

Pages 240-249: courtesy of the artist and Goodman Gallery, Johannesburg.

Pages 253-261: © Graeme Williams.

Page 264: courtesy Fred Torres Collaborations © David LaChapelle.

Page 265: courtesy of Kehinde Wiley Studio and Roberts & Tilton, Culver City, California.

Pages 266/267: courtesy of the artists and Goodman Gallery, Johannesburg.

Page 276: courtesy of Galerie Seippel, Köln.

Page 278: courtesy of the artist.

Page 280: courtesy of Michael Stevenson, Cape Town © Sabelo Mlangeni.

Page 282: courtesy of MAKER © Santu Mofokeng.

Page 285: courtesy of the artist and Jack Shainman Gallery, New York.

Page 288/289: courtesy of Michael Stevenson, Cape Town © Zanele Muholi.

Page 293: courtesy of Michael Stevenson, Cape town © Berni Searle.

Page 295: courtesy of the artist.

Standard Bank is delighted to partner with the V&A to present Figures & Fictions: Contemporary South African Photography. Since its founding in Port Elizabeth in 1862, the Bank has become a deeply rooted part of South Africa, with representation in 17 African countries, as well as many others abroad.

In addition to its significant Corporate Art collection, the Standard Bank Gallery was opened in 1990 in the heart of downtown Johannesburg to showcase local and international art. It also hosts the annual Standard Bank Young Artist Award. Three of the participants in Figures and Fictions have been recipients of this prestigious award (Nontsikelelo Veleko, 2008; Pieter Hugo, 2007 and Berni Searle, 2003). Standard Bank continues its commitment to introducing audiences to emerging artists and reflecting the diversity of the arts in Africa.

 Standard Bank